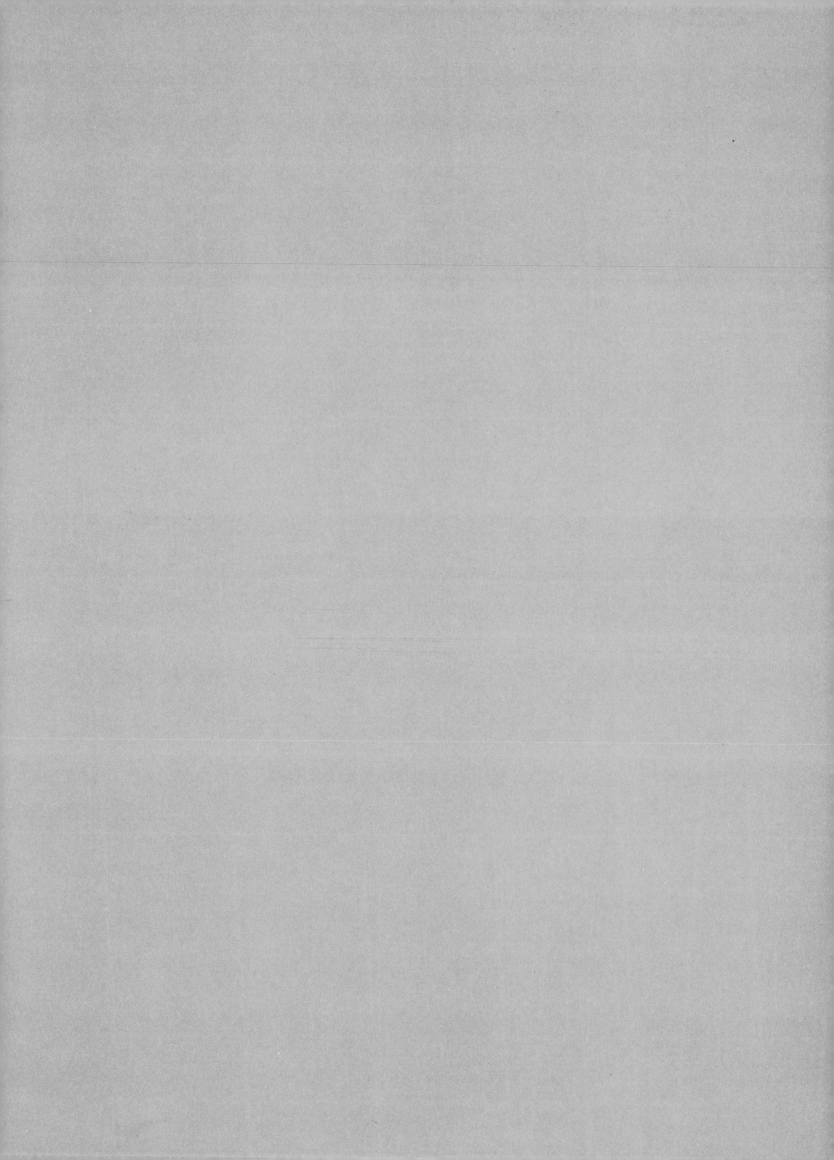

THE HUNGARIAN NATIONAL GALLERY

THE HUNGARIAN NATIONAL GALLERY

Edited by

ANNA SZINYEI MERSE

Written by

Éva R. Bajkay, Enikő Buzási, Géza Csorba,
István Dévényi, Anna Jávor, Viktória L. Kovásznai,
Gizella Szatmári, Anna Szinyei Merse, Antal Tóth,
Gyöngyi Török

Preface by

Lóránd Bereczky

CORVINA

CONTENTS

© Anna Szinyei Merse

Authors: Éva R. Bajkay (p. 15, 92–103),
Lóránd Bereczky (Preface),
Enikő Buzási (p. 33–34, 38–38 [above]),
Géza Csorba (p. 13–14, 70–89),
István Dévényi (p. 16, 104–115),
Anna Jávor (p. 35–37, 39 [below]),
Viktória L. Kovásznai (p. 14–15, 90–91),
Gizella Szatmári (p. 6–8, 16–19),
Anna Szinyei Merse (p. 9–12, 40–64),
Antal Tóth (p. 12–13, 66–69),
Gyöngyi Török (p.8–9, 21–32)

Title of the Hungarian original: Magyar
Nemzeti Galéria
Translated by Ervin Dunay and Zsuzsa Gábor

Colour photographs by Zsuzsa Bokor and
Tibor Mester
Black–and–white photographs by Zsuzsanna
Berényi, Zsuzsa Bokor, Katalin Fehér and
Tibor Mester

Photos for the chapter on the history of the
museum by Tibor Mester, National
Protectorate of Historic Monuments (p. 17),
Mária Szenczi (p. 16 top)

Cover photograph by András Dabasi

Design by Éva Illyés

Published by Corvina Books, Ltd.,
1051 Budapest, Vörösmarty tér 1, Hungary
Printed at Dürer Printing House, Gyula, 1994

ISBN 963 3929 7

This volume has been published with the support
of the MAGYAR KÖNYV ALAPÍTVÁNY (Hungarian Book Foundation).

PREFACE

The history of the Hungarian National Gallery, which was founded only in 1957, comprises two very distinct periods. In the first fifteen years of its existence, the curators collected only 19th- and 20th-century works of art by Hungarian artists, and artists living and working in Hungary. The collection became historically complete during the early 1970s, when the works of artists from previous ages, previously held in the Museum of Fine Arts in Budapest, were added to the Gallery's growing collections, and the museum itself was moved to its present location, the central tract of the Royal Palace of Buda.

The National Gallery's increased scope of interest, of course, brought with it a number of major conceptual changes in both the theoretical and the practical work of the curators. After the Gallery's move to its new home, in addition to allocating the space, ensuring the day-to-day running of the institution and establishing the proper communication channels with other institutions of its kind, an operational mode had to be devised as well for the acquisition, scientific processing and publication of material that spans in time from the foundation of the Hungarian State in 1001 A.D. to the present. It was this historically huge scope of interest that made the Hungarian National Gallery the preeminent treasuretrove of the Hungarian fine arts.

At the present time, the Hungarian National Gallery consists of three great collections: The Old Hungarian Collection, The Nineteenth- and Twentieth-Century Collection, and the Modern Collection, and this reflects the way in which the exhibitions themselves are organized. The aim was to present the development of the fine arts as accurately as possible within the context of Hungarian history. This endeavour is stated in the Gallery's programme as follows: *"The Hungarian National Gallery grew out of the traditions of galleries and museums established to promote the flourishing and development of the fine arts in Hungary. In this sense, the word "national" has a two-fold meaning; on the one hand, it means that the works of art stored, processed, and displayed here, and the values they represent, all belong to the nation. On the other hand, it also refers to the historical mission of the museums and galleries founded in Hungary at the end of the last century."*

In keeping with the definition of "national" in its initial programme, the Hungarian National Museum will continue to evolve as a vital part and chronicler of the spritual and intellectual life of the country.

LÓRÁND BERECZKY
Director

THE HISTORY OF THE HUNGARIAN NATIONAL GALLERY AND ITS COLLECTIONS

The Hungarian National Gallery was founded in 1957 as a public collection. It was established to document the origins and the development of the fine arts in Hungary. The way to its foundation was prepared, however, by popular movements which hoped to introduce bourgeois reforms to Hungary in the first decades of the 19th century. Concrete steps were first taken by the establishment of a National Museum and the National Picture Gallery and later a Museum of Fine Arts and the Picture Gallery of the Capital. It was from these latter that all the Hungarian fine arts material from paintings, sculptures and coins, through drawings and prints were brought together in 1957 to form the backbone of the first national museum dedicated to the fine arts in Hungary.

1802 Count Ferenc Széchényi made a generous offer, which was eventually legislated in 1807. According to this, Széchényi *donated in full his vast library of select books, valuable coins, collection of coat of arms of eminent families, together with his maps, pictures and manuscripts, to the Hungarian nation, thus showing commendable magnanimity by laying the foundations of a future national museum.'* However, the number of paintings thus bequeathed to the nation still did not reach a dozen in 1816. In 1823 István Ferenczy's marble sculpture in Classicist style, *Shepherd Girl*, was donated by Palatine Joseph. Using funds coming in from public donations, the National Museum purchased two large paintings on historical subjects in 1826, one showing Miklós Zrínyi's heroic charge on the Turks from the fortress of Szigetvár, the other depicting the coronation of Emperor Francis I in Buda in 1792, both painted by Peter Krafft.

1832–1836 The Diet purchased Miklós Jankovich's collection, including nine 15th- and 16th-century easel paintings from Northern Hungary which previously formed part of various triptychs. In 1836 János Pyrker, the Bishop of Eger, donated to the country his collection which consisted of 196 paintings. However, the work of only one Hungarian painter featured in the collection; the others were the works of masters of the great Italian, Dutch, Spanish and German schools. One Hungarian work, Károly Markó the Elder's painting entitled *The Pearls of St. Hajdan,* illustrated a

similarly entitled poem written by the Bishop.

June 7, 1840 The Art Society of Pest (the *Pesti Műegylet*), founded in the previous year, organized its opening exhibition in the Redoute. With its careful selection and high quality, this was the first true "art show" in Pest.

1845 The Society for the Foundation of the National Gallery was established explicitly for the patronage of Hungarian art. Its aim was *"to purchase and to popularise the most notable works made by artists, of the past or the present, who were either born in the friendly association of countries united under the Holy Hungarian Crown, or were settled down here."* The deed of foundation further declared that the works purchased must be *"intended to enrich the national collections of the National Museum"*; furthermore, Article 6 stated that the location of the Society *"[should be] next to the National Museum's collection of paintings, of which, being the property of the Nation, it continually form a department".* The aim of the museum was *"to explore the lives and art of former and contemporary artists, to record their life-story and to compile a list of their works, as well as to purchase the most outstanding of these",* and even to have copies made of certain Hungarian works of art found abroad.

March 19, 1846 On St. Joseph's Day, the name-day of their patron Palatine Joseph, the Society opened its first exhibition in the building of the National Museum. The Society continued to function until 1875, when it merged into the National Fine Arts Association, founded in 1861.

September 8, 1851 The National Picture Gallery was opened as an independent department of the museum. With regard to its aims, tasks, area of interest, and nationwide authority, the National Picture Gallery was the precursor of the Hungarian National Gallery. The Picture Gallery wished to secure the funds necessary for the regular purchase of works of art by raffling high quality lithographs, though it also came by new acquisitions through donations by private individuals, societies, and institutions. Miklós Barabás's beautiful painting, *Roumanian Family off to the Fair,* was, for example, donated to the collection in 1846 by the Pest Corp of Civic Guards. During

the 1860s further valuable pieces were acquired by the Picture Gallery. In 1863 the Art Society of Pest donated two works, Ágost Canzi's *Grape Harvest Near Vác* (in 1860) and Mór Than's *Recruiting Before 1848.* In 1861 Bertalan Székely sent home his work entitled *The Discovery of the Body of King Louis the Second* from Munich. Another two of his paintings, *Dobozi and his Spouse* and *Women of Eger*, were purchased in 1862 from donations by the women of Székesfehérvár and Eger, respectively. In 1864 the industrialist Mihály Gschwindt of Pest donated to the museum Miklós Izsó's sculpture *Sad Shepherd.* Viktor Madarász's work *Péter Zrínyi and Ferenc Frangepán in the Wiener-Neustadt Prison* was acquired by the Picture Gallery in 1866 as a present from Miksa Teleki.

1862 The paintings were divided into four groups to form the Portrait Gallery, the General Gallery, the Pyrker Gallery, and for the Hungarian material, the National Picture Gallery.

1865 After several decades of preparation, the gallery of the Esterházy family opened in the halls on the second and third floors of the Hungarian Academy of Sciences. Only two of the 637 pictures, formerly held in Vienna, were believed to be the work of Hungarian painters: *Girls after the Ball* by József Borsos and *Bathing Girls* by József Molnár.

1868 Edited by Director Ágoston Kubinyi, the catalogue of the newly-arranged gallery of the Hungarian National Museum was published. It was the first Hungarian-language catalogue covering the material of an entire museum department. Bálint Kiss, who was appointed curator of the Gallery in 1847 and remained in that position until his death in 1868, was followed by Antal Ligeti, who then continually improved on the presentation of the dynamically increasing collection.

1870 The State purchased the Esterházy Collection. In 1871 the valuable collection consisting of approximately 55,000 pieces was given the name of The National Gallery. Still in the same year, Imre Henszlmann, "the father of Hungarian art historians", proposed in Parliament the unification of the two galleries and the raising of a larger and more appropriate building to accommodate the joint collection.

1872 The doyen of Hungarian art historians, Arnold Ipolyi donated a sixty-piece collection of early Italian paintings to the National Gallery. Later he augmented his donation with Hungarian easel paintings which he had bought when he was bishop of Besztercebánya.

1880 The legislative body of Budapest allocated an annual sum of 4,000 forints to the patronage of the fine arts. Part of the money from this fund was used to purchase Imre Greguss's painting, *Home Guards' Camp*. Simultaneously, the elected representatives of Budapest called on the government to set up similar funds.

1888 As evidenced by the former inventory of the National Gallery, the Director Károly Pulszky ordered the rearrangement of the paintings according to their place of origin. Paintings produced in the schools of Amsterdam, Delft, Haarlem, etc., as well as those produced in Hungary during the 15th and 16th centuries by artists such as the Master of Okolicsnó, were displayed in separate rooms.

1896 The country's leadership commemorated Hungary's thousand-year existence as a nation by issuing important decrees in the field of culture. One seciton of the so-called Millennial Act announced the establishment of the Museum of Fine Arts. During the Millennial Celebrations, the government spent 200,000 forints on purchasing works by Hungarian artists.

December 1, 1906 The Museum of Fine Arts opened in Heroes' Square. Ernő Kammerer became the first director of the public collection, which united the holdings of the National Picture Gallery and the National Gallery. At that time, the museum consisted of the Old Collection, the Modern Collection, and the Collection of Prints and Drawings. A Sculpture Hall was added on the ground floor, which was intended to illustrate the universal development of sculpture from Antiquity until the 19th century with the help of plaster copies. In these collections, the works of Hungarian and foreign artists were displayed side by side.

1907 The Museum of the Capital City of Budapest opened in Stefánia út, in the Palace of Exhibitions, where the National Exhibition of 1885 was

held. It primarily collected works of art which were somehow connected to the capital: fragments of buildings, the designs of works of art which were found in public buildings or in public areas, etc. (Collection was begun back in 1887 by Chief Archivist László Toldy on the suggestion of Károly Gerlóczy, Deputy Mayor of Budapest.) The aquarelles, drawings, prints and oil paintings showed the various parts of Budapest. Gyula Benczúr's large canvas, *The Recapture of Buda Castle*, which was commissioned by the city council on the two-hundredth anniversary of the ousting of the Turks from Buda, was also exhibited here.

1912 The fabulous Pálffy Collection was acquired by the Museum of Fine Arts. Gábor Térey, the departmental head of the museum, re-organized the exhibition in the interest of introducing the collection, separating the works of foreign artists from the works of Hungarian masters. In the exhibition, which showed the works in chronological order, separate rooms were assigned to the Markó family. A considerable number of works were also on display by such greats as Károly Lotz, Mihály Zichy, Mihály Munkácsy and László Paál, together with the Biedermeyer artists and those attending the Munich Academy. Historical paintings were also shown in a room of their own. Three rooms and a cabinet were reserved for the more recent artists.

1914 The appointment of the art critic Elek Petrovics launched twenty-one years of rapid growth for the Museum of Fine Arts. His name is associated with the work of preparing the way for the transfer of old Hungarian works from the Museum of Applied Arts and the National Museum to the Museum of Fine Arts. His carefully planned purchases, together with the donations of his art-patron friends, helped complete the collection, in terms of quality and quantity alike, on a scale never experienced before. By launching the publication of the museum's yearbooks, Petrovics also contributed to the invigoration of research work.

1920 Petrovics reorganized the Modern Gallery, adding to it the works purchased after 1913, as well as material dug out from store-houses and safe-custody. In the area of new acquisitions, too, the museum benefited from his excellent connections with contemporary artists.

October 23, 1921 The Count Jenő Zichy Museum of the Capital City of Budapest opened in the first-floor halls of the School of Industrial Design. The bequest, which came complete with an impressive ethnographical and archaeological collection, went into the city's possession in 1911. Besides 17th-century Dutch and Flemish art and 16th, 17th, and 18th-century French painting, Hungarian art was also represented by, among others, Ádám Mányoki (*Portrait of Count Werthern*),

Károly Markó the Elder (*Fishermen, Biblical Scene, The Desert*), and Antal Ligeti (*Rocky Landscape*).

1928 In order to rationalize the growing number of new acquisitions and in order to highlight Hungarian art more to its advantage, Elek Petrovics reorganized the exhibitions. He set up the New Hungarian Gallery on the first floor of the former building of the Palace of Exhibitions (now housing the Academy of Fine Arts), where the works of contemporary artists and their immediate forerunners were shown, beginning with the establishment of the Artists' Colony of Nagybánya. Contemporary art was represented by 79 works. Károly Ferenczy was represented with 18 paintings, József Rippl-Rónai with 11 paintings and four drawings, Adolf Fényes and János Nagy Balogh with six paintings each, and László Mednyánszky and János Vaszary with five paintings each. Due to the shortage of available space, the 15 sculptures were exhibited only through illustrations (for example, János Pásztor's *Girl Carrying Water,* István Szentgyörgyi's *Playing Boy,* Fülöp O. Beck's *The Artist's Portrait,* and Vilmos Fémes Beck's *Female Dancer*).

1933 A permanent exhibition entitled 'Gallery of the Capital City Budapest' opened in the Károlyi Palace. Jenő Zichy's collection of paintings and sculptures was put on display as well as works of art acquired after 1880, such as Miklós Barabás's *Self-Portrait* and *The Portrait of Mrs. István Bittó,* Géza Mészöly's *Landscape of Lake Balaton with Cows,* József Rippl-Rónai's *Woman with Bird-cage,* Károly Ferenczy's *Joseph Sold into Slavery by His Brothers,* István Csók's *Reclining Nude,* Lajos Gulácsy's *Encounter of Dante and Beatrice,* István Szőnyi's *Mother,* Vilmos Aba-Novák's *An Old Town in Sicily;* furthermore, *The Sower* by János Pásztor, *Horseman* by György Vastagh the Younger, *Toldi Wrestling with the Wolves* by János Fadrusz, *Tom Thumb* by Ede Telcs, *Éva* by Fülöp Ö. Beck, *The Artist's Wife* by Alajos Stróbl, and *Faun and Nymph* by József Róna.

1934 An agreement was reached concerning the transfer of the works of old Hungarian art from the National Museum to the Museum of Fine Arts. The practical realization of the plan continued until 1940. The works of art thus transferred included the Tabernacle of Trencsén, two *Virgin Maries from Toporc,* the *Altar of the Virgin Mary from Csíkmenaság,* the *Altar of St. Anne* and *The Annunciation Altarpiece from Kisszeben,* and the *Altar of the Assumption of Mary Magdalene* from Berki.

1935 Following Elek Petrovics's retirement, Dénes Csáky, the new director, had the material of the New Hungarian Gallery returned to the building of the Museum of Fine Arts. The exhibitions organized in the old Palace of Exhibitions after 1939 featured the works of modern artists from abroad.

1944 During World War II a number of valuable works of art disappeared, while several others were destroyed or taken out of the country. Especially great was the damage caused by the hasty, unprepared evacuation of the most valuable pieces. The majority of the paintings were moved back to the museum between 1946 and 1947.

1949 In the Museum of Fine Arts permanent exhibitions were opened one after the other, including one in which the New Hungarian Gallery introduced the museum's 19th- and 20th-century paintings. The material of the Old Hungarian Collection was temporarily put up in two halls.

1952 As a result of the joint effort by the New Hungarian Gallery and the Gallery of the Capital City of Budapest, an exhibition of 20th-century art was opened in the building of the Picture Gallery of the Capital entitled 'From Nagybánya until Today'. The exhibition of 1954, which consisted of 318 works, was entitled 'Hungarian Painting until the Country's Liberation'. Important temporary exhibitions were also mounted, one of the works of Pál Szinyei Merse (1948), another of the works of Mór Than (1953), and a third in honour of Gyula Rudnay (1953–1954). A Munkácsy-exhibition was held in the Palace of Exhibitions in 1952. Also, several travelling exhibitions were organized.

1953 The Budapest Gallery was merged into the Museum of Fine Arts, thus uniting all the Hungarian art holdings of public collections in one place.

1957 The establishment of the Hungarian National Gallery was decided upon. The new gallery was to be established by integrating the New Hungarian Gallery of the Museum of Fine Arts, the Department of Modern Sculpture, the Department of Prints and

Detail of the assembly hall in the Curia, the former building of the National Gallery with paintings and sculptures by Mihály Munkácsy and Alajos Stróbl

Drawings, and the Department of Coins and Medals, in order to form a separate national museum for the fine arts. At the time, the collection consisted of 6,000 paintings, 2,100 sculptures, 3,100 medals and coins, 11,000 drawings, and 5,000 prints. The new museum was opened on October 5, 1957, in the building formerly housing the High Court in Lajos Kossuth tér. The exhibitions comprised Hungarian works produced between the early 19th century and 1945. For almost a quarter-of-a-century, the Gallery was headed by Gábor Ö. Pogány.

1959 In line with the custom in other countries, the government appointed the Royal Palace of Buda as the future location of the National Gallery. The building, set aside for cultural and educational purposes, was also going to accommodate the Historical Museum of Budapest, the Museum of the Working Class Movement (now the Museum of Modern History) and the National Széchényi Library. The work of moving the Gallery's collections to the new building, just then renovated, began in 1973.

October, 1975 The Hungarian National Gallery opened its doors in the Royal Palace of Buda. By then the collections had been augmented with material from the Old Hungarian Department of the Museum of Fine Arts. In 1974 the Department of Contemporary Hungarian Art was set up. As a result of the above additions, the entire history of art in Hungary from the 11th century until today was covered. During the following decades, the permanent exhibitions were reorganized several times.

1983 A permanent exhibition of 20th century Hungarian art up until the 1970s was opened.

1986–1987 The permanent exhibition of 19th century art was reorganized.

1988 The Ludwig Foundation of Hungary was set up; the event was accompanied by an exhibition show-

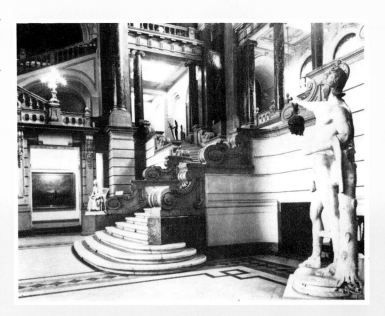

ing the works of 69 contemporary artists from abroad from the Ludwig Collection of Aachen.

1989 Although not as part of the collection, the crypt of the Habsburg Palatines was opened within the museum building.

THE OLD HUNGARIAN COLLECTION

During the 19th century the Romantic partiality for the Middle Ages was manifested in the growing popularity of collecting, as a result of which the museums acquired a large number of excellent works of Hungarian art. The paintings, sculptures and carvings made between the early Romanesque and the late Baroque periods — and originally stored in a number of different places — were first united under the name of Old Hungarian Collection in the Museum of Fine Arts in 1934. When the Hungarian National Gallery moved into the Royal Palace of Buda, it also took over the Old Hungarian Collection of the Museum of Fine Arts, thus allowing the presentation of both old and more recent Hungarian works in one museum.

The collection consists of nearly a thousands items made between the 11th century and the end of the 18th century. These works of art were all created in the territory of historical Hungary, and although some of them were produced by artists who originally came from abroad, their works, too, have by now become an organic part of Hungarian culture. The most significant pieces of the collection are the winged altarpieces, paintings and

wood sculptures made during the 15th and 16th centuries. The Romanesque and Renaissance periods are represented with fewer works of art than their true significance would normally justify. The Romanesque period is mainly represented by stone carvings.

As far as we know, the oldest pieces of the collection are those altar paintings which were acquired by the museum owing to the artistic discernment of the collector and art patron Miklós Jankovich. Although the place of origin of most of these pieces is not known, they include such major works of art as the altar paintings *The Flagellation of Christ* from 1514 and *The Mass Celebrated by St. Mark*. The Baroque works include a sketch of the main altar painting of the Cathedral of Nagyvárad by Gáspár Bachmann.

The National Museum began to collect those Romanesque stone carvings which now enable us to appreciate the high standard of medieval architectural sculpting. The most typical works of Romanesque art were made during the reign of the kings of the Árpád dynasty (1000–1301). The enormous capital decorated with animal figures, found at Dömös, praises the work of 12th-century sculptors. Important architectural and sculptural fragments from the 13th-century cathedral of Kalocsa were uncovered during the excavations carried out by Imre Henszlmann during the last century. *András Báthory's Madonna,* one of the most important works of Hungarian Renaissance art, was donated to the National Museum in 1815 by László Kálmán, Bishop of Vác. The sculptures of *St. Stephen*, *St. Ladislas*, and *St. Emericus* were all removed from the pediment of the St. Elisabeth

Church of Kassa because of the poor condition they were found to be in during the renovation of the church building in 1859–1860. The city of Kassa donated these sculptures to the National Gallery in 1863.

The museum deliberately focused on the collection of works of medieval art. It purchased two altar wings from Csíksomlyó, and two complete triptychs from Csíkszentlélek and Csíkmenaság respectively, one in 1914 and the other in 1915. Then, in 1916–1917, the National Museum purchased the following works: the *Virgin Mary Altarpiece* and the *St. Nicholas Altarpiece* from Nagyszalók, the *St. Andrew Altarpiece* and the *Virgin Mary Altarpiece* from Liptószentandrás, as well as the *St. Anne Altarpiece* with the altars of two canonized bishops from Leibic. These altars and paintings, together with other objects of applied art from the same period, mostly liturgical objects, were shown to the public in the form of a historical exhibition. Between 1936 and 1939 the museum handed over these works of art, together with some Baroque paintings, to the Old Hungarian Collection of the Museum of Fine Arts. The majority of the Baroque paintings, including such works as the *Epitaph Tablet* of Anna Rozsályi Kun, Wife of István Tárkányi, or the royal portrait series painted around 1600 by an unknown master in Hungary and showing St. Ladislas, St. Stephen, and St. Emericus, had formerly been held in the Hungarian Historical Painting Gallery.

In spite of the rather haphazard nature of its acquisitions, in 1888 it became possible to include a room dedicated to old Hungarian art among the exhibitions of the National

Gallery. This tradition was continued in 1906, when the Museum of Fine Arts opened its Old Paintings Gallery with a small Hungarian collection. Some major works of art were also acquired around this time. For example, Master M.S.'s painting, *The Visitation*, was purchased in 1902.

Up until 1974 the ceiling of the museum's Trecento Hall was decorated with the coffered wooden ceiling from Gógánváralja purchased in 1903. *The St. Martin Altarpiece* from Cserény, held in the Church of Our Lady (the Matthias Church) in Buda since 1880, was transferred to the Museum of Fine Arts between 1901 and 1907. In 1909 *St. John the Baptist* from the Kisszeben high altar was taken over from the Museum of Applied Arts; after 1928 this work was exhibited in the Marble Hall of the museum. During the fighting in 1944, the altar was seriously damaged, and is presently being restored. Following the persistent research by the art historian Kornél Divald, the two altarpieces from Kisszeben, *St. Anne* and *The Annunciation,* were also transferred to the collection of the Museum of the Applied Arts. Until 1934, these precious masterpieces were exhibited in the central hall.

The Museum of Applied Arts continued to transfer material to the Museum of Fine Arts, including a fine collection of Baroque sculptures in the 1950s. The most important pieces of the collection were the wooden sculptures which served as models for the tomb of the Esterházy princes, the carved heads of the stalls of the Cathedral of Pozsony (Bratislava), and the *St. Donat* and *St. Florianus* representations from Körmöcbánya, the latter two by Dionysus Stanetti.

The organized collection, processing and exhibition of old Hungarian art in the Museum of Fine Arts became possible with Elek Petrovics's appointment as head of the museum. After the First World War, Petrovics enlarged the medieval and Baroque exhibitions, putting them in a separate room. He also purchased major works of art, and most importantly, he prepared and began the transfer and union of all the works of old Hungarian art found in the other great museums. In addition, he greatly contributed to the cataloguing of the museum's holdings. It was at this time that a number of works, assumed to be made by artists working in Hungary, were transferred to the Old Hungarian Collection from the various departments of the Museum of Fine Arts. One such piece, the fragment of a Renaissance fountain from the Royal Palace of Buda, was acquired by the Museum of Fine Arts from the bequest of the sculptor István Ferenczy in 1902. Its curiosity is that its motifs were used by Ferenczy for the design of the monument entitled *King Matthias on Horseback.* (The sketches are in the Department of Prints and Drawings of the National Gallery.)

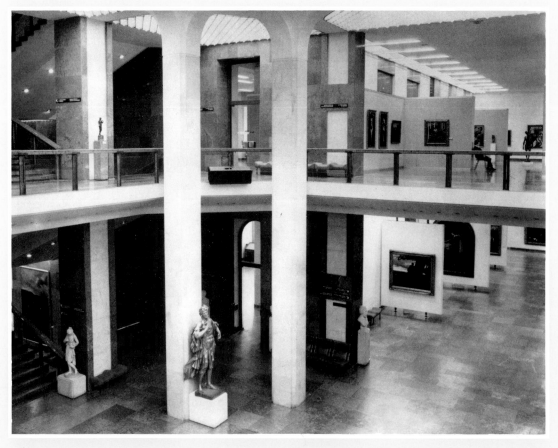

Detail of the first and second floor exhibition

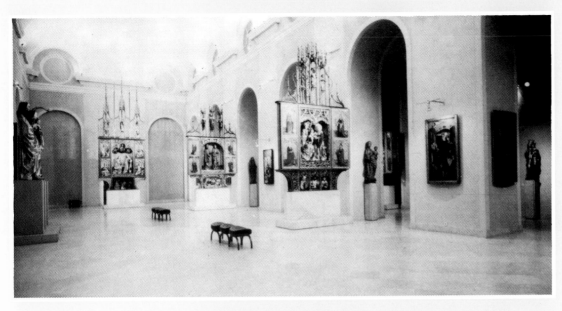

Exhibition of triptychs in the former Throne Hall

Of the Baroque paintings, Ádám Mányoki's *The Portrait of Prince Ágost II* was acquired by the Museum of Fine Arts in 1877 from the Esterházy Collection; the paintings by Jakab Bogdány and Tóbiás Stranover, one from each artist, were purchased in London in 1907. Four still-lifes by Jakab Bogdány, two landscapes by József Orient, and *The Portrait of Prince Ferenc Rákóczi II* by Ádám Mányoki were all donated to the collection by Marcell Nemes between 1908 and 1925. The *Self–portrait* of the Pozsony sculptor Antal Marschall was acquired by the museum in 1912, and two fine sculptures from Egervár by Philipp Jacob Straub, *St. Sebastian* and *St. Roch,* in 1916. As a result of the transfer of material from the Picture Gallery of the Capital and from the National Centre of Museums and Monuments, the collection of Baroque paintings and sculptures expanded considerably during the 1950s. János Márton Stock's *Portrait of Sámuel Teleki* and Antal Taferner's *Self-portrait* are just two examples of paintings transferred from the Picture Gallery of the Capital.

Elek Petrovics was sent into retirement and therefore was unable to complete his large-scale plans. Under Dénes Csánky's direction the plan of uniting the old Hungarian art in a single collection was, indeed, carried through, although the medieval material was completely shut off from the public, and only the works of Baroque art were exhibited. As a result, the enumeration, processing and publishing of the material of the Old Hungarian Collection became very difficult after the war.

Between 1952 and 1970, Dénes Radocsay was entrusted with the management of the collection in the Museum of Fine Arts. The first complete corpus of medieval Hungarian

paintings (1955) and wooden sculptures (1967) was the result of his methodical research. It was also during this period that the regular restoration of the items began. And although there were only two modest-sized rooms available for the permanent exhibition of the most important pieces, with the help of a few temporary exhibitions the public's attention was drawn to the importance of Hungarian works of art made in the past. Exhibitions entitled 'Ádám Mányoki' (1957), 'Old Art in Hungary' (1959), and 'Renaissance Art in Hungary' (1969) were organized at home, while the showing of the museum's material abroad began in Neuchâtel and Paris in 1966, in London in 1967, in Moscow in 1971, and in Rome in 1972. The most beautiful pieces of the collection, together with the modern collections of the Hungarian National Museum, were shown in the Royal Palace of Buda in 1969, during the 22nd International Conference on Art History, under the title 'Hungarian Masterpieces'.

In 1973 the transfer of the Old Hun-

garian Collection from the Museum of Fine Arts to the Hungarian National Gallery and the setting up of the Department of Old Hungarian Art, together with the accompanying restoration workshop, were organized by Mrs László Gerevich and Gyöngyi Török. The setting up of the permanent exhibitions of medieval art and the scheduling of restoration work are also associated with their names. Between 1976 and 1989, the department was headed by Miklós Mojzer.

The beginning of the transfer of the collection was marked by the exhibition entitled 'Old Art in the Hungarian National Gallery', held in 1974 in the building formerly accommodating the Curia, or the High Court of Justice. The Hungarian National Gallery opened its doors in the Royal Palace of Buda in 1975 with a representative selection, including the winged altarpiece of Csíkmenaság which was set up in the dome. In 1976 the National Museum handed over to the Gallery two major works by Georg Raphael Donner — two angels from the high altar of the Cathedral of Po-

zsony (Bratislava), which legally had belonged to the Old Hungarian Collection since 1936. The heavy figures made of lead were transferred to the National Museum in 1875, as the Baroque high altar had been taken off ten years earlier, to be replaced by a Neo-Gothic altar.

The first permanent exhibition of the National Gallery, the show of Baroque art, was opened in 1979 on the first floor of Building D; later it was reorganized several times, as new acquisitions were added to the collection, partly purchased from the Church and from private collectors, and partly borrowed from other museums. The significant growth of the collection is also associated with Miklós Mojzer's name, who managed to acquire paintings by such eminent Central-European Baroque artists as Franz Anton Palko, Caspar Franz Sambach, and Christoph Paudiss.

The permanent exhibition of Baroque paintings and sculptures was successfully complemented by two temporary exhibitions: in 1980 there was a graphics exhibition entitled 'Baroque Plans and Sketches (1650–1760)', followed by the showing of the 'Ancestral Galleries of Aristocrats and Family Portraits from the Hungarian Historical Painting Gallery' in 1988.

Medieval art was also moved to its final location. More complete than ever, the material was arranged according to painters, schools, chronology and topography. The permanent exhibition of 14th-century wooden sculptures and 15th-century paintings and wooden sculptures was opened in the ground-floor rooms of Building D; then, in 1980, the medieval stone collection from the period between the 9th and the 15th centuries was opened in the hall of Building D. The Late-Gothic winged altarpieces have been on display in the Throne Room of the Palace since October 1982. The dimensions of this magnificent hall make it suitable to present the high altars with their soaring pediments, of which 15 have been insalled until now. Such an exquisite collection of complete winged altarpieces is rare, anywhere in the world.

The exhibition of Renaissance art is based on the research of Jolán Balogh, the outstanding expert of the period, and was opened in Schallaburg in Austria in the same year. In 1983 the exhibition entitled 'King Matthias and Renaissance Art in Hungary: 1458–1541' was also opened. The Renaissance stone collection, which was set up on the ground floor of Building C near the main entrance in 1985, owes its origin to that exhibition.

THE COLLECTION OF NINETEENTH-CENTURY PAINTING

The best part of 19th-century Hungarian paintings found their way into public collections rather late and often by chance. As a result of the nation-

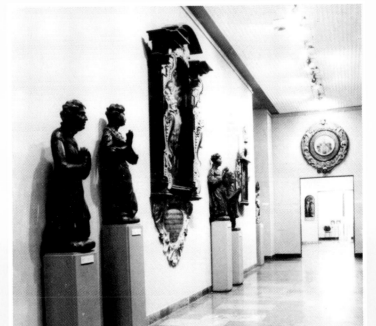

Detail of the Baroque exhibition

wide collecting work of the Society for a National Picture Gallery, an organization established to promote a collection of Hungarian paintings (a rather modest collection during the decades immediately following the establishment of the Hungarian National Museum), 52 paintings by 29 Hungarian artists were displayed permanently in the National Picture Gallery in 1851. Besides the five landscapes by Károly Markó the Elder, which featured both in the Pyrker Collection and among the purchases of the Pest Art Society, Hungarian art of the period was mostly represented by the paintings of Miklós Barabás, János Donát, Károly Kisfaludy, Bálint Kiss, Antal Ligeti, Jakab Marastoni, Soma Orlai Petrich, and Mihály Zichy. The paintings donated by the artists themselves were supplemented with pictures bought from the money donated by enthusiastic Hungarian patriots, and so the modest collection could be increased continuously in spite of the complete lack of official funding. The Art Society of Pest donated to the museum a number of paintings, the lithographic copies of which were distributed among members of the Society as membership gifts. The Society also bought paintings for the museum from its own savings. It was then that the Picture Gallery Society bought, in addition to the pictures by József Molnár, Mihály Kovács and Mór Than, Viktor Madarász's masterpiece, *The Mourning of László Hunyadi.* Among the new acquisitions of the 1850s, two bequests deserve special mention, that of Károly (Charles) Brocky, who worked and died in England, and of the art writer Zsigmond Ormós. The new additions of the 1860s began with eight landscapes purchased from Markó's bequest in Florence. The majority of the new acquisitions were, however, recently finished historical paintings. Four large compositions by Bertalan Székely were bought from public donations, while the Art Society donated Sándor Wagner's *Titusz Dugovics* and Madarász's *Ilona Zrínyi.* The Picture Gallery Society bought for the museum Gyula Benczúr's first historical painting, *The Mourning of László Hunyadi.* Munkácsy's painting, *Storm in the Plains,* made in Munich, was also purchased around this time.

After the Compromise between Hungary and Austria in 1867, which to some extent eased political tensions, a welcome change took place in the life of the National Museum, as the Ministry of Religion and Public Education, the museum's newly appointed supervisory body, was able to help the painting collection by regularly funding competitions for painters from government money. Having incorporated the Art Society first and the Picture Gallery Society next, the National Fine Arts Society gradually became the most important counselling organization of official art policy, and as such, it acquired a major influence on the purchase of works of art.

At the time of its foundation in 1871, the National Picture Gallery owned only a very small number of paintings by Hungarian painters (works by József Borsos and József Molnár). Yet its birth had a pronounced influence on the Hungarian material exhibited in the National Museum, since both in 1875 and in 1877, it was able to swap its old paintings for the National Picture Gallery's modern paintings and, at the same time, it could enlarge its exhibition of Hungarian paintings. Later this rearrangement laid the foundations of the Old Gallery and the Modern Gallery, which at that time still incorporated the Hungarian paintings.

In the last quarter of the 19th century, the size of the National Picture Gallery's collection underwent a dramatic increase. Even though there was a decrease in public donations for particular works of great importance, the store-rooms continued to receive paintings in large numbers, sent as presents. People from all walks of life — aristocrats and clergymen, as well as members of the nobility and the bourgeoisie, and of course the artists themselves — readily sent their donations to the museum. In addition, the number of government purchases continued to grow. They went ahead with the purchasing of the most important historical paintings — this was the one subject in which the museum strove for completeness. The monumental works of a number of artists educated at the Munich Academy, and called the Academic painters, were made especially for museums (Gyula Benczúr: *The Baptism of Vajk,* Sándor Liezen-Mayer: *St. Elizabeth of Hungary*). Finally, the landscapes and the genre-paintings also made their way into the museum. In 1871 Gusztáv Kelety's *The Park of the Exile* was purchased; Géza Mészöly's *Fisherman's Shack by the Lake Balaton* followed suit in 1877. Nevertheless, a great deal of time still had to pass before those artists who followed a new approach to nature were given their due place within the museum's walls.

Another urgent task was the acquisition of works by those artists who had made a name for themselves abroad, most notably the painter Mihály Munkácsy. In fact, this wildly popular painter was asked to make copies of some of the works he had already sold, explicitly for the museum. *(The Condemned Cell* was one such painting, and this was exhibited next to another recently purchased painting, *Corn Field.)* Even so, until the artist's death, only eleven of his paintings had been acquired by the museum. (Incidentally, in 1880, after his young friend and protégé László Paál's untimely death, Munkácsy was asked by the Hungarian Ministry to select two landscapes for the National Museum to be bought at the Paris auction of the László Paál bequest.)

The exhibition of Hungarian paintings took up four rooms in the National Museum. The approximately 300 works were hung closely to one another in several rows, completely covering the walls. The chaotic but by no means unusual arrangement could not conceal the randomness of the acquisition. The old paintings took up two rooms, while the works of Markó's school were put in the third room, and the art of the last decades of the 19th century was shown in the fourth room in a rather arbitrary arrangement. Furthermore, the painters Szinyei Merse, Mednyánszky and Károly Ferenczy were completely ignored, although these deficiencies could have easily been remedied from the funds allocated by the government for purchases in connection with the Millennial Celebrations.

The regular collection of Hungarian works of art began in earnest only in 1896, with the enactment of the legislation announcing the establishment of the Museum of Fine Arts. And although right until the museum's opening in 1906, the majority of the numerous new acquisitions collected at first were relegated to various storerooms, the purchases conducted under strict public control on the whole demonstrated the good judgment of the buyers. That was the time when a number of works by Brocky, Zichy, Mészöly and Paál were finally acquired by the museum, together with several paintings by Munkácsy and a long-standing obligation, Szinyei Merse's beautiful and innovative *Picnic in May.* Works of art could be purchased at the auctioning of artists' bequest and from private owners; similarly, the works exhibited in the Palace of Exhibition by contemporary artists were closely watched for purposes of possible acquisition. Of the latter group, a list of typical purchases included Károly Kernstock's *Agitator,* József Koszta's *Home-coming,* István Csók's *This Do in Memory of Me,* József Rippl-Rónai's *Elderly French Lady,* Adolf Fényes's *Widow* and *Family,* Imre Révész's *Panem!,* and Károly Ferenczy's *Evening Mood.*

When the Museum of Fine Arts opened, 11 rooms and two display cabinets were set aside for the display of 19th-century and contemporary Hungarian art. This was the first occasion that every major exponent of Hungarian art was represented with several works. Complete with the works of a considerable number of smaller masters, the exhibition was able to provide a broad perspective of the best of Hungarian painting. Of the modern painters previously neglected, Szinyei Merse, Károly Ferenczy and Adolf Fényes were given the greatest emphasis. In the course of the rearrangement of the Modern Gallery, Gábor Térey added a few major new acquisitions, beside laying greater emphasis on the latest developments, including the work of József Rippl-Rónai. The most outstanding new acquisitions consisted of one series each by Munkácsy, Paál, Lotz, Szinyei, Ferenczy and Rippl-Rónai.

The methodical collection of the best of Hungarian art became an established practice under the directorship of Elek Petrovics. In spite of the financial hardship of the period during and after the First World War, and despite the significant reduction in government subsidies, Elek Petrovics found a way to organize a large group of generous art patrons in support of the museum. The museum's yearbooks launched by Petrovics, together with the regular display of new acquisitions, continuously reported purchases and donations of major significance. The entire Hungarian material was taken under revision by Petrovics, who was the first to see the shortcomings of the collection. He tried to provide a balanced picture of certain major artists whose art had earlier been given a one-sided view. For example, before his directorship, Bertalan Székely was represented with historical paintings only; now a list of portraits, landscapes and genre-paintings by the same artist were acquired by the museum, partly as a result of a generous donation by the journalist Tivadar Lándor, and partly through purchases from the artist's bequest. Several works by Munkácsy, Szinyei, Benczúr, Gyárfás and Hollósy were also acquired, together with some minor masters who had not been represented in the collection before (for example, Gábor Melegh and Ferdinánd Schimon). In Petrovics's words, *"We try ... to recall the forgotten, to introduce the unknown, thus providing the best possible view of the development of Hungarian art."* By purchasing landscapes, portraits and genre-paintings from bequests or collectors (Ottó Baditz, Béla Pállik, etc.,) Petrovics even took the trouble of restoring the reputation of artists who had been previously represented in the museum's collection with officially commissioned paintings that did not do justice to them.

The Society of Art Patrons was founded in 1913; it went bankrupt during the war, and was subsequently revived in 1928 under the new name Friends of Art Museums. Several of their possessions were deposited in the museum indefinitely. (Szinyei's *Woman in Lilac Dress,* Benczúr's *Etelka* and Alajos Györgyi Giergl's *Self-portrait* were acquired by the museum as a result of the collecting work of the original Society.) Of the major donors, Marcell Nemes's name stand preeminent; he donated 56 paintings to the Museum of Fine Arts, not all by Hungarian painters. Very few art collectors were able to resist Petrovics when he tried to persuade them to donate their valuable paintings to the museum. Here is a partial list of the outstanding patrons: Frigyes Déri, Lajos Ernst, Frigyes Glück, Lipót Mór Herzog, Ferenc Hatvany, Ferenc Hopp, Ignác Alpár, Adolf Kohner, Fülöp Weiss, Jenő Káldy, and Mrs Vilmos Perlep-Prokopius. In addition to donating his collection of copies of masterpieces, the painter Ede Balló also set up a fund for purchasing further works. László Paál's *Stormy Landscape* was, for example, bought from this fund.

After long preparation, the Modern Gallery, arranged by Petrovics himself, was opened in June 1920. In his selection he strived after perfection: every art school and every deserving artist was represented with one or more works. The exhibition included 201 works never before exhibited, half of which were new acquisitions. Four masters were given a separate room: Székely, Munkácsy, Paál, and Szinyei; the works of others were displayed in 11 rooms and three cabinets,

grouped according to style and school. The contemporary works were also given a separate room. This arrangement was so successful, that it inspired the setup of the exhibition of 1949, as well as successive shows.

In 1924 Petrovics managed to acquire for the museum the first-floor rooms of the old Műcsarnok building on Andrássy út. With the establishment of the New Hungarian Gallery, he was able to fulfill his lifelong ambition: to present a finely balanced exhibition of contemporary painting. He set the year 1896 — the foundation of the Nagybánya School of painting — as the beginning of the period. (The current permanent exhibitions of the Hungarian National Gallery have preserved the same division.) In this way the movements just preceding the Nagybánya School were continued to be represented in the halls of the Museum of Fine Arts in a somewhat enlarged edition. Meanwhile, the collection continued to increase, as there were 14 new acquisitions by Munkácsy, 12 by Benczúr, ten by Szinyei, and four by László Paál since the 1920 exhibition of the Modern Gallery. Contemporary paintings were added in remarkable numbers. After the rearrangement of the Old Gallery in 1933–1934, Petrovics also planned the revision of the Modern Gallery but because of his unexpected retirement, this work was taken over from him by Dénes Csánky. Csánky abolished the New Hungarian Gallery, and replaced it with the Modern Foreign Gallery, uniting the 19th- and 20th-century Hungarian material under the name of the Modern Hungarian Gallery. Under his directorship the professional standard of the institute declined; he also gave away paintings as presents to Fascist politicians, then shipped off much material to the west without proper packaging and due professional care. However, during the nine years of his directorship, the collection continued to grow, mostly as a result of Petrovics's preparatory work. The acquisition of the art collector and art writer Lajos Ernst's portrait collection was the most important addition, but the donations by Pál Majovszky, Emil Kiss, Jenő Káldy and Oszkár Back were also significant.

The material shipped off to the west was returned to the museum in 1947, but much of it — approximately 500 works of art, mostly leased to public institutions to decorate their rooms — were lost or destroyed. Later, several paintings were returned to the Museum of Fine Arts, so the actual damage was somewhat less. In the partially renovated museum, the New Hungarian Gallery was also able to open its own show in 14 rooms and seven cabinets. This time separate rooms were assigned to the works of Munkácsy, Szinyei, Ferenczy and Rippl-Rónai, with separate cabinets reserved for works by Nagy Balogh and István Nagy.

The collection grew considerably after 1945, when new acquisitions came from donations and bequests, as well as from the art treasures left behind

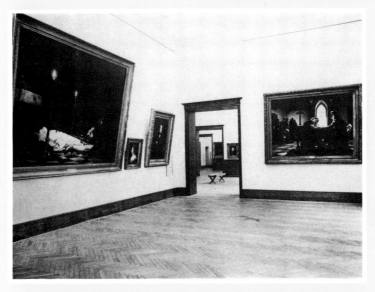

by war criminals fleeing the country, as well as works from the property previously belonging to people who died in the war. After the war, other museums and institutions also gave art works to the Museum of Fine Arts.

There were fewer purchases than during the pre-war years. The acquisitions of the next decade nevertheless included 81 paintings by Mednyánszky, 46 paintings by Székely, 24 works by Munkácsy, 18 compositions by Deák Ébner, 16 paintings each by Szinyei Merse and Mészöly, 14 pictures by Bihari, 12 works by Benczúr, 11 paintings by Barabás, ten compositions by Lotz, and eight works each by Madarász and Paál. Among these works there were such masterpieces as *Churning Woman* by Munkácsy and *Drying Cloth* by Szinyei. Several of the new acquisitions came from the valuable collections of Gyula Wolfner, Ottó Fettich and Géza Dános.

The merging of the Picture Gallery of the Capital's material into that of the Museum of Fine Arts added many works to the collection of the New Hungarian Gallery within the museum. The co-operation began a few years earlier when, as a result of the dynamic exchange of material between the two institutes, their joint 19th-century collection was exhibited in the Museum of Fine Arts, while their combined 20th-century material was displayed in the Károlyi Palace. After 1880 the art patronage of the city of Budapest was manifested in the purchase of major works. The Picture Gallery of the Capital held a huge exhibition in 1933, when 332 paintings and sculptures — partly 19th- and 20th-century Hungarian works, and partly the old European paintings of the Jenő Zichy bequest — were exhibited in 22 rooms. On this occasion, separate rooms were reserved for the paintings of the great 19th-century masters, Székely and Lotz.

In an attempt to complement the collection of the Museum of Fine Arts, the Gallery formed a distinctive profile. It was the aim of the director, Jenő Kopp, to rescue from obscurity lesser known masters who were not represented in the collection. He also

tried to acquire works by established artists that were either rarities, or else helped to shed light on their working methods. The exhibitions of 1940 and 1943, introducing the most recent acquisitions, demonstrated the consistency of this aim. It was also at this time that the major new additions of the 1930s (works by Miklós Barabás, Ágost Canzi, József Borsos, Károly Brocky, Alajos Györgyi Giergl, Károly Lajos Libay, and Soma Orlai Petrich) were rounded out with an impressive collection of works by lesser artists of the Reform Age, which has to this day remained one of the strongest points of the Gallery's collection of 19th-century paintings.

The host of paintings recovered from provincial mansions and palaces of aristocrats and the high clergy brought to the fore painters whose name had almost completely been unknown previously. (With the reunion of Hungary and Transylvania, and as a result of the temporary improvement of the transportation to Upper Hungary, the Hungarian paintings could be transferred from private owners living in these regions to public collections; it was in this manner, for example, that the Gallery was able to acquired its entire Jenő Gyárfás collection and Géza Dósa material.)

Viktor Madarász's paintings at the permanent exhibition in the Curia.

The city of Budapest, too, proved to be a generous art patron. In 1939 and 1940, nearly 300 items representing 19th-century painting, drawings and prints were transferred to the Gallery, together with 200 items of contemporary art; then, in 1941–1942, the Gallery acquired further 300 works of art from the 19th and 20th centuries. So comprehensive was the Gallery's 19th-century material that when an exhibition was held in 1948 with the title 'The Art of the Reform Age', only ten items had to be borrowed out of the 113 items listed in the catalogue. At the same time, a number of popular masterpieces, such as Munkácsy's *Christ before Pilate,* together with paintings by Madarász, Székely, Lotz, Mednyánszky and Hollósy, were purchased for the Gallery.

When after two decades of successful operation the Picture Gallery of the Capital was finally merged into the Museum of Fine Arts, the public collections made up of the nation's art treasures were already slated to go one day towards the establishment of the Hungarian National Gallery.

After careful preparatory work, the Hungarian National Gallery was opened in 1957 in the building of the Curia, the former Supreme Court. The permanent exhibition of 19th-century art, arranged by the general director Gábor Ö. Pogány, took up 13 rooms and two corridors, featuring 277 paintings — nearly twice the number of works exhibited in previous permanent exhibitions. Several works in the rooms introducing the art of the Reform Age were put on permanent display for the first time, and the monographical review of the great masters was counterpointed with the more interesting paintings of lesser artists from the same period. The exhibition was subsequently rearranged several times. The greatest rearrangement took

The hall of Szinyei and Mészöly in the old National Gallery

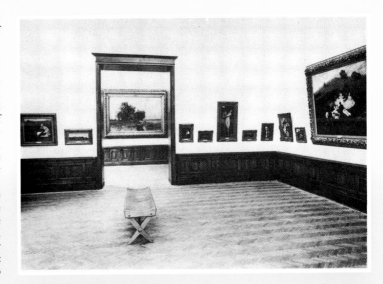

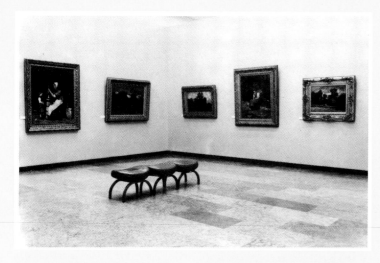

place in 1968–1969, when a number of automatically controlled air-conditioned display cabinets were installed to store the endangered paintings of Munkácsy.

Major new pieces of 19th-century Hungarian painting continued to be added to the collections of the Hungarian National Gallery even after its foundation in 1957; however, the rate of growth at the later times never even came close to the rate witnessed during the early days of the Gallery's foundation. By that time most of the outstanding works of Hungarian painting had already been acquired by public collections. Now any newly surfacing painting in the rather modest market was purchased by the public collection in order to give a more complete representation of the period in question. Quite a few works painted during the Reform Age and around the middle of the 19th century were bought, and the material of the great masters was continuously complemented. Of the latter category, especially important was the addition of 15 paintings by Munkácsy, including major works such as his *Self-portrait* and *The Condemned Cell*. The most outstanding composition of the newly acquired historical paintings by Madarász was a masterpiece entitled *Dobozi and His Spouse*. In addition to the works of Székely, Benczúr, Paál and Mednyánszky, *Apple Harvest* by Lajos Karcsay, a major composition by the lesser known painter from the late 19th century, was also bought, while Lajos Deák-Ébner's *Boat Warpers* and János Thorma's Art Nouveau *Portrait of a Lady,* shed light on the lesser known aspects of these masters' art.

However great an achievement was the establishment of a separate fine-art collection of the nation, the acute shortage of space in the building of the Curia frustrated all attempts to provide an overview of Hungarian art from its earliest years. A similar shortage of space characterized the National Gallery, now residing in the Royal Palace of Buda. Meanwhile the collections continued to grow and in the Curia, as well as in the Palace, only about ten per cent of the entire collection of 19th- and 20th-century paintings were shown to the public even in the last, and most complete, arrange-

ment of the material. For technical reasons, the paintings of Munkácsy and Paál were shown completely separated in the permanent exhibition of 19th-century painting, opened in 1975 and arranged by the general director and Éva Bodnár, head of department. Using the architectural layout of the Palace, the new permanent exhibition, completed in 1987 according to a concept devised by Zsuzsanna Bakó and Anna Szinyei Merse, separates the conservative and progressive schools of 19th-century painting within each stylistic period, thus providing a balanced overview.

THE COLLECTION OF NINETEENTH-CENTURY SCULPTURE

Similarly to the other special collections, the Sculpture Collection, too, grew out of the Hungarian National Museum's Department of Archaeology. The museum collected sculptures

on a modest scale and in a rather haphazard manner. István Ferenczy's *Shepherd Girl,* a major work by the artist, stood in the Royal Palace from the moment it arrived in Hungary in 1822 right until 1846, the time it was shown to the public in the museum. In 1870 it was transferred to the National Picture Gallery, apparently with a view to setting up a museum specializing in the fine arts. The other sculptures held in the Department of Archaeology followed suit: two *Matthias reliefs* by Ferenczy, donated by two art patrons in 1845, together with Miklós Izsó's *Sad Shepherd,* presented to the museum by Mihály Gschwindt in 1864, among others. Ágoston Kubinyi put the number of sculptures listed in the painting collection at 49 in 1884, and at 89 in 1896. Of the latest acquisitions, he specifically mentioned József Engel's sculptures *Eve* and *Reclining Cupid*. A number of sculptures, including *Sad Shepherd*, were exhibited with the paintings, while the rest were shown in the intermediate spaces, such as the landing of stairs or the space under the Dome, functioning as adornment alongside the portraits decorating the building.

The foundation for the sculpture collection was essentially laid down by the Museum of Fine Arts, which laid great emphasis on collecting works by contemporary Hungarian and foreign artists alike. From the profusion of talent at around the turn of the century,

Detail of the new 19th-century permanent exhibition

artists such as József Engel, János Fadrusz, Ferenc Szárnovszky, Gyula Bezerédi and József Damkó were chosen to represent Hungarian sculpture of the period. In 1904 the museum acquired from Mrs. András Jánosdeák István Ferenczy's bequest consisting of 28 works, including the portraits of *Ferenc Kazinczy and Rozália Schodel;* in 1905 several works by Lőrinc and László Dunaiszky were acquired, while in 1912 Károly Dosnyai's *Liszt Relief* was added to the collection. After 1906 the Museum of Fine Arts took over from the National Museum and the National Picture Gallery their 19th-century Hungarian sculpture. Among the first pieces to be thus acquired were 52 items of the Izsó Bequest, which had been purchased in 1876, immediately after Miklós Izsó's death. The process of transfer took several years, with Ferenczy's *Kölcsey* being the last item to be transferred in 1941.

In this manner, the most important Hungarian sculptures made after 1800 became united in the modern collection of plastic arts of the Museum of Fine Arts, the first major sculpture collection, both in terms of quality and quantity, to be held in a Hungarian museum. For over two decades, the display of the sculptures was, however, only temporary; what is more, the collection became sadly incomplete with the passing of time.

The art historian and archaeologist Zoltán Oroszlán arranged the permanent exhibition entitled 'Modern Collection of Sculptures' in 1926, which presented to the public 19th-century Hungarian sculpture, in a hall set aside for this purpose and partially separated from the European material. The exhibition showing the works of 15 contemporary sculptors in the New Hungarian Gallery in 1928 formed a sequel to this. In 1924, with the help of the Society of the Friends of the

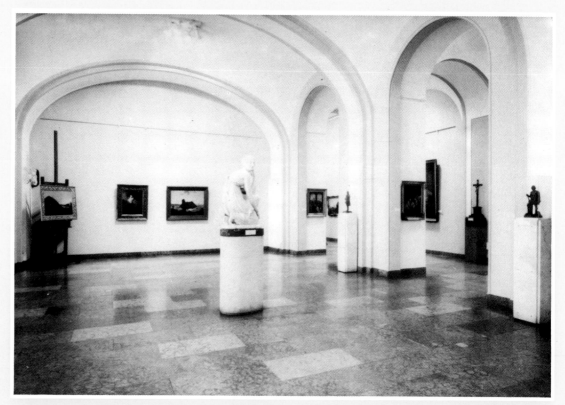

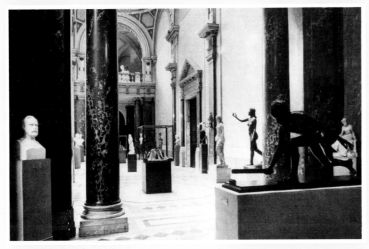

Museum, Alajos Stróbl's *Self-portrait* was purchased; this was followed in 1930 by the acquisition of the entire Stróbl Bequest, including *Perseus,* which was made possible by the support of the Ministry of Religion and Public Education. Then, in 1937, Lajos Ernst donated three sculptures by Miklós Izsó. During the 1950s the portraits of Hungarian statesmen by Miklós Izsó, Adolf Huszár and Ferenc Kugler were transferred to the museum from other institutes, such as the Hungarian Academy of Sciences and the Parliament. The re-arranged exhibition of sculptures was opened in the Museum of Fine Arts in 1952, with 38 sculptures by Hungarian masters.

In 1953 a large number of sculptures were transferred from the Picture Gallery of the Capital. From the very beginning, the Picture Gallery regarded as its main task, in addition to collecting material associated with local history, the establishment of a contemporary fine art collection. Its collection of 19th-century sculptures was less significant; in this respect it was unable to compete with the Museum of Fine Arts. Between 1924 and 1931 sculptures were acquired from Alajos Stróbl, Miklós Ligeti, József Róna, Antal Lóránfi, Ödön Szamovolszky; then, between 1933 and 1943, the works of the following artists were acquired, mostly from the Ernst-collection: Károly Alexy, Rudolf Czélkuti Züllich, and László Dunaiszky. It was around this time that the director Jenő Kopp decided to purchase the following sculptures: *Matthias* by Károly Alexy, *Orlai Petrich* by László Dunaiszky, the *Matthias-head* by János Fadrusz, the sketches made for the minor characters of the by now demolished *Maria Theresa monument,* busts by István Ferenczy, József Kugler's *Reclining Venus* and András Schossel's *Kossuth portrait.*

In 1957 the sculpture collections of the Museum of Fine Arts and the Picture Gallery of the Capital were united and transferred to the Hungarian National Gallery. Since at that time the new institution's profile was designed to cover the Hungarian art of the 19th and 20th centuries, the Gallery was extremely interested in 19th-century sculpture, especially since new acquisitions in this area were

increasingly difficult to come by. The major new acquisitions of the New Hungarian Sculpture Collection, then led by Erzsébet Csap, were as follows: the bequests of Béla Radnai and József Róna, the fragments of the monument for Pozsony (Bratislava) by János Fadrusz, the sketches of the Queen Elisabeth statue, made for a competition, and the small-scale version of the sculpture *Matthias on Horseback* in Kolozsvár, all by János Fadrusz; as well as several sculptures by József Engel, László Dunaiszky and Miklós Izsó. János Fadrusz's two sketches for his *Atlas,* András Schossel's *Hephaistos* and his portraits of poets, and Miklós Izsó's sculpture *Csokonai* were all acquired after 1985. After 1957 the 19th-century sculptures were exhibited in the Dome of the Curia building, in the surrounding first-floor corridor, and on the landings of the stairs; they were shown in similarly representative surrounding in the intermediate spaces of the Royal Palace of Buda. Since 1987, they have been displayed mixed with the paintings of the re-arranged exhibition.

THE COLLECTION OF TWENTIETH-CENTURY PAINTING AND SCULPTURE

The Twentieth-Century Collection consists of works made during the period between 1900 and 1945. (The material produced after 1945 forms part of the Contemporary Collection). However, from a historical point of view precise chronological limits can be ascribed neither to the act of collecting nor to the current function of the art collection itself. This is evident from the permanent exhibition of the Twentieth-Century Collection, which was opened in 1983, and which was intended to demonstrate the continuity of the development of Hungarian art from around the turn of the century on the one hand, and the major trends between the two world wars and after 1945 on the other.

The two fundamental collections of the Hungarian National Gallery's Twentieth-Century Collection came from the Museum of Fine Arts and the Picture Gallery of the Capital. The

collection and the exhibition of the works of new Hungarian art began at the end of the 19th century, at a time when these art treasures were purchased for public collections, quite often representing the works of young artists. The government purchases for the Museum of Fine Arts, an institute existing only on paper at the time, began in 1896, and the Fine Arts Council, which conducted these purchases, mostly selected the works from the exhibitions of the National Salon and the Palace of Art. Several major works of art were snapped up for the museum immediately after their first exhibition. This was how a number of major works by the most important masters of modern Hungarian painting — for example, Károly Ferenczy, István Réti, Béla Iványi Grünwald, József Rippl-Rónai, Adolf Fényes — came into the possession of the Museum of Fine Arts as early as the turn of the century.

After 1914, following Elek Petrovics's appointment as Director, the collecting work was given a renewed impetus and became more planned. Petrovics regarded the collection of the works of contemporary Hungarian art one of the most important tasks of the Museum of Fine Arts. His entire strategy was based on the organic links between the museum, the artists and the private collections. His programme was summed up as follows: *"One thing that has not happened yet, and which nevertheless has to be done, is the conscious and planned revision, from the museological point of view, of the collecting work done so far ... Ours is the only comprehensive collection of Hungarian art; we must make it as perfect as we can. This is an obligation that we accept not only as Hungarians but also as people sharing in the universal culture, where the division of work is such that it first of all demands from us the accomplishment of this particular task. The only way to realize this elementary truth is ... that we make regular collection, and make it in a way that we grab not only at things that offer themselves by chance, but seek out and track down items that are particularly needed."*

It was due to this acquisitional programme, in many ways still applicable today, that between 1914 and 1935 the Museum of Fine Arts founded the most important 20th-century Hungarian fine art collection, which happily combined the requirements of high quality with the demand to be able to document the period in question. As early as in 1928, Petrovics already completed the permanent exhibition of this collection in the New Hungarian Picture Gallery. The collection continued to grow even after the war, often in the form of donations and bequests, rather than purchases. The greatest increase, both in terms of numbers and of artistic merits, was meant by the merging of materials between the Picture Gallery of the Capital and the Museum of Fine Arts.

Parallel with the Museum of Fine

Arts, although with dissimilar goals and under different conditions, the other major public collection of 20th-century Hungarian fine arts was established, thanks to the art patronage of the city of Budapest. The paintings and sculptures owned by the capital (over four hundred works of art, if we include the 19th-century material) were first shown to the public in the Palace of Art in 1924. Later the Picture Gallery of the Capital became the greatest collector of modern Hungarian fine arts, which, together with the material of the Museum of Fine Arts, came to form the basis of the Hungarian National Gallery's Twentieth-Century Collection in 1953.

With the following list we only wish to illustrate the wealth of the collection; with a few exception, all the works are shown at the National Gallery's current exhibition of 20th-century art, arranged by deputy general director Géza Csorba. The works exhibited included two major pieces from Károly Ferenczy's so-called "sunny" period, *Evening in March* and *Sunny Morning,* János Thorma's *The First of October, Watering* by Béla Iványi Grünwald, *My Father and Uncle Piacsek Drinking Red Wine* by József Rippl-Rónai, and *In Serbia* by László Mednyánszky. Of the paintings by the masters of the Alföld School, who considered their artistic purpose the depiction of the landscape and the people of the Great Hungarian Plains, the following works are of special importance: *Poppyseed Cake* by Adolf Fényes, one of the most powerful paintings he ever painted, József Koszta's *Three Magi,* Gyula Rudnay's *Nagybábonyi Street,* János Vaszary's *City Lighting, Godfather's Breakfast* by István Csók, and *Plum-Pickers* by Károly Kernstok. In 1919, only two years after the artist's death, the entire bequest of János Nagy Balogh passed into the possession of the Museum of Fine Arts. The other paintings that deserve mention are both pieces of the *Klára Zách Diptych* by the art nouveau master of the Gödöllő artists' colony, Aladár Körösfői-Kriesch, two outstanding works by Gyula Derkovits, *By the Railroad* and *Three Generations,* István Szőnyi's *Evening, Riviera* by Aurél Bernáth, and József Egry's painting, *Self-portrait in Sunshine.*

The collection of the sculptures began simultaneously with the collection of paintings, although initially its growth was slower and more casual. The Museum of Fine Arts purchased several sculptures shortly after their completion, including *Farewell* by János Pásztor, *Complaint* by István Szentgyörgyi and *Young Girl* by Imre Csikász. The material handed over by the Picture Gallery of the Capital contained an important collection of sculptures, and the collection resulting from the merge contained some major pieces of Hungarian sculpture such as *Kuruc Head* by Fülöp Ö. Beck, *Mother and Child* and *Mopping Woman* by Ferenc Medgyessy, *Singing Boy* by Márk Vedres, *Nude Boy Kneeling* by Vilmos Fémes Beck, *Girl Standing* by Béni Ferenczy, *Self-portrait in Hat* by Dezső

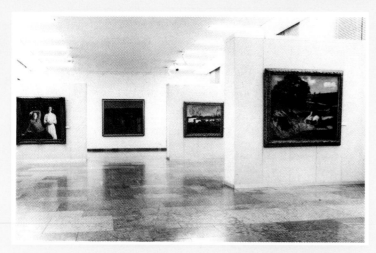

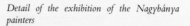

and schools whose art represented this development in the most characteristic manner, and emphasizing the major styles and stages in the development of the modern Hungarian fine arts.

Bokros Birman, and *Prodigal Son* by László Mészáros.

The Hungarian National Gallery was opened with this prestigious exhibition on 20th-century art; and immediately in the following year Gábor Ö. Pogány arranged two exhibitions entitled 'Hungarian Painting in the 20th Century' and 'Hungarian Sculpture in the 19th and 20th Century'. Now the guiding principles of the collecting work became the best possible representation of the most important painters' and sculptors' entire lifework on the one hand, and the acquisition of works by smaller masters inadequately represented in the collection on the other hand.

Those works and collections which were donated to the National Gallery always played an important role in the formation of the collection's character; this kind of art patronage continued to form an indispensable part of acquisition. Of all the old and well-known private art collectors whose inheritors greatly enriched the museum's Twentieth-Century Collection in the past decades by donating the works of the greatest artists of the period, we should definitely mention the names of Péter Véghelyi (who left his Hungarian works of art to the National Gallery in his will), Lajos Hatvany, and Lajos Fruchter. The complete list of the donors is extremely long, and it frequently contains the names of Hungarians who are now living abroad.

In the nearly three-and-a-half decades since its foundation, the Twentieth-Century Collection of the National Gallery has more than doubled; and although there are gaps and discrepancies in it, the collection provides a relatively complete and balanced view of the development of Hungarian fine arts during the period. With a few exceptions, the stylistic development of the prominent masters of the various schools can be followed throughout their careers, from beginning to end.

To illustrate the latest growth of the collection we mention but a few of the new acquisitions. These include Károly Ferenczy's late Post-Impressionistic painting *Shooting Arrows, Peasant's Yard* by Simon Hollósy, *The Market-Place of Kecskemét in Winter* by Béla Iványi Grünwald, *The Manor of Körtvélyes,* a masterpiece from the so-called

'corn' period of József Rippl-Rónai, *Seaside Town* by Tivadar Csontváry Kosztka, *The Knight of the Rose* and *Self-portrait in Hat* by Lajos Gulácsy, *Riders by the Water,* a large composition by Károly Kernstok; three works by József Nemes Lampérth, *Still-life with Plants, Self-portrait,* and *Female Nude, Icon-Analysis* by Béla Uitz, and early paintings by József Egry, *Dock Workers,* together with one of his major works, *Echo, Self-portrait* and *Funeral in Zebegény,* two paintings by István Szőnyi, *Self-portrait* by Aurél Bernáth, together with one of his finest landscapes, *Winter, Woman Playing the Cello* by Róbert Berény, three important works by Gyula Derkovits: *Bridge-Builders, Fishmonger,* and *Injunction,* two paintings by Lajos Vajda: *Icon with Masque* and *Silver Gnome,* and *Szentendre Motif II* by Dezső Korniss. Of the sculptures, the following works should be mentioned: *Resting* and *Dancing Woman* by Ferenc Medgyessy, *Aphrodite* by Fülöp Ö. Beck, *Boy Playing the Flute* by Márk Vedres, a dynamic small bronze sculpture by Sándor Gergely, *Woman Dancing,* which is an important illustration of the Activist movement in sculpting; and the small plastics *Seated Peasant Lad, Freedom,* and *Viewing the Land* by László Mészáros.

There has been a lavish collection of 20th-century sculptures in the new building of the Hungarian National Gallery from the moment of its foundation, and on several occasions, although only for shorter intervals, 20th-century Hungarian painting, or some of its major periods, were introduced to the public. The selection of paintings that made up the material of the exhibition 'Hungarian Painting in the 20th Century' in 1977-1978 covered the entire period in question, and consisted of over a hundred paintings, including works of contemporary artists. In 1979 an exhibition entitled 'Selection from the Hungarian National Gallery's 20th-Century Material' was opened, in which 84 paintings were displayed from the period ending with the 1930s. The works of the members of the Nagybánya artists' colony were not included in either of the exhibitions, since these paintings were shown in an exhibition of their own.

In the early 1980s the growth of the collection permitted the setting up of a permanent 20th-century exhibition, representing the entire period on a scale, and in depth, which has never been seen before. It was opened in the second- and third-floor rooms of the National Gallery in 1983. This exhibition was organically linked to the revised permanent exhibition of 19th-century art, opened in 1987. The exhibited works (over 500 paintings, sculptures and coins) illustrated the nearly half-a-century-long artistic development in Hungary in its entire complexity, focusing on the masters

Detail of the 20th-century exhibition on the third floor

THE COLLECTION OF COINS AND MEDALS

The collection specialising in Hungarian medals of artistic value received a department of their own only after the foundation of the Hungarian National Gallery. The Historical Picture Gallery and the Museum of Applied Arts began collecting medals and plaquettes towards the end of the 19th century, although the regular collecting work is associated with the Museum of Fine Arts.

From the early 1900s onwards the Museum of Fine Arts purchased the works of the leading masters of Hungarian small plastics, an art form then becoming popular: works by Fülöp Ö. Beck, József Reményi, Lajos Berán. The collection especially benefitted from Elek Petrovics's campaign launched in 1919; that was the time that the majority of Vilmos Fémes Beck's coins went into the possession of the museum. Later the works of Ede Telcs and Walter Madarassy were added to the collection; this material was eventually deposited in the Modern Collection of Sculptures. In addition to purchases, the continuing donations also increased the collection little by little. The most important donation was made by Mrs. András Jánosdeák at the beginning of the century; she donated coins made of bronze and wax by István Ferenczy.

From the moment of its foundation, the Picture Gallery of the Capital spent much effort on the collection of coins and medals. The majority of the rare coins from the first half of the 19th century were acquired by the Gallery in 1941, with the transfer of Dr. Alfréd Schulek's collection. In addition to the outstanding works by Fülöp Ö. Beck and Béni Ferenczy, the Gallery

purchased coins made in the subsequent periods by almost every single artist involved in small plastics; the comprehensive character of the present Coin and Medal Department derives from this effect.

Two major purchases gave new foundations to the Picture Gallery of the Capital's Department of Coins and Medals, as far as both quality and quantity were concerned. Elemér Pompéry's collection was acquired by the Gallery in 1940, and Béla Procopius's collection was added to it in 1944. The scale of increase is well illustrated by the fact that at the time of the Gallery's foundation half of the material in the Department of Coins and Medals derived from these two purchases. As competent experts of Hungarian coins and medals, both collectors strived after completeness with regard to the historical material, at the same time being very perceptive towards the contemporary material. So, as a result of their collecting work, as well as due to the earlier regular acquisition work, a wealthy collection covering all schools and movements could be developed inside the Picture Gallery of the Capital, ranking among the similar collections of the other European museums. On the strength of that collection the exhibition 'The Art of Coin and Medal Making in Hungary' could be put together in 1949, when, for the first time in Hungary, an attempt was made to illustrate the history of the genre.

After the Picture Gallery of the Capital merged into the Museum of Fine Arts, extensive efforts were made to process and to make inventory of the material in the coin and medal collection; and in 1957, when a separate Department of Coins and Medals was established under the direction of Mrs. Csengery Zsuzsa Nagy, a storage and inventory system, then considered modern, was devised as a result of these efforts. Adding new acquisitions to the collection continued to be an important task. One way of doing this was purchasing directly from the artists, hence the new additions of works by Tamás Vigh, Tibor Duray, Iván Szabó, Walter Madarassy, András Kiss Nagy, Béni Ferenczy; then, after the mid-1960, the modern collection continued to grow after works were purchased from Gyula Kiss Kovács, Antal Czinder, Erika Ligeti and Tamás Asszonyi. In 1971 Fülöp Ö. Beck's family sold to the National Gallery a large collection of the artist's medals. A hundred valuable pieces from the Papanek Collection, including several 19th-century rarities, was bought over in 1985. In the same year a rare item, the golden version of István Ferenczy's *Pius VII Medal*, was sold to the Coin Department by descendants of the artist. To a lesser degree, the collection also grew as a result of government purchases and private donations. In 1959 Mrs. György Markos donated coins made by Elza Köveshází Kalmár, and in 1970 Ferenc Wilde's bequest containing works by Béni Ferenczy was acquired by the Gallery.

While earlier the exhibitions dedicated entirely to the display of coins and medals were rare, after 1959 some changes could be experienced in this respect. That was the year that the exhibition 'The Art of Coin Making in Hungary during the 19th and the 20th Century' was opened; then, in 1975, the show, which had in the meantime been functioning as a permanent exhibition, was moved to the Royal Palace of Buda, illustrating the development of the genre using the joint material of the two institutes after the merge. The 1972 exhibition dedicated to József Reményi was the first occasion that an artist specializing in coins and medals was introduced to the public in a monographic form. The exhibition 'Ede Telcs and His Students', which was held in 1974, showed a less familiar phase in the history of medal making. In 1977 the Conference of FIDEM, the International Association of Coinage, was held in Budapest. In line with the traditions, the conference was accompanied with a large international exhibition, the preparation and the organization of which was done by the employees of the Department of Coins and Medals. At present, the collection consists of 5,000 items, with the most beautiful pieces on display in the Gallery's permanent exhibitions.

THE DEPARTMENT OF PRINTS AND DRAWINGS

With its 50,000 items, the Department of Prints and Drawings is the largest one in the Hungarian National Gallery. This treasure house of works on paper is divided into three separate sections. The largest and the most important of the three contains the individual works: drawings, aquarelles, pastels, gouaches and tempera. The section of prints consists of 12,600 sheets, from copper-plate engravings to serigraphs. The section of posters comprises about 10,000 items, with several hundreds of new acquisitions added annually. The oldest material in the Department of Prints and Drawings belongs to the section of prints. The edition of Nádasdy Mausoleum for the Coronation of Joseph I (*Effigies Ducum et Regum Hungariae*) dates back to 1687, for example.

Prints and drawings have, from the beginning, been stored together in all the Hungarian museums. The National Museum handed over works to the National Picture Gallery in twelve stages, which were then united in the Museum of Fine Arts. A particular division within the collection was formed by the nearly 200 mostly full-size studies for frescoes made for the decoration of important public buildings (Károly Lotz's murals for the Opera House, the Hungarian Academy of Sciences, and the Matthias Church, and Mór Than's designs for the National Museum and the Bakáts Square Church, among others).

Parallel with the Historical Picture Gallery, established in 1884, the regular and professional collection of drawings and prints began in earnest in the Museum of Fine Arts. Important donations, bequests and purchases preceded the setting up of such a comprehensive collection of 19th-century Hungarian drawings and prints in the National Gallery. It is worth realizing, for example, that Mihály Zichy's illustrations for János Arany's ballads became the property of the museum back in 1899, only two years after their completion. Also valuable are the donations of the artists themselves, most notably the series of lithographs presented by József Rippl-Rónai to the Museum of Fine Arts. Gusztáv Morelli gave his engravings, while Viktor Olgyai, a teacher of graphical arts at the Academy of Fine Arts, donated to the museum the 19th-century lithographical portraits of József Marastoni. In 1901 the painter and art collector István Delhaes bequeathed his comprehensive collection to the Museum of Fine Arts. As a result of the purchases of the Ministry of Finance, the original drawings of all 515 illustrations made for the book *The Austro-Hungarian Monarchy in Words and Pictures,* including the works of some of the greatest figures in Hungarian painting, went into the possession of the museum. The material bequeathed to the Department of Prints and Drawings by the outstanding painters of 19th-century Hungarian art — Miklós Barabás (1903), Károly Lotz (1905), Károly Brocky (1914), Bertalan Székely (1915), Károly Lajos Libay (1937) — further enhanced the importance of the collection.

Together with the contemporary material acquired during the 1910s, some modern works by artists officially not yet recognized were also added to the collection. The fact that a significant collection of the works of the classical masters of the Hungarian avant-garde was founded so early on resulted from the courageous policies of acquisition, the credits for which were due in no small part to the management of the museum and to Károly Ferenczy, who headed the Purchase Committee with great expertise. The Art Directorium of the Republic of Councils of 1919 bought a large number of graphics from various masters, which were later organized in a representative album. The intentions were not only social or political, the selection contributed new values. During the 1920s the collection's growth was mostly due to private donations by people such as Lajos Ernst and Henrik Tamás, Ernő Rados and Géza Dános. Keeping an eye on the work of Hungarian artists living abroad became almost impossible. Therefore, the task of completing the material produced between the two world wars was left to the last few decades, and therefore required extra effort. In this area, too, the lifework bequeathed to the museum by the artists continued to bear importance; Noémi Ferenczy's works were acquired in 1958, Imre Ámos's in 1967, Béla Uitz's in 1969, Lajos Tihanyi's in 1970, and Sándor Bortnyik's in 1977.

After the Second World War the annual purchases were subsidized by the Ministry of Culture. In addition to the continuous and regular purchases of contemporary works of art, this was how important collections went into the possession of the museum, such as the almost complete collection of Gyula Derkovits's prints. The donation by the College of Fine Arts also contributed to the museum's acquiring the works of major 20th-century artists. After 1981 the collection was enlarged as a result of the transfer of prints from the University Library.

The Poster Collection of the National Gallery was founded only in 1958. The first impulse was provided by the purchase of the eminent art collector, Rudolf Bedő's posters. With the transfer of the Palace of Art's posters after 1963, and with the handing over of the best posters of the year by Magyar Hírdető (Hungarian Advertiser), a dynamically developing collection was taking shape, which well complemented the National Széchényi Library's selection of compulsory copies.

Sketchbooks, which provide a valuable inside view of the working methods of artists, have a special place within the Collection of Prints and Drawings. Mednyánszky's 215 sketchbooks, together with Munkácsy's 32 sketchbooks, most of which were bought in Hannover, are of outstanding importance.

The thematically or chronologically closely associated prints are kept in folders, while the drawings are bound together in albums. This method of storage serves to help the work of researchers by preserving interconnections and setting up blocs of organically linked material within the lifework of an artist. The most important items in the collection are the albums by Bertalan Székely and János Nagy Balogh, and the original drawings made by Jenő Barcsay for his world-renowned publications, *Anatomy for the Artist* (Budapest, 1953) and *Man and Drapery* (Budapest, 1958).

Because of the susceptibility of paper to light, heat and humidity, the collection's material is relatively less suited for public display. An overview of the collection was provided in the grand opening exhibition held in 1975, immediately after the collection's move to the Royal Palace of Buda; the exhibition also marked the inauguration of the rooms dedicated to graphic art on the third floor of building C.

The items of the collection often feature in various temporary exhibitions, both in Hungary and abroad. There have been exhibitions that grouped the material according to genre: cityscapes and travel drawings (1976), the portraits of artists (1976), genre drawings (1981), as well as the exhibitions of the great masters of Hungarian drawing, Mihály Zichy (1977), Miklós Barabás (1985), and Károly Markó the Elder. (1990). In addition, the drawings and prints made by Hungarian artists working abroad have also been exhibited, grouped according to location: Vienna 1919–1933 (1983), Germany 1919–1933 (1989).

THE COLLECTION OF CONTEMPORARY ART

Similarly to its legal predecessors, the Hungarian National Gallery has been collecting the works of contemporary artists ever since its foundation. On account of the shortage of space in the Curia building, the permanent exhibitions staged by the museum in its former location could only cover Hungarian art before 1945. Thus the Gallery's holdings of more recent art could only be shown in temporary exhibitions.

The departments specializing in 19th- and 20th-century art had great difficulties in meeting the demands of an assignment, which was frequently based on a new kind of social connections and essentially required a different type of museological approach. Simultaneously with the Hungarian National Gallery's move to the Royal Palace of Buda, certain conditions for setting up a separate department dedicated to contemporary art were realized. The Department of Contemporary Hungarian Art, established in January 1974, began immediate preparations for an exhibition introducing contemporary Hungarian art. The Department's area of interest covered works made after 1970 and acquired by the museum after 1974, regardless of genre. However, the earlier defined chronological limits turned out to be very difficult to observe. The addition of Béla Kondor's bequest, together with the acquisition of the main pieces in György Konecsni's lifework and of the collection of works by Lili Ország and Menyhért Tóth, each in itself transgressed the chronological boundaries set up for practical purposes.

Initially the acquisition work mainly consisted of the Art Foundation's purchasing new pieces. To a lesser degree, there was scope for purchases by the Gallery itself, or the transfer of works from other institutes, or even for accepting private donations on some occasions. In the meantime the process of government purchases had gradually gone through changes. Earlier the museums were passive observers of this process; they could select only from a given material, material that had been purchased by others, and thus they were unable to realize their own policies of acquisition. By the late 1970s, the associates of the institute were allowed to indicate their interest in certain items, and later they were more and more drawn into the work of the committee concerned with proposals for purchases; then, in the late 1980s, the Gallery's associates were asked to make suggestions prior to the purchasing of new works.

The Fine Arts Department of the Ministry of Culture contributed to the growth of the Gallery's contemporary collection by purchasing works from the artists directly. It became easier to access the works purchased earlier by the Ministry, too, and the collection handed over, containing numerous important works essential for the presentation of not only the art of the 1970s but also of the 1960s; at the same time, it made the lifework of a number of artists already represented in the collection (Endre Bálint, Dezső Korniss, Erzsébet Schaár, Tibor Vilt) more complete.

Beside the acquisition of new works, making "blueprints" for temporary exhibitions also became a major task

of the Gallery. These included a number of exhibitions showing the latest developments in various genres of the fine arts (for example, the series of exhibitions on prints and drawings), or exhibitions introducing an important artist's oeuvre (Dezső Korniss in 1980, Béla Kondor in 1984); then there were the exhibitions analyzing the art movements of a certain period ('Eclecticism' in 1985, 'The 1960s' in 1991). The exhibitions were also taken outside the Gallery building, to the provincial towns, as well as abroad. Also, by lending several hundreds of works every year, the Gallery is helping the work of other institutions as well.

To a large extent, the permanent exhibition of 20th-century art, which was opened in the National Gallery in 1983, relied on the collection; in the part introducing Hungarian art after 1945, the works collected by the Department featured heavily. Parallel with the preparation for the permanent exhibition, the closing year for works to be included in the collection was extended from 1945 to the present. As a result of the structural changes in the Gallery, the Department was made into the Chief Department of Contemporary Collections in the mid-1980s, and those works of art which, although qualifying for the Collection on account of their dates of origin, had previously been held in other departments, were gradually transferred. With nearly 10,000 works of art, the contemporary collection is therefore large enough to form the basis of a future Museum of Modern Art, the demand for which has existed for decades.

THE BUILDING OF THE HUNGARIAN NATIONAL GALLERY

The history of the Royal Palace of Buda dates back to the 13th century. In the years following the invasion of the Tartar hordes, sometime around 1244, King Béla IV (1235–1270) ordered the erection of a fortress reinforced with stone walls, which consisted of the so-called Old Tower and the inner castle. Adjacent to the northern end of the castle stood the civic town. Buda became an actual royal seat in the 14th century, when King Louis the Great (1342–1382) moved his residence from Visegrád to here. The Gothic art associated with his court formed an outstanding period in the history of Hungarian art. Also, the king continued to reinforce and to enlarge the fortress. One of the results of his efforts is the István Tower, the preserved remains of which can be found, together with the other medieval buildings, inside the area of today's Budapest Historical Museum.

The construction work carried out under the Anjou kings was continued

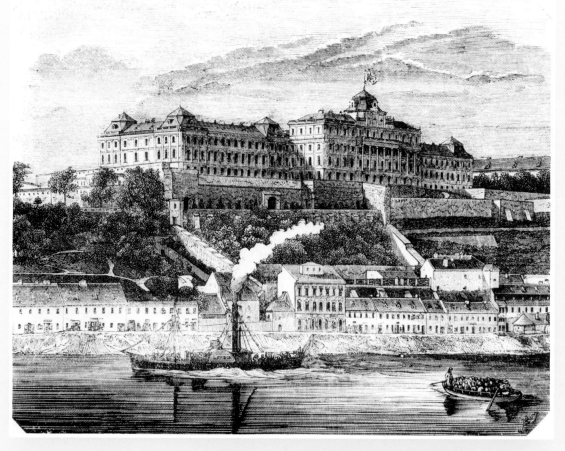

by King Sigismund of Luxemburg (1387–1437). Friss Palota (Fresh Palace), built in the Late-Gothic style north of the earlier buildings, is associated with his name, together with the completion of the defence system and the erection of the unfinished Csonkatorony (Incomplete Tower). The world-renowned Renaissance palace of King Matthias (1458–1490) — with its chapel named after John of the Alms and with the Corvina Library — is situated between the ceremonial courtyards of the Anjous and Sigismund.

During the Turkish rule that followed the Hungarian army's catastrophic defeat at Mohács, the palace suffered serious damage, and burnt down several times; in 1686, after a long siege, the castle was recaptured from the Turks by the army of the Holy Roman Empire, commanded by Charles of Lorraine and supported by the other European countries. The reconstruction work was directed by Johann Hölbling who, between 1715 and 1724, had all the medieval walls pulled down almost to the basement, filling the moats with the debris. On the resulting open area a simple and unornamented building of square layout was built according to Hölbling's design, adjoined from the north-west by an elongated wing. (This block — today's Building E — now houses the Budapest Historical Museum.)

The history of the Hungarian National Gallery's building reaches back to the reign of Maria Theresa (1740–1780). The construction work began in 1750 under the direction of Ignác Oracsek, according to the plans of the Imperial Chief Architect, Jean

Nicolas Jadot. The first occupants of the palace were the Mary Ward nuns, who were moved there temporarily; then, after 1766, the building served as residence for Duke Albert of Saxony, the Palatine of Hungary, and Princess Maria Christine. At that time the north wing (today's central tract) was still incomplete for lack of available funds. The residences of the empress and the emperor were on the first floor of today's Building D. The residence of the empress could be approached from the north through the Diplomats' Staircase. The ceremonial hall, designed in Louis XVI style and having a coved vault, was situated between the antechambers of the empress and the emperor. (In the same hall, which was after 1856 known as the Great Throne Hall, are the Late-Gothic winged altars exhibited today.) The university was moved here from Nagyszombat between 1777 and 1784; then the Viennese Court appointed the Royal Palace of Buda as the seat of the Palatine and his household. During the terms of Alexander Leopold, and of Joseph after 1795, the sessions of the Viceregal Council and the Seven-man Council were held there.

The restoration of the buildings, severely damaged during the War of Liberation of 1848–1849, was completed in 1856. The extension and the large-scale rebuilding, internal as well as external, of the palace was aimed at the creation of a royal seat and was launched after Francis Joseph's coronation as King of Hungary in 1867. On the west side looking down on the district of Krisztinaváros a new row of buildings (today's Building F, housing the National Széchényi Library) was

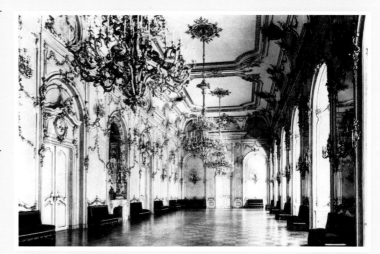

The Neo-Baroque ball room in the early 20th century

designed by Miklós Ybl. The construction works, which were interrupted by Ybl's death, were continued in 1893 under the directions of Alajos Hauszmann. He designed a wing (today's Building B) adjoining Building C from the north, similar to Building D. This links up with Building A, which is now used as the Museum of Modern History. Previously there was a military depo here.

In Hauszmann's concept, the entire group of building was connected with the help of the roof of unitary design. The frontal view of the central tract of the building overlooking the Danube, together with the two-storey Habsburg Hall behind it, were emphasized by the dome and the central projection. Hauszmann designed an ornamental staircase in front of the building. The façade was decorated with sculptures of symbolic figures and vases. Hauszmann put a series of arcades on the court-side. A new ceremonial hall was designed for special state functions. (It was also known as the Great Dance Hall, or the Ballroom. Today a section of the 19th-century permanent exhibition is shown here.) It is adjoined on the Danube side by an elongated room or a corridor, the so-called Buffet Hall, where the works of Mihály Munkácsy and László Paál are displayed today. The extension work associated with Hauszmann's name was completed in 1905.

The sculptures and carved architectural ornaments now decorating the building were also installed during that phase of the construction work. *Turulmadár*, a sculpture made by Gyula Donáth in 1903 (installed in 1905) representing the Hungarians' sacred eagle, embellishes the side closer to the Danube of the ornamental railing in Szent György tér. In the eastern front of Building A there is Károly Senyei's fountain, *Children Fishing* (1912).

József Róna originally fashioned the equestrian monument of Prince Eugene of Savoy for the town of Zenta (1900). On the landing of the Habsburg staircase, by now demolished, stood two sculptures by Miklós Ligeti, *Csongor and Tünde*; now these sculptures are put on each side of the museum's central entrance on separate pedestals in Building C. Alajos Stróbl's work, the *Matthias Well* (1904), is now seen in the northern front of St. Sigismund Chapel. Horseman, the sculpture in front of Building B, which was made by György Vastagh Jr. in 1899–1901, originally stood in front of the southern front of the stables, now demolished. The stone lions of the so-called Lion Courtyard (surrounded by Buildings D, E, and F) were fashioned by János Fadrusz in 1901–1902. Telegraph Gate by the entrance at the court side of Budapest Historical Museum in the southern end of the Lion Courtyard is decorated by Károly Senyei's sculptures, *War* and *Peace* (1900).

The palace, which was gradually turned into an administration centre for the government, suffered extremely serious damages during the Second World War. Consequently, reconstruction took forty years — from 1945 until 1985. The northern wings (Buildings A and B) were renovated according to Alajos Hauszmann's original plans in eclectic and Neo-Baroque style; the southern wings (Buildings E and D) were given back their Baroque image as conceived by Ignác Oracsek. The central tract (Building C) forms a transition between the two styles.

The first exhibition of the Hungarian National Gallery was opened in its new home, the renovated buildings B, C, and D of the Royal Palace of Buda, in 1975.

GENERAL INFORMATION

The Hungarian National Gallery is a national museum, therefore, according to Paragraph 9 of the so-called 'Museum Act' of 1963/9, it is an *"institute holding and academically evaluating a collection of items of outstanding national significance, striving to be complete both geographically and historically."* The institute is headed by one general director and two deputy general directors. There are about 80,000 items held in its de-

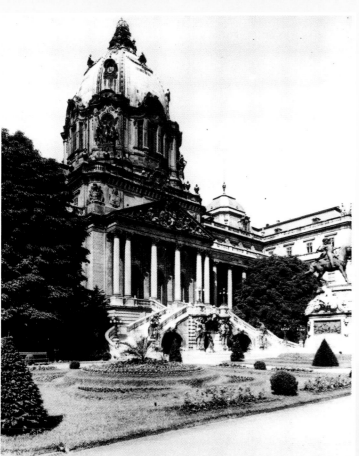

The domed main building with the Habsburg Stairway after Hauszmann's reconstruction with the equestrian statue of Eugene of Savoy in the foreground

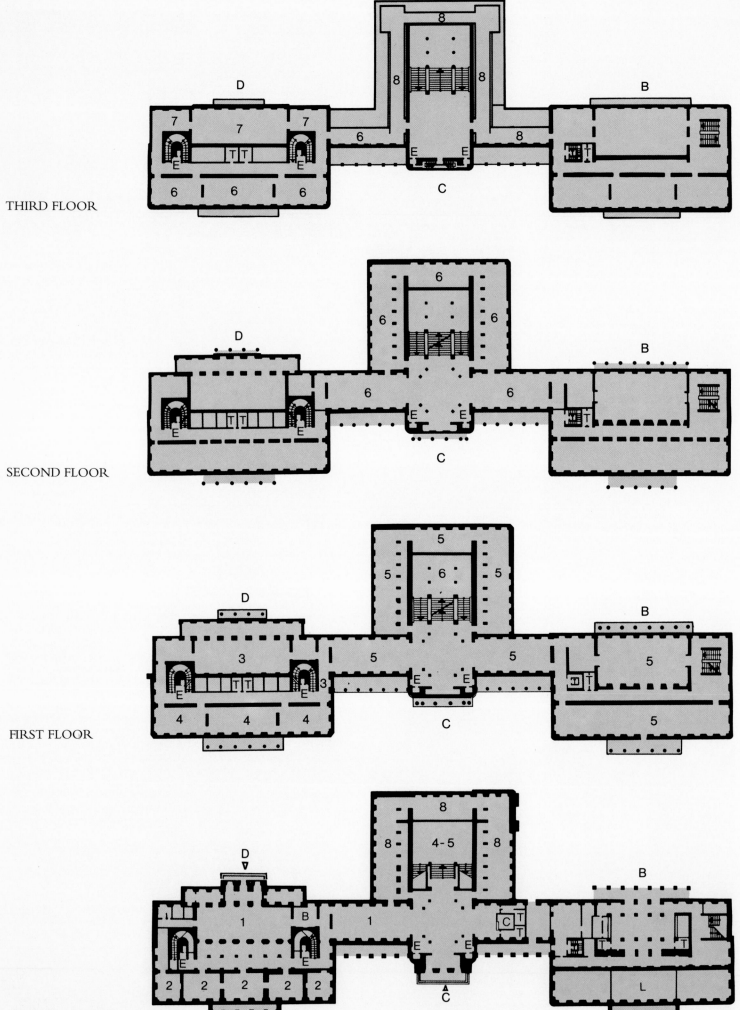

THIRD FLOOR

SECOND FLOOR

FIRST FLOOR

GROUND FLOOR

partments (Old Hungarian Collection: 1,000; New Hungarian Gallery Collection of Nineteenth- and Twentieth-Century Paintings: 10,000; New Hungarian Sculptures — Collection of Nineteenth- and Twentieth-Century Sculptures: 4,500; Department of Coins and Medals: 5,000; Department of Prints and Drawings: 50,000; Department of Contemporary Art: 10,000.) The Gallery's Department of Documentation keeps a record of all the protected works of art, beside running a public information service on art objects and issuing permits to take works of art out of Hungary. Documents related to Hungarian artists are collected and ordered in the Gallery's database, which consists of approximately 90,000 entries. Under the scheme of international exchange of publications, the Gallery's specialized library of 84,000 volumes is linked up with all the major museums of the world. The explicitly museological functions are complemented with a photo archive, photographic studios, restoration workshops specializing in paintings, drawings, prints and frames, and a team of exhibition designers.

Lighting: in addition to natural light, the necessary luminosity is provided by incandescent and neon lights.

The museum's permanent exhibitions are as follows:
– Medieval and Renaissance stone collection
– Gothic wooden sculptures and paintings
– Late-Gothic winged altars, wooden sculptures and paintings
– Late-Renaissance and Baroque art

– Nineteenth-century paintings, sculptures, coins and medals
– Twentieth-century paintings, sculptures, coins and medals
– Contemporary art
The total number of works exhibited: 1,950 items.
A large part of the temporary exhibitions were retrospective and monographic in character; in the course of these exhibitions, the works of over a hundred Hungarian artists were shown to the public in details. The Workshop Series provided the opportunity for contemporary artists' chamber exhibitions. There were also nearly 40 thematic exhibitions, which were organized around groups of artists, schools, genres, and so on. The Hungarian National Gallery also welcomes foreign exhibitions: presentations from all over the world and on almost every period have already come to its building. Also, by making its collections available to foreign museums, the Gallery is contributing to the presentation of the various Hungarian art movements to foreign audiences.

The Department of Public Education has been successful in exploiting the educational values of the museum: thousands of children are taken on guided tours in the Gallery every year, and the schools can have classes related to their curriculum in the museum. Tour-guides in all the major languages are available to visitors on request. The Society of Friends of the Hungarian National Gallery has been organizing colourful programmes for its members since 1980.

The Hungarian National Gallery's Art Workshop for Children and Young Adults serves the development of children's creativity. About half a million people visit the museum every year.

Opening hours: 10 a.m. until 6 p.m.; 10 a.m. until 4 p.m. during the winter. Closed on Mondays and on the days following public holidays. Free admission on Saturdays.

General Directors of the Hungarian National Gallery:
1957–1980: Gábor Ö. Pogány
1980–1982: Gyöngyi Éri
1982–present: Lóránd Bereczky

Major Publications of the Hungarian National Gallery
Bulletin de la Galerie Nationale Hongroise. 1959–1965. Volumes I–V
Annales de la Galerie Nationale Hongroise. 1970–1991. Volumes 1–4 (both publications are in Hungarian and French)

Catalogues:
Pogány, Ö. Gábor: *A Magyar Nemzeti Galéria* [The Hungarian National Gallery]. Budapest, 1965
Telepy, Katalin: *Landscapes in the Hungarian National Gallery.* Budapest, 1973
B. Supka, Magdolna: *Genre Painting in the Hungarian National Gallery.* Budapest, 1974
Solymár, István (ed.): *Collections of the Hungarian National Gallery.* Budapest, 1976
Pogány, Ö. Gábor—Bodnár, Éva: *The New Hungarian Gallery.* Budapest, 1976
Kisdéginé Kirimi, Irén: *Still-lifes in the Hungarian National Gallery.* Budapest, 1977
Mojzer, Miklós: *A Magyar Nemzeti Galéria késő reneszánsz és barokk kiál-

lítása. Képek és szobrok* [High Renaissance and Baroque Exhibitions in the Hungarian National Gallery. Paintings and Sculpture]. Budapest, 1982
Mojzer, Miklós (ed.): *The Hungarian National Gallery. The Old Collections.* Budapest, 1984
Csorba, Géza—Szinyei Merse, Anna—Egry, Margit (ed.): *XX. századi festészet és szobrászat* [20th-Century Painting and Sculpture]. Catalogue of the permanent exhibition. Budapest, 1986
Csorba, Géza (ed.): *The Collections of the Hungarian National Gallery.* Budapest, 1987
Bodnár, Éva: *Kard és ecset. Történelmi képek a Magyar Nemzeti Galériában* [Sword and Paintbrush. Historical Paintings in the Hungarian National Gallery]. Budapest, 1987
Bakó, Zsuzsanna—Kovásznai, Viktória—Szinyei Merse, Anna—Tóth, Antal: *XIX. századi magyar festészet és szobrászat a Magyar Nemzeti Galériában* [19th-century Hungarian Painting and Sculpture in the Hungarian National Gallery]. Catalogue for the permanent exhibition. Budapest, 1988
Török, Gyöngyi: *Late-Gothic Altarpieces in the Hungarian National Gallery.* Catalogue for the permanent exhibition. Budapest, 1989
Török, Gyöngyi: *The Altarpiece of St. Nicholas from Jánosrét in the Hungarian National Gallery.* Budapest, 1989

A catalogue was published for almost every temporary exhibition organized by the Hungarian National Gallery.
A list of all the collections have been regularly published since 1959.

Buildings **B—C—D**

1 Medieval and Renaissance stone exhibition

2 Gothic wooden sculpture and panel painting

3 Late Gothic triptychs, wooden sculptures and panel paintings

4 Late Renaissance and Baroque art

5 Paintings, sculpture, coins and medals from the 19th century

6 Paintings, sculpture, coins and medals from the 20th century (until 1945)

7 Art of the present

8 Temporary exhibits

L Lecture room

B Books and reproductions

C Café

T Toilettes

E Elevator

THE COLLECTION OF OLD HUNGARIAN ART

1 | HUNGARIAN MASTER
Apocalyptic Elder. From Pécs

2 | HUNGARIAN MASTER
Tympanum. From Szentkirály

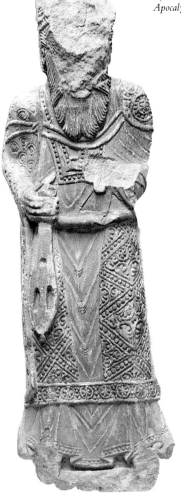

1 The collection's medieval stoneworks consist mostly of the remains of Romanesque and Gothic architecture and sculpture. Before it was radically rebuilt at the end of the 19th century, the Romanesque Cathedral in Pécs had been a basilica with three aisles, three apses and two pairs of towers. The best part of the several hundreds of stoneworks uncovered on the site so far is kept in the Cathedral's store-room. The stone carvings suggest great artistic skills on the part of the group of sculptors who were the first to bring the style of Burgundy to Hungary. The stone carving originating from the third quarter of the 12th century and representing one of the twenty-four *Elders* described in the Book of Revelations most probably belonged to the rood-screen of the Cathedral, together with a few other similar fragments. This stonework is especially interesting for its rendering as a sculpture in its own right, as well as for its lavish and decorative carving technique.

2 The master who produced the 13th-century relief decorating the portal of the Church of Szentkirály in Vas county must have been familiar with North Italian-Lombardian sculpture; the similarity in style is also underlined by the geographical location of the old church. The couple — the donors —shown with the enthroned Redeemer in the *tympanum* represent a type which can be found on a number of Hungarian buildings: in Bátmonostor, Sopronhorpács and Mosonszolnok. The figure of the couple donating money for the erection of the church is fitted into the arched composition with great skill. The two members of the Vas county nobility hold in their hands the model of the church and the bottom of a pillar; they wear period-costumes, and the expression on their faces is idealized, rather than portrait-like. The representation of the Enthroned Redeemer is Byzantine in origin, and the archaic arrangement of the drapery reminds the viewer of the 13th-century Maiestas Domini representations.

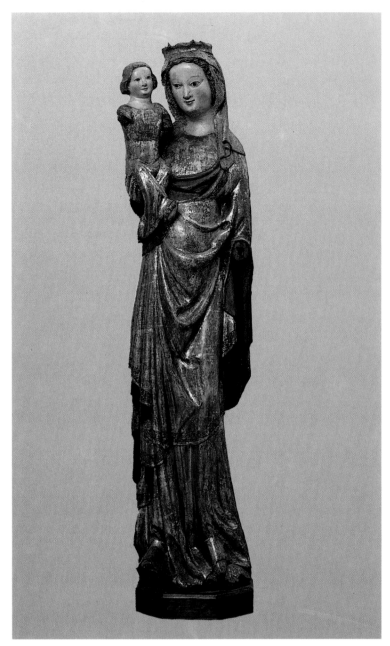

3 One of the earliest finds from Szepesség is this *Virgin and Child* representation made some time around 1370 or 1380, the slim and ethereal features of which were, according to an old photograph, further enhanced by the reticulated quatrefoil embellishment of the Virgin's headdress. The origin of this type can be traced back to France, or to the Virgins with Lion found in Silesia. The master who produced this sculpture was, in all probability, the same person who carved the figures of Apostles decorating the frieze of the high altar in the St. Jacob Church of Lőcse. These Apostle-figures survived as part of one of the early altars of the Church. In this way, the Virgin and Child from Slatvin serves to prove, among the very few early finds, the high standard characterizing the art of the sculptors working in 14th-century Lőcse.

4 | HUNGARIAN MASTER
St. Dorothy. From Barka

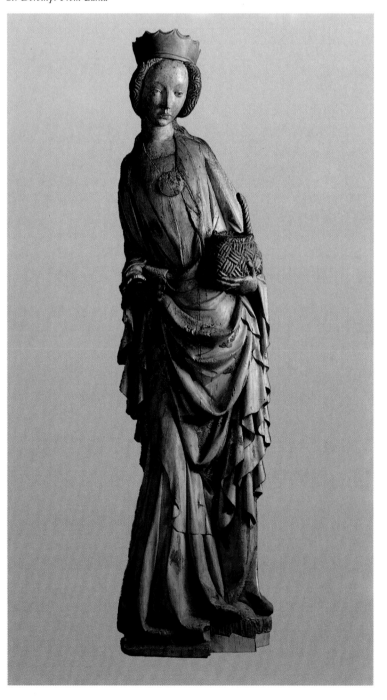

4 Together with the statue of St. Catherine, held in a private collection in Budapest, *St. Dorothy,* a sculpture originating from Barka along the road between Kassa and Rozsnyó, but in fact still inside the cultural irradiation of Kassa, most probably was decorating a larger tabernacle in the company of other female saints flanking the representation of the Virgin Mary. The sculpture is one of the most exquisite examples of the International Soft Style created in Hungary around 1410 or 1420. With its slender figure and sincere and thoughtful facial expression, *St. Dorothy* is unique among the similar statues found in this region; it is taller than the other Beautiful Virgins, and the drapery of her dress, together with her attribute, the flower basket, smoothly follows the outline of her body. Although the folds of her robe and the curve of her arms resembles the classical manner of presentation, they never become an independent plastic form; instead, they follow closely the soft S-line of the body. The sculpture is distinguished from its close relatives, the Virgin Mary of Kislomnic and St. Magdalene of Dénesfalva, by the fineness of the carving, the sincere expression of the face, as well as by the more balanced arrangement and its exceptional proportions.

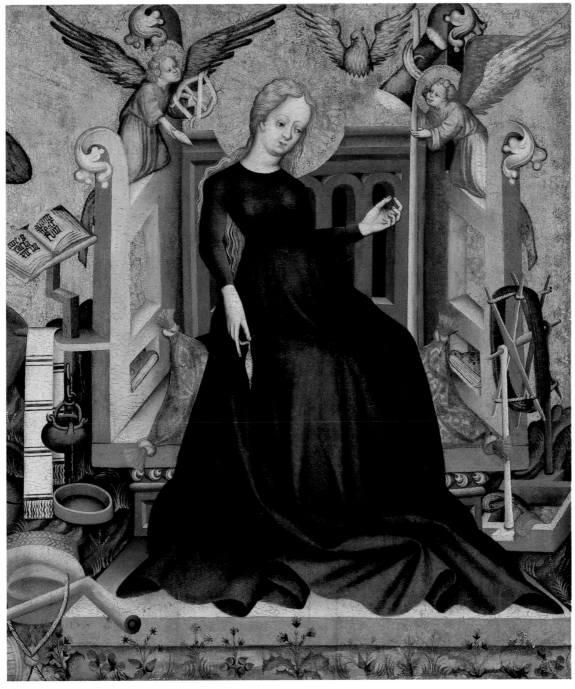

5 | HUNGARIAN MASTER
The Virgin at the Spinning-wheel. From Némétújvár

5 *The Virgin at the Spinning-wheel,* a painting made around 1420 or 1430 and acquired from Németújvár, originally made up one of the several scenes of a Mary altarpiece. It shows St. Joseph's doubts, the explanation for which can be traced back to the apocryphal text of the Greek Proto-Evangelium Jacobi, dating from the 2nd century. On the left hand side of the mutilated painting once there were the figures of St. Joseph and an angel. There are flowers in the foreground, together with the attributes of the Virgin Mary — the wash-basin, the cauldron of water and a towel — all of which became frequent features of German and Austrian paintings influenced by Netherlandish art. The undulating folds of Mary's robe, which suggest her pregnancy, are characteristic of the Soft style akin to the Viennese painting, although the master of the painting reveals a more individualistic artistic conception than his forerunners do.

6 | HUNGARIAN MASTER
House Altar. From Trencsén

6 The small-scale representation of the Virgin and Child on a *house altar* for private devotion from Trencsén, dating from around 1440 or 1450, resembles the late-14th-century icons by its reliquary, restored in the Baroque age. The type of the Virgin Mary representation itself tells of a redefinition of the icons. This is underlined by the embossed decoration of Mary's crown imitating gem inlays, as well as by the intimate contact between the Virgin and the Infant Jesus, holding the clasp of her mantle. A certain discrepancy between the style of the figures of the central piece and of the wings can also be detected. Although they are very closely related, as far as the technique of execution is concerned, the paintings on the wings are still closer to the Soft style, while the sharply defined folds of the Virgin Mary's robe, the twisted head-dress and the eyes cast down suggest the influence of the more modern Netherlandish school. The fineness of Mary's elongated fingers also prove that the master painting this particular work belonged to the best artists of mid-15th-century Hungary.

7 | THE MASTER OF KASSA
St. Jerome and St. Gregory. From Kassa

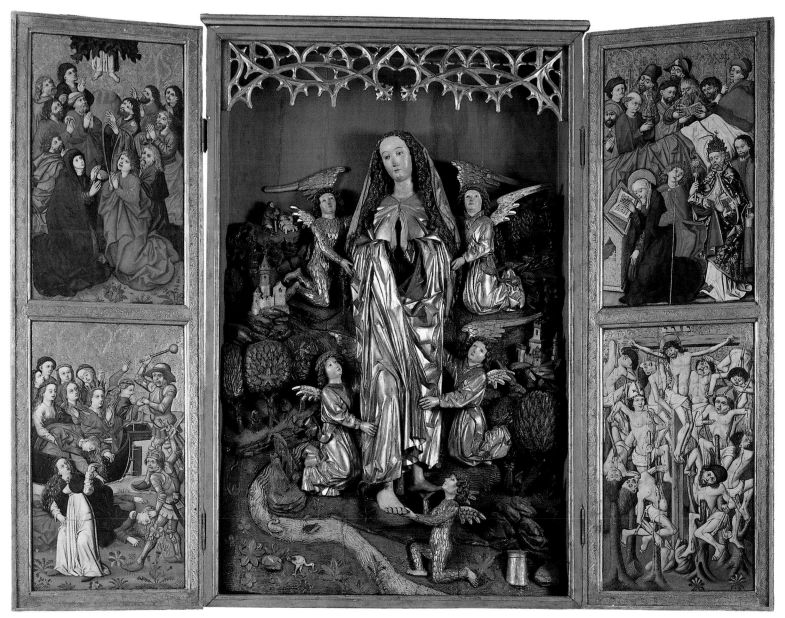

8│HUNGARIAN MASTER
The Assumption of Mary Magdalene. From Berki

7 The figures of *St. Jerome and St. Gregory,* characterized by the realistic rendering of their bony and scorched faces, sagging eyes, as well as by the intellectual superiority of the elders that comes through even in their wretched physical condition, together with the sharply defined folds of their robes that sets the whole composition in motion, are among the major representatives of the school of sculpting marked by the name of Nicolas Gerhaert van Leyden. According to the evidence of the sculptures of the High Altar of Kassa, this school of sculpting arrived in Kassa from Bécsújhely via Buda very early on, sometime around the 1470s. The figures were made around 1480 in the same workshop that produced the high altar of the St. Elizabeth Church in Kassa, and the possibility that originally they, too, were made for the altar, cannot be dismissed. The lion climbing up on St. Jerome's cloak is of Netherlandish origin; examples of it can be found, among other German works of art, on the pulpit from Strassburg.

8 The relief on the *altar of The Assumption of Mary Magdalene* dating from around 1480 or 1490, is a characteristic example of the art of the Sárospatak school of sculpting, itself testifying to the great influence of the carvings of the high altar in Kassa. Although the artist evidently knew the composition of Master E.S.'s copper-plate etching, nevertheless Mary Magdalene's figure, wrapped in a mantle, together with the altering of the number of angels, suggest a certain ingenuity on his part. He especially took delight in the detailed depiction of the landscape in the background, thus providing a fairy-tale atmosphere for the legend. Although the paintings on the wings are the works of a less capable artist, they were undoubtedly made for the same altar, and they also contain a number of iconographical characteristics popular in Central Europe, including representations of the Virgin Mary's last prayer, the Calvary, and the Ten Thousand Martyrs.

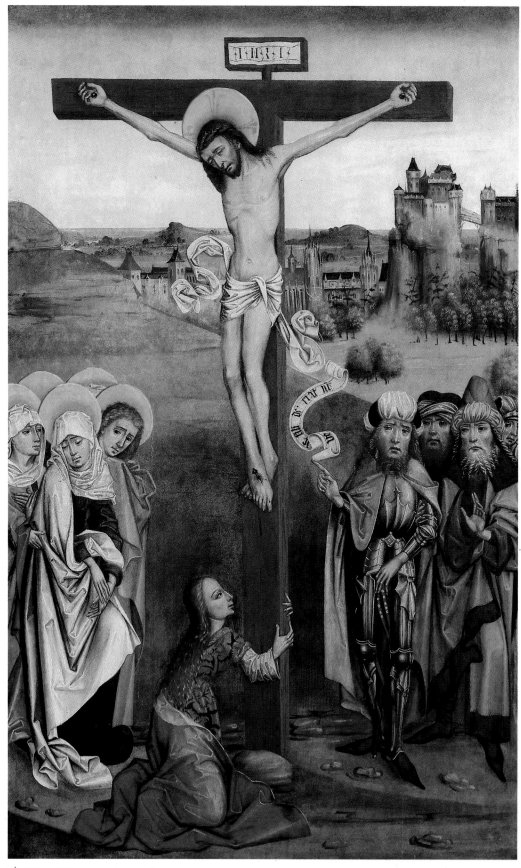

9 | THE MASTER OF JÁNOSRÉT
Crucifixion. From the St. Nicholas high altar from Jánosrét

9 Judging by the style of the paintings on the outside panels of the St. Nicholas high altar of the church in Jánosrét (Calvary, Mount Olives) made around 1480, the Master of Jánosrét must have been an outstanding representative of the mining towns school during the late 15th century; he turned out to be an important mediator of Netherlandish art in the age of King Matthias. The figure of the centurion wearing a turban and pointing at Christ with a sword in his extended arm can be traced back to Martin Schongauer's copper-plate etching depicting the *Crucifixion*; the same etching provided the pattern for the figures of the Virgin Mary and St. John. As far as the artist's skills are concerned, certain stylistic elements — such as the harmonious relationship between the figures and the landscape, the representation of the atmospheric perspective or the careful composition — are more important than the assimilation of certain motifs.

10 The *fragment of an* altar from the 1490s was uncovered from the outer wall of the Pauline church in Diósgyőr. According to the evidence of the bishop's coat of arms, the person commissioning the altar was most likely the Bishop of Csanád, Johannes de Zokol, who retired to the Pauline monastery of Diósgyőr in 1493 to live the rest of his life there as a monk. Sometime around 1486 or 1487 the sculptor Giovanni Dalmata, a celebrated artist who had worked in Rome and in Trau (Trogir), arrived at Buda, where the construction of King Matthias's Renaissance palace was under way at the time. Dalmata's style can be recognized on a number of fragmented stoneworks of the Royal Palace of Buda. King Matthias bestowed upon his favourite sculptor awards and property, and it seems very likely that he also commissioned the artist to fashion his tomb. In spite of its fragmented condition, the relief shows the stylistic marks of Dalmata's best Italian works, providing ample proof of the high standard of Renaissance sculpting in the age of King Matthias.

11 The parish church of Mateóc in Szepesség was dedicated to the memory of King Stephen (1000–1038), the founder of Hungary. The 15th-century painted triptych of the church is the only surviving memento showing scenes from the lives of St. Stephen and his son, St. Emericus. In addition to the religious veneration, the three male saints in the House of Arpád — Stephen, Emericus and Ladislas — also enjoyed another kind of admiration, profane and national in character. The fact that they were referred to as *Sancti Hungariae reges* (sacred kings of Hungary) and were depicted together indicates that they embodied the type of the ideal sovereign. The aged and bearded *St. Stephen* possesses the most general traits of a sovereign, which in the case of this particular statue even resembles the representation of God. *St. Ladislas,* who is portrayed at an age between the ages of the other two kings, is shown as a warrior wearing armour. The sculptures, which were made around 1500 and came complete with the figure of St. Emericus, originally must have decorated the middle section of a triptych. The carving technique used in fashioning the beard and the hair, and especially the cloak, reveals the influence of the sculptor Veit Stoss. The dancing step of St. Ladislas is in harmony with the type of portrayal fashionable around the 1480s, and can be traced back to the art of Gerhaert van Leyden.

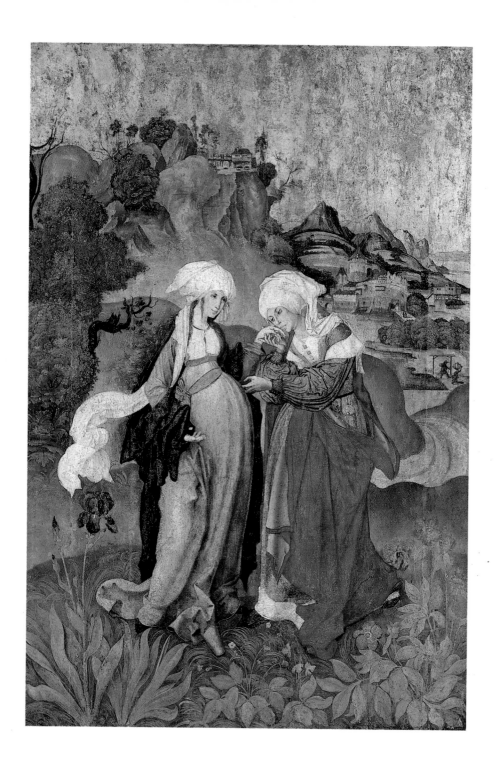

12 | MASTER M.S.
The Visitation

12 No written sources have been found so far on the life of the Master M.S., the most important representative of Late Gothic painting in Hungary. The only clue concerning his activity is the date 1506 and the signature MS on the sarcophagus of one of his paintings, The Resurrection of Jesus Christ, held in the Christian Museum of Esztergom. There is even uncertainty concerning the identity of the church for which his closely associated paintings were made. The most widely accepted view identifies it as the Church of St. Catherine of Selmecbánya, since most of the paintings were found in the vicinity of this important mining town. There are four Passion paintings in the possession of the Christian Museum; the painting *The Birth of Christ* is held in Hontszentantal, while The Adoration of the Magi is kept in the Museum of Lille in France. According to the earlier attempts at reconstructing the master's work now at the National Gallery, the paintings were supposed to decorate the outer panels of a large triptych when closed; when opened, the triptych was assumed to reveal reliefs, since traces of such reliefs can be found on the obverse of the Passion scenes. Recent studies by restorers cannot exclude the possibility that the scenes taken from the life of the Virgin Mary and the Passion scenes were in fact parts of two different triptychs.

The painting entitled *The Visitation* depicts the meeting of the two saints, the Virgin Mary and St. Elizabeth, with poetic intimacy: Elizabeth recognizes Mary as the mother of God and kisses her hand. The idyllic landscape, which is in harmony with the figures, further enhances the poetic mood of the picture. The iconographic representation of the Visitation, in which the two saints meet in the open air, rather than in Elizabeth's house, first became popular in the painting and book illuminations of Netherlandish artists. The flowers iris and the peony shown in the foreground are the symbols of Mary. However, while in the paintings of Rogier van der Weyden, for example, the earlier mentioned flowers were modestly hidden in the meticulously painted grass, in Master M.S.'s work they became the corner-stones of the composition. The representation of these flowers suggest the direct study of nature, which could have been associated with the wide spread of herbariums.

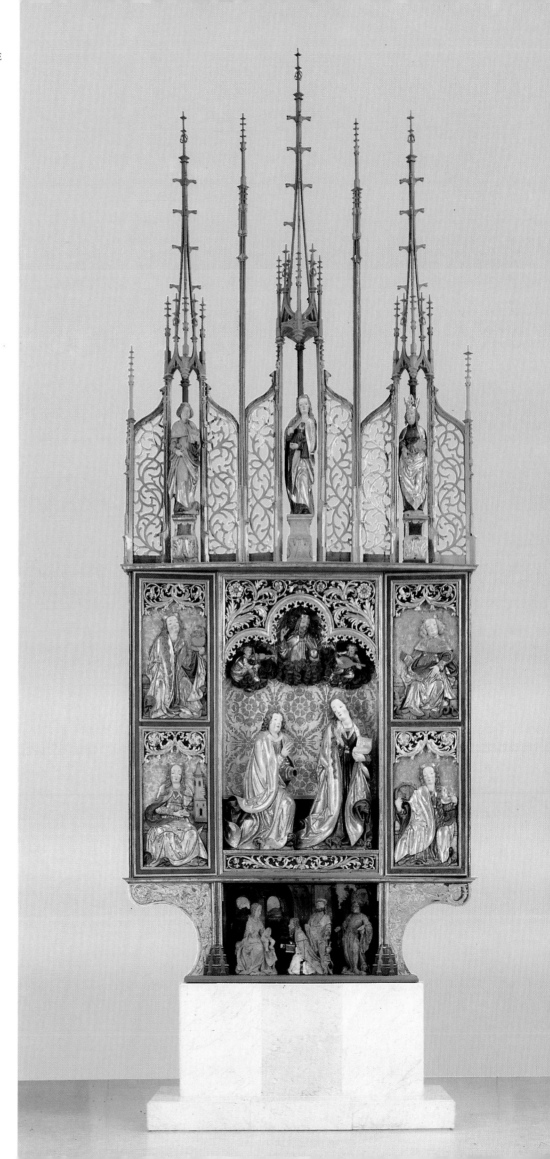

13 The number of altars increased considerably in the 15th century when, in addition to the altar dedicated to the church's patron saint, which stood in the crypt, altars were also erected by influential families and pious brotherhoods in the aisles — either next to the pillars or in the side-chapels. The triptychs were created jointly by painters, woodcarvers, carpenters, and gilders, all working in guilds. The most significant sculptor in Szepesség in the early 16th century — as well as the best propagator of the art of Veit Stoss — was Master Pál Lőcsei. The artists referred to as the Master of the Altars of St. Anne, who worked in the counties of Szepes and Sáros, followed the style of Master Lőcsei; two of his works made in Nagyszeben between 1510 and 1520 are owned by the National Gallery. Both are characterized by the relief decoration on the inner side of the wings and, especially in the case of the *Annunciation*, the contrast between the dramatic effect of the shell-like drapery and the lyrical expressions of the faces. The paintings on the wings faithfully follow the composition of Dürer's woodcut series from 1511, and are associated with the so-called Danube School of Renaissance painting. The tabernacle and the reticulated floral ornamentation on the top part of the reliefs also indicate the spread of Renaissance motifs.

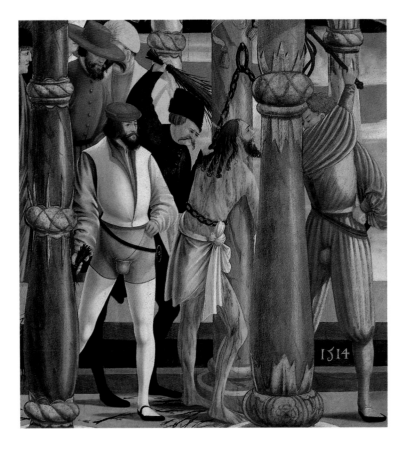

14 Together with three other panels in the collection of the National Gallery, *The Flagellation,* dating from around 1514, once decorated the outside of the wing of an altar. The origin of the painting is unknown, though it is often regarded as Transylvanian. Some art historians also identify it with the circle of the Danube School, while others believe that it is related to similar works originating from Salzburg. Undoubtedly, the painter was familiar with the achievements of the Danube School, but this Renaissance school, as a matter of fact, was widely known in Transylvania. The artist evoked the Renaissance ambiance very ingeniously, which he emphasized by the style of the columns. By the contrast of the colours, of light and shade, and by the rhythm of the columns and figures, he achieved an admirable feeling of space.

15 *St. Anne with the Virgin and the Infant* originates from Eperjes, and was painted around 1520. This composition is the only panel in the collection which includes the portraits of the donor and his son with his patron saint, who is commending them to the protection of the Virgin Mary. The donor can be identified from the coat of arms above his head. Senator János Hütter commissioned a type of devotional picture which was related to the late medieval cult of Saint Anne. Furthermore, because of the presence of St. Joseph, the painting is a variety of the so-called 'Holy Family' or 'Relatives of Christ' type. The rich depiction of the interior, which was unusual in Hungarian painting, as well as the painterly style of the picture reveals an Augsburgian connection. This may be due to the Thurzó-Fugger commerce which was at the height of its activity in those years. For the Renaissance architectural details the painter may have gotten inspiration from the towns of Eperjes and Bártfa, which were rebuilt in the Renaissance style around that time.

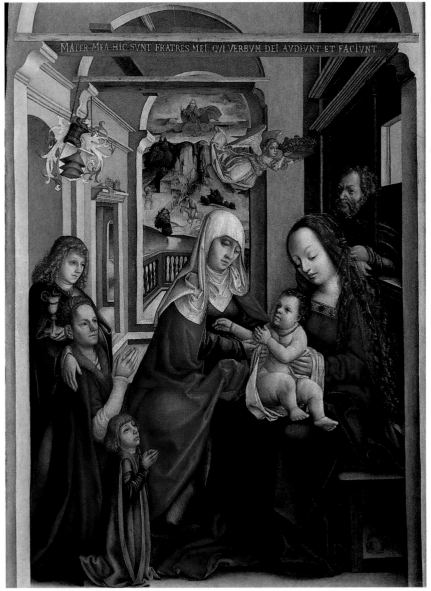

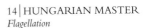

16 In the former St. George's Church in Nyírbátor, there are a number of works to illustrate the broad area of interest of the Báthory family's art patronage. The inscription of *András Báthory's Virgin and Child* reveals not only the name of the donor and the date of origin — 1526, a tragic date in Hungarian history, the year of the Battle of Mohács —, but it also indicates that the marble relief was probably meant to be displayed above the entrance of either the church or the chapel. The tabernacle of the Church of Nyírbátor was an early work of the same master, and the Renaissance sedile there was probably also made in the same workshop. The relief is one of the most characteristic examples of Hungarian Renaissance art, providing a new interpretation of a popular Madonna-type from Florence. The marble relief is framed by an ornamental motif popular in Renaissance architecture, which acts to provide the illusion that the Madonna is looking down on the viewer from an open window.

17 The relief entitled *Christ Taking Leave of his Mother,* together with the fragment showing the three apostles, now kept in Nyitra but originally forming the right side of the relief, was probably the central part of an epitaph erected in memory of a deceased person. The epitaph most probably stood in the bishopric cathedral of Nyitra. The iconographical curiosity of the relief is that the Virgin Mary touches Christ's attire in a way reminiscent of the *Noli me tangere* representations. The figures of Mary and Christ, and especially the depiction of Christ's head, prove the artist's familiarity with a woodcut of the same subject in Dürer's series, The Small Passion. The balanced composition, together with the long folds of the robes and the tranquil brush-work, point to the influence of northern Renaissance art, and shows similarities with the art of Hans Daucher and Peter Vischer in particular.

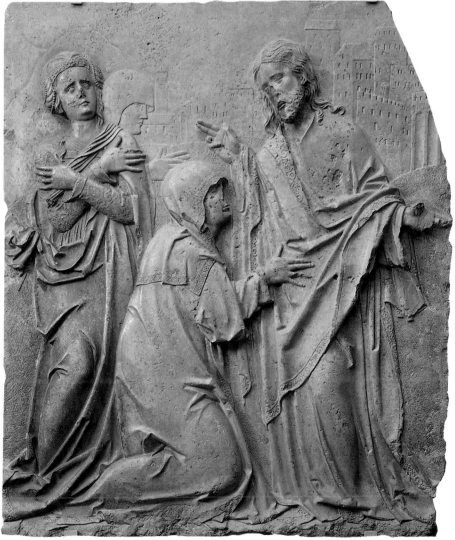

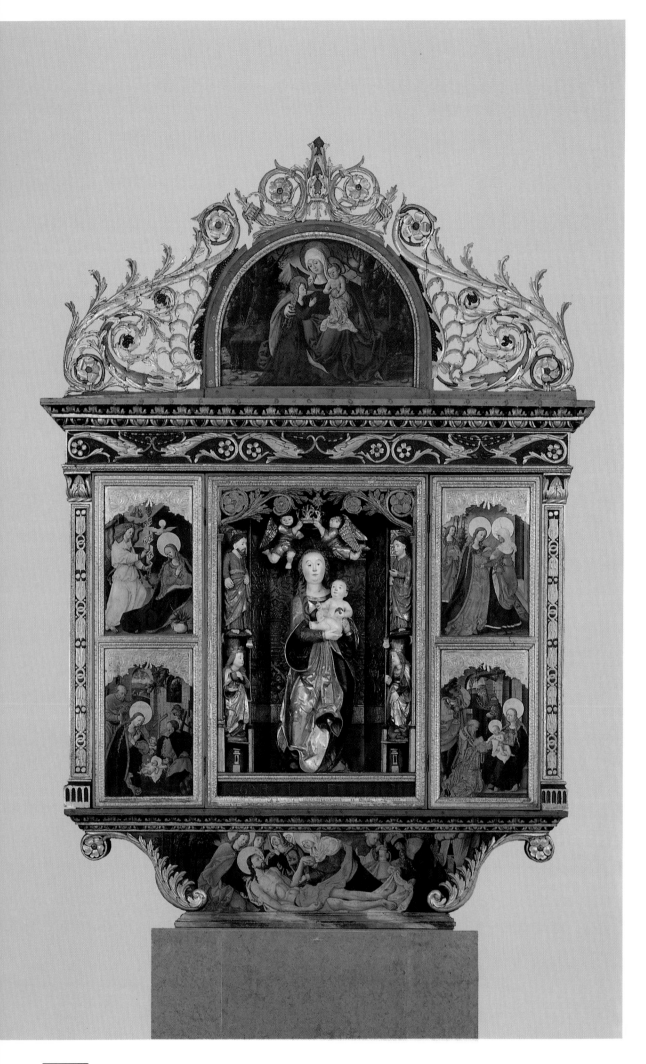

18 The structure of the *High Altar of the Virgin Mary* of Csíkmenaság, as well as its carved ornamentation, reveal the influence of Renaissance art. The ornamental carving framing the lunette on the pinnacle of the altar consists of branches combined with the image of a dolphin and a cornucopia, while the cornice running across the altar also features pairs of dolphins facing each other. Using the compositional elements of Dürer's famous woodcut series, the artist introduces the four main episodes in Mary's life in the paintings of the altar wings, while the Lamentation of Christ is shown on the predella. When closed, the altar displays eight scenes from the Passion. The painting on the pinnacle of the altar features Madonna and Child with St. Anne. With its giant trees and mountains, the landscape in the background suggests a careful observation of nature. Underneath the altar's sculptures the date 1543 indicates not only the year of the completion of the most complete Transylvanian altar, but also the end of the medieval triptych in Hungary.

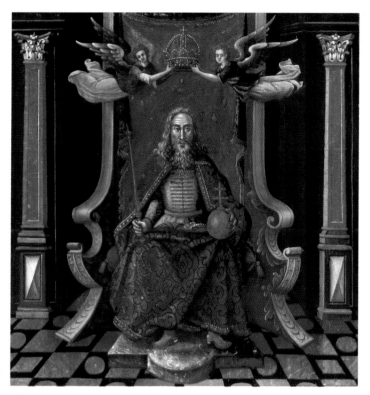

19 | HUNGARIAN PAINTER
King Saint Stephen

20 The wooden epitaph is found in the interiors of many 17th-century churches. The most wonderful examples are displayed still in their original place in Csetnek and Lőcse. The *Epitaph tablet of Anna Rozsályi Kun, Wife of István Tárkányi* made in the second quarter of the 17th century and acquired from the Church of Kisszekeres, the burial place of the Rozsályi Kuns, is very much like the other wooden epitaphs originating from around the same time, as far as the composition, the architectonic design, and the decoration, both painted and sculptural, are concerned. In the central piece, which is a little larger than the usual size, we see Anna Kun wearing a widow's dress under the cross — the Tree of Redemption — accompanied by both of her husbands as well as all the children from both of her marriages. The frame is decorated with herm-pilasters of a dynamic design and harmoniously coloured open-work carvings with elements of the so-called pinna or cartilage style. The same set of motifs, originating from Silesia, are seen on the contemporary altars, choir-screens, pulpits, and organs. It is not inconceivable that the master making the Tárkányi epitaph also helped decorating the interior of the St. Jacob Church of Lőcse. The sharply defined features of the herms decorating the frame on both sides, as well as the grotesque grimace of the cherub above the carving, all derive from the herms decorating the steps to the pulpit of the St. Jacob Church.

19 In 1541 Buda Castle, a prospering seat of royal power as well as a centre of Renaissance art and Humanist culture, was captured by the Turks. The country was split into three parts: the Kingdom of Hungary in the west and the north; the Principality of Transylvania; and the remaining parts under Turkish suzerainty. After a period of decline, art life, which had earlier been centred around the royal court, began to show signs of recovery in the early 17th century, primarily as a result of the art patronage of the bourgeoisie and the Renaissance courts of the aristocracy. Then, with the spreading of the Baroque style by foreign masters under the patronage of the Church, Hungarian art once again linked up with the mainstream of European art.

Alongside the portraits of St. Ladislas and St. Emericus, the panel painting made around 1600 and showing *St. Stephen* was, perhaps, originally part of an extensive series featuring Hungarian kings. On this occasion St. Stephen, similarly to St. Ladislas, was represented as a sovereign and a historical personality. His throne, which is decorated with tapestry and has a capricious design, is painted in the Mannerist style, while the insignias in the hand, as well as the crown of Hungary deported by angels, are rather accurate depictions of the coronation insignias in line with the concept of the period. St. Stephen — just like his son in the other painting — is dressed in the Hungarian attire typically worn in the late 16th and the early 17th centuries, and reflect the national sentiments associated with his person. Although compositional analogies between these paintings and the corresponding sheets of a series of copper-plate etchings entitled Mausoleum, made in Prague in the 1610s, cannot be found, a related compositional approach and certain similarities in the details suggest some connection between them. The closest stylistic analogies of these pictures, executed with the meticulousness of miniature painting, can be found in heraldic representations.

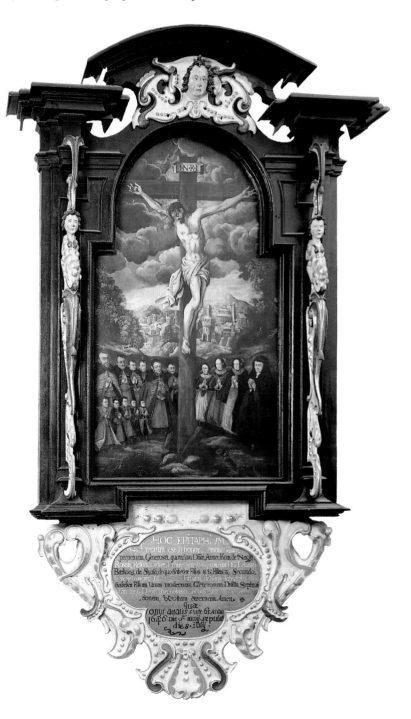

20 | WORKSHOP IN UPPER HUNGARY
Epitaph Tablet of Anna Rozsályi Kun, Wife of István Tárkányi

21 | JAKAB BOGDÁNY
Still-life with Birds

22 | ÁDÁM MÁNYOKI
Self-portrait

21 It was probably in Vienna that Jakab Bogdány, the son of a Protestant family in the town of Eperjes, began his studies; later, between 1684 and 1688, he worked in Amsterdam, which was then the centre of the bourgeois genres, most notably of still-life painting. For the young painter, the Dutch influence proved decisive on several account: it can be detected in his still-lifes with flowers and fruits in the use of colours, while the genre-like composition of his paintings depicting birds reveals the assimilation and expansion of Melchior de Hondecoeter's paintings of animals. Elegant parks with beautiful birds are the sites of Bogdány's high society genre scenes. The exquisite components, such as fountains or antique ruins, enhance the grace and refinement of the composition. The painter obeyed the taste of his commissioners and made their paintings to fit into their surroundings. Bogdány, who moved to England in 1688 and worked for the royal family and for the members of the English aristocracy, died as an esteemed artist. He studied the main attractions of his compositions, the exotic birds from the colonies, in the then very fashionable birds' houses; their precise depiction can also be seen in the painting *Still-life with Birds* from the 1710s. Bogdány's paintings are still kept in their original surrounding, in English mansions and in the summer resorts of the Royal Family.

22 Ádám Mányoki is one of those Hungarian artists who, for lack of possibilities at home, made their name famous abroad. He studied in Hamburg, then worked in the Berlin court for a while, but he also travelled to Vienna. During his time, Mányoki was esteemed as a court painter of the Electors of Saxony, whom he served first in Warsaw, then in Dresden. Mányoki's way of rendering was generally dispassionate, and he avoided the customarily used extremes of the Grand Manner which concentrated on the grandeur of the members of the Court. He interpreted portraiture more intimately than daringly; thus, his style was attractive not only to his bourgeois patrons, but also to the members of the Dresden intelligentsia. His paintings were often reproduced in copper-plate engravings; there are several of them, in fact, which had been handed down to us only in printed form. Between 1707 and 1709 Mányoki worked in Hungary as the Court painter to Ferenc Rákóczi II. The Prince helped his development as an artist by financing a trip to Holland. The well-known portrait depicting Prince Rákóczi, which was painted during his Polish emigration, show the traits of the style of Dutch portrait-painting. Mányoky's *Self-portrait* is probably related to his stay at the Prussian court in Berlin in 1711. The influence of contemporary Italian — mainly Venetian — painting, which

was transmitted to Mányoki by Antoine Pesne, a Court painter who settled in Berlin after studying in Italy, is seen in this gay and congenial self-portrait.

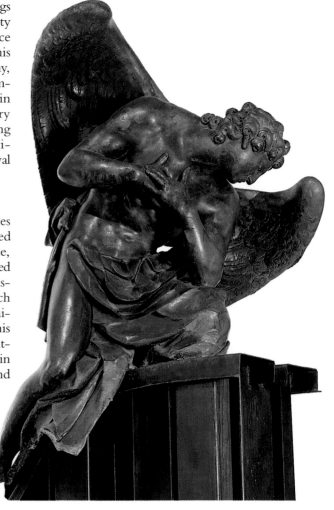

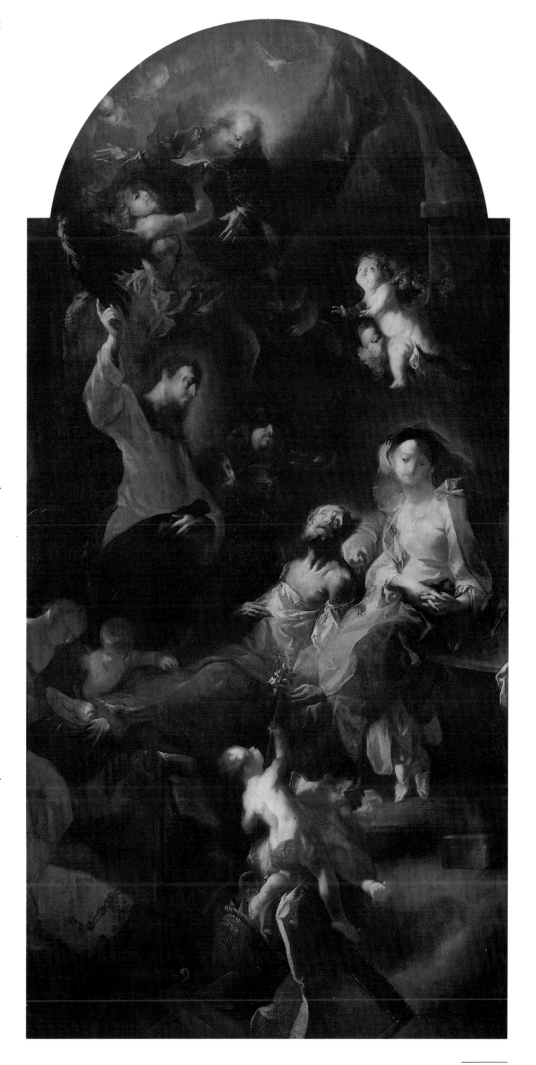

23 Georg Raphael Donner, one of the most prominent sculptors in 18th-century Europe, was employed by Archbishop Imre Esterházy in Pozsony (Bratislava), then the capital of Hungary. The high altar of the Cathedral in Pozsony was his most significant accomplishment; under a baldachin, the mounted figure of St. Martin, titular saint of the church, was depicted sharing his cloak with a beggar seated on the ground. The sculpture bore the features of the doner, Imre Esterházy, and wore a typically Hungarian costume. The scene was watched by two large *Adoring Angels.* The Baroque high altar was dismantled during the 19th century; the group of St Martin and the beggar today stands in the side aisle of the church, while the two angels are in the Hungarian National Gallery. The angels were molded in 1733–1735, and represent the artistic development of Donner starting from Baroque tradition and arriving at a more individual Neo-Classical style. The high altar was cast in an alloy of lead and tin — a material often used by Donner. The artist was helped by a number of assistants in the process of casting. The experience of these helpers and the direct example of his sculptures in Pozsony had a major impact on the development of Hungarian Baroque sculpture.

24 Franz Anton Maulbertsch, after having surpassed the style of Viennese Academy and assimilating various influences, developed his own individual style, which later inspired several artists. Starting in the 1750s, he often worked in Hungary. The frescoes in the parish church at Sümeg, which he completed in 1767, were among the major works of this period of his career. *The Death of St. Joseph,* an altar painting from 1767, belongs to his best "visionary" period. It was probably intended for the church of the Trinitarians in Buda. In an obscure interior, in enigmatic lighting, the Holy Father looks down at Christ's worldly step-father, Joseph, who is lying on his death-bed. Life-like details and visions dovetail in the composition, ascending in a spiralling motion. The third participant of the legendary scene is Mary, whose fragile, heart-rending figure is a constantly reoccurring type of Maulbertsch's paintings, just like the translucent bodies of the child-angels playing on the ground and in the air.

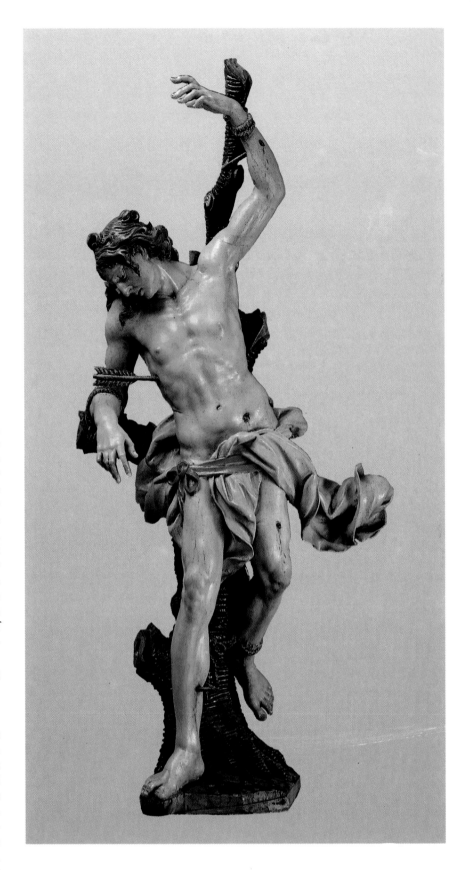

25 Together with another sculpture representing St. Roch, *St. Sebastian* stood in the tabernacle of the high altar of the parish church in Egervár, Zala county. These two saints were believed to be protectors against the plague, and their image occurred most often in open-air memorials. Philipp Jacob Straub, an artist born in Wiesensteig, was a member of one of the most distinguished Baroque sculptor dynasties. Trained in Munich and in Vienna, Straub settled in Graz in 1733. His refined Rococo style greatly enriched the development of art in the Alpine region, which already had rich traditions in wooden sculpture. The relationship between some of the nobility of the Graz area and some Transdanubian noble families had been uninterrupted since the 16th century; this is the circle where the influence of Straub's workshop was manifest. The desired effects — dismay and delight — are achieved through a sensual beauty, brilliance and the naturalistic rendering of the bleeding wounds.

26 The one-and-a-half-times larger than life-size statue of *St. Florian*, made in 1764, was taken to Budapest from the Church of Our Lady of Körmöcbánya together with its counterpart showing St. Donat, after it was demolished at the end of the last century. Although his name sounds Italian, the artist Dionysius Stanetti was born to a Silesian family of sculptors. His uncle Giovanni was even commissioned to work in Vienna for the Imperial Court, while two of his brothers were also active in their hometown, Teschen. A shortage of commissions back at home must have induced the artist, who was equally well trained in working with wood and with stone, to leave his home and venture to the east; be it as it may, from 1743 until his death, he worked in the mining towns of Hungary. The two saints, Florian and Donat, both lived in the age of the Roman Empire and were worshiped for their protective powers against natural disasters. At the feet of Florian, who was supposed to give protection against damage by fire, a burning house is shown. Florian is usually depicted dressed as a soldier, wearing a helmet and holding a bucket and a flag; in the case of this statue, this latter attribute was lost.

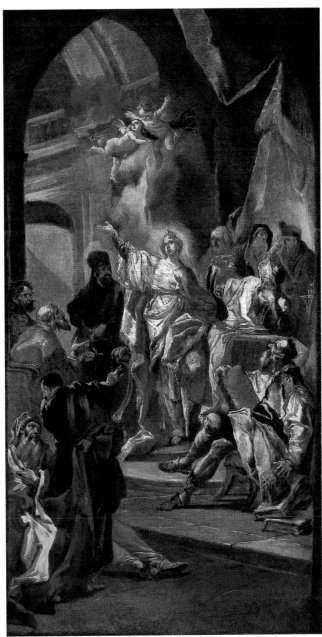

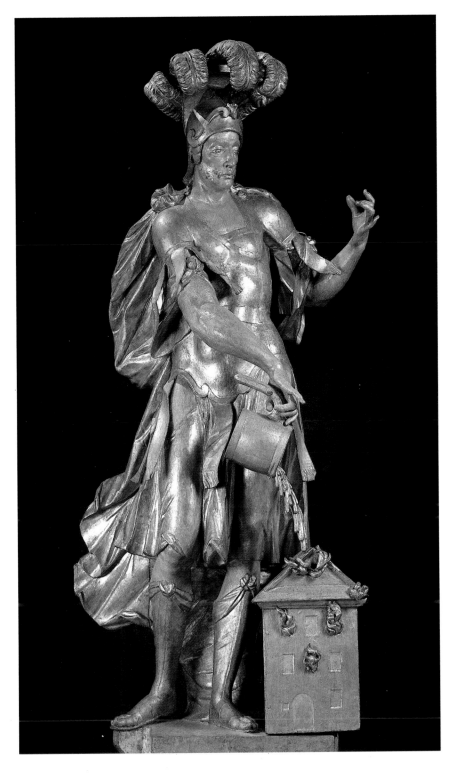

27 Johann Lucas Kracker was born to a Viennese family of sculptors. He studied at the Academy, and was a follower of the influential painter Paul Troger. In the 1740s he moved to Moravia, and through the Premonstrensian Order he regularly worked on Hungarian commissions. In 1764, after completing the frescoes and the altar paintings of the Abbey of Jászó, he offered his services to the Bishop of Eger, Károly Esterházy, and shortly after that he moved to the lovely Hungarian town. His most important work from this period is the fresco of the library, showing the Council of Trent, which he finished in 1778. He painted a large number of altar paintings, the most important being the St. Catherine High Altar of the parish church of Egerbakta. He painted a colour study for this painting in 1775, which was later purchased by the Hungarian National Gallery. The composition of the picture, which is entitled *The Dispute between St. Catherine of Alexandria and the Philosophers,* closely follows that of Troger's work entitled Jesus at the Age of Twelve, with the glorious and radiating female figure at the centre. The use of warm colours, the vibrant brush-work, and the types of Eastern figures suggest a Venetian influence. The story of Catherine converting fifty philosophers and the Empress in the course of a religious dispute propagates the tenets of the Catholic Church.

28 Following family traditions, and most notably the example of his grandfather, Miklós the Magnificent, *Prince Miklós Esterházy II* became a knowledgeable and generous art patron. As well as being Haydn's last patron in the Esterházy family, he was the founder of the Esterházy Gallery and Graphics Collection, which later came to form the basis of the Old Gallery of the Museum of Fine Arts. In his case, therefore, the intimate posture, which he assumes leaning over the statue of Minerva, the antique patron of arts, is quite justified; besides, this form of portraiture had, by then, become widely popular. Esterházy, who was equally successful in the diplomatic service and in his military career — he was Bonaparte's choice for King of Hungary — in this portrait wears the uniform of the captain of the Hungarian Royal Guards. Together with its counterpart (the Portrait of Archduke Charles Louis of Habsburg, owned by an Austrian collector), this painting, which was made in 1792–1793, was originally held in the Esterházy Palace in Pápa. This portrait is a light and Baroque version of the large-scale final work held in the Palace of Kismarton, the colour and the style of painting of which are closer to the Classicist school. The painter, Martin Knoller from Tirol, worked for the Esterházy family on more than one occasion; he painted the portraits of Prince Miklós and his brother, Pál Antal, for the Palace Guards in Vienna round about the same time.

29 | KARL PHILIPPE SCHALLHAS
Landscape with River

29 Karl Philippe Schallhas, who was born in Pozsony (Bratislava) but worked in Vienna all his life, was a charming although not widely known landscapist in the late 18th century. He studied at the Academy of Vienna under Johann Christian Brand. Those few known oil paintings which he left behind all testify to his talent, as, indeed, does the speed with which he rose in his career: he became a member of the Academy in 1790, and by 1795 he was an instructor at the School of Landscape Painting. One year before his death he was appointed assistant lecturer, first under his master and then under his master's brother. Although Schallhas learned to paint landscapes by following his master's example on the one hand, and by studying the classic traditions of Dutch painting on the other. His paintings, which give a slightly nostalgic rendering of nature, reveal the individual synthesis of all these influences. With their excellent perspectival view and staffages, Schallhas's landscapes never represent an actual countryside; rather, like the present work, entitled *Landscape with River* (1790–1795), they are projections of the Romantic ideal of nature — the painterly expressions of the harmonious relationship between man and nature, composed of meadows, brooks with bridges and rivers running through the forest.

30 The Viennese Academic painter István Dorfmeister, who moved to Sopron as a young man, became the most productive artist of the last third of the 18th century in the part of Hungary lying west of the Danube. A significant part of his monumental paintings have historical subjects, conveying the political messages of the enlightened clerics and the national aspirations of the Hungarian nobility. A scene from the Battle of Mohács was, for example, incorporated in the decoration of the reception hall of the Cistercian Abbey of Szentgotthárd as a counterpart of the pannels capturing the Battle of Szentgotthárd. The main episodes from the history of the Cistercian Order of Hungary provided the theme for the series, beginning with the foundation of the Order. The painting *Béla III Founding the Cistercian Monastery at Szentgotthárd in 1183* was made in 1795–1796. It captures the moment when the French monks were received in front of an antique porticus. The king and his escort are shown wearing colourful Hungarian costumes. In the background we see the distant view of 18th-century Pest-Buda, with a few medieval details added; behind the monks the imaginary view of the Romanesque Church and Abbey of Szentgotthárd is depicted. The pure forms, the simple light effects and the use of light colours — the stylistic marks of Late Baroque mixed with the elements of Neo-Classicism, so appropriate at the end of the 18th century — suggest an optimistic view of history, which is a rarity in Hungarian art.

THE COLLECTION
OF NINETEENTH-CENTURY
PAINTING AND SCULPTURE

31|JÁNOS DONÁT
Woman Playing the Lute

31 János Donát was a typical exponent of Viennese Academic painting, which exerted a profound influence on Hungarian art for a considerable period of time. He was already an elderly man when he moved to Hungary. Donáth became a friend of the writer Ferenc Kazinczy, a leading figure of the Hungarian Enlightenment, and it was his recommendations that opened the way for Donát to become one of the most popular portrait painters of the 1810s and 1820s, one of the great periods of portrait painting among the nobility and the higher circles of the bourgeoisie. Donát also produced altarpieces and mythological compositions. *Woman Playing the Lute* well represents his reliable, a little too tediously executed, Neo-Classicist portrayals, in which the personality of the model is barely captured; instead, the painter seems to have been taking more enjoyment in idealizing his models. He did not strive for the kind of representation typical of Baroque paintings; instead, his portraits were much more characterized by a certain detached decorativity.

32 Károly Kisfaludy, renowned poet and playwright, as well as landscapist, is generally credited for the early breakthrough of Romanticism in Hungarian art. Storms, the raging of the elements — like in the case of *Maritime Peril* — was a favourite motif of his landscapes. Such themes gave the artist a chance to emphasize the dramatic contrast between light and dark, turbulence and calm. Although Kisfaludy attended the Viennese Academy for a while, and also worked in Italy, his literary activities prevented him from paying more attention to improving his painting technique. Therefore, a certain degree of naiveté can be seen in his emotionally highly-charged paintings and drawings.

32|KÁROLY KISFALUDY
Maritime Peril

33 Károly Markó the Elder was the first Hungarian landscapist of great influence. He spent most of his life in Italy, where he painted idealized landscapes in the Classicist style. When he was younger, the capturing of a precise physical likeness of his subjects was more important for him; in the most significant painting of this period, *Visegrád,* Markó emphasized the peculiar character of the landscape. Not striving for the representation of minute details, the painter depicted this important location of Hungarian history from a distant view, with elegantly economical colouring. This painting also shows that placidly balanced composition and accurateness were more important components of Markó's art than the emotional identification with historical ruins evoking stormy chapters from the Hungarian past. The cool greens and blues found on this composition do not recurr on his successful Italian landscapes, reminiscent of Claude Lorrain's paintings; in these, he depicted the landscape and the people of the southern regions with warm, golden rays.

33 | KÁROLY MARKÓ THE ELDER
Visegrád

34 Miklós Barabás was the most successful and productive painter during the Hungarian Reform Age. He was a portraitist above all, but in the 1840s, when a great demand emerged for paintings depicting the lives of the common people, especially villagers, he turned to the depiction of genre scenes. *Romanian Family off to the Fair,* which he painted in 1843-1844, was first exhibited at the Pesti Műegylet (Pest Art Society) in 1845. The picture was later copied several times. In the meticulously executed painting showing a group of well-off Romanian shepherds descending from the Transylvanian mountains, the subject was interpreted a little too idealistically, but very much in accord with the taste of the times. The minutely worked-out details show that Barabás had a good eye for particulars. The figures were grouped and composed within several triangles, yet their grouping does not strike the viewer as unnatural. In 1835 — after travelling to Transylvania, Vienna, and Italy — Barabás moved to Pest. His presence in the city enlivened the art scene; following his settlement, more and more artists gave up working abroad, because gradually the Hungarian public was able to support them.

34 | MIKLÓS BARABÁS
Romanian Family off to the Fair

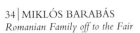

35 Portraiture during the first half of the 19th century can be classified in several ways: the ones depicting the model in an interior or outdoors; portraits of families belonging to the bourgeoisie, aristocracy or to the nobility; pictures with only a few figures, or showing more than one generation together. The serenity or animation of a composition can also be a basis of comparison. After studying in Vienna, Munich and Italy, Henrik Weber became an acknowledged painter of genres and historical compositions. The Portrait of *Composer Mihály Mosonyi and His Wife*, painted in the 1840s, is an intimate portrayal of Weber's sister and brother-in-law, rendered with soft, warm tones. Mihály Mosonyi (Brand) was a composer of operas and other musical forms, and an enthusiastic propagator of Hungarian national music and the music of Richard Wagner.

36 | SOMA ORLAI PETRICH
Portrait of the Artist's Mother

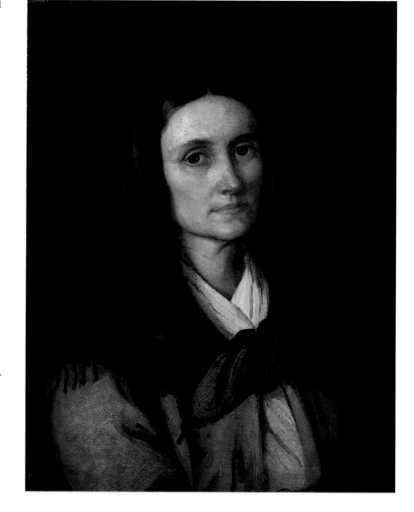

36 Soma Orlai Petrich's *Portrait of the Artist's Mother,* painted about 1853, was among the earliest Hungarian examples of a realistic approach to portrait painting. The artist depicted the person dearest to him very simply, yet the picture makes a strong statement. The collected, energetic brush-strokes and the psychological approach anticipated the dramatic character of Mihály Munkácsy's paintings. Orlai was a friend and relative of the great 19th-century poet, Sándor Petőfi; together they undertook the mission of popularizing art by displaying elements of Hungarian folklore. Orlai was also one of the first Hungarian artists to paint historical compositions, and in this he was the first to take up themes which later became popular. Unfortunately, his technique of painting figures was lacking in stability, and thus his achievements were soon surpassed by his pupils. Nevertheless, with his portraits and his genre scenes from the lives of the everyday people — worthy of his teacher, Waldmüller — Orlai had a lasting effect on Hungarian art.

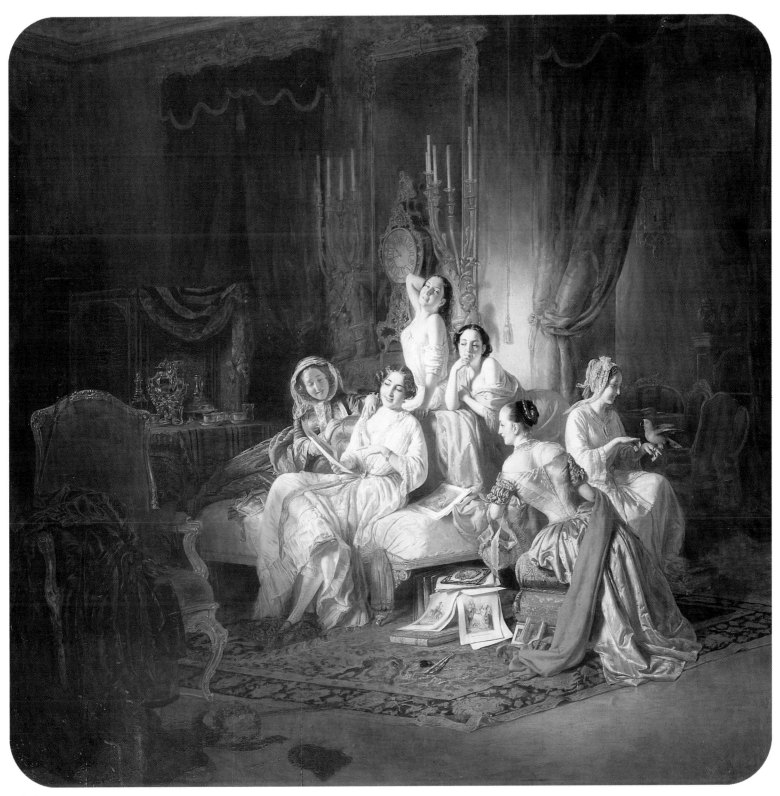

37 | JÓZSEF BORSOS
Girls after the Ball

37 *Girls after the Ball,* painted by József Borsos in 1850, is a fine example of the Viennese influence on Hungarian genre painting. The composition of the figures and the gestures of the girls seem very natural. The amiable mood and light-heartedness conveyed by the picture was meant to conceal the national bereavement which followed Hungary's defeat in the War of Independence of 1848–1849, ending with the Hungarian army's military surrender at Világos a year before. Despite the fact that he depicted several events and figures of the 1848 Revolution, Borsos — who enjoyed great popularity both in Pest and in Vienna — did not have to suffer persecution. Soon he moved back to Vienna, where he continued to produce genres decorated with pompous settings and apparels.

38 The glory of the 1848-1849 Revolution and War of Independence and the national bereavement that followed its tragic outcome were depicted relatively rarely in Hungarian genre paintings. This was one of the reasons why the Hungarian National Gallery purchased a previously unknown painting entitled *Consolation* by the acknowledged portrait and genre painter, Alajos Györgyi Giergl. The picture, painted in 1852, shows a girl grieving for her lover, who has set off to fight in a battle. An old suttler woman, dressed in home-guard's uniform, tries to console her. The picture is filled with romantic emotions. The finely painted scene was probably very well received in its time, when Austrian censorship did not allow making more direct references to the fateful events.

39 Károly Telepy, a typical representative of Romantic landscape painting, was the secretary of the National Fine Art Society for decades. Similarly to several other painters in the second half of the 19th century, he was very much attracted to the events of ancient Hungarian history. This is one of the reasons why he so often depicted castles, the witnesses of stormy events. *The Ruins of Diósgyőr Castle* was painted in 1860. The significance of the ruins in the background is doubled by their image, mirrored in the lake. The colourful group of women in the foreground creates a fine counterpoint in the well-balanced composition. The painting shows the impact of Markó's Italian circle.

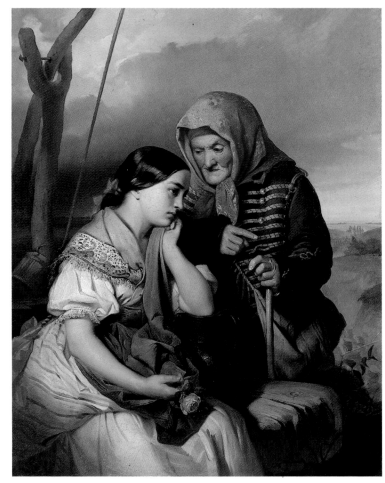

38 | ALAJOS GYÖRGYI GIERGL
Consolation

39 | KÁROLY TELEPY
The Ruins of the Diósgyőr Castle

40 | KÁROLY LOTZ
Stud in a Thunderstorm

40 On returning home from Vienna where he had studied, the young Károly Lotz looked at the Hungarian landscape and people with a fresh eye. Indeed, his excellent observations were way ahead of his age. Although his paintings depicting the landscape of the Great Hungarian Plains during storms were still rooted in Romanticism, their emotional charge, variegated compositional methods and, most of all, their realistic colours justified Lotz's personal ambitions. *Stud in a Thunderstorm,* painted in 1862, is an excellent example of these qualities. His depiction of the clouds whirling in the depth of the space, his felicitous rendering of the horses and his ability to capture the feeling and unique world of the people of the flatlands could not be matched by any of his contemporaries. Lotz was also a renowned fresco painter; he was the first to demonstrate in this lesser known genre in Hungary how an architect and a painter could work together in order to achieve a homogeneous work of art.

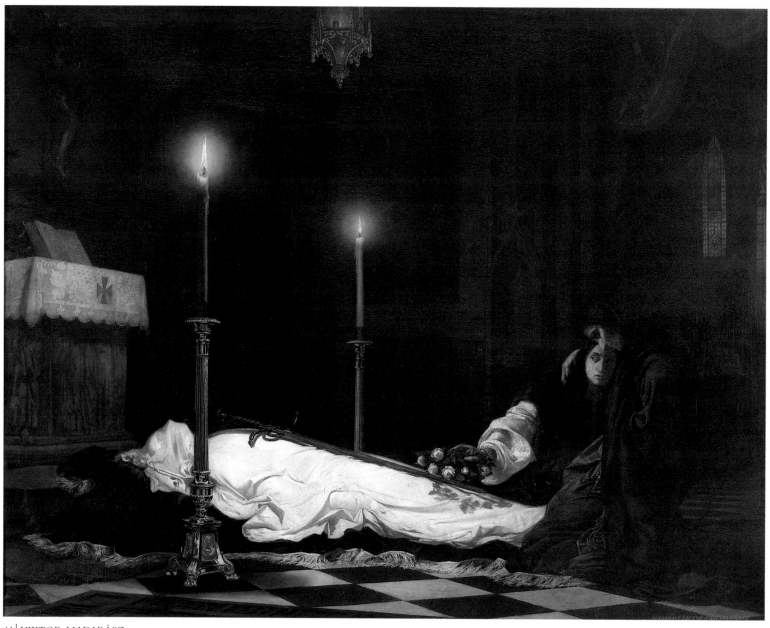

41 | VIKTOR MADARÁSZ
The Mourning of László Hunyadi

41 *The Mourning of László Hunyadi* is probably one of the most famous pieces of Hungarian Romantic historical painting. Viktor Madarász completed it in 1859, and it immediately won him a Gold Medal in the Paris Salon, where apart from the painting's evident beauty, the Parisians were struck by the tragic fate born with so much dignity by a distant nation. The composition, which the art critics christened the Hungarian Piéta, became the pride of the Hungarian National Museum. The laconic composition was built on the contrast of the bright and the dark zones. The episode, which happened four-hundred years earlier, was meant as an obvious allegory of the events taking place in Hungary only a decade before the birth of the painting. In 1457 the ensnared László Hunyadi — son of János Hunyadi, the outstanding Hungarian commander who fought the Turkish army so successfully — was beheaded by Habsburg Ladislas V. The Mourning of László Hunyadi was therefore an obvious allusion to the shameful act by the young Emperor Franz Joseph, who had the dauntless Hungarian generals executed after crushing the country's fight for independence.

42 The young Viktor Madarász fought throughout the entire War of Independence. After a short study-trip to Vienna, he lived in Paris for fourteen years, where he was influenced by his teachers, Léon Cogniet and Paul Delaroche. Yet, *Dobozi, and His Spouse* painted in 1868, two years before his return home, shows the impact of Delacroix's Romanticism. The landscape and the horse — depicted as a magic steed — reveal the horror of the last moments of the couple running away in full gallop from the blood-thirsty Turks; on realizing that there is no escape, they commit suicide. The wide horizontal format and the horizontal line of the clouds at sun-set are used to emphasize the deadly speed of the race. In different forms, the Dobozi theme was depicted repeatedly by Hungarian painters during the 19th century, for whom the suicide of the couple symbolized the idea of choosing death instead of slavery.

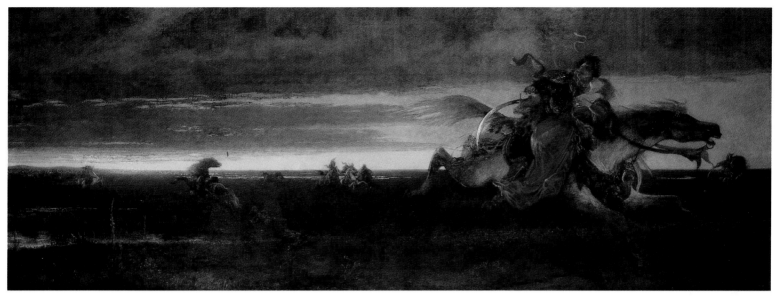

42 | VIKTOR MADARÁSZ
Dobozi and His Spouse

43 | SÁNDOR LIEZEN-MAYER
Queen Elizabeth and Queen Mary at the Sarcophagus of Louis Anjou the Great of Hungary

43 | SÁNDOR LIEZEN-MAYER
Queen Elizabeth and Queen Mary at the Sarcophagus of Louis Anjou the Great of Hungary

43 Besides a few visits to his home country, Sándor Liezen-Mayer, who was born in Győr, spent his entire life in Munich, where he was a much respected professor at the Academy. He painted this study as a young man in Karl Piloty's class in 1862. *Queen Elizabeth and Queen Mary at the Sarcophagus of Louis Anjou the Great of Hungary* is a courageous, though avowedly theatrical composition built on the contrast between the splendid coronation ceremony of Small Charles of Durazzo, scene in the background, and the graveness of the two queens vowing vengeance at the grave of King Louis the Great. The sinister atmosphere of the painting is a reference to the bloody fights resulting from the event depicted, which occurred in 1383 at Székesfehérvár.

44 | MÓR THAN
King Emeric Captures His Insurgent Brother, Andrew

44 Mór Than won First Prize of the Pest Art Society's historical painting competition in 1857 with this picture entitled *King Emeric Captures His Insurgent Brother Andrew*. The Academic style of the composition is characteristic of the Viennese school of the painter Rahl, where Than studied. Than always paid close attention to the gestures bounding the various groups of figures together, to the balance of tones and forms, and he arranged the composition around a central axis. These stylistic elements were especially becoming in his monumental frescoes which he produced later in his career. King Emeric's forceful, royal gesture dominates this picture. Emeric (1196–1204) had one of the most turbulent lives among the kings of the Árpád Dynasty: he had to fight throughout his life against his younger brother, Andrew, who also claimed the throne, and whom he eventually captured. Finally, after Emeric's death, his brother did become king of Hungary under the name Andrew II (1205–1235).

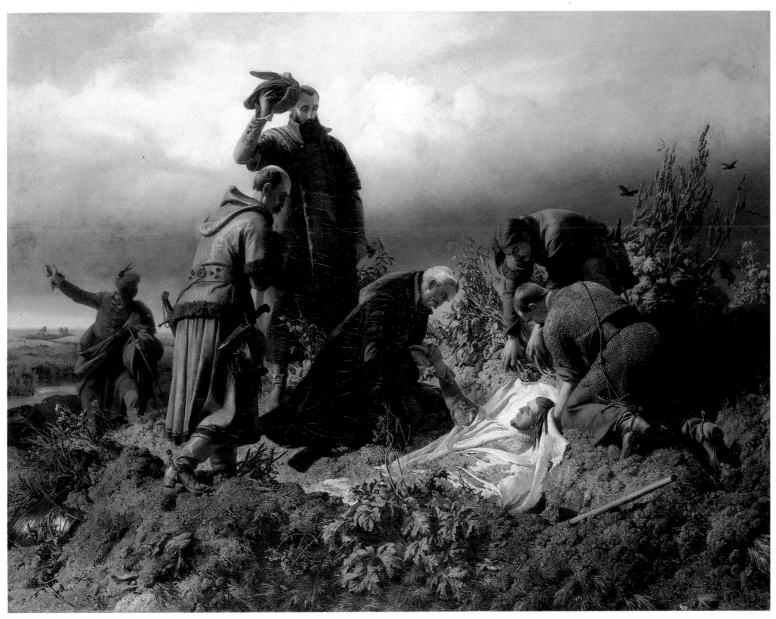

45 | BERTALAN SZÉKELY
The Discovery of the Body of King Louis the Second

45 Bertalan Székely was the most fastidious master of the style known as historicism. He harboured the idea of painting *The Discovery of the Body of King Louis the Second* already during the years he spent in Transylvania following his studies in Vienna. After having clarified the role of each element of the composition, he painted the great work in 1860 in Munich, where he was studying under Piloty. Working out the structure and the accent of colours in detail was of prime importance for Székely. The last Hungarian king from the Jagello Dynasty, the young Louis II (1516–1526), was slain in the Battle of Mohács. His passing symbolizes the death of the nation and the beginning of the Turkish suzerainty which lasted 150 years. The gestures of respect for the dead as well as the white shroud, which contrasts dramatically with the sombre atmosphere, work in unison to focus our attention on the tragic figure of the Hungarian king.

46 | BERTALAN SZÉKELY
The Dancer

46 Bertalan Székely, who produced great paintings in various different genres, first turned to the problem of capturing the gracious movements of female dancers in the 1860s, at the time of painting Ladislas V and Ulrik Cillei. Later the same theme reappeared in his series The Life of the Woman and The Life of the Lascivious Woman. He painted his *The Dancer* around 1875. Here he seems to have been much preoccupied with lighting and the impressionistic delineation of the tired dancer at rest. Despite the warm yellow-red tones, a quiet resignation dominates the painting — this mood is probably in reference to the letter the fragile female beauty is holding in her hand.

47 Antal Ligeti remained a faithful follower of Károly Markó the Elder throughout his entire career. Even during the 1870s he painted similarly to his mentor. Just like in Markó's landscapes, the golden rays flooding his pictures evoked Italian reminiscences. Ligeti spent a great deal of time travelling; he painted landscapes of the Middle East and of Hungary as well. There were also several realistic details in these pictures. In *Mártonhegyi Road,* painted in 1876, he depicted the suburbs of the capital exactly as they looked at the time. Since then, this part of the Buda Hills has seen tremendous development, but one hundred years ago it was still a peaceful agricultural land. The outlines of the town are seen only in the distance. In the nearer side of the River Danube, the silhouette of Buda Castle and its buildings are discernible.

48 The fastidious style of Markó's followers also influenced the subdued and refined lyricism of Géza Mészöly's landscapes. Mészöly spent two years in Vienna studying art, then devoted his entire life to the representation of the Hungarian plains. His pictures, painted with light brush strokes and patches of colour, lacked all definite contours; the waterfront landscapes — which he often depicted — corresponded very well to this style. *Fishermen's Ferry at the River Tisza* (1872–1877) is a characteristic example of his landscapes, in which, by emphasizing the atmospheric effects and the coloured shades, he got very near to *plein air* painting. Simple people, who are almost always present in his landscapes, symbolize the idyllic and devout connection between man and nature.

47 | ANTAL LIGETI
Mártonhegyi Road

48 | GÉZA MÉSZÖLY
Fishermen's Ferry at the River Tisza

49 | PÁL SZINYEI MERSE
The Swing

49 While in Hungary the exhibitions were still being dominated by minutely detailed and romantic landscapes and genre paintings, in the stifling atmosphere of Piloty's school in Munich — but in sharp contrast with it — the first significant piece of modern Hungarian painting was born, *The Swing* by Pál Szinyei Merse (1869). The young painter approached his themes without preconceptions. He painted the colourful, sunlit world which he saw around himself, and he worked out his own method to achieve the effect he needed. In The Swing, the harmony of the picture was no longer achieved by a ruling tone, but by the value of tones and hues: the equal light value of the multi-coloured patches of colours gleaming in the diffuse light under the foliage. This invention made Szinyei a close associate of the French Impressionists without ever having seen their paintings.

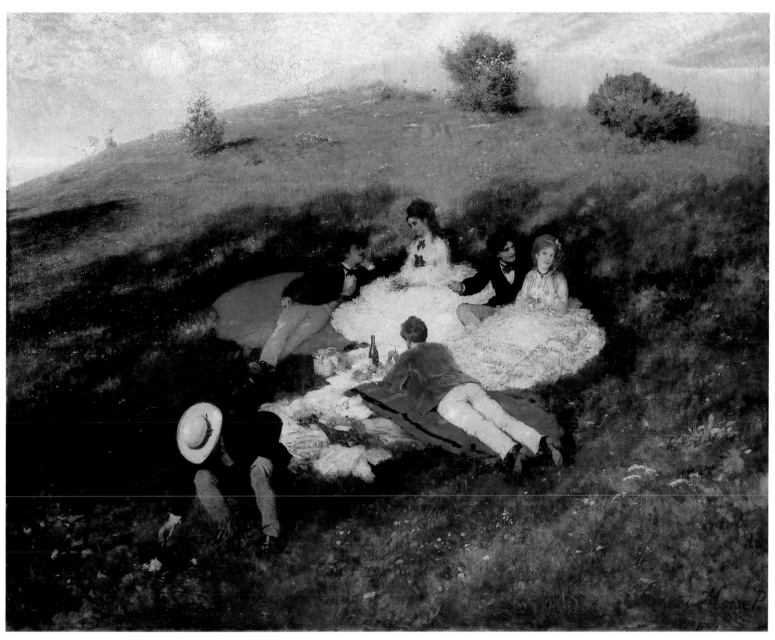

50 | PÁL SZINYEI MERSE
Picnic in May

50 Szinyei's *Picnic in May* (1873) is the most beautiful Central European example of the new approach to nature in painting. It is a perfectly balanced *plein air* composition, in which eventuality is only illusory; each element in the picture reinforces the mutual effect of the whole. Pure, complementary colours, shining like gems, played a major role in capturing the optical image of what Szinyei saw. He achieved the fresh realistic effect and the glowing, light-filled atmosphere of his paintings by the use of the widest range of transparent paint — and especially by the numerous shades of green. However, in his method of painting with light, the visual elements are not divided up into details as minute as in the pictures of the French Impressionists, who took to analyzing their surfaces. Despite all his modernity, the fact that the objects retained their mass in his paintings made Szinyei's art simultaneously the zenith of the classical tradition and the start of a revolutionary, modern approach to painting in Hungary.

51 | PÁL SZINYEI MERSE
The Balloon

51 *The Balloon* (1878) is one of the most original paintings by Szinyei. The striped balloon triumphantly reigns in the sky, and the person in it is no longer interested in his fellow men swarming below; his eyes rest, instead, on the line of the tree tops. He floats, drunken with freedom, thus becoming the symbol of the free flight of thought, the freedom of art which does not disappear into cosmic distances, but remains close to Earth, the living human environment. However, since his contemporaries did not appreciate Szinyei's exceptional artistic merits, he even gave up painting for a long time. Szinyei's ideas were eventually taken up and renewed by the painters of the Nagybánya Artists' Colony.

52 The only artist similar to Szinyei in his natural, non-conventional approach was Géza Dósa. Dósa also studied in Vienna and later in Munich, but his rising career was curtailed by his suicide at the age of 25. He painted his modern study, *Playing the Piano*, around 1870. The picture is characterized by gentle and vivacious colours, transparently thin layers of paint and light, and wide brush-strokes. Dósa's way of grasping the moment goes beyond the conventional works depicting everyday scenes. This, together with his ability to create an intimate atmosphere, made him an artist comparable to Szinyei.

53 Although he painted for less than ten years, László Paál became one of the most outstanding figures of Hungarian realistic landscape painting. After studying in Vienna, the Netherlands and Dusseldorf, he settled in Barbizon, where he painted nothing but forest scenes. Besides accurately depicting nature, his paintings — sometimes lyrically refined, at other times dramatically disturbing — were also faithful representations of the artist's state of mind. *Poplars* (1876), made in Barbizon like Paál's other paintings, is very passionate, and its composition is generously comprehensive — qualities that made Paál one of the most important painters of the later period of the Barbizon School.

52 | GÉZA DÓSA
Playing the Piano

53 | LÁSZLÓ PAÁL
Poplars

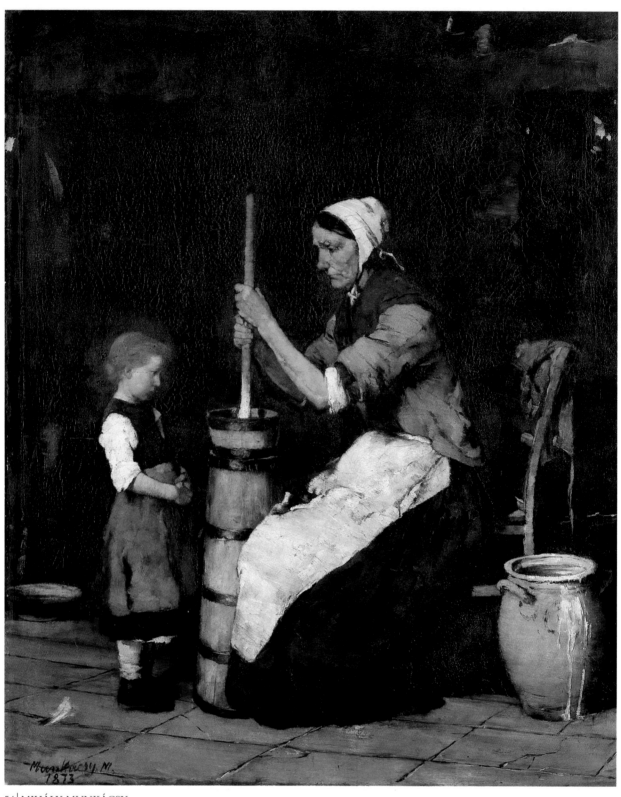

54 | MIHÁLY MUNKÁCSY
Woman Churning Butter

54 Mihály Munkácsy was the most influential and successful painter among the Hungarian masters of Critical Realism. Following his studies in Vienna and Munich, he started to paint scenes from the lives of the poor during his Dusseldorf period. These paintings were characterized by powerful and compact forms, a concentrated, relief-like composition, and a colour scheme based on the contrast between light and dark — rich in tones and sparse in colours. Munkácsy's strength of portraying people was especially evident in his genres depicting the lives of the poor, such as *Woman Churning Butter,* painted in 1873. In this picture the artist was able to avoid the theatrical effects so disturbing in his larger compositions, and he was also able to treat his childhood and adolescent years more directly.

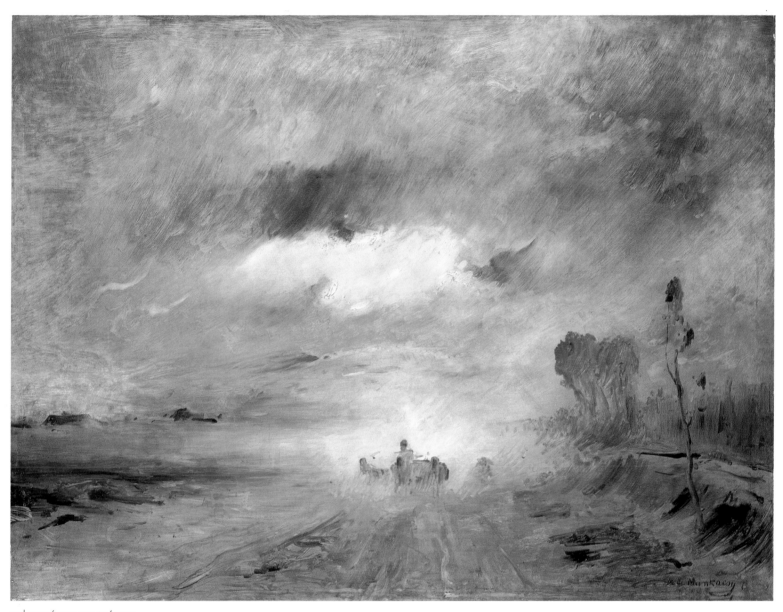

55 | MIHÁLY MUNKÁCSY
Dusty Counry Road II

55 In addition to producing genre paintings, portraits, and still–lifes, Munkácsy was also a successful landscape painter. Following his visit to his young friend, the landscapist László Paál in Barbizon in 1873, he frequently painted landscapes by way of relaxation. The two versions of the painting *Dusty Country Road* commemorate the painter's visit to his homeland in 1874. (Munkácsy moved to Paris in 1871.) While in the first version the blurred outlines of a farm house by the road are also shown, when painting the second version, Munkácsy seemed to have been interested only in recording the atmosphere. Painting this landscape brought Munkácsy closer to the Impressionists, of whom he actually thought very little, and even to Turner, whose works he had seen during a brief visit to London.

56 *The Baptism of Vajk* by Gyula Benczúr won First Prize in a competition Minister of Culture József Eötvös announced with the purpose of promoting historical painting in Hungary. In the study prepared for the painting, which was eventually entered for the competition, a conspicuous group of pagan Hungarians was present. When the final picture was completed in 1875, there was no indication of the pagans, i.e. the opposition; after the political compromise between Hungary and Austria in 1867, those who financed the competition preferred a rendering of this decisive event without allusions to any conflicts. Vajk (the later King St. Stephen) is seen kneeling in the foreground, to be baptized by Saint Adalbert, dressed in ornate attire. With the help of his ability to paint pompous materials and set up vivid compositions — which he acquired from his master, Piloty, and by studying the art of Rubens and Tiepolo, Benczúr created a representative tableau of Historicist painting. It is not without reason that Benczúr became the king of painting in Hungary during this period, the favourite of rulers and of the aristocracy; moreover, he became a professor at the Academy of Art in Munich and later at the Master's School in Budapest. He possessed both the technical virtuosity and the ability to conform with the requirements of his patrons — two assets which were necessary for obtaining his position in art.

56 | GYULA BENCZÚR
The Baptism of Vajk

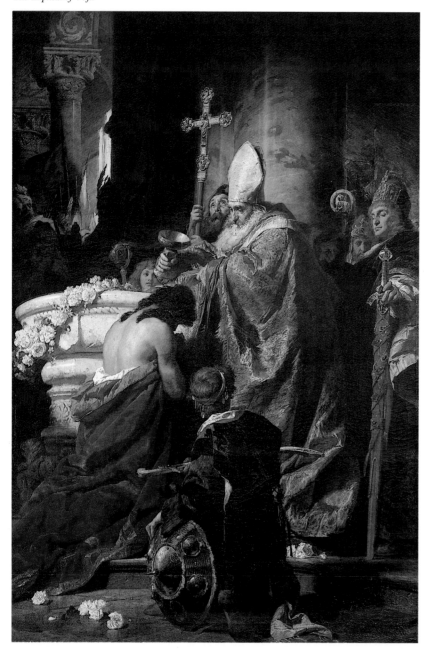

57 | GYULA BENCZÚR
The Recapture of Buda Castle in 1686

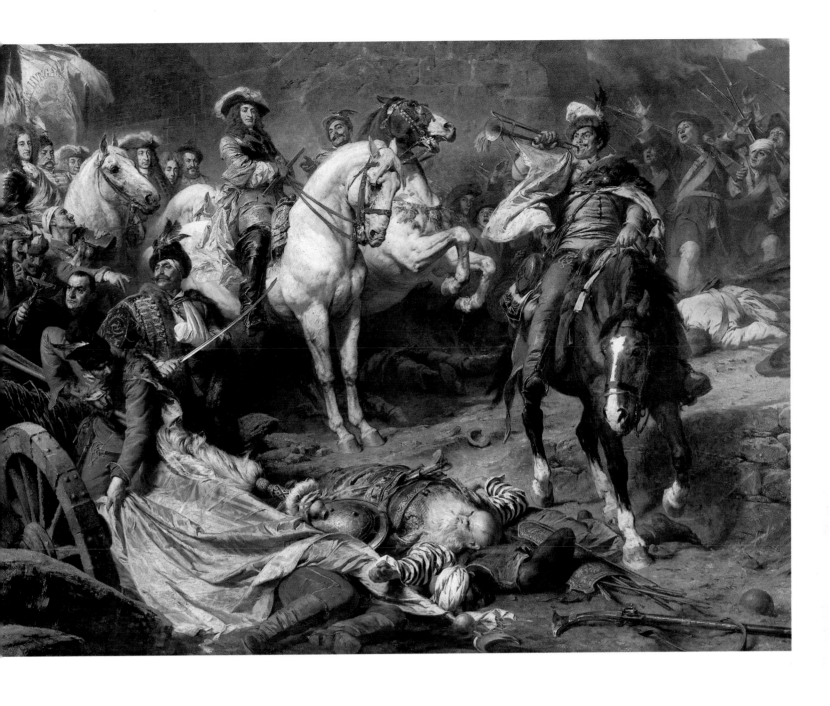

57 Benczúr started to paint *The Recapture of Buda Castle in 1686* in 1885; the composition was completed for the Millennial Celebrations in 1896. This huge painting was the last such venture of Benczúr and of Hungarian Historical painting in general, since by the turn of the century this genre became out of date. The composition implies the historical necessity of the Austro-Hungarian Empire by emphasizing that Hungary was freed from Turkish suzerainty in 1686–1687 by the help of Karl of Lotharingia and Eugene of Savoy. Benczúr groups the figures ingeniously; thus, in spite of the numerous characters, the presentation still remains fluent. The careful studies of costumes, props and faces, and their realistic and colourful rendering, were required to establish the historical authenticity of the final work.

58 After studying in Munich, Lajos Deák-Ébner worked in Paris for fifteen years. However, after his first visit to Szolnok in 1875, he spent every summer at its artists' colony. His approach to *plein air* painting was formed by the influence of Millet and Bastien-Lepage. The landscape of the Great Hungarian Plain suited his method admirably: instead of Academic artificiality, Deák-Ébner wished to reveal the vivid complexity of life. If not in his style, Munkácsy's influence was discernible in the compassionate way he depicted the hard life of his impoverished models. *Boat Warpers,* painted in 1878, is an excellent example of his pictures produced in Szolnok. The most striking qualities of these paintings are the beauty of tones and — especially in the case of the smaller works — the way the artist captured the sun-lit colour values.

59 | LÁSZLÓ MEDNYÁNSZKY
Rain-washed Road

60 | JENŐ GYÁRFÁS
The Ordeal of the Bier

59 After spending some years in Munich, Paris and Barbizon, László Mednyánszky, who was on the road during his entire life, arrived at Szolnok in 1877. The Great Hungarian Plain held a deep fascination for him, but for reasons entirely different from his contemporaries. Very early on he painted swampy, blurry, foggy landscapes, such as *Rain-washed Road,* made around 1880. Due to the atmospheric effects, even those few human figures which are present in his compositions seem to dissolve into nature, poetically transubstantiated by the painter's brush. Buddhism, encountered by Mednyánszky in Paris in 1889, also influenced his pantheistic approach to the world. This religion soothed the soul of the artist so inclined to mysticism. Mednyánszky, a true eccentric, was familiar with the works of his contemporaries, but none of them had any real impact on his art. He was accordingly able to preserve the novelty and uncommon ambience of his paintings.

60 Jenő Gyárfás was a Transylvanian artist who learned everything there was to know about the Academism of Munich. In his smaller paintings he proved what an excellent, realistic illustrator of the human soul he was. In 1881, in line with his affinity for drama, he chose the most tragic moment of *The Ordeal of the Bier,* a ballad by the renowned 19th-century Hungarian poet, János Arany, to be the theme of his major monumental painting. Benő Bárczi lies on his catafalque; to the right, shocked by the sight of him dead, stands his bride, Abigél Kund, whose crime of thoughtlessly having helped him to his death is divulged by her victim's bleeding wound. The accurate psychological interpretation of the tragic situation is the main virtue of the compact composition of the large painting. The picture won the grand prize of the National Fine Art Association in 1881. Contemporary critics emphasized the masterly double lighting and the differentiated depiction of the petrified accessory figures, but found the demented face of the mentally crushed main character much too overstated. Looking at the painting today, we may miss the freshness and the modern poignancy of the drama, still present in the study but sadly missing from the more rigid final version.

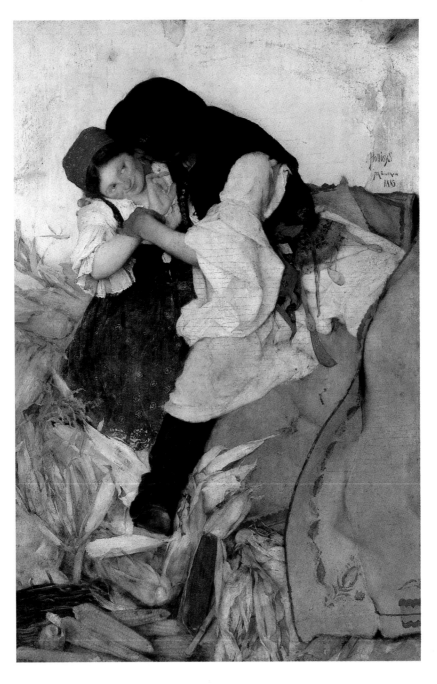

61 | SIMON HOLLÓSY
Corn Husking

61 The last artist to bring new ideas into Hungarian genre scenes depicting the lives of peasants was Simon Hollósy, who painted *Corn Husking* in 1885. Following the great success of the picture, he founded a private school in Munich, which soon played a decisive role in the development of modern Hungarian art. Young artists were attracted to Hollósy because of his tender love for reality and his honest lyricism, which he always adjusted to what he saw. Thus, Hollósy returned to Hungary in 1896 and settled in the small, picturesque town of Nagybánya, where he taught a new, more direct approach to the depiction of nature. A defined rendering of forms, the differentiation of the soft tones by the use of many distinct hues, and the balance of fine movements woven through the surface of the canvas all contributed to the freshness and liveliness of Corn Husking and, at the same time, facilitated a better expression of the joyful unaffectedness of social life in the village.

62 Besides Munich and Paris, there was another way which led to Naturalism: Vienna — Paris — Szolnok. This second was chosen by Sándor Bihari, although his naturalism was more faithful to the objects, and was, in fact, closer to realism. Affected by the visits he made to the artists' colony at Szolnok, Bihari started to produce *plein air* paintings around 1890. From this time on, without giving up the narrative character of his paintings, he uninhibitedly depicted man and nature with fresh colours. Beyond characterizing a canvassing future member of Parliament and the citizens of the village excellently, *Programme Speech,* painted in 1891, also allows a glimpse of the humorous side of the artist.

63 László Pataky left Piloty's class in Munich to move to Paris, where he was awarded a Munkácsy Scholarship. The effect of the great master is particularly evident in Pataky's paintings of rustic scenes. The astonishing composition of *The Interrogation,* painted in 1897, reveals an interesting connection with another disciple of Munkácsy, the German painter Fritz Uhde. Pataky's way of naturalistic rendering favours grayish tones, while it is full of light — characteristics which also related his art to the painters of Nagybánya, the school founded by Hollósy.

63 | LÁSZLÓ PATAKY ▷
The Interrogation

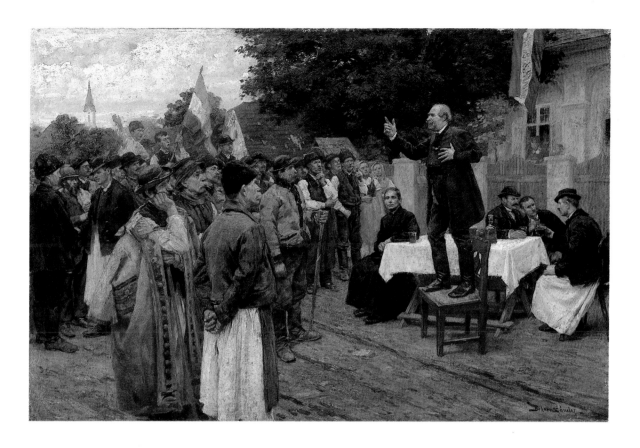

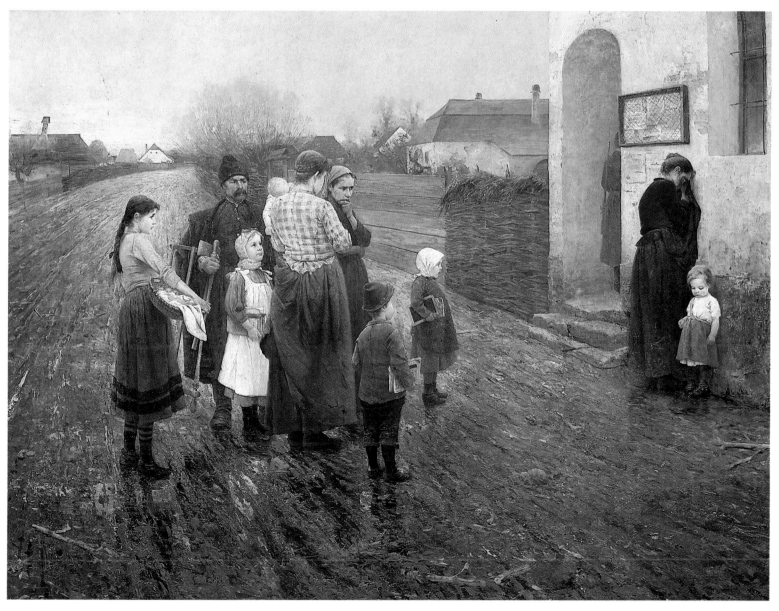

64 *Boys Throwing Pebbles into the River,* painted in 1890, was one of the major works born during the time that Károly Ferenczy spent in the town of Szentendre. By that time Ferenczy had already been to Paris, and after having settled in the small town near the River Danube, he tried to synthesize the experiences he gained in the French capital with his own way of perceiving nature. The figures of the boys are monumentally set against the melancholy, barren landscape. Their movements are well observed, the rendering is far removed from any kind of narrative character. Although the gestures show different phases of motion, Ferenczy emphasizes the eternal character of the figures. With not a single bright colour patch to be found, the various shades of pearly grays dominate the finely wrought, dull colours. Ferenczy later joined the artists' colony at Nagybánya, where he developed a new style of painting.

65 Béla Iványi Grünwald, like all the other members of Hollósy's circle in Munich, was greatly influenced by the fine naturalism of Jules Bastien-Lepage. Right until his Nagybánya period, he painted in a similar style. *The War Lord's Sword* (1890), a painting worthy of the standard set by Bastien-Lepage, is set apart from his other paintings from the same period; in this painting, just like in Bastien-Lepage's works, the rustic scenes are depicted with tender sympathy. This painting takes us back to the world of legends dealing with the origin of the Hungarian people. According to the legend, in Attila the Hun's time a shepherd found God's sword standing thrust into the earth. The king interpreted this as a manifesation of God's will, and set off to conquer the western world with the sword. Iványi depicted this scene very simply, in accordance with the rules of tonal painting. As a result, the painting is very different from the representative historical tableaux produced during the time of the Millennial celebrations.

66 János Thorma's artistic development was similar to many of his contemporaries. After spending some time with Hollósy's circle in Munich, he went to Paris and became fascinated by the refined version of naturalism he found there. The affinity towards social and historical themes was definitive for Thorma's career. He was also influenced from the very beginning by Bertalan Székely's example. After completing his studies in Paris, he painted *Suffering* in Nagybánya, in 1892–1893. He exhibited the picture in Paris, where it won him recognition. This painting may be considered the most important piece produced during the artist's first creative period. His way of perceiving social issues reveals the influence of Zola, while the style shows Thorma's familiarity with Bastien-Lepage's painting. The young artist showed surprising maturity in his approach to the topic: the oppressive atmosphere of the scene is emphasized by the spectacle of the cemetery, which evokes the notion of the transitoriness of life.

64 | KÁROLY FERENCZY
Boys Throwing Pebbles into the River

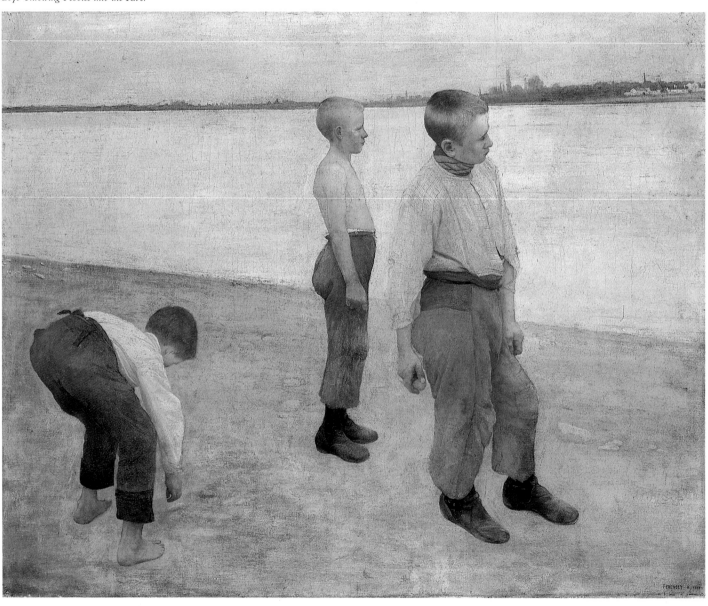

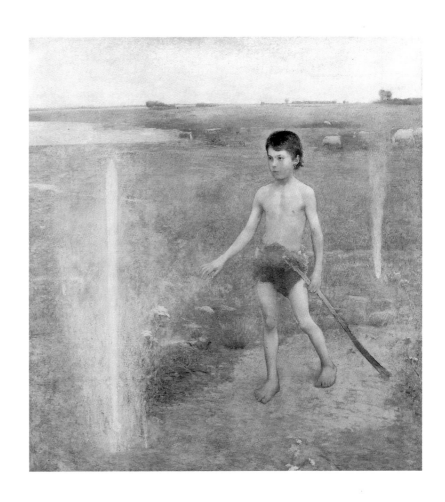

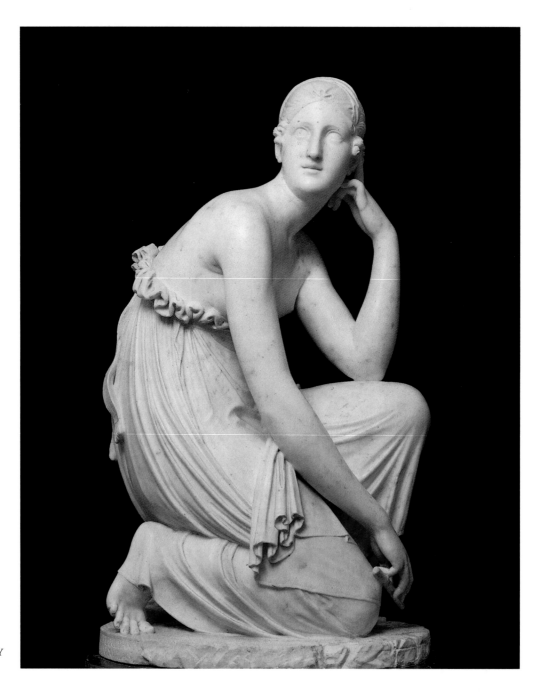

67 | ISTVÁN FERENCZY
Shepherd Girl

67 The first great Hungarian sculptor, István Ferenczy, lived in Rome for several years where, after 1818, he worked in Thorwaldsen's atelier. *Shepherd Girl* (1820–1822) is one of his major works; with the help of Canova's assistant, Baruzzi, he carved this symbolic sculpture after an archetype known from a number of drawings and paintings, such as Joachim von Standrart's etchings, a painting by David Allan in the St. Luke Academy in Rome, and a relief by Johann Gottfried Schadow. The sculpture symbolizes the origin of drawing, the source of art — in other words 'the beginning of the fine arts'. Ferenczy dedicated this work to Palatine Joseph and, alongside with the bust of the Hungarian poet, Mihály Csokonai Vitéz, he sent it home from Rome. This composition, a perfect expression of the Classicist ideal, inspired Ferenc Kazinczy, a Hungarian poet and the leader of the Enlightenment, to write an epigram.

68 | KÁROLY ALEXY
King Matthias

69 Expressing their love for the nation was especially important for the artists of Hungarian Romanticism. Miklós Izsó's shepherd and peasant figures — which were the first examples of the portrayal of typical Hungarian folk characters in the form of sculpture — were the equivalents of those genre paintings which depicted scenes from the lives of the peasantry. Izsó was still a student at the Munich Academy in 1862 when he carved *Sad Shepherd* after a live model, his brother, dressed in an ethnographically authentic attire worn in Bugac, a region of the Great Hungarian Plain. In the matter of payment there was some argument between Izsó and Mihály Gschwindt, the

69 | MIKLÓS IZSÓ
Sad Shepherd

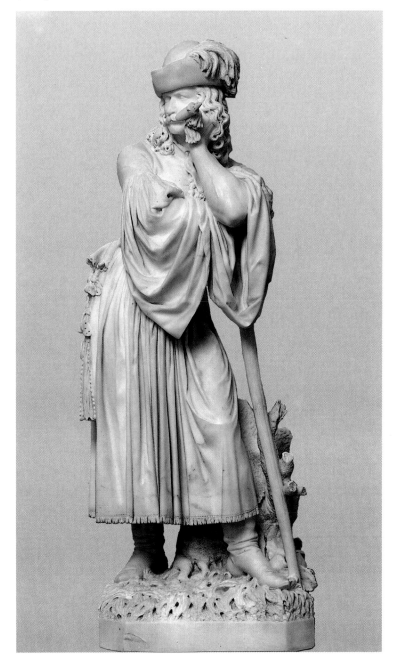

68 While Ferenczy wanted to create Hungarian sculpture by following the forms and aesthetic ideas of international Classicism, the exponents of the next generation, among them Károly Alexy, followed the ideas of the more nationalistic German Romanticism. He studied under Josef Klieber in Vienna. Since he relied mainly on Austrian and German commissions, he produced a 16 piece series consisting of small portraits of 17th-century German military commanders. The portraits of Daun, Starhemberg and Eugen von Savoy are the more widely known among these. In the bronze sculpture of *King Matthias,* made in 1844, he mixed the style of the Vienna Academy with elements of Ernst Rietschel's art. Mátyás, or the Hunyadis in general, was a frequently used symbol of national identity during the Reform Age in the 19th century; they would have occupied the main positions in an imaginary sculpture park of the nation. Several sculptors of the period — István Ferenczy, Károly Alexy, László Dunaiszky, Rudolf Züllich and Marco Casagrande — created or planned to create a statue or a memorial of King Matthias.

person commissioning the work, which eventually had to be settled in court. After winning the case, Gschwindt donated the sculpture to the Hungarian National Museum to everyone's satisfaction. Acknowledging that this statue opened a new phase in the history of Hungarian art and culture, Izsó's contemporaries — among them Imre Henszlmann, Károly Keleti and Mór Than — showed a great appreciation for this statue, which reflected the ideas of the poets Sándor Petőfi and János Arany.

70 | MIKLÓS IZSÓ
Dancing Peasant

70 *Dancing Peasant,* modeled by Miklós Izsó in 1870, is used as one of its emblems by the Hungarian National Gallery. This small terracotta statue is one of a 15-piece series created by Miklós Izsó between 1860 and his death. It is a generally accepted opinion that this statue is the peak of Izsó's career, and it is also an outstanding product of Hungarian Romanticism. The figure renders the nationalist-populist ideal using purely sculptural means. The artistic intent is closely bound to the cult of folk dance which originated in the 19th century — the character displays raw strength and masculine fineness, also portrayed in the works of Dániel Berzsenyi, János Arany and Mór Jókai.

71 Alajos Stróbl, who studied under Kaspar Zumbusch, incorporated the impressions he gained from French realistic sculpture (Dalou, Carpeaux, Dubois). One of the finest examples of his "sensitive realism" is *Our Mother,* modeled after the artist's own mother in 1896. The sculpture is characterized by a simple composition, generous yet detailed modeling, and sensitive working of the surface. Our Mother rightly won recognition at the Paris Universal Exhibition in 1900, where it was awarded the Grand Prix. In 1896 the state purchased the sculpture and had it carved in marble for the Museum of Fine Arts.

72 | JÁNOS FADRUSZ
Toldi Wrestling with the Wolves

71 | ALAJOS STRÓBL
Our Mother

72 The acceleration of the social development and the Millennial Celebrations generated a booming art scene in Hungary at the end of the 19th century. The number of sculptures rose; monuments were erected everywhere, and sculptural decoration on buildings became fashionable. János Fadrusz was one of the best sculptors of his time. He studied under Viktor Tilgner and later under Edmund Hellmer at the Viennese Academy. During his short career he hardly produced any smaller sculptures; he was mainly engaged in producing large-scale monuments. *Toldi Wrestling with the Wolves* was commissioned by the Buda Sport Association in 1901. This character from János Arany's poem was chosen to become a sport prize. The epic realism and robust force of Fadrusz's art, which had many connections with Hollner's ample monumentality, is well represented by this sculpture. Fadrusz also won recognition outside of Hungary: the Matthias monument in Kolozsvár was awarded the Grand Prix at the Paris Universal Exhibition in 1900.

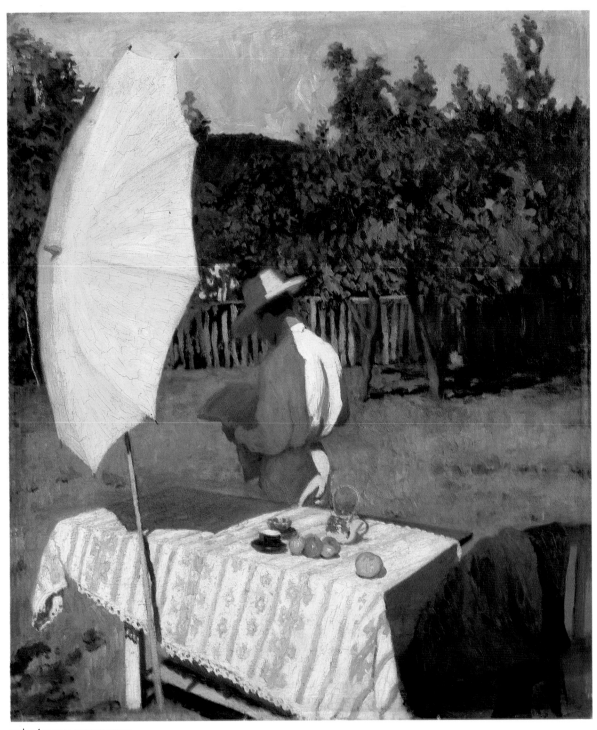

73|KÁROLY FERENCZY
October

74 | BÉLA IVÁNYI GRÜNWALD
Outing in Spring

73 Károly Ferenczy was the greatest among the prominent masters who lived and worked at the artists' colony in Nagybánya. He created a new style which effected virtually the entire development of 20th-century painting in Hungary. In 1896, after a few years spent studying in Munich, he joined the artists' colony in Nagybánya, where Simon Hollósy and his circle of friends and pupils spent the summer. Later he lived permanently in the picturesque Transylvanian town. The so-called "sun-lit" period of his art started in 1902; *October,* painted in 1903, is an outstanding pictorial achievement born during this period. Everything that is necessary to explore the various lighting effects and reflexes are present in this harmonious composition, which was, however, obviously arranged according to a consciously artificial manner. The significance of this painting goes far beyond the sphere of technicalities: when expressing the unity between man and nature, Ferenczy delineated one of the major issues of the Nagybánya programme.

74 Béla Iványi Grünwald, another significant master of the Nagybánya colony, worked in the town between 1896 and 1909. A major piece born during the artist's impressionistic period was *Outing in Spring,* painted in 1903. The spring sun and air transforms the elements of the landscape into soft, vibrating zones. The figures painted with faint contours also become impersonal — dissolved in the complexity of the image, they merely constitute a part of nature. By attempting nothing more than the capturing of a fleeting moment and a vanishing mood, of all the artists of Nagybánya, Iványi came closest to the ideas of the French Impressionists.

75 The younger generation of the artists working in Nagybánya around 1905 were influenced by the new French trends, especially by Fauvism. They were often referred to as the "Hungarian Fauves" or "Neos" (Neo-Impressionists). Lajos Tihanyi also belonged to this circle. His *View of a Street in Nagybánya,* painted in 1908, shows a part of the town which had been depicted before many times. What makes this painting especially interesting is the fact that this well-known motif is now rendered in a new style. The painting is an excellent example of the way one division of Hungarian avant-garde branched off from *plein air* painting. Later Tihanyi joined the circle called The Eight and the Activist movement.

76 Based on his style, Róbert Berény's career could be divided into two distinct periods. After studying in Budapest and Paris, he participated in the work of the group called The Eight, the first avant-garde circle to be formed in Hungary. In the beginning of the 1910s, parallel with the other radical intellectual movements emerging at the time, The Eight attempted to rejuvenate Hungarian art by employing the achievements of French Post-Impressionism and German Expressionism. Berény exhibited his rationalistic, constructive-decorative paintings at the National Salon together with The

Eight in 1911 and 1912. He immigrated to Berlin in 1919. The works he produced after returning to Hungary stand closer to the Post-Nagybánya School in their approach of painting from nature. *Still-life with Jug* was born during the artist's first period in 1909, when instead of the decorative approach of Fauvism, Cézanne's constructive representation dominated his canvases. The precise structure of the composition and the almost geometrical rendering of the objects demonstrate this influence.

77 Sándor Ziffer was another significant representative of the Hungarian "Neos" (Neo-Impressionists). He painted *Landscape with Fence,* showing the miners' district of the town, in Nagybánya during the early 1910s. Its artistic approach is typical of the new trends branching off from the *plein air* approach of the Impressionists. The influence of French Fauvism is also manifest in the picture. Ziffer no longer wishes to submerge himself in the landscape's intimate atmosphere, but by "correcting" the accidental character of nature, he wants to realize his own, personal model. He simplifies the forms; and out of the motifs of the rusty, late-autumn hillside and of the houses and trees, he creates a decorative system of enhanced colours.

75 | LAJOS TIHANYI
*View of a Street
in Nagybánya*

76 | RÓBERT BERÉNY
Still-life with Jug

77 | SÁNDOR ZIFFER
Landscape with Fence

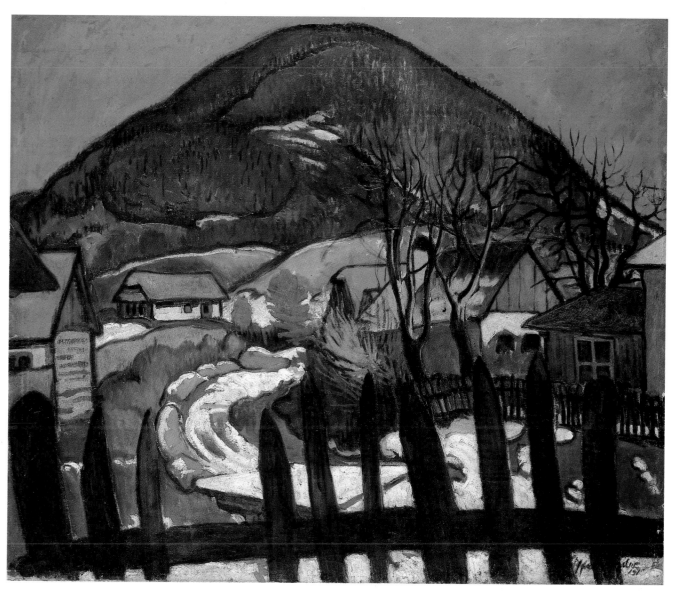

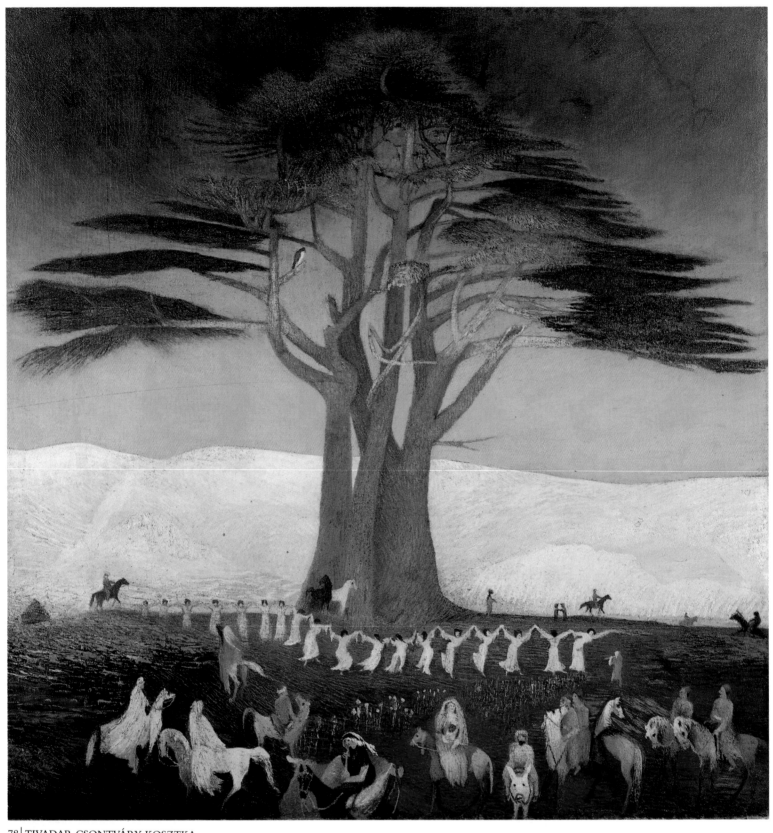

78 | TIVADAR CSONTVÁRY KOSZTKA
Pilgrimage to the Cedars of Lebanon

78 Tivadar Csontváry Kosztka's paintings are unique and unclassifiable in the corpus of turn of the century works produced in Hungary. Conventionally, he is compared to Henri Rousseau, but Csontváry's universal approach, the origin of his mysticism, the system of his symbolism and even his style are far from the French painter's Primitivism. Because of their multiple layer of meaning, his two pictures depicting cedar trees — the one entitled Solitary Cedar is held by the Csontváry Museum at Pécs — stand out of his allegorical compositions. Undoubtedly, in *Pilgrimage to the Cedars of Lebanon,* painted in 1907, as well as in Solitary Cedar, the cedar tree was intended as a symbol of the artist himself, marking the place the painter occupied in the pantheistic world he created for himself. In the National Gallery's painting, the complexity of this symbol is further enriched by the scene referring to ancient magical rites.

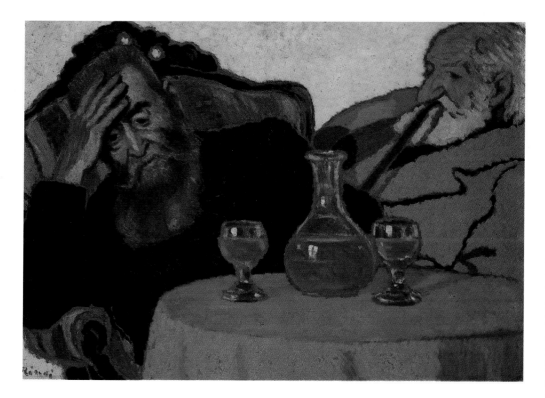

79 The art of József Rippl-Rónai developed in the spiritual environment of the fin-de-siécle. Starting in 1887 he spent more than a decade in France, where he had close connections with the Nabis. This relationship dominated his first creative period, characterized by Art Nouveau, but also featuring some elements of Symbolism. After returning to Hungary, Rippl-Rónai lived in Kaposvár, his home-town; from this point on, the themes of his paintings were taken from this small-town environment and its life-style. *My Father and Uncle Piacsek Drinking Red Wine* was painted in 1907, during a transitional period. It combines the soft painterliness and emotional richness of the earlier period and the elements of Rippl-Rónai's new style harmoniously. The painter found a striking name for his new period by referring to it as his "corn"-style; indeed, the closely packed patches of paint in these pictures resemble the kernels on a corncob. This special technique help to produce a decorative effect, more pure colours and a more rigid composition, and was an important component of the Post-Impressionistic character of Rippl-Rónai's art.

80 Alongside István Csók, József Rippl-Rónai, Tivadar Csontváry and others, János Vaszary was a representative of that complex tendency which can best be described as Hungarian Post-Impressionism. Their careers were significant both in regards of the quantity of work they produced and in regards of their significance in the history of Hungarian art. Besides paintings, Vaszary also designed gobelins. His beautiful tapestry, *Gingerbread Vendor* was conceived in 1906. In this stylistic period, the artist was predominantly influenced by Art Nouveau, in painting and in textile design alike. Nevertheless, despite the strong Art Nouveau influence, Vaszary retained some elements of the naturalistic style which characterized his early works. Although the technique of weaving could have allowed for more abstract ornaments, the pictorial composition of his gobelin design remains classical, and Vaszary preferred to use realistic elements of expression.

82 | LAJOS GULÁCSY
Ancient Garden

81 The artists' colony in Gödöllő was the intellectual centre of Hungarian Art Nouveau. During the first years of the 20th century, a school was also organized there by Sándor Nagy and Aladár Körösfői-Kriesch. Nagy's art was a mixture of the religious philosophy of the Nazarenes of the early 19th century, of the English Pre-Raphaelites' doctrines, and of Tolstoy's ideas. The painter and his wife are portrayed in *Ave Myriam* (1904), an outstanding piece of a cycle, in which Nagy created an allegory of the course of his own life and, in a broader sense, an allegory of the stations in man's life on Earth.

81 | SÁNDOR NAGY
Ave Myriam

82 It is very difficult to define Lajos Gulácsy's place in 20th-century Hungarian painting. Gulácsy was, above all, attracted to medieval and Renaissance art, but he was also effected by French Rococo and the spirituality of the English Pre-Raphaelites. He often chose the subject of his paintings from the literature and art of these eras; at other times he just evoked the ambience of these historical periods. The figures of his own fairy-tale world evoke some kind of timeless environment. But a peculiarly modern sensitivity and a suggestive symbolism also radiate from each of his works, which indisputably make him an artist rooted in his own time. *Ancient Garden* was painted in 1913. It is actually a landscape with staffage figures, yet the picture is immersed in imaginary memories and the emotional atmosphere of fairy-tales.

83 | LÁSZLÓ MEDNYÁNSZKY
Portrait of a Vagabond

83 As well as painting monumental landscapes, László Mednyánszky portrayed the poor, the vagabonds, and the apocalypse of war. He depicted human misery, reprobation and repressed hostilities. Although he came from an old family of nobles, Mednyánszky was nevertheless interested in the fate of the people living on the fringe of society, and chose his models from this walk of life. The series of compassionate works depicting the lives and emotions of vagabonds constituted a significant part of his oeurve. *Portrait of a Vagabond,* born after 1905, is one of the most forceful and most dramatic pieces in this series.

The facial character and the style of the painting stands close to those pictures in which the artist depicted World War One. In this rough portrait, rendered with exulted brush strokes, Mednyánszky represented human suffering on an unsurpassed level.

84 | JÁNOS TORNYAI
Farm on the Great Hungarian Plain

85 | ISTVÁN NAGY
Schoolboy

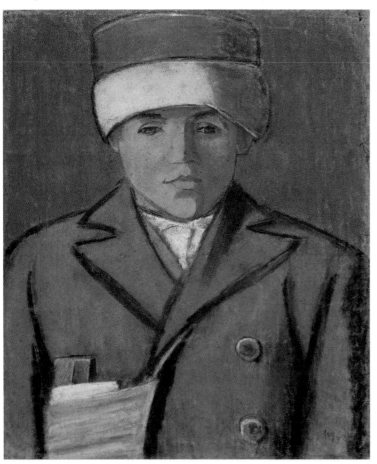

84 After completing his studies abroad, János Tornyai settled in Hódmezővásárhely, the town of his birth. It was mostly due to his efforts that the most characteristic branch of what is called the Alföld School, depicting the landscape and people of the Great Hungarian Plain, became associated with this town. Small farms standing alone in the vast flat land provided the most characteristic form of livelihood in the Alföld; both in literature and in painting, these became the symbols of the life of the Hungarian peasantry, of underdevelopment, of isolation, and of poverty. Tornyai painted *Farm on the Great Hungarian Plain* around 1910; in it he depicted the barrenness and despairing tranquility of the small farms by relying on pictorial means which are small in number but powerful in effect, revealing, among other things, the artist's compassion for his subject.

85 István Nagy, who was born in Transylvania, is also often mentioned among the painters of the Alföld School, who influenced his works for a short time during the 1920s. Indeed, he often depicted the lives of the peasantry, while the folkloristic elements in his realistic approach also show his affinities to the Alföld masters. Nevertheless, Nagy's art could better be characterized by emphasizing his independent approach — he never belonged to any school or any style in particular. The impenetrable rendering, the emphatic geometrical structure of the images, coupled with a kind of compact composition, made him a representative of new directions without, however, making him an avant-garde painter. These typical attributes are well illustrated by his pastel picture, *Schoolboy*, completed around 1932. The frontal presentation, the symmetrical composition and the decorative effect of the different colour zones distinguish this portrait. The handsome, pure face of the peasant lad is depicted with great empathy.

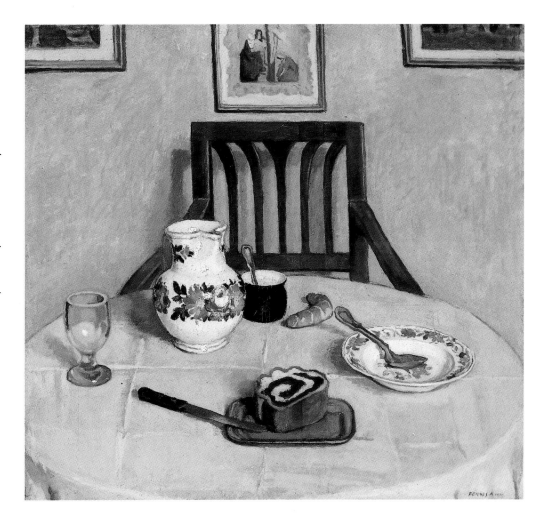

86 One of the centres of the Alföld School at the beginning of the 20th century was the town of Szolnok, but the tradition of painting landscapes which show the special character of a particular region, and genres that depict the lives of the people living on the Great Hungarian Plain, stretch back to the middle of the 19th century. Adolf Fényes was one of the founding members of the artists' colony at Szolnok, where he lived and worked for almost forty years. The works from his first period reveal the influence of Mihály Munkácsy's Romantic Realism. After the 1900s, though, Fényes's art went through significant changes. Although still influenced by French Post-Impressionism, this new style was undoubtedly individual. Its most characteristic aspects are beautifully shown in *Poppyseed Cake*, painted in 1910. In striving for a natural effect, Fényes used carefully devised methods, such as a well-balanced composition, pronounced decorative rendering, and a seemingly objective depiction of the objects — which in reality meant the accentuation of their character.

87 In the beginning of the 20th century, the school of Alföld painting represented, above all, a kind of preference for portraying the lives of the peasantry, which included not a little moral condemnation of big city life. Accordingly, its artistic programme entailed a realistic approach and rendering, rooted in progressive Hungarian traditions, especially in the art of Mihály Munkácsy. Among the Alföld painters'it was József Koszta who went the furthest in pursuing an intuitive, expressive style of painting by the use of brilliant colours and daring brushstrokes. Almost all his landscapes showed people; for him, the depiction of working peasants provided the means of expressing the relationship between man and nature — a programme which also reflected the influence of the Nagybánya painters on Koszta's art. The topic of corn harvesting became one of the painter's favourite subjects. *Corn Harvesting*, a three-figure composition painted around 1917, is the most mature piece of this series.

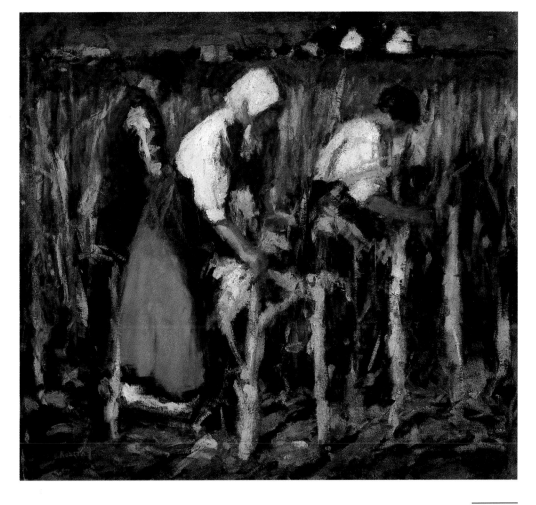

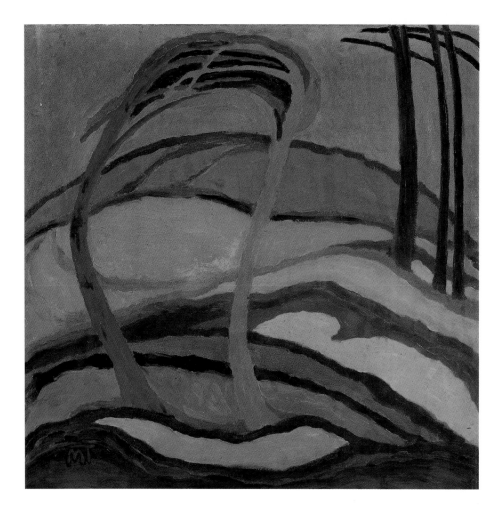

88 "I actually had no stations, and I had no masters either. I am a child of the 20th century... I began with Kassák and his circle, with the group of the 'MA' — that is, with a revolutionary approach both in art and in my social views," wrote János Máttis Teutsch in his autobiography of 1932. He joined the circle of MA, the avant-garde periodical edited by Lajos Kassák, in 1916, and which embraced the Activist movement. Activism, in fact, was the most dynamic approach to art and literature at the end of the 1910s. Máttis Teutsch's decorative-expressive style, which contained elements of Art Nouveau, actually developed in the circles of the German Expressionists, in particular, Der Sturm in Berlin, and Der Blaue Reiter in Munich. Máttis Teutsch was especially affected by the art of Vasili Kandinsky and Franz Marc. *Landscape,* together with all the other works produced during the 1910s — all variations on very similar themes — was characterized by these stylistic elements. In the realm of Activism, Máttis Teutsch's art demonstrated most purely the Expressionistic tendency that was approaching pure abstraction.

89 | JÓZSEF NEMES LAMPÉRTH
Self-portrait

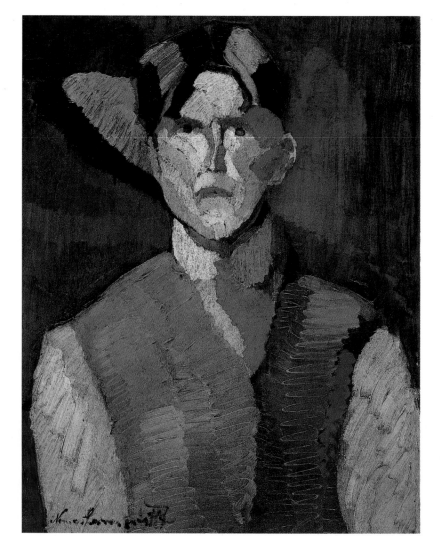

89 József Nemes Lampérth began his career with the avant-garde group known as The Eight, then exhibited his works with the Activists. All those stylistic traits which destined him to play such a unique role in the period's Hungarian art can first be observed in *Self-portrait*, painted in 1911. Technically, the painting is a mixture of geometrical formal tendencies borrowed from Cubism and a kind of distinctively expressive, unsettled use of the brush. In respect of the artistic character, in this painting Nemes Lampérth emphasizes a subjective and often depressed emotional state projected on every image of the outside world. Despite his early death, Nemes Lampérth became one of the most significant artists of the Hungarian avant-garde movement.

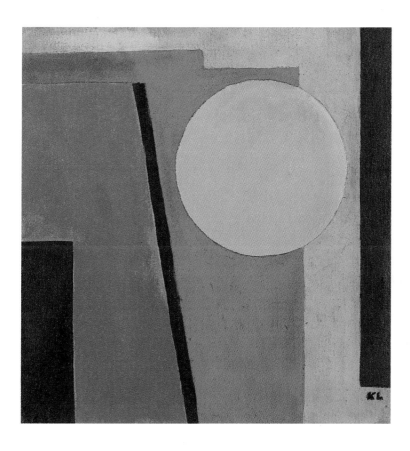

90 Lajos Kassák, the organizer and the leader of the Hungarian Activist and Constructivist avant-garde movements, became interested in experimenting with various painting techniques after 1920, during his immigration to Vienna. Rejecting traditional painting, he projected into the future the utopian visual harmony of a more beautiful, new world by the use of pure colours and geometrical forms. In 1921, under the title Picture architecture, he composed a manifesto which was published in the progressive periodical MA, which he edited. Kassák's first black-and-white typographic compositions, influenced by Russian Suprematism, Dutch Neo-Plasticism and French Purism, also appeared in the magazine. Later he enhanced his geometrical compositions with colours. *Picture Architecture II* conveys the essence of his program.

91 | SÁNDOR BORTNYIK
The New Eve

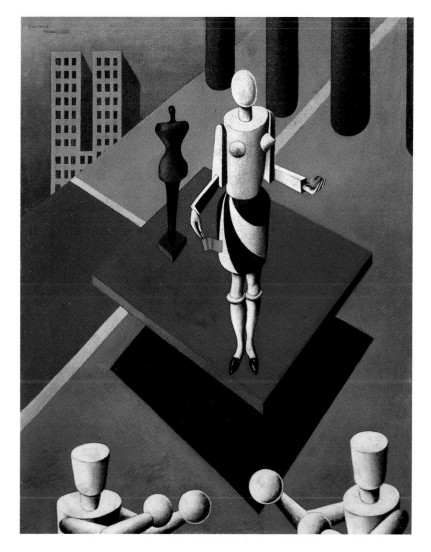

91 In *The New Eve,* painted by Sándor Bortnyik in 1924, the motifs of Constructivist geometrical space arrangement, of Bauhaus functionalism, and of the allegorical approach of the Italian Metaphysical painters combine to form an effective mixture. However, by perfectly blending these borrowed agents, Bortnyik created individual forms and developed a very personal style. He gave a special interpretation to the modern idea of women. In The New Eve, a female figure composed of schematic geometrical forms stands on a high platform in a highly abstracted space; below her there are the two men in fierce fight for the "eternal woman". The tall building in functionalist Bauhaus-style and the geometrical order of pillars together evoke the concept of eternity. The portrait exults the industrialization which took place during the 1920s, while at the same time it conveys the painter's doubts, concealed by his ironic treatment of his theme.

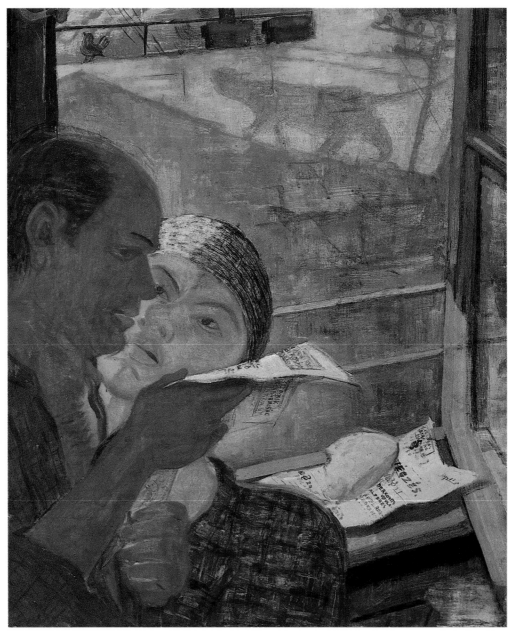

92│GYULA DERKOVITS
Injunction

92 The lifework of Gyula Derkovits, a highly committed artist, has a prominent place in the art of Hungary between the two world wars. Derkovits's art was organically bound to the various stylistic trends of this period. In the beginning of his career, he was influenced by the art of The Eight, especially by Károly Kernstok; later, after emigrating to Vienna in 1923, he was inspired by Expressio-nism. However, the unique character of his works owed their origin to a system of highly individual motifs and symbols conveying collective messages. *Injunction*, painted in 1930, displays the entire profusion of his individual language and artistic devices. The crowded composition, the contrast of hard and soft colours, convey strong symbolic content.

93 Béla Czóbel began his studies as an artist in Nagybánya. In 1903 he travelled to Paris, where he discovered the art of the Fauves. After returning to Hungary, Czóbel became an influential member of the "Neos", the new generation of painters working in Nagybánya in a style influenced by modern French examples, and later joined The Eight. Modern painters often experimented with the motif of a picture within the picture. This challenging artistic problem of creating a composition of dual space enabled them to develop a special effect. *In the Studio,* painted in 1922, is actually a self-portrait set up in an interior, seen in a mirror. The conventional motif was enriched with a new element: through a window seen in the mirror a third — outside — space is brought into the picture. This painting is the product of Czóbel's transitional period, when he was still very much influenced by French Fauvism, particularly by Matisse, an influence which was manifested in the use of colours and in the decorative rendering. At the same time, however, the artist's new dissolved and sketchy style — which was to last throughout his career — was already in development.

94 István Csók's lifework embraced almost an entire century. He was an exponent of the characteristically Hungarian branch of Post-Impressionism, in which the affects of turn-of-the-century western European — mainly French — styles, the Nagybánya colony's approach to nature, elements of Art Nouveau, and even some motifs of Hungarian folklore were mixed. The above listed influences inspired Csók in that order, and by the time he produced his individual and very lyrical paintings during the 1930s, these influences were thoroughly assimilated. *Amalfi* was painted in 1937 in remembrance of a trip to Italy. By combining his still-life with lemon with a seascape, Csók adopted the method of poetry: he expressed the ambiance and character of a geographical place by calling symbolic motifs to his aid. Amalfi combines the impressionistic rendering of the Nagybánya painters and the decorative style of French painting.

94 | ISTVÁN CSÓK
Amalfi

95 Aurél Bernáth began to paint at the Nagybánya school in 1915. During the first half of the 1920s, he lived and worked in Vienna and Berlin, where — influenced by various avant-garde tendencies — he experimented with Expressionism and non-figurative art. After this diversion, Bernáth returned to the traditions of Nagybánya painting and, on the basis of the subjective interpretation of his images, he further developed this legacy, thus becoming the most influential artist of the so-called Post-Nagybánya school. Bernáth painted *Morning*, a major work from the beginning of his career, in 1927. The subject of this picture is a window, both in reality and symbolically. In art, counterposing the outside and the inside space usually expresses either a conflict or nostalgia. This particular rendition of the theme was especially frequently used by the masters of Romanticism. Bernáth sets a strict, protected, decorative, almost rational inner space against a dissolved, expressive, emotionally interpreted outside space. This contraposto reflects the duality of the artist's intellectual and emotional worlds.

96 | ISTVÁN SZŐNYI
Evening

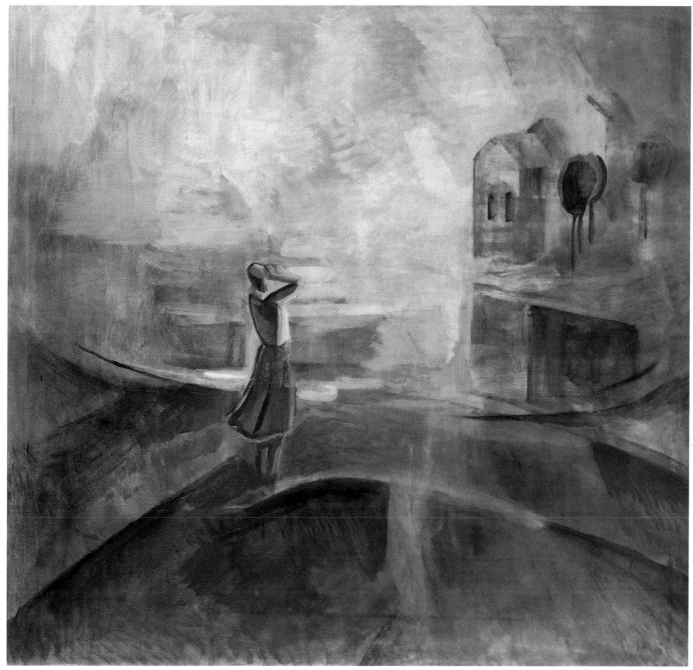

97 | JÓZSEF EGRY
Echo

96 The fact that he began his career in Nagybánya influenced the entire lifework of István Szőnyi. During the first years of the 1920s, he was temporarily affected by the various avant-garde movements, and some of his expressive Constructivist works brought him recognition. However, affter moving to the picturesque small town of Zebegény during the second half of the 1920s, Szőnyi returned to the Nagybánya tradition. This is the period when he developed his own personal style and unique tempera technique, which consisted of harmonizing colours which avoided the sharp contrasts between colours and hues. The tempera painting *Evening* (1934) is one of the best examples of this method, and may, in fact, be regarded as the manifesto of the artist, since it pays tribute to the family, peace, work and man's harmony with nature. Szőnyi was an outstanding master of the so-called Post-Nagybánya painting which dominated the period between the two world wars. As a teacher, he also had a great impact on the development of the new generations of artists who began their careers after the Second World War.

97 József Egry's oeuvre, all its motifs and ambiance, is associated with the painting of just one landscape, that of Lake Balaton. He moved to Keszthely, a town situated at the south-western end of the lake, at the end of the 1910s, and then the Balaton and its surroundings wholly enformed his vision and style. *Echo*, painted in 1936, obviously implied the actual echo of the Tihany Peninsula, which juts into the lake — a theme which had long held mythical substance in Hungarian art. Using light as the foundation of the composition was the most important characteristic of Egry's style. "I am interested in space and eternity ... light itself ... the atmosphere, which is architectonic," he wrote. The composition Echo is also dominated by light; it disintegrates the objects and arranges the composition. The symbolic meaning of the painting is expressed in the relationship between the image of eternal space and the tragical loneliness of the human figure.

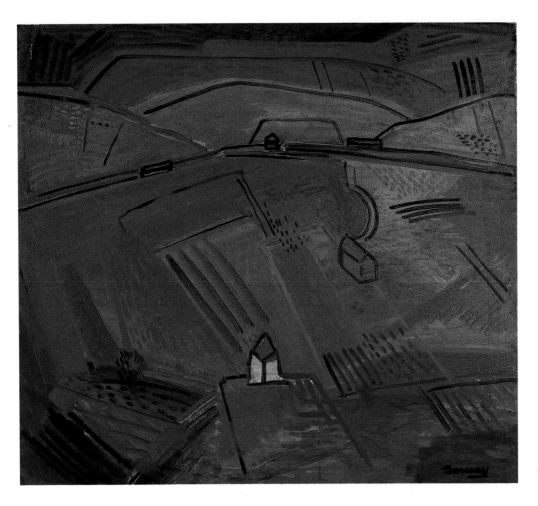

98 Jenő Barcsay was one of the most significant artists of Constructivism in modern Hungarian art. His views and artistic methods were always derived from the images of nature, which he regarded all along as a refreshing starting point for his experiments; in this manner, toward the last years of his life, he arrived at the reduction of the picture to a plane structure of geometrical forms. *Rolling Hills*, painted in 1934, represents an important station in Barcsay's development. In it he summarized, for the first time, the results of those experiments which later led him to two-dimensional Constructivism. Instead of the converging lines of natural perspective, Barcsay applied a diverging order of lines; instead of depicting the images that make up the landscape — the houses, hills, plots, he drew only their contours. The colour composition, too, followed strict rules. After 1929, Barcsay often worked in Szentendre, a small, picturesque town lying along the River Danube, which has several Serbian Orthodox churches. It was the town of Szentendre and its motifs which from that time forward determined his art. The painter's Rolling Hills shows Pismány Valley in the vicinity of Szentendre.

99 Lajos Vajda's art was the beginning of Hungarian Surrealism in general, and of the Szentendre School's surrealistic trend in particular. He developed his programme together with Dezső Korniss on the basis of the correlation between folklore and the concept of internationalism. These ideas began to take shape around 1936, the time when Vajda painted *Self-portrait with Lily.* Already in the first years of the 1930s, during a trip to Paris, he became interested in primitive art. In 1935–1936, after having returned to Hungary, he began to study the folklore and naive art of Szentendre and the surrounding region. He was absorbed, most of all, in Eastern Orthodox icon painting. In his so-called "icon period", Vajda's paintings gradually underwent a transformation from a reliance on harmonious, tranquil forms taken from nature to the more abstract rendering of the turbulent state of mind typical of Surrealism. Self-portrait with Lily was one of the first products of this period. The rigid icon-like composition is here dissolved in forms reminiscent of Art Nouveau. The influence of Hungarian folklore is also discernible in the decorative elements.

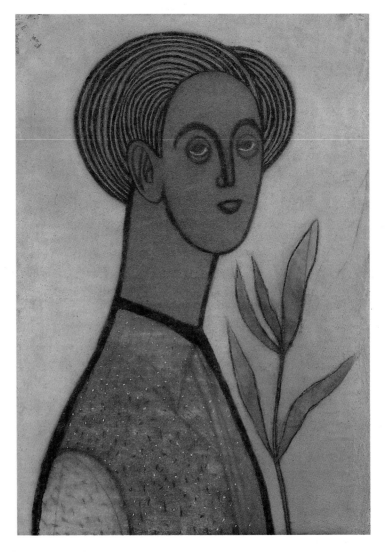

99 | LAJOS VAJDA
Self-portrait with Lily

100 | DEZSŐ KORNISS
Szentendre Motif II

100 *Szentendre Motif II,* painted by Dezső Korniss in 1947–1948, is one of the most important works of the avant-garde movement which emerged in Hungarian art during the early 1930s, and which was primarily related to the town of Szentendre. This picture was a programme and a conclusion all in one. Korniss and Vajda defined their artistic programme in relation to Zoltán Kodály and Béla Bartók: "Nothing can be done without tradition, which under Hungarian circumstances means folk art. We want to accomplish the same thing as Bartók and Kodály have done in music…" Korniss painted several so-called Constructivist-Realist pictures, each of which was entitled Szentendre Motif. From the elements of folklore, naive art and architecture discovered in Szentendre, Korniss created an amalgamation of Surrealistic, Symbolic, Structural and Constructivist compositions which conveyed radically new meanings.

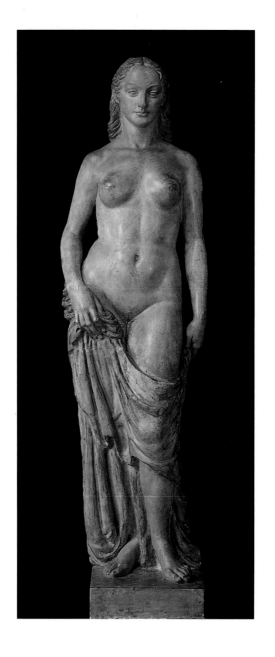

101 As in other countries, in Hungary, too, sculpture soon followed in the footsteps of the radical changes that were taking place in the sphere of painting. Yet paradoxically, those artists whose programme was the rejuvenation of Hungarian sculpture looked for inspiration in archaic and classical forms. Fülöp Ö. Beck's medals and "metal sculptures" showed the stylistic marks of Art Nouveau from the very beginning. In 1905, the artist became acquainted with Adolf Hildebrand's art in Munich, whose cult of classical Greek art had a profound influence on European sculpture. The theme, and even more so the harmonious plastic rendering, of *Aphrodite* (1914) stand as witnesses to this inspiration. Classical tradition, the fondness for decorativity typical of Art Nouveau combined with the modernism of the beginning of the 20th century uniquely blend in this creation of the pioneer of modern Hungarian sculpture.

102 Ferenc Medgyessy was among the first to avoid using the generally accepted Academic style, which was either classical or impressionistic. Reaching back to Egyptian, Greek and Etruscan art for inspiration, he portrayed a new type, the figure of the peasant living on the Great Hungarian Plain. His rusticly modelled, monumental statues opened up new grounds for Hungarian sculpture. Between 1905 and 1907, Medgyessy studied in Paris, where he met Aristide Maillol, who himself was inspired by archaic traditions. A series of monuments for tombs constitute an important segment of Medgyessy's lifework. *The Lengyel Family's Tomb* was commissioned in 1917. Of all his statues, this one shows the closest resemblances to Greek sculpture; the tightly and harmoniously composed female figure leaning on a column and summoning the meditative mood of Greek stelae evokes a feeling of timelessness.

103 The same social commitment that was manifested in Gyula Derkovits's paintings was also evident in László Mészáros's sculptures made between the two world wars. He modeled *The Prodigal Son*, his most important work, in 1930. In the figure of the peasant lad, Mészáros created a complex, multifarious symbol. In the sculptor's interpretation, the biblical figure of the Prodigal Son symbolizes the social resistance of an entire period.

104 The portrayal of writers and poets has a long and rich tradition in Hungarian art. This is especially true for the poet Endre Ady, himself a revolutionary in his works. Ady had close relationship with the modern artists at the beginning of the 20th century, especially with József Rippl-Rónai and the members of The Eight. Portraits by the sculptors Fülöp Ö. Beck, Dezső Bokros Birman, Béni Ferenczy and Géza Csorba are the best known witnesses to these friendships. Bokros Birman modelled his Ady portrait in 1924, five years after the poet's death. This head is distinguished by the complexity of the unique and general, of the physiognomic and spiritual characteristics it embodies. Bokros Birman's *Ady* image is more than a portrait; it is the personification of the general and the idealized image of the Poet. During the 1920s, the sculptor produced several portraits using a similar approach. The influence of Cubism is noticeable in the rudimentary plastic rendering and the smooth surfaces of these sculptures.

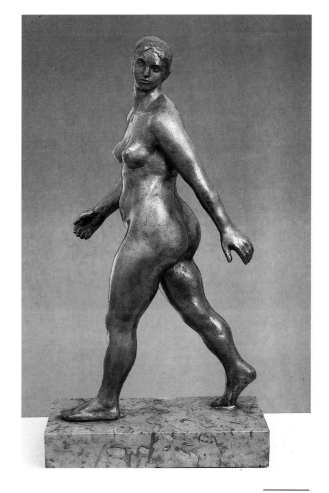

105 There were three outstanding figures among the several artists in the Ferenczy family: Károly Ferenczy was the leading master of the artists' colony at Nagybánya; his daughter Noémi was an outstanding gobelin artist, while his son Béni became an acknowledged sculptor. Béni Ferenczy briefly experimented with Cubism during the 1910s. Then he developed his personal style drawing from Antique sources and from the example of two great masters of modern European sculpture, Maillol and Despiau. He rendered dynamic movement perceptible by pure sculptural means in the perfectly balanced composition of *Stepping Woman*, modeled in 1939. Béni Ferenczy's sculpture and unique medals, together with his teaching work between 1946 and 1949, had a great impact on the younger generation of artists.

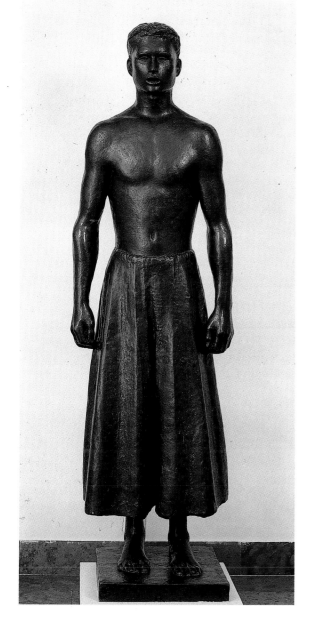

105 | BÉNI FERENCZY
Stepping Woman

THE COLLECTION
OF COINS AND MEDALS

106|JÓZSEF DÁNIEL BOEHM
Annual Meeting Held in Temesvár

106 The Society of Hungarian Physicians and Natural Scientists, founded in 1841, was one of the first of its kind in the world, and a medal was issued to commemorate each of its meetings, which were held annually in various towns of the country. József Dániel Boehm, a renowned master of classicist European coinage, designed the medal for the *Annual Meeting Held in Temesvár* in 1843. An antique female figure stands in a gracious posture on the obverse, surrounded by various objects representing the activities of the members: she holds a sphere decorated with circles, besides her there are a pair of binocu-lars, a retort, books, and a scroll on top of a pillar. Propped up against the pillar, there is an aesculap-cane ending in a serpent, symbolizing the science of medicine. The legend, BRING HAPPINESS BY AMELIO-RATION, emphasizes the importance of medicine and the natural sciences. On the obverse, within the double circular legend referring to the function of the medal, two standing horses hold the coat of arms of Temesvár. The antique figure depicted in an allegorical scene, the tranquility of the composition, the minutely detailed, fine workmanship, and the high rim are typical stylistic characteristics of Classicism.

107|FÜLÖP Ö. BECK
Miklós Ybl

107 Fülöp Ö. Beck's medal was struck in 1924 as a piece of a series portraying distinguished Hungarian architects. *Miklós Ybl* created numerous great buildings, among them the Budapest Opera, and many palaces. The striking portrait on the obverse avoids details; thus, the tranquil, aloof surface, the settled forms evoke the art of Ybl. Symbolic figures representing Ybl's trade are depicted on the reverse of the medal: three female nudes holding above their heads a model of the Budapest Basilica, which was completed by Ybl. The movement and lines of the figures create an almost musical effect. The obverse and the reverse are in harmony; the shape and location of the letters further enhance the design's succinctness and artistic value. The interpretation of the figures suggest the late influence of the constructive tendency of Art Nouveau as practiced in Munich. The rhythmic quality of the well-proportioned figures further enhance the musical effect.

108 | BÉNI FERENCZY
Béla Bartók

108 Béni Ferenczy's medal, made in 1936, is one of the most powerful portrayals of *Béla Bartók*. The features of the portrait on the obverse, especially the high forehead, reveal a personality with outstanding intellect. Despite the large format, there is no legend on the obverse; thus the central idea of the work can exercise its full impact without any distractions. Ferenczy's harmonious, yet dramatic style relies on Antique traditions, a fact which is especially apparent in the composition on the reverse. The breakthrough in the classical interpretation of the relationship between obverse and reverse is well illustrated on this coin when the artist reinterprets the central idea on the reverse. A quotation from Endre Ady, written in artistic letters, paraphrases the river meandering between flat beaches and the cone-shaped hills in the background. The surface of the medal was carefully chiselled, so that the light shining on the bronze creates a painterly effect.

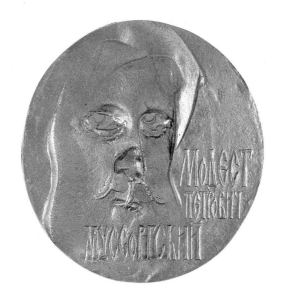

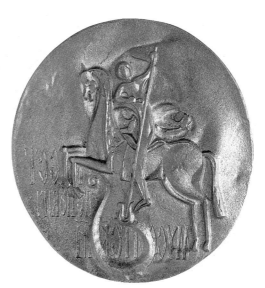

109 | ERIKA LIGETI
Mussorgsky

109 A significant change can be observed in the form of medals struck after the late 1960s, when the artists attempted to reinterpret the idea of what a medal must be like. One of the most innovative application of positive and negative forms, fully exploiting the playful possibilities hidden in the contrasts, is Erika Ligeti's medal portraying the Russian composer *Mussorgsky*, made in 1972. The extravagant portrait on the obverse, decoratively framed by the Cyrillic letters of the composer's name, unfolds from negative forms. The interplay between positive and negative was also repeated between the obverse and reverse. The letters on the obverse are repeated on the reverse as in a mirror, but here they frame the figure of St. George. Mussorgsky, a member of "The Five" group, was one of the initiators of the new music; his activities are well illustrated in the scene of the Saint just springing into the saddle to set off in defence of the princess. It should not be forgotten that St. George was one of the most popular saints in the Eastern Church, too, as well as being the patron saint of Russia.

THE DEPARTMENT OF
PRINTS AND DRAWINGS

110 | SÁMUEL KISS
Portrait of the Mayor of Brassó

111 | KÁROLY MARKÓ THE ELDER
The Pest Organ (From the Aggtelek Cave Series)

112 | MIKLÓS BARABÁS
Vesuvius Seen from the Island of Capri

110 In comparison to paintings depicting moral issues or historical scenes, portraits and landscapes were considered of lesser value at the beginning of the 19th century. However, with the emergence of the French artist Jean-Baptiste Isabey and the English portraitist Thomas Lawrence, miniature portraits painted on ivory and on parchment paper soon became fashionable in Vienna. The Transylvanian artist Sámuel Kiss attended the Academy in Vienna, where he learned the technique of painting miniatures. After returning home in 1813, he became a teacher in the town of Debrecen where, besides writing essays on the theory of drawing and architecture, he also produced portraits. The *Portrait of the Mayor of Brassó*, copied in 1805 after a painting, shows one of the former mayors of the town holding the scroll outlining the new plans of Brassó in his hand. In respect of their functions, these miniature portraits were the predecessors of photographs. This depiction, with its daring use of yellow and crimson, is a fine example of the genre.

111 With the advancement of the natural sciences in the beginning of the 19th century, the exploration of caves, such as the Baradla Cave in Aggtelek, became a popular passtime. Károly Markó the Elder produced a six-part series of monumental pictures showing the stalagmite which at the time could then only be seen by torch-light. Exotic forms resembling a crypt, an altar, a church, and sometimes a waterfall, rise to view from the romantically dark surrounding. *The Pest Organ*, completed in 1821 as the last piece of the series, conveys the contrast between light and dark very forcefully.

112 Miklós Barabás, the most distinguished Hungarian portraitist of the 19th-century, also painted several landscapes in watercolours. These paintings suggest that he enjoyed the artistic freedom provided by this genre, which was in sharp contrast with the tediousness of portrait painting. His sojourn in Italy during 1834 and 1835 enabled Barabás to discover this new way of expression. He travelled with an English companion, the artist William Leitch, from whom Barabás learned a freer technique of aquarelle painting. Instead of the customary approach of travelling painters, in *Vesuvius Seen from the Island of Capri* (1835), he depicted the outbreaking volcano with daring yellow-blue contrasts. The swirling smoke and the trembling vapon in the air produce a forceful atmospheric effect. This new type of composition leads the eye uninterruptedly from the sensuously depicted waves in the foreground towards the volcanic mountain painted at the centre of the picture.

113 Károly (Charles) Brocky adopted the everyday, idyllic, petit-bourgeois views of the Biedermeier age during the years he spent studying in Vienna. The artist, who was widely known for his sentimental female portraits, left Central Europe looking for better possibilities. After 1846, he settled in England, where he produced, among other things, a series of portraits of women and children, which were genres by character. *Young Woman Watering a Plant by the Window*, painted about 1847, belongs to this series. The freshness and lightness made possible by aquarelle technique, and the transparent and fine colours suggest Brocky's Italian experiences. In comparison to the tedious technique of oil painting as practiced in the mid-19th century, the colours and forms of these aquarelles strike us as being very relaxed. The unique tradition of English aquarelle painting probably also influenced Brocky's art.

114 Károly Lajos Libay was a typical travelling painter of the 19th century. He travelled throughout his homeland, Upper Hungary, as well as in Austria, Germany, and Italy; then, accompanied by his Viennese patron, he also visited Egypt. Later, following the custom of the times, he published a collection of lithographs based on his aquarelles. The fine details painted after nature and their harmonious, rich colouring made his *vedutas* a great success. The aquarelle *Regensburg: View of the River Bank* was painted during a trip to Germany in 1849. Libay, always travelling with a sketchbook, freshly drafted whatever he saw; in this case, a distant panorama of Regensburg and the rustic surroundings of a fisherman's shack along the bank of the river. In his best works, Libay no longer followed the strict rules of Academic landscape painting. He placed the chief motif, the view of the city, in the far distance, and closed down the foreground in the left with a daring diagonal line. The contrast between the confined and the almost empty zones adds to the artfulness of the composition.

113| KÁROLY BROCKY
Young Woman Watering a Plant by the Window

115 Mihály Zichy painted his monumental work The Triumph of the Genius of Destruction for the Paris World Fair of 1878. *Demon* was a study drawn for the central figure, but in its arrangement and romantic rendering, it is more than a mere sketch. In this drawing, Zichy depicted his own version of a demon — a being full of contradictions. In the Academically conceived, idealized body of this beautiful and young male, the artist captured an evil spirit endangering both universal and personal happiness. Elevated to a monumental scale, the figure of the demon is a late descendant of the Antique god Mars and, at the same time, the forerunner of the approaching fin-de-siècle's demons of death. With its imposing and dynamic composition, this study stands out of the innumerable aquarelles, ink drawings, and detailed illustrations by Zichy.

114| KÁROLY LAJOS LIBAY
Regensburg: View of the River Bank

115│MIHÁLY ZICHY
Demon

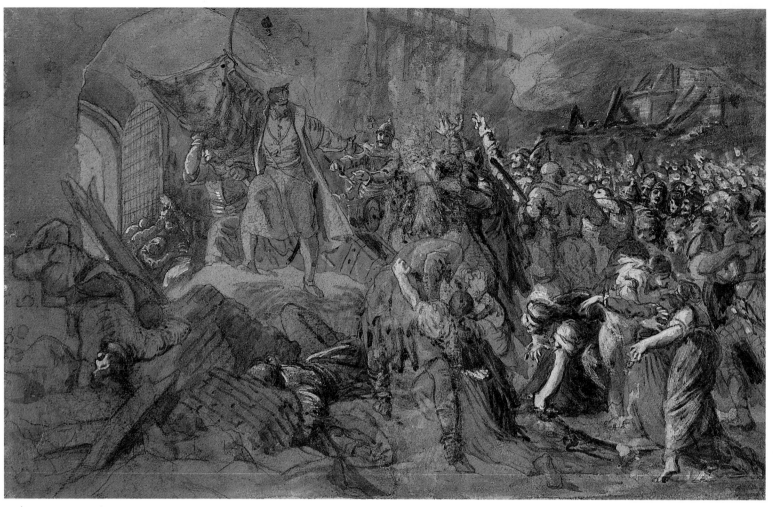

116 | BERTALAN SZÉKELY
Zrínyi's Charge from the Fortress of Szigetvár

116 Bertalan Székely, a faithful disciple of the Viennese and the Munich Academy, always made meticulous preparation for each oil painting and drew several studies before starting a project. As captain of the fort of Szigetvár, in 1682 Miklós Zrínyi attempted to stop the Turkish army attacking Hungary from the south. The theme of this heroic battle began to interest Székely in 1862; this particular drawing, however, was made shortly before 1884. In addition to revealing the superb drawing skills of the artist, *Zrínyi's Charge from the Fortress of Szigetvár* is also proof of Székely's flair for composition; the sketch emphasizes the contrast between the crowd ready to fight on the right, and Zrínyi's figure, focused with the help of architectural elements, on the left. Besides drawings, Székely made several colour and composition studies in oil before completing his great painting in 1884.

117 *Seashore,* made in about 1890, was thought to be the only aquarelle that Mihály Munkácsy ever painted — a supposition straightened by the dedication added to the top left corner of the painting in 1895. And indeed, the carefree style of the aquarelle, which was made on the occasion of an excursion outside Paris, was uncharacteristic of Munkácsy, who mainly painted biblical and historical themes at the time, and who favoured somber colours and a dramatic approach. In this sense this aquarelle is, indeed, exceptional, although not unprecedented, in the artist's oeuvre. The freshness of the brush strokes and the haziness of the forms suggest that, despite the differences in ideals, the French Impressionists did not leave the Hungarian painter — whose salon paintings were highly sought after on the Parisian art market — unaffected. This outstanding small masterpiece was bought by the National Gallery in New York in 1964.

118 Károly Lotz, painter of romantic compositions in oil, and later of frescoes, rarely took up prosaic topics. With the exception of this *fan* designed by him in about 1890 for Kornélia, his adopted daughter, he never designed objects for everyday use. There are several versions of the fan design in the museum's collection. The semi-circular drawing reproduced here shows a scene depicting a Spanish dancer in an interior, with decorative elements filling out the bottom sections. The dancer, placed centrally, is holding a red fan, thus emphasizing the function of the design. In another variant, Kornélia's portrait occupies pride of place. In the version showing the Spanish dancer, the decorative elements were conceived in the Historicist style, while in the other one, Kornélia's portrait was encircled in typically Art Nouveau foliage.

117 | MIHÁLY MUNKÁCSY
Seashore

118 | KÁROLY LOTZ
Fan Design for Kornélia Lotz

119 In 1895 Samuel Bing, owner of the Art Nouveau Gallery in Paris, commissioned József Rippl-Rónai, the Hungarian artist then living in Paris, to produce a volume of drawings. The lithographs were published in the company of poems explicitly written for these drawings by Georges Rodenbach under the title Les Vierges. The theme of women in a garden was often taken up by the Nabis, a group of modern painters to which Rippl-Rónai also belonged. Maurice Denis, Edouard Vuillard, Paul Ranson and other members laid emphasis on inner felicity and a feeling of constancy. The pattern always filled out the picture plain evenly, and the design was characterized by the rhythm of decorative contours. The pictorial interaction between mood and idea in Rippl-Rónai's drawing *Women in the Garden (Walking Women)* is symbolized by the walking female figure, a representation of fertility. The same theme was later varied in a gobelin design.

120 | LAJOS GULÁCSY
Paolo and Francesca

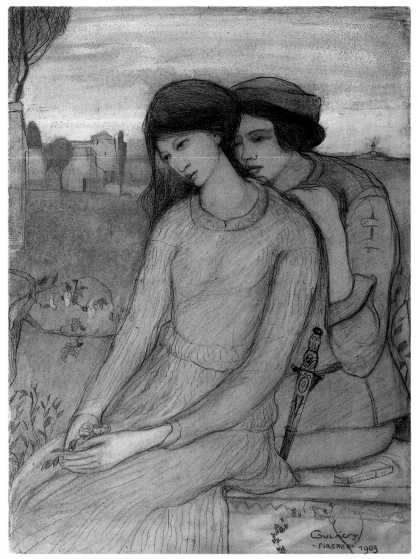

120 The nostalgic representation of *Paolo and Francesca,* two figures from Dante's immortal Divine Comedy, symbolizes Gulácsy's attempt to turn his back on the new art movements of the late 19th century and to escape into the world of the Middle Ages. Gulácsy created this pencil and oil picture in 1903, on the occasion of a trip to Florence. Similarly to many other artists, Gulácsy felt most at home in Italy, and created for himself a fantasy world resembling the small Italian towns of bygone ages.

121 After his early Naturalist and Art Nouveau period, János Vaszary fell under the spell of modern French art. The composition of this *Seated Female Nude Viewed from Behind* is built on pure line; it is the Hungarian counterpart of Matisse's drawings, which were based on a single circular contour. This drawing, produced in 1910, is a fine example of those Hungarian paintings and drawings which were created under French influence around that time. Vaszary's academic studies gave him a firm basis for his decorative, synthetic nude drawings. Like the entire oeuvre of the artist, these drawings are full of the joy for life and, at the same time, they suggest a kind of urban frivolity.

122| KÁROLY KERNSTOK
Riders

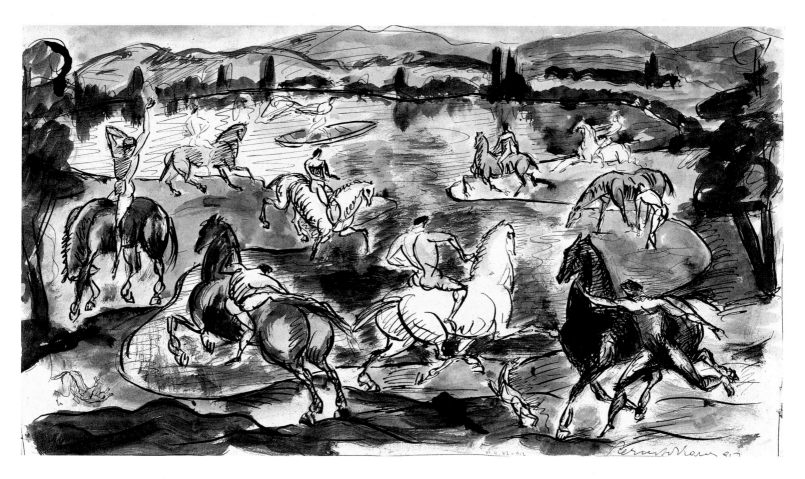

122 Károly Kernstok was a leader of The Eight, the first organized artists' group of the Hungarian avant-garde, who followed in Cézanne's footsteps. He painted Riders on the Shore in 1910 as a symbolic summary of the group's strivings, intending it be the summary of their mainfesto on art. *Riders,* drawn in ink two years later, is much more light-handed and balanced than the stylized, simplified figures of the oil composition. The dynamic drawing evenly fills out the picture, thus providing a harmonious rendering of riders and the landscape. The motif of the riding nude was depicted by Kernstok innumerably. This india ink and wash drawing is the most successful summary of these sketches, which originate from nature, but always go beyond the particular image. A copper-plate version of this drawing is also known.

123 From the very beginning of his career, the art of József Nemes Lampérth was influenced by French art, thanks to the mediation of The Eight. *Interieur,* an aquarelle painted in 1912, shows that he was most indebted to Cézanne, although at that time he had not yet been to Paris. However, his more expressive and raw colours give an individual character to his works. By the use of dramatic colour contrasts, the artist turned a bourgeois interior into an autonomous composition. The bottle and the woman with her head leaning on the table suggest tragedy; yet, these motifs placidly fit into the homogeneous composition. With this painting, Nemes Lampérth also expressed the feelings of the intelligentsia in reaction to the existential problems of Austria-Hungary shortly before the disintegration of the Austro-Hungarian Monarchy. The vigorous brushstrokes and the expressive and novel colour scheme and formal vernacular all serve to convey the same feeling.

123 | JÓZSEF NEMES LAMPÉRTH
Interieur

124 Béla Uitz produced monumental drawings in the expressive style of the Hungarian avant-garde movement, Activism. *Mother and Child,* a piece of a series drawn by him in 1918, depicts his wife and three-year-old son. The forms are defined with strong contours; the three-dimensional effect was achieved by charcoal shading. By contrast to his early charcoal drawings emphasizing a personal fate, in this work Uitz depicted the universal feeling associated with belonging to one another, as well as the protective and nurturing love of a mother. Uitz transformed the mother into an eternal figure, at the same time making a statement about the actual human problems of the First World War. This mother-type is an emotional and determined, strong and receptive woman, the woman of a new age, the impersonation of the artist's ideal human being.

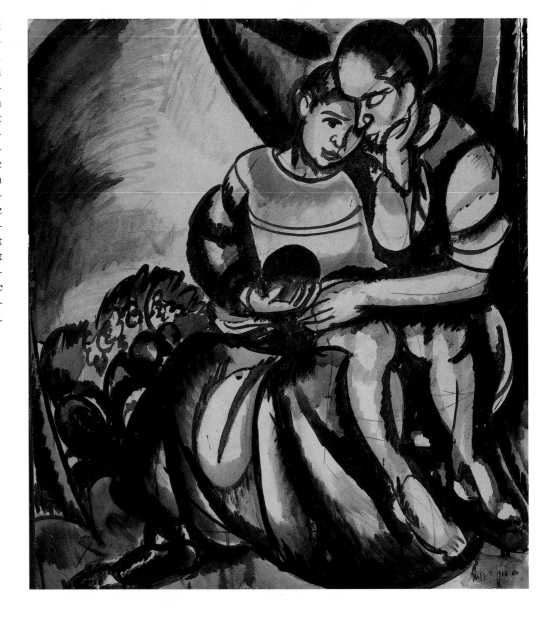

124 | BÉLA UITZ
Mother and Child

125 Sándor Bortnyik's stencils, made in 1921 in Vienna, were the first examples of Hungarian Constructivism. A year later, however, Bortnyik left Lajos Kassák's circle and moved to Weimar where, in the shadow of the Bauhaus, he continued his experiments with two-dimensional geometry, moving on to three-dimensionality. As his aquarelle *Geometrical Composition* reveals, Bortnyik was also influenced by the Constructivist De Stijl group, although with his approach to the problem of transparency — the interaction between the squares and the daring circular shapes — he actually stood closer to the ideas of László Moholy-Nagy. The way he incorporated the letter 'b' — his signature — and the date 1922 into the composition reveals the influence of earlier avant-garde trends and shows Bortnyik's freer, more painterly rendition.

126│LÁSZLÓ MOHOLY-NAGY
Construction

126 The "Dynamic-Constructive" manifesto was published by Moholy-Nagy and Alfréd Kemény at the end of 1922. Moholy-Nagy explored in this work — just like in the subsequent lino-cuts and lithographs — the tensions generated between form and space. El Lisitsky and the Hannover-based Kestner Society, known for its support of modern strivings in art, commissioned a series from Moholy-Nagy in the spring of 1923. The six lithographs were published under the title *Constructions*. The sheet reproduced here is the second piece of this series. The six lithographs varied geometrical elements with the idea of exploring the phenomenon of transparency. In sharp contrast to the crimson base of the first sheet, here the motifs are set against a neutral gray background. The transparency of the compact black and the translucent light elements anticipate Moholy-Nagy's major work, Light-Space Modulator.

127 István Farkas, a lonely figure in Hungarian art, is generally referred to as a visionary painter. He painted this *Self-portrait* in 1932 in Paris. The painting is the meditative confession of someone trying to reconcile the conflict between a bourgeois upbringing and artistic self-realization. The painting reveals how the artist went beyond the search for order as exemplified by Cubism, thereby approaching the dreamworld of the Surrealists while never really leaving the reality of his own constricted, immediate surrounding. The pale, translucent colours reveal an extraordinary sensitivity, while the artist's subjects expose his sense of seclusion. Behind the apparent tranquility of this self-portrait there is an inner tension which characterizes all of Farkas's remarkable oeuvre as well as his own death at Auschwitz.

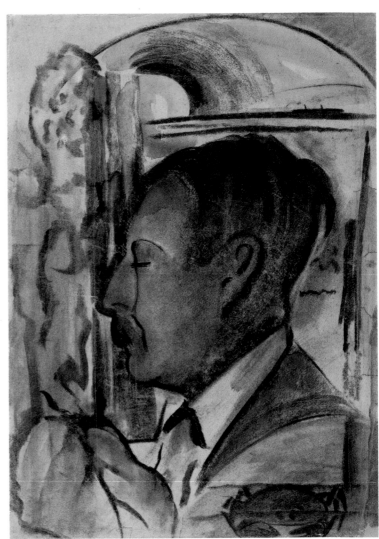

127 | ISTVÁN FARKAS
Self-portrait

128 In *Still-life with Tower Plate*, created in 1936, as in his other montages, Lajos Vajda, one of the many major artists to have settled in Szentendre, depicted his closer and wider surroundings in unity. In this still-life, the Baroque church towers of Szentendre and the humble motifs of the artist's everyday life forms a peculiar pictorial unity. The over-sized plate in the place of the church-clock, the integration of the architectural motifs and still-life elements, conveys symbolic meaning. The simultaneous presence of separate layers of reality reveal a new interpretation of space and time, a method that was referred to by the artist as "Constructive-Surrealist schematics".

128 | LAJOS VAJDA
Still-life with Tower Plate

129 Imre Ámos called himself a creator of visionary pictures, and quite rightly so. But instead of the subconscious world, he chose the often cruel outer reality as his starting point. This is how Jewish tradition, the problematic present and the premonition of a bleak future came to be tragically bound together in his paintings. His own death in a Nazi concentration camp proved that his terrifying visions were nothing less than prophetic. Ámos's drawings are confessions of the artist's concern for the human race. Most of them are inspired by events in his own life, like *Couple in Front of a Wire Fence*, painted in 1944. The couple, seeking shelter in the trunk of a tree are here turned into the symbol of love, and the tree into the final asylum. But the mutilated branches of the tree forecast the nearing end: the space, defined by the wire fence, is an explicit reference to Fascism. This drawing is a typical example of Ámos's Expressionism.

129 | IMRE ÁMOS
Couple in Front of a Wire Fence

130 Jenő Barcsay became a professor at the Budapest Academy of Fine Arts in 1945. At the age of fifty he was commissioned to draw a book of anatomy especially for artists. With a sharp pencil he traced from point to point the various parts of the skeletal structure and the muscles, and between 1951 and 1953, he produced 126 brilliant drawings. The volume, Anatomy for the Artist, was published in Hungarian in 1953. The *Anatomical Study* reproduced here constituted sheet CXXIV in the book; five years later it was reproduced again on the XXVIIth page of Man and Drapery, a second volume of drawings in which Barcsay explored the complex problem of the nude and the covered body, which never ceased to interest the artists from Antiquity to our own days.

130 | JENŐ BARCSAY
Anatomical Study

THE COLLECTION OF CONTEMPORARY ART

131 | TIHAMÉR GYARMATHY
Dynamic Composition

132 | ENDRE BÁLINT
Grotesque Funeral

131 Tihamér Gyarmathy belongs to the second generation of Hungarian avant-garde. After graduating from the Budapest Academy of Fine Arts, between 1937 and 1939 he travelled around Europe. On this trip he met Piet Mondrian, André Breton, Jean Arp and Max Bill. After the Second World War Gyarmathy became a member of Európai Iskola (European School, a short-lived Hungarian avant-garde movement hoping to make Hungarian art less provintial), but he left the group in 1946 and, together with the art critic Ernő Kállai, he founded the artists' group known as the Gallery to the Four Winds. *Dynamic Composition*, completed in 1946, represents this period. The painting illustrates the unity of the micro- and macrocosms. Gyarmathy's purpose was to depict the dynamic relationship between space, time and movement. Ernő Kállai described this and similar works by the artist as follows: "With their relentlessly changing colours and forms, they open up a shining mirror of organic existence and infinite permanence ... Our eyes are immersed in a spatial world, in the intricate tunnels of which life proliferates copiously, growing thousands of roots everywhere we look."

132 Though Endre Bálint became a close friend of Lajos Vajda during the latter part of the 1930s, he did not occupy himself with Vajda's Constructive-Surrealism until the fifties, when he gradually adopted it to suit his own aims. Bálint emigrated to France in 1957 where, besides paintings, he also produced photo-montages. The publication of the Jerusalem Bible in 1959, which was illustrated by him, brought Bálint great success. In 1962 he returned to Hungary, where he painted *Grotesque Funeral* in 1963. Its motifs, the round moon — the symbol of the artist's solitude — the black female figure — the personification of anxiety —and so on, were already present in his Parisian paintings, but they appeared in this picture more expressedly, thus resulting in a more complex meaning than could be observed in earlier works by the artist.

133 As early as the 1940s, the art critic Ernő Kállai referred to Tamás Lossonczy's lyrical-abstract and abstract-surrealist compositions with admiration. Bio-Romanticism, a concept forged by Kállai, is perhaps best illustrated with Lossonczy's art. *Purging Storm*, made in 1961, was an elemental vision, a cathartic conclusion of the emotional tension of the artist forced into internal exile during the fifties. Although the painting was not exhibited until 1978, it was still an emblematic document of the revival which gradually began in the early 1960s and which led to the slow recovery of the art scene.

133 | TAMÁS LOSSONCZY
Purging Storm

134 | IGNÁC KOKAS
Around Man I

134 After the early 1960s, Ignác Kokas gradually moved away from his earlier Post-Impressionist, painterly, dramatic genre painting towards a style combining Surrealism with Expressionism. He gave up depicting the life of the peasantry, and chose more general subjects, such as loneliness, struggle and death. His motifs originated from the surroundings of his native village, Ginza Puszta. This "turning back the clock" resulted in the artist's inclination towards introspection and self-examination. Kokas painted a series based on the region around his native village, and his return to the scene of his childhood caused an eruption of emotional and moral conflict. A whole series of pictures attest for this mental struggle, his loyalty and infidelity (I Leave my Village, The Prodigal Son). *Around Man I,* painted in 1969–1970, is a typical piece from this cycle, and shows very clearly the moral commitment of the artist.

135 | BÉLA KONDOR
God Save Me from Newton's Belief!
Illustration for a poem by Blake

135 Béla Kondor was active for less than two decades, and his life-work cannot be divided into separate periods. Rather, it evolved around a certain organically linked cycle of genres and motifs. His graphic art is best described as intellectual; this intellectualness, which was also the essence of his paintings, brought new life into Hungarian graphic art. Kondor created his own individual myths; he felt a close affinity for Expressionism, although in his artistic devices he also took advantage of the Surrealist vernacular. He combined the symbols of various historical periods in order to express his personal feelings and experiences. It was hardly a coincidence that he felt William Blake's art so close to his own. He reinterpreted several of Blake's works, a fine example is *God Save Me from Newton's Belief!,* made in 1961.

136 Using the vernacular developed by Simon Hantai and Max Ernst, Tibor Csernus gave a new direction to the Naturalist movement associated in Hungary with the name of Aurél Bernáth. His paintings created a new school by the evocation of the elements of Tashism and Surrealism, and by the abundance of vegetation. Art historian Géza Perneczky called this loose group of artists the Sur-Naturalists, who were " able to turn a perceptive and pantheistic naturalism into avant-garde art." However, though we can accept this concise description with regard to the group as a whole, Csernus himself was not preoccupied with the compatibility of avant-garde and naturalism; rather, he was absorbed in the absurd mass of visual memories stripped of coherence, or to use Oskar Kokoschka's words, the problem of the "possibility of depicting existence". Csernus painted *Model Makers* in 1963 in memory of György Endresz, the eminent Hungarian aviator. Especially when considered in the context of other works made in the 1960s on the subject of flying, the painting symbolizes the fatality of the artist's existence.

137 Sándor Altorjai was already a certified chemist when he enrolled into the Academy of Fine Arts. After completing his studies, he joined the circle of Sur-Naturalist artists for a short while. He made friends with Miklós Erdély, and until 1968 he regularly participated at the various avant-garde events. *Let Me Sink Up!*, composed in 1967, is one of the outstanding examples of Hungarian Pop Art. Miklós Erdély also contributed to the picture, and he was the model of the photographs, too. The method of making this picture is best described in Miklós Erdély's essay, Montage Hunger. The picture is divided into two parts which are on different scale; they connect like two shots in
a film. With the participation of the viewer, the moving elements of the picture and the text-instruction create a theatrical effect.

138 On the basis of such sculptures as Street (1974) and Room of Mirrors (1975), in the eighties some art historians regarded Erzsébet Schaár as a maker of Pop Art. However, looking at the entire oeuvre, the emphasis seems to lie elsewhere. The question of outside and inside, together with the problem — both formal and thematic — of mirroring, were already present in her sculptures made in the latter half of the 1940s. Starting in the middle of the sixties, her "anti-sculptural" — essentially two-dimensional — silhouette-like figures materialized in the context of architectural elements. Then after 1966, Schaár became interested in using polystyrene plastic, because this material made it possible for her to create life-size figures. *Sisters* was originally also modelled in polystyrene plastic in 1968. The elegiac tone and a unique relationship to time make this sculpture different from others created by the artist with a similar method during that period.

138 | ERZSÉBET SCHAÁR
Sisters

139 When still an art student, Sándor Molnár organized an avant-garde artists' group which later became the Zuglói Kör (Zugló Circle). The main purpose of the group was the investigation of modern theoretical concepts in practice and the discussion concerning the results. The members tried to develop relationships with the avantgarde artists of the older generation by visiting them in their studios. During the fifties, most of these older artists were forced into the periphery of the art scene because of their beliefs. Sándor Molnár painted *Dragon Killer* — a synthesis of the prospects of lyrical abstraction based on French painting — in 1966. This was also the time when some members of the Zuglói Kör began to go their own way. With the series of the so-called "empty" pictures, Molnár also set off into a new direction. *Principle*, created in 1968, is primarily a meditative object, in which the colour green calls for contemplation.

140 Imre Bak belonged to the hard-core of the Zuglói Kör. Before 1964, the analytical tendency of lyrical abstraction, represented by Jean Bazaine and Alfred Manessier, was already present in Bak's work. During a trip to Western Europe in 1965, he became acquainted with the new geometrical trend and made friends with Karl Pfahler and Thomas Lenk. From this time on, uninterruptedly until 1970, his art was directly bound to the "hard edge". Trying to approach exactitude and, by way of avoiding all personal manifestations, the consistent enforcement of structural purity, this is what constituted his chief aim. *Blue Frame* was shown at the first of the famous and scandalous avant-garde exhibitions organized in 1968 at the state-owned design firm, Iparterv. The sharply delineated geometrical forms, the intense colour effects and conscious Structuralism are clearly evident in the composition.

141 The oeuvre of Pál Deim can be considered as the organic continuation of the so-called Szentendre School of painting. During the late 1960s his style was bound to a certain branch of Constructivism; his individual world included the reinterpretation of the symbols of this small town of unique traditions. One of the basic characteristics of Deim's oeuvre was the dynamic transformation of the organic and the geometrical systems. The composition of *Man and House* in 1969 comprised both systems. The fact that it was Deim's first two-dimensional relief made this picture a key work. The sculptural notion, which he brought up in this picture for the first time, later became the basis of several compositions.

142 Ilona Keserű's works painted in the first half of the 1960s were of crucial importance in the assessment of the period. Using the means of abstract expressionism and gesture painting, her paintings were, in her own words, instantaneous expressions of her intellectual and mental state. She discovered the heart-shaped tomb stones at the cemetery of Balatonudvar in 1967; from this time on these shapes — especially the top segment — became the basic motif of her pictures. This simplified form was accompanied with a reduced, but at the same time very meaningful colour selection in the oil paintings on pressed canvas. All these resulted an organic structure of relationships which was linked to personal experiences. *Villány II* painted in 1972 is a good example.

142 | ILONA KESERŰ
Villány II

145 In works such as *The Queen of the Night* (1980), Ildikó Várnagy developed organic systems based on elemental associations; these entail things of infinite number, yet they retain their special quality lying in that they can be traced back to the basic formula. This is her way of creating the elements of "writing in space" without ever disclaiming the peculiarities of three-dimensionality. In her terracotta portraits, instead of the outside appearance and physiognomical likeness, Várnagy brings the model face to face with his mental qualities, thus embarrassing both the sitter and the viewer. Her idols summon the magical acts of primitive peoples, but they are never archaic. This is especially true for those sculptures which are built of ready-made objects. By their meaning, which preserve the original character of the object, these sculptures formulate a typically 20th-century world view, devoid of ceremoniousness and solemnity.

143 There are several Hungarian artists among the pioneers of kinetic art. However, István Haraszty did not follow in their footsteps. His oeuvre was determined by his creative relationship to structures, which was apparent already in his childhood. Haraszty's mobiles do not reflect the technical world, nor the relationship between man and engine. His objects function on the basis of the rules set by mechanics and electronics; but this is only the foundation, the starting point, because he illustrates the paradoxes of the situation of the entire structure. *Brain-cannon* was created in 1980–1981 as an epitome of the absurd game played in the story of political careers in society. The balls symbolize functionaries; these are organized in a hierarchy on the basis of their sizes. Their course is complex, yet predetermined by the structure.

144 His Pop Art pictures made László Lakner's name well known during the 1960s. He was attracted to hyper-Realism during the seventies. In the middle of the decade he moved to West Berlin; from this time on he paid a special interest to written documents. He acquainted the new tendencies of American painting on the occasion of a trip to New York in 1980. Influenced by graffiti — by allowing a larger place in his art for the gestures — his art took a turn in the direction of expressiveness. Lakner submitted *Untitled* to a show organized by the Palace of Exhibition in 1982 entitled Homage to the Homeland. The picture was created by using the oldest Hungarian written document, the Funeral Sermon. The black and brown letters protrude from a tortured, flat surface. Besides initiating complex associations, these letters astound the viewer by the weight of a personal confession.

146 Avant-garde art made the last steps towards total freedom during the seventies. The crossing over from one genre to another was ensured; the rigid structure of the various genres was broken up; the unlimited use of all material and techniques was allowed; and the barrier between art and non-art was demolished. For Imre Bukta this state of affairs was already natural and he utilized his experiences in a creative way. In his 'agro-art' (agricultural art) works, like the *Free Spraying at Dawn* created in 1985, he made reflections to the new values of village life which were built on banalities. His actions and his installations were assembled of trivial materials (dung, garbage); they are the monuments of an ironically conceived, grotesque ritual.

146│IMRE BUKTA
Free Spraying at Dawn

147 István Nádler painted lyrical abstract compositions during the first half of the sixties. After a tour of Western Europe with Imre Bak, he followed the trend of new geometric art. Then, after a period ruled by the principle of structure, in the middle of the eighties his career took a radical turn. In 1984 Nádler's Malevich-interpretations partially constituted references made to his own artistic programme during the 1970s. On the other hand, he monopolized the motif of a wedge which he interpreted as a topos taken from cultural history in a way, that the personal message — built on the motif — gradually became more emphasized. After the second half of the eighties his choice of colours became more subdued: solemnity, rather than the passionate tone, and tragedy, rather than the dynamism of the drama, came to provide the basic elements of his works. *Untitled (Temesvár—Bucharest II),* painted in 1990,is a good example of this transition.

147 | ISTVÁN NÁDLER
Untitled (Temesvár — Bucharest II)

148 Ákos Birkás's art was bound to the sociological branch of hyper-Realism during the early seventies. In his picture-and-wall cycle he discussed the issue of the value crisis as the fundamental existential question. In the middle of the decade Birkás changed his method: he documented his media researches by photographs and films. Human face, as the central element, already appeared on these works. During the first years of the 1980s he returned to painting. He used an aggressive form of expression — the equivalent of strong emotional outbursts. He regarded symmetry as the fundamental of the structure; he stressed this point by the three-finger wide distance between the separate parts of the picture — which meant not only an axis, but also a line of break. After 1985 his works were reduced to a single, basic motif, that of the oval, as the synopsis of the "world's face". This form, which originally carried "multiple meaning", now started to convey "all meaning" in his tension-filled works, such as *Head 14* (1986), for example.

148 | ÁKOS BIRKÁS
Head 14

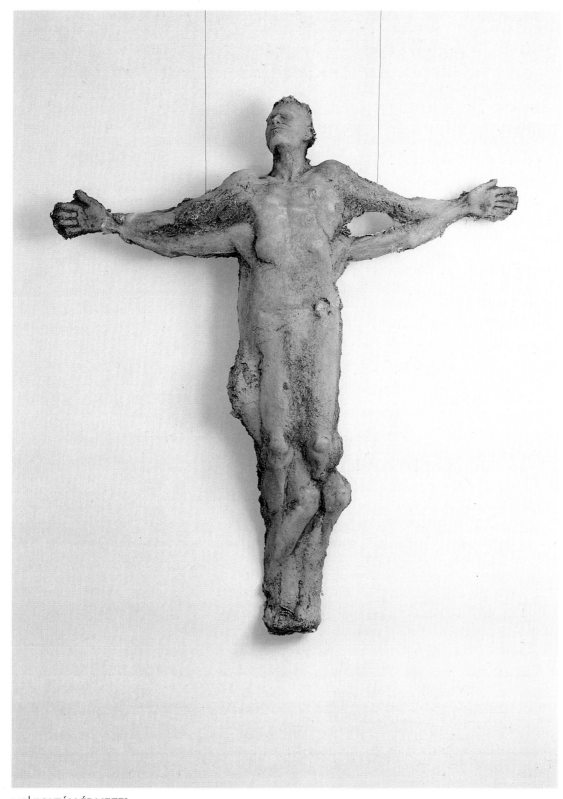

149 | ZOLTÁN ÉRMEZEI
Dual Corpus

149 Zoltán Érmezei's art follows the ideas of the conceptual branch of the radical avant-garde, where "life is transformed into art ... (and) ... art is experienced as reality" His self-consistent career enabled Érmezei to gain a background which helped him to sublimate his experiences when an illness threatened his life. *Dual Corpus* was made in 1990. In the position of the crucified Christ he cast his own body in plaster. Following Christ's example was the essence of this gesture; it exemplified the suffering he consciously undertook. Beyond the personal implication, this work radiates the acceptance of the meaning of human life — that of suffering and action.

FURTHER MAJOR WORKS FROM THE COLLECTIONS
OF THE HUNGARIAN NATIONAL GALLERY

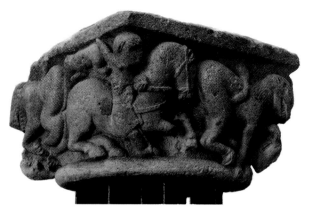

1| HUNGARIAN MASTER
Capital. From Dömös

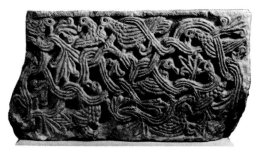

2| HUNGARIAN MASTER
Frieze. From Somogyvár

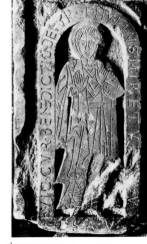

3| HUNGARIAN MASTER
Detail of a Gate (?). From Pécs

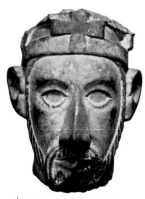

4| HUNGARIAN MASTER
King's Portrait. From Kalocsa

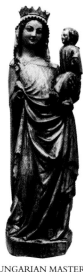

5| HUNGARIAN MASTER
The Virgin Mary. From Toporc

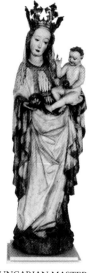

6| HUNGARIAN MASTER
The Virgin Mary. From Toporc

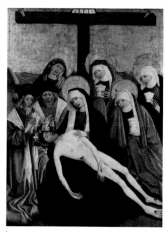

7| HUNGARIAN MASTER
Piéta. From Turdossin

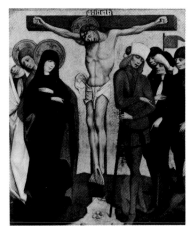

8| MASTER PN
*Stations of the Cross. From the high altar
at Liptószentmárton*

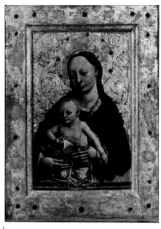

9| MASTER OF THE VIRGIN MARY
FROM BÁRTFA
(THE MASTER OF THE CHOIRS)
The Virgin Mary. From Bártfa

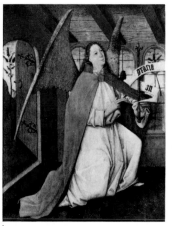
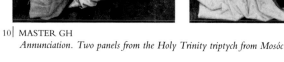

10| MASTER GH
Annunciation. Two panels from the Holy Trinity triptych from Mosóc

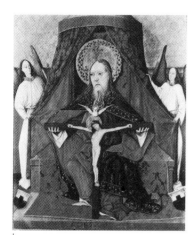

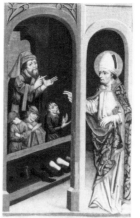

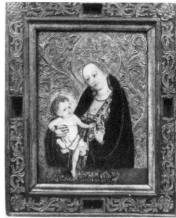

11| MASTER GH
*Holy Trinity. Panel from the Holy Trinity
triptych from Mosóc*

12| THE MASTER OF KASSA
The Man of Sorrows. From Kassa

13| THE MASTER OF JÁNOSRÉT
*St. Nicholas Commands the Thieves
to Return the Treasures. Scene from
the legend of St. Nicholas. Painting from
the St. Nicholas high altar from Jánosrét*

14| HUNGARIAN MASTER
The Virgin Mary. From Liptónádasd

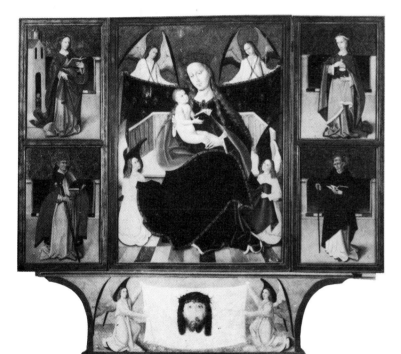

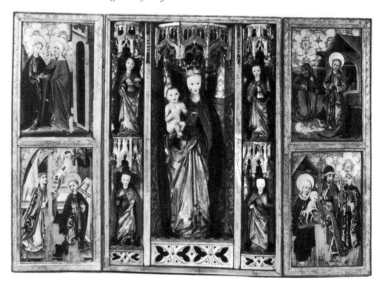

16| THE MASTER OF THE HIGH ALTAR
AT SZMRECSÁNY
The Virgin Mary Altar. From Nagyszalók

15| HUNGARIAN MASTER
The Virgin Mary Altar. From Liptószentandrás

18| HUNGARIAN MASTER
*The Annunciation. From the wing
of an altar from Szepeshely*

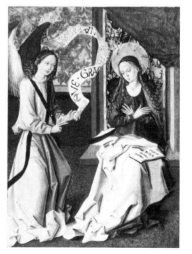

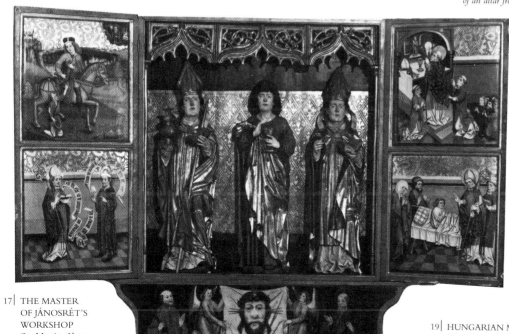

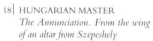

17| THE MASTER
OF JÁNOSRÉT'S
WORKSHOP
*St. Martin Altar.
From Cserény*

19| HUNGARIAN MASTER
*Mass Cerebrated by Bishop St. Martin.
From an altarpiece of unknown origin*

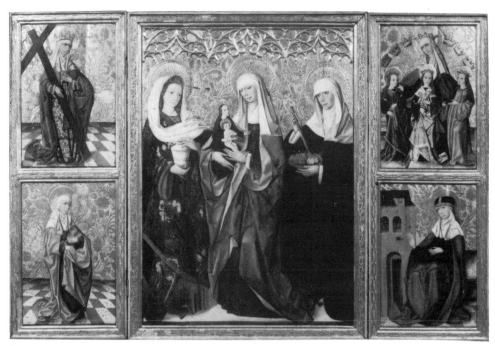

20| HUNGARIAN MASTER
St. John the Baptist.
From the Kisszeben
high altar

21| HUNGARIAN MASTER
Zechariah's Offering.
From the Kisszeben
high altar

22| HUNGARIAN MASTER
Mettercia Altarpiece. From Berzenke

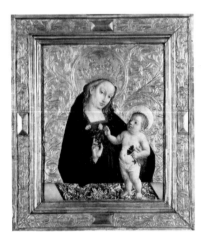

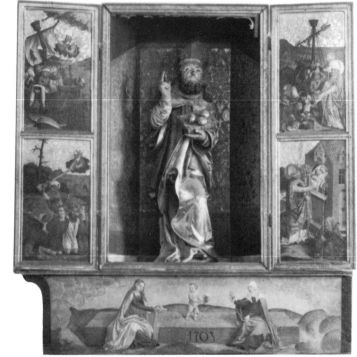

23| MASTER OF KASSA
The Virgin Mary. From Kassa

24| HUNGARIAN MASTER
Piétà. From Keszthely

25| HUNGARIAN MASTER
St. Nicholas Altarpiece. From Nagyszalók

26| THE MASTER OF OKOLICSNÓ
Lamentation. From the Okolicsnó
high altar

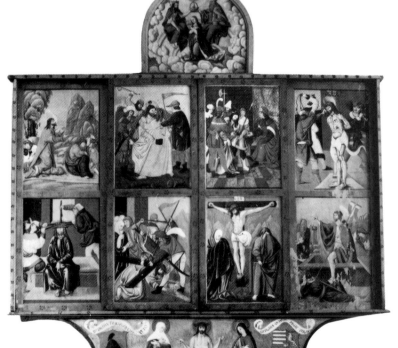

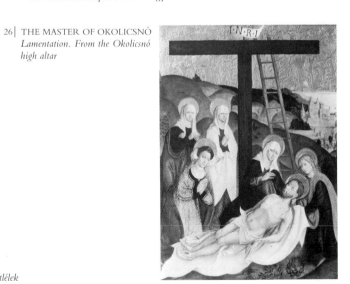

27| HUNGARIAN MASTER
High Altar from Csíkszentlélek

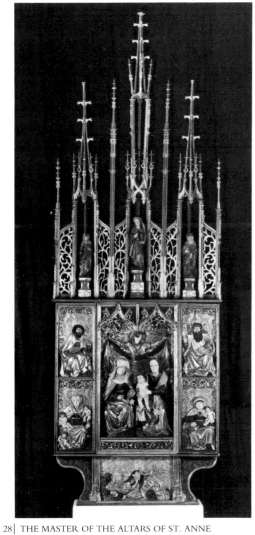

28│ THE MASTER OF THE ALTARS OF ST. ANNE
The St. Anne Altarpiece from Kisszeben

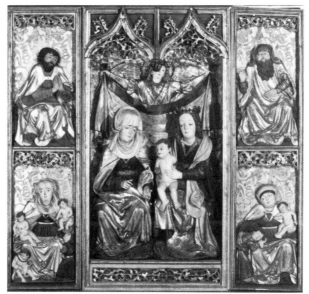

29│ THE MASTER OF THE ALTARS OF ST. ANNE
*The Shrine and the Wings of the St. Anne Altarpiece
from Kisszeben*

30│ HUNGARIAN MASTER
*The Vision of St. Anthony the Hermit.
From Szepesbéla*

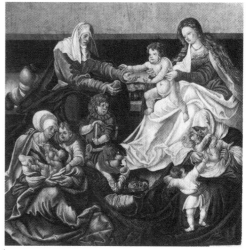

32│ HUNGARIAN MASTER
The Relatives of Christ. From Dubravica

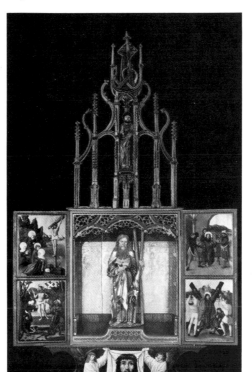

31│ HUNGARIAN MASTER
The St. Andrew Altarpiece. From Liptószentandrás

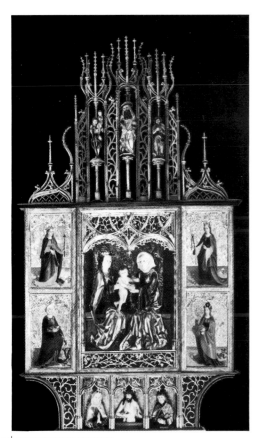

33│ HUNGARIAN MASTER
The St. Anne Altarpiece. From Leibic

34│ THE MASTER
OF THE ALTARS
OF ST. ANNE
*The Shrine of the
Annunciation
Altarpiece
from Kisszeben*

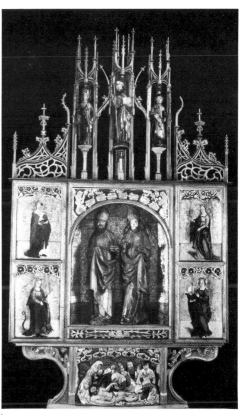

35│ HUNGARIAN MASTER
The Altarpiece of Two Bishop Saints. From Leibic

36| OTTAVIO ZANUOLI (?)
Maria Christierna. The Wife of
Zsigmond Báthory, Prince of Transylvania

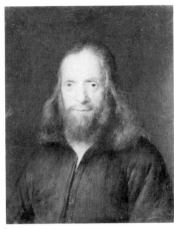

37| CHRISTOPH PAUDISS
Portrait of a Man

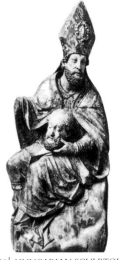

38| HUNGARIAN SCULPTOR
Bishop St. Denis

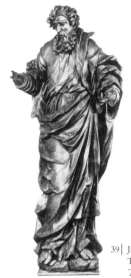

39| JANOS STRECIUS
THE ELDER
The Apostle St. Peter

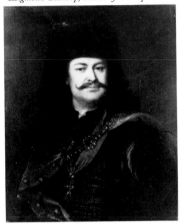

40| ÁDÁM MÁNYOKI
Portrait of Ferenc Rákóczi II

41| ÁDÁM MÁNYOKI
Portrait of Count Georg Wilhelm Werthern

42| JÓZSEF ORIENT
Landscape

43| TÓBIÁS STRANOVER
Barnyard with Cat and Pigeons

44| JOHANN GEORG
DOMINICUS GRASMAIR
Christ Being Nourished
by Angels in the Desert

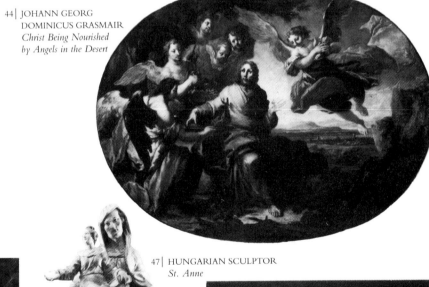

47| HUNGARIAN SCULPTOR
St. Anne

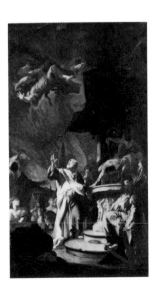

45| GEORG RAPHAEL DONNER'S
WORKSHOP
Portrait of the Emperor Charles VI

46| PAUL TROGER'S WORKSHOP
The Dereliction of Magus Simon

48| ISTVÁN IZBÉGHY (VÖRÖS)
Still-life with Crabs, a Haban Jug, a Cup,
a Loaf of Bread and a Mouse

120

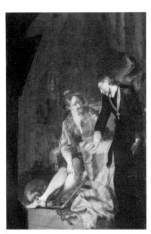

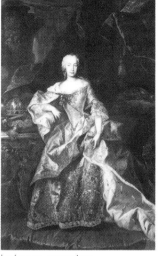

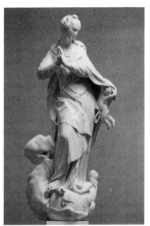

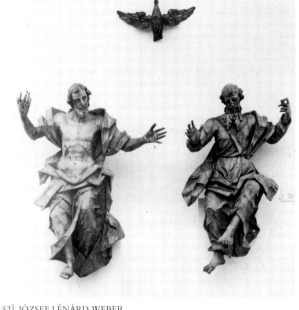

49| FRANZ ANTON PALKO
*St. John of Nepomuk Received
by King Wenceslaus*

50| SÁMUEL HORVÁTH
Maria Theresa, Queen of Hungary

51| JACOB CHRISTOPH
SCHLETTERER
Immaculata

52| JÓZSEF LÉNÁRD WEBER
The Holy Father — The Holy Son

53| FRANZ ANTON
MAULBERTSCH
*St. Stephen Offers His Crown
to the Virgin Mary*

54| ADAM BRAUN
*The Angel Makes Habakuk Bring Food
to Daniel into the Lion's Den*

55| FRANZ XAVER WAGENSCHÖN
The Judgement of Paris

56| CASPAR FRANZ SAMBACH
St. Anthony of Padua with the Infant Jesus

57| ANDRÁS ZALLINGER
The Apotheosis of King St. Ladislas

58| FARKAS KÖPP
Landscape with Ruins

◁59| JÁNOS MARTON STOCK
Portrait of a Lady

60| FERENC NEUHAUSER
Saxon Peasant Women Milking a Cow in the Barn

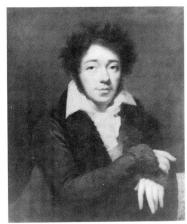

61| JÁNOS ROMBAUER
Portrait of a Man

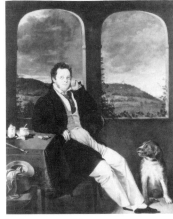

62| GÁBOR MELEGH
The Portrait of Franz Schubert

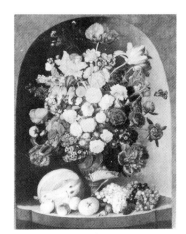

63| JÁNOS SZENTGYÖRGYI
Still-life with Flowers

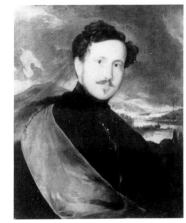

64| SÁNDOR KOZINA
Self-portrait

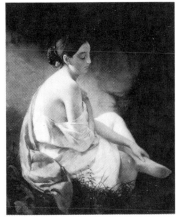

65| ALBERT TIKOS
Before the Bath

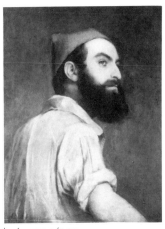

66| SÁMUEL LÁNYI
Self-portrait

67| HENRIK WEBER
A Citizen of Pest

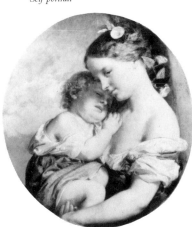

68| KÁROLY BROCKY
Mother and Child

69| KÁROLY MARKÓ THE ELDER
*Landscape with a Scene
Showing Wine Harvesting
Near Tivoli*

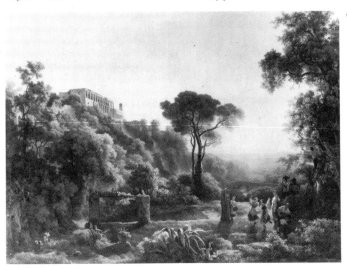

70| KÁROLY MARKÓ
THE ELDER
*View of the Great Hungarian
Plain with Draw Well*

71| MIKLÓS BARABÁS
Pigeon-post

72| MIKLÓS BARABÁS
Portrait of a Women

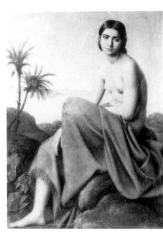

73| MIKLÓS BARABÁS
Portrait of the Wife of István Bittó

74| ÁGOST CANZI
Portrait of a Lady

122

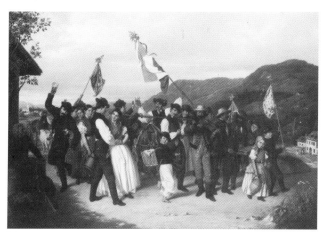

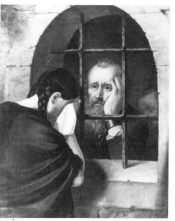

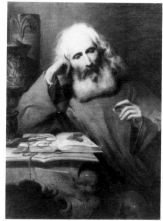

75 | ÁGOST CANZI
Grape Harvest Near Vác

76 | BÁLINT KISS
János Jablonczai Pethes Bidding Farewell
to His Daughter

77 | EDE HEINRICH
The Antique Collector

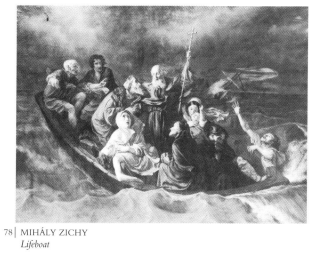

79 | MIHÁLY KOVÁCS
Battle Scene

80 | FERENC ÚJHÁZY
Sad Soldier

78 | MIHÁLY ZICHY
Lifeboat

81 | JÓZSEF BORSOS
The Dissatisfied Painter

82 | JÓZSEF BORSOS
The Widow

83 | JÓZSEF MOLNÁR
Dezső Heroicly Sacrifices Himself for Caroberto

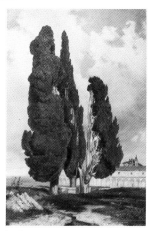

84 | JAKAB MARASTONI
Greek Woman

85 | JÓZSEF MOLNÁR
Rendezvous

86 | KÁROLY STERIO
The Beginning of the Hunt

87 | KÁROLY TELEPY
The Cloister of the Carthusians

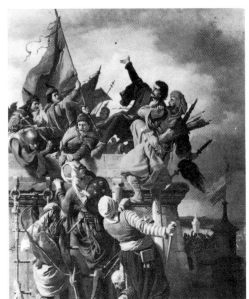

88 | SÁNDOR WAGNER
Titusz Dugovics Sacrifices Himself

90 | VIKTOR MADARÁSZ
Self-portrait

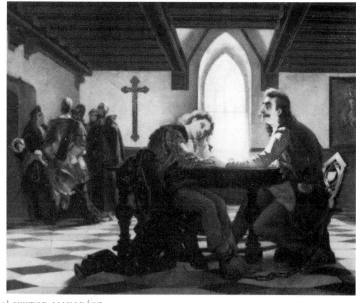

89 | VIKTOR MADARÁSZ
Zrínyi

91 | VIKTOR MADARÁSZ
*Péter Zrínyi and Ferenc Frangepán
in the Wiener-Neustadt Prison*

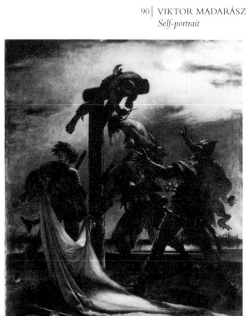

93 | JÁNOS JANKÓ
The Birth of the Folk Song

94 | MIHÁLY SZEMLÉR
Conference

92 | VIKTOR MADARÁSZ
Dózsa's People

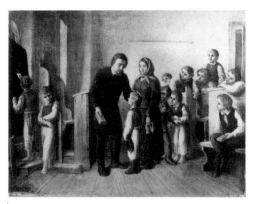

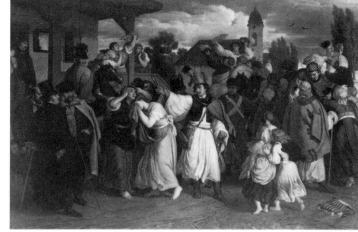

95 | SOMA ORLAI PETRICH
Village School

96 | ALAJOS GYÖRGYI GIERGL
Portrait of Szidónia Deák

97 | MÓR THAN
Recruiting Before 1848

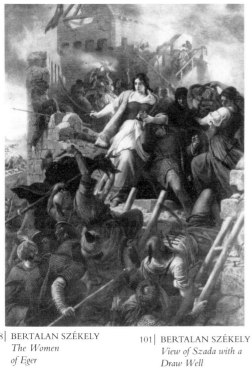

98| BERTALAN SZÉKELY
*The Women
of Eger*

99| BERTALAN SZÉKELY
Self-portrait

100| BERTALAN SZÉKELY
Red-haired Girl

102| FERENC MARKÓ
Hungarian Landscape

101| BERTALAN SZÉKELY
*View of Szada with a
Draw Well*

103| SÁNDOR BRODSZKY
View of Lake Balaton

104| GUSZTÁV KELETY
The Park of the Exile

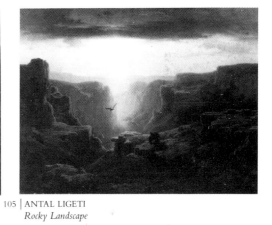

105| ANTAL LIGETI
Rocky Landscape

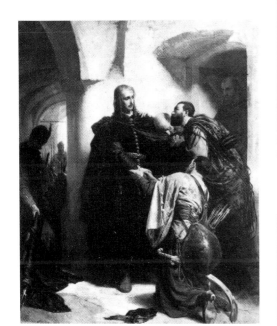

106| GYULA BENCZÚR
László Hunyadi's Farewell

107| GYULA BENCZÚR
*Louis XV and
Madame Dubarry*

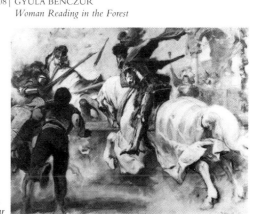

108| GYULA BENCZÚR
Woman Reading in the Forest

109| GYULA BENCZÚR
Among Hollyhock

110| GYULA BENCZÚR
Matthias and Holubar

125

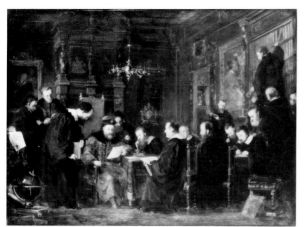

111| GÉZA DÓSA
Gábor Bethlen Surrounded by His Advisors

112| MIHÁLY MUNKÁCSY
Yawning Apprentice

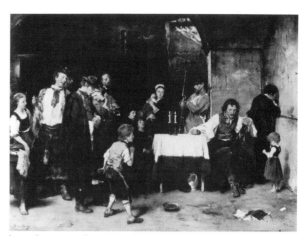

113| MIHÁLY MUNKÁCSY
The Condemned Cell

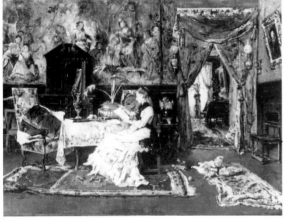

114| MIHÁLY MUNKÁCSY
Paris Interieur

115| MIHÁLY MUNKÁCSY
Self-portrait

116| MIHÁLY MUNKÁCSY
The Colpach Park

117| MIHÁLY MUNKÁCSY
Still-life with Flowers

118| PÁL SZINYEI MERSE
Hanging Out the Wash

119| PÁL SZINYEI MERSE
On the Garden Bench

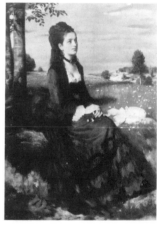

120| PÁL SZINYEI MERSE
Lady in Violet

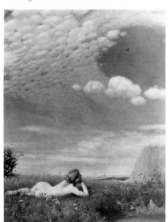

121| PÁL SZINYEI MERSE
Lark

122| PÁL SZINYEI MERSE
Thawing Snow

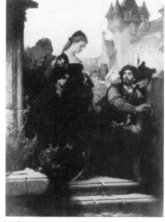

123| SÁNDOR LIEZEN-MAYER
Faust and Margaret

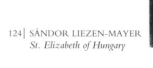

124| SÁNDOR LIEZEN-MAYER
St. Elizabeth of Hungary

125| KÁROLY LOTZ
Towing

126| KÁROLY LOTZ
After the Bath

127| KÁROLY LOTZ
*Design for the Fresco
on the Ceiling of the
Budapest Opera*

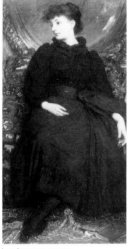

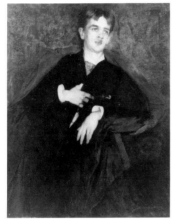

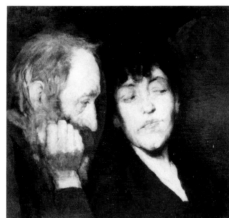

128| KÁROLY LOTZ
Kornélia Lotz Dressed in Black

129| JENŐ GYÁRFÁS
Portrait of Bertalan Karlovszky

130| JENŐ GYÁRFÁS
Youth and Age

131| GÉZA MÉSZÖLY
Szigetvár

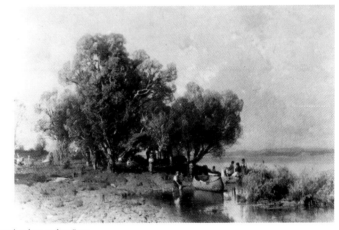

132| GÉZA MÉSZÖLY
Fisherman's Shack by the Lake Balaton

133| GÉZA MÉSZÖLY
Lido

134| LÁSZLÓ PAÁL
Landscape with Cows

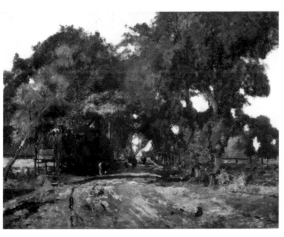

135| LÁSZLÓ PAÁL
Frog Swamp

138| LAJOS DEÁK-ÉBNER
The Road of the Wood Mallows

136| LÁSZLÓ PAÁL
Morning in the Woods

137| LÁSZLÓ PAÁL
Footpath in the Forest of Fontainebleau

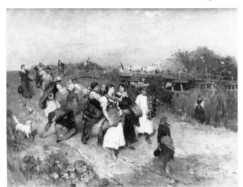

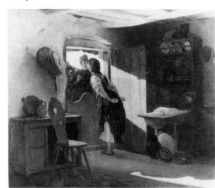

141| PÁL BÖHM
Scene at the Bank of the River Tisza

139| LAJOS DEÁK-ÉBNER
Harvesters Returning Home

140| GYULA AGGHÁZY
Kneading Young Woman

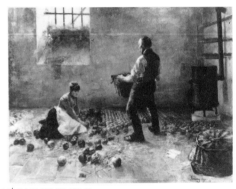

144| LAJOS KARCSAY
Apple Picking

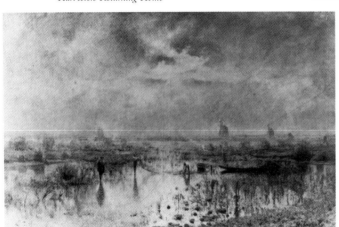

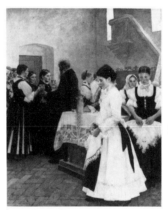

143| ISTVÁN CSÓK
"This Do in Remembrance of Me"
(Holy Communion)

142| LÁSZLÓ MEDNYÁNSZKY
Fishing at the River Tisza

147| KÁROLY FERENCZY
Bird Song

145| ÁRPÁD FESZTY
Golgotha

146| ISTVÁN RÉTI
Bohemian Christmas

148| FRIGYES STROBENTZ
Walking

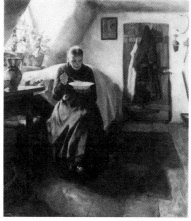

149| TIVADAR ZEMPLÉNYI
The Home of the Poor Woman

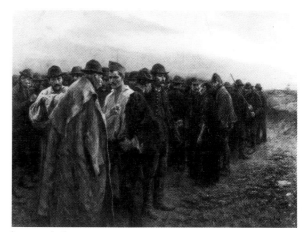

150| IMRE RÉVÉSZ
Panem!

151| LŐRINC DUNAISZKY
Tomb

152| ISTVÁN FERENCZY
Rozália Schodel

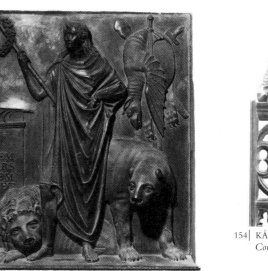

153| ISTVÁN FERENCZY
The Allegory of Power. Detail of the Matthias Memorial

154| KÁROLY ALEXY
Count Starhemberg

155| KÁROLY DOSNYAI
Franz Liszt

156| ANDRÁS SCHOSSEL
Hephaistos

157| LÁSZLÓ DUNAISZKY
*Self-portrait of the
Artist as a Young Man*

158| JÁNOS MARSCHALKÓ
István Széchenyi (Sculpture design)

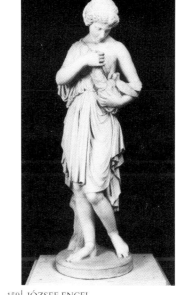

159| JÓZSEF ENGEL
Innocence

160| FERENC DINNERT
Flora

129

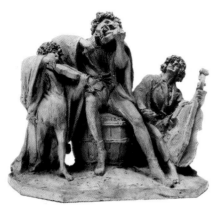

161| MIKLÓS IZSÓ
Gipsy Laokoón

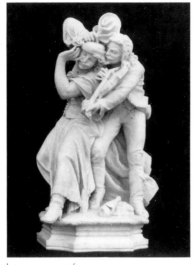

162| ADOLF HUSZÁR
"Play on Gypsy!"

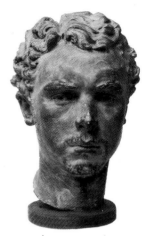

163| ALAJOS STRÓBL
Self-portrait

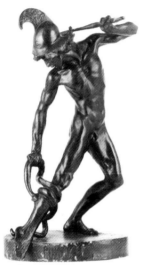

164| GYÖRGY ZALA
Philoktetes

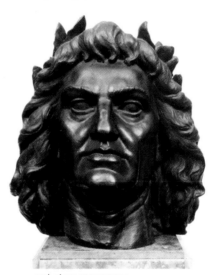

165| JÁNOS FADRUSZ
King Matthias (Head)

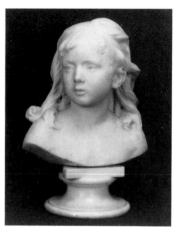

166| ALAJOS STRÓBL
Luischen

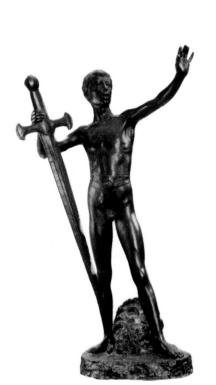

167| EDE KALLÓS
David

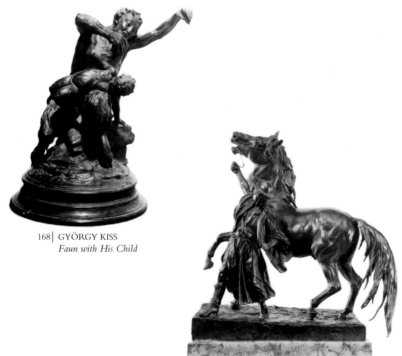

168| GYÖRGY KISS
Faun with His Child

169| GYÖRGY VASTAGH JUNIOR
Horseman

170| JÓZSEF DAMKÓ
Hungarian Farmer

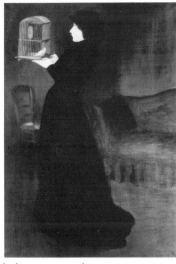

172| JÓZSEF RIPPL-RÓNAI
Christmas

173| JÓZSEF RIPPL-RÓNAI
Self-portrait in Red Hat

174| TIVADAR CSONTVÁRY
KOSZTKA
Self-portrait

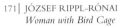

171| JÓZSEF RIPPL-RÓNAI
Woman with Bird Cage

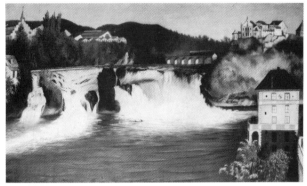

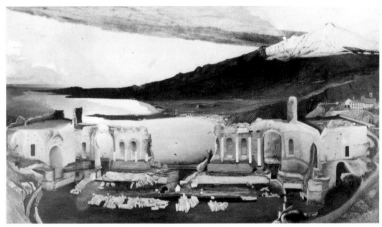

175| TIVADAR CSONTVÁRY KOSZTKA
Waterfall in Schaffhausen

176| TIVADAR CSONTVÁRY KOSZTKA
The Ruins of the Greek Theatre in Taormina

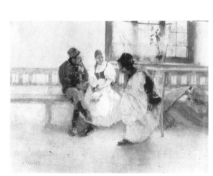

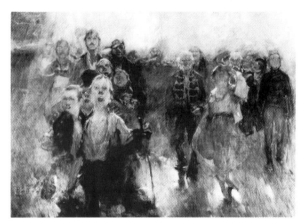

177| SIMON HOLLÓSY
Between Two Fires

178| SIMON HOLLÓSY
The Rákóczi March (Sketch)

179| SIMON HOLLÓSY
Peasant Yard with Cart

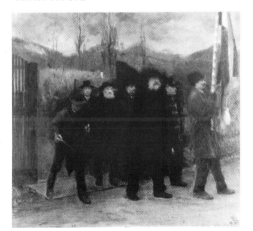

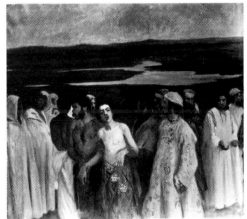

180| ISTVÁN RÉTI
The Funeral of a Homeguard

181| ISTVÁN RÉTI
Old Women

182| KÁROLY FERENCZY
Joseph Sold into Slavery by His Brothers

131

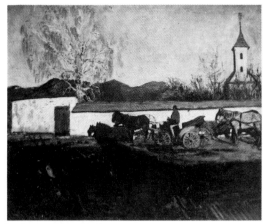

183| KÁROLY FERENCZY
Evening in March

184| KÁROLY FERENCZY
Shooting Arrows

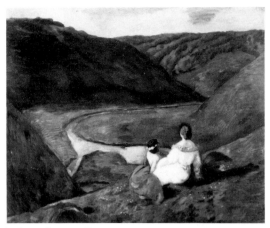

185| BÉLA IVÁNYI GRÜNWALD
Between Crags

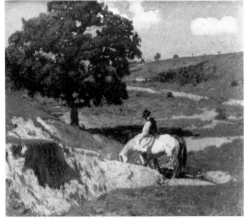

186| BÉLA IVÁNYI GRÜNWALD
Watering

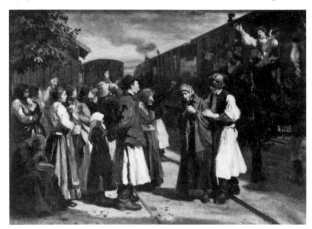

187| JÁNOS THORMA
The First of October

188| BÉLA CZÓBEL
Man Seated

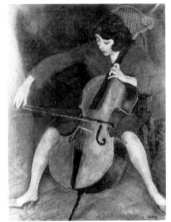

189| RÓBERT BERÉNY
Woman Playing the Cello

190| RÓBERT BERÉNY
Scratching About

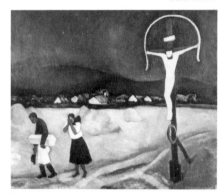

191| DEZSŐ CZIGÁNY
A Child's Funeral

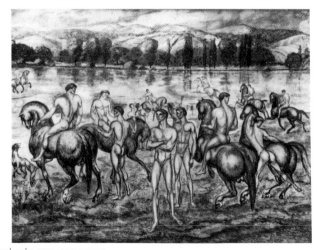

193| KÁROLY KERNSTOK
Nude Boy Leaning Against a Tree

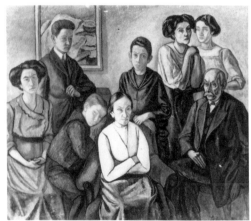

194| BERTALAN PÓR
Family

192| KÁROLY KERNSTOK
Riders on the Shore

195| ÖDÖN MÁRFFY
Forest Path

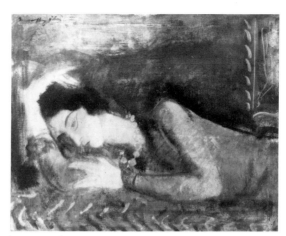

196| ÖDÖN MÁRFFY
Reclining Woman

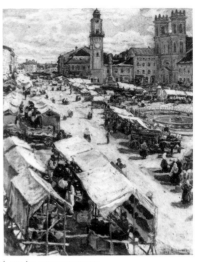

197| IZSÁK PERLMUTTER
Fair in Besztercebánya

198| LÁSZLÓ MEDNYÁNSZKY
Farm

199| LÁSZLÓ MEDNYÁNSZKY
In Serbia

200| ADOLF FÉNYES
A Lad and a Girl

201| JÓZSEF KOSZTA
In the Field

202| JÓZSEF KOSZTA
Girl with Geranium

203| JÁNOS TORNYAI
Share (Sketch)

204| GYULA RUDNAY
Woman Wearing a Lace Kerchief

205| ISTVÁN NAGY
Landscape in Csík

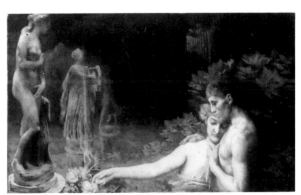

206| JÁNOS VASZARY
Golden Age

133

207│ JÁNOS VASZARY
In the Park

208│ LAJOS GULÁCSY
Magic

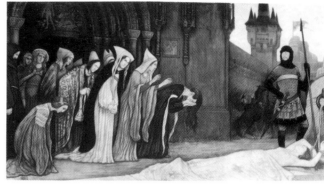

209│ ALADÁR KÖRÖSFŐI-KRIESCH
Klára Zách II

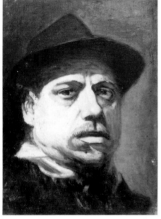

210│ JÁNOS NAGY BALOGH
Self-portrait

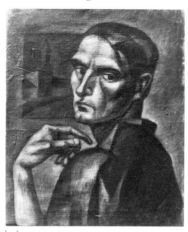

211│ JÁNOS KMETTY
Self-portrait

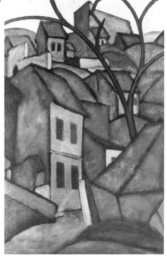

212│ SÁNDOR GALIMBERTI
Tabán

213│ JÓZSEF NEMES LAMPÉRTH
The Catafalque

214│ JÓZSEF NEMES LAMPÉRTH
Female Nude

215│ LAJOS TIHANYI
Lajos Kassák

216│ JÓZSEF EGRY
Dock Workers

217│ JÓZSEF EGRY
St. John the Baptist

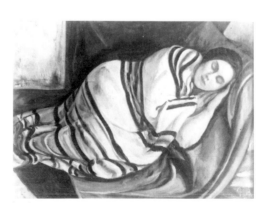

218│ BÉLA UITZ
Reclining Woman

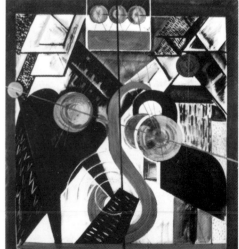

219│ BÉLA UITZ
Icon Analysis

134

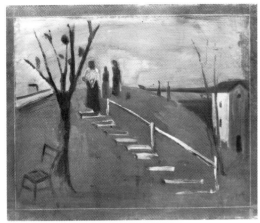

220| ISTVÁN FARKAS
On the Hill

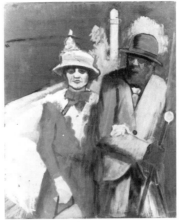

221| ISTVÁN FARKAS
Walking by the Water Tower

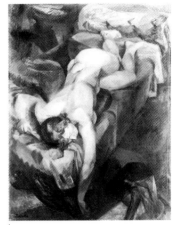

222| IMRE SZOBOTKA
Reclining Nude

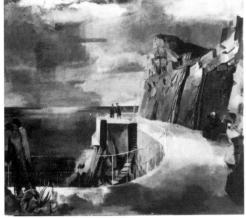

224| AURÉL BERNÁTH
Winter

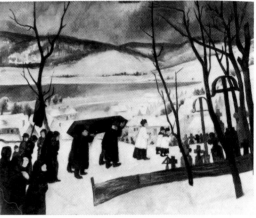

223| AURÉL BERNÁTH
Riviera

225| ISTVÁN SZŐNYI
Funeral in Zebegény

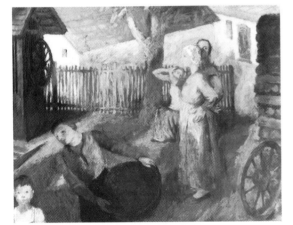

226| ISTVÁN SZŐNYI
In the Yard

227| GYULA DERKOVITS
Still-life with Fish

228| GYULA DERKOVITS
Generations (Three Generations)

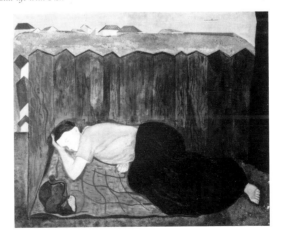

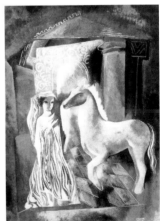

229| GYULA DERKOVITS
By the Railroad

230| ISTVÁN DÉSI HUBER
Break at Noon

231| BÉLA KÁDÁR
Memory

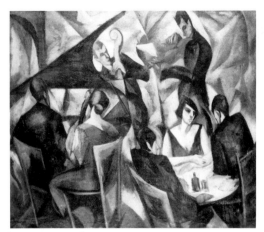

232| ARMAND SCHÖNBERGER
In the Café

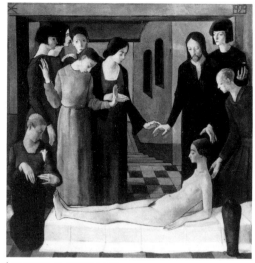

233| ENDRE DOMANOVSZKY
The Resurrection of Jairus's Daughter

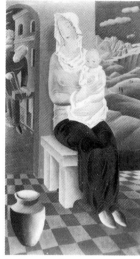

234| PÁL MOLNÁR C.
The Virgin Mary

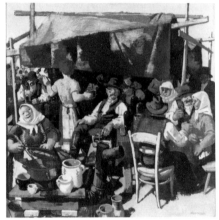

235| VILMOS ABA-NOVÁK
The Kitchen of the Market in Szolnok

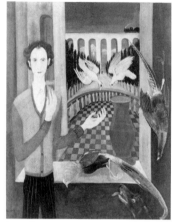

236| JENŐ PAIZS GOEBEL
Golden Age

237| LAJOS VAJDA
Icon with Mask

238| IMRE ÁMOS
The Painter

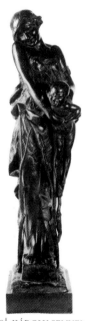

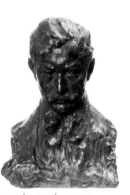

240| MIKLÓS LIGETI
Béla Iványi Grünwald

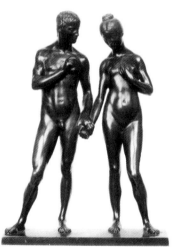

242| MÁRK VEDRES
Boy Playing the Flute

241| MÁRK VEDRES
Human Couple

239| KÁROLY SENYEI
Design of a Well

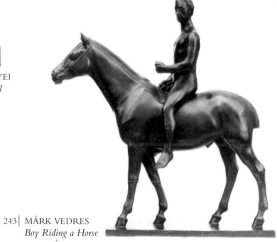

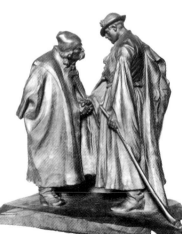

244| JÁNOS PÁSZTOR
Farewell

243| MÁRK VEDRES
Boy Riding a Horse

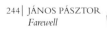

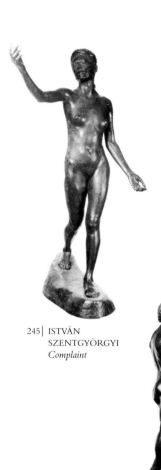

245| ISTVÁN
SZENTGYÖRGYI
Complaint

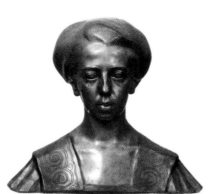

246| ÖDÖN MOIRET
Portrait of a Lady

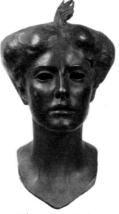

247| ALAJOS STRÓBL
Genius

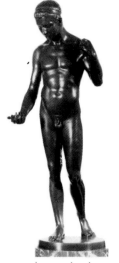

248| KORNÉL SÁMUEL
Narcissus

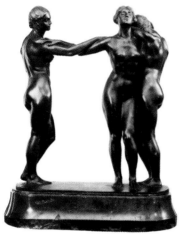

249| ZSIGMOND
KISFALUDI STROBL
Finale

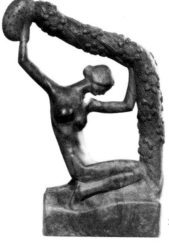

250| ELZA KÖVESHÁZI KALMÁR
Kneeling Girl

251| FÜLÖP Ö. BECK
Reclining Nude

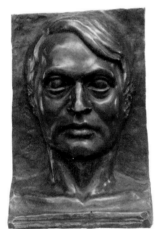

252| FÜLÖP Ö. BECK
Ady

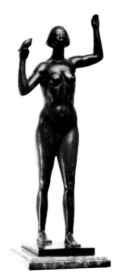

253| VILMOS FÉMES BECK
Woman with Bird

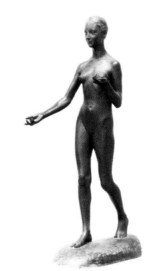

254| IMRE CSIKÁSZ
Young Girl

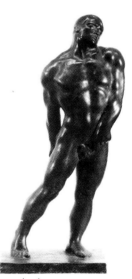

255| GÉZA CSORBA
*The Son of Góg
and Magóg*

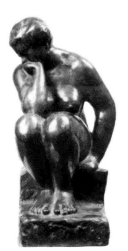

256| FERENC MEDGYESSY
Seated Nude (Fat Thinker)

257| FERENC MEDGYESSY
Young Rider

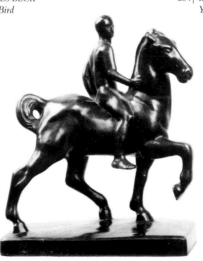

258| FERENC MEDGYESSY
Sowing Seed

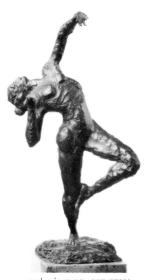

259| SÁNDOR GERGELY
Dancing Woman

260| BÉNI FERENCZY
Young Man

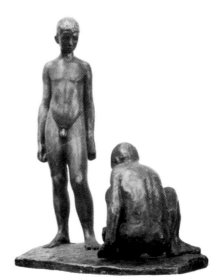

261| BÉNI FERENCZY
Playing Boys

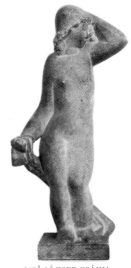

262| JÓZSEF CSÁKY
Female Nude

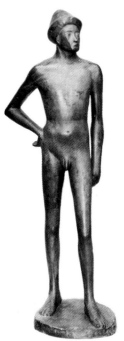

263| DEZSŐ BOKROS BIRMAN
Don Quixote

264| PÁL PÁTZAY
*Portrait of the Painter
Aurél Bernáth*

265| LÁSZLÓ MÉSZÁROS
Self-portrait

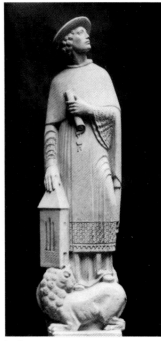

268| BÉLA OHMANN
Portrait of Domokos Kálmáncsehi

266| LÁSZLÓ MÉSZÁROS
Seated Peasant Lad

267| GYÖRGY GOLDMAN
Seated Worker

269| ISTVÁN FERENCZY
Pope Pius VII

270| FERENC SZÁRNOVSZKY
St. Ladislas

271| ANTAL LÓRÁNFI
István Széchenyi

272| ISTVÁN SCHWARTZ
Portrait of a Girl

273| EDE TELCS
Portrait of the Painters Wife

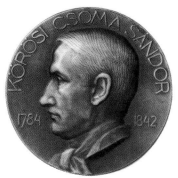
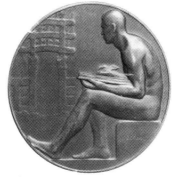

274| LAJOS BERÁN
Sándor Kőrösi Csoma

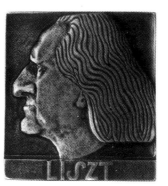

275| FÜLÖP Ö. BECK
Franz Liszt

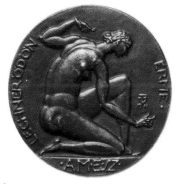

276| VILMOS FÉMES BECK
Ödön Lechner

277| GYULA MURÁNYI
*Shop-window Display
Competition in Budapest*

278| JÓZSEF REMÉNYI
*"For the wonderful invention…"
(The reverse of the
Semmelweis Medal)*

279| FERENC MEDGYESSY
Self-portrait

280| BÉNI FERENCZY
Pál Scharl

281| WALTER MADARASSY
Self-portrait

282| FERENC CSÚCS
King Matthias

283| MIKLÓS BORSOS
Mozart

284| ANDRÁS KISS NAGY
Evening

285| TAMÁS VIGH
*The Medal of the Hungarian
Academy of Sciences*

286| ENIKŐ SZÖLLŐSSY
*The Powers of the
Universe III*

287| TAMÁS ASSZONYI
Outside and Inside

288| RÓBERT CSIKSZENTMIHÁLYI
Winter Night

289| GÁBOR MELEGH
Count Vince Esterházy

290| SÁNDOR KOZINA
Portrait of Ferenc Pulszky

291| KÁROLY MARKÓ THE ELDER
Landscape with Waterfall

292| MIKLÓS SZERELMEY
*Pannonhalma: Interior
of St. Martin's Church*

294| JÓZSEF MARASTONI
John the Hero's Fairwell to Iluska

295| GUSZTÁV KELETI
Gödöllő

293| MIKLÓS BARABÁS
*Portraits of Zsigmond Kemény, Mór Jókai,
Pál Gyulai and Lajos Kövér*

298| GÉZA MÉSZÖLY
The Big Forest in Debrecen

296| JENŐ GYÁRFÁS
The Resurrection of Jairus's Daughter

297| PÁL SZINYEI MERSE
Paganism II. Study

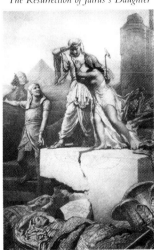

299| MIHÁLY ZICHY
*Imre Madách:
The Tragedy of Man
(Illustration)*

300| MIHÁLY ZICHY
*János Arany:
Inauguration II
(Illustration)*

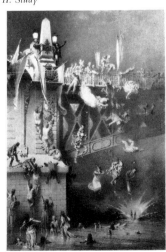

301| JÓZSEF RIPPL-RÓNAI
Village Carnival III

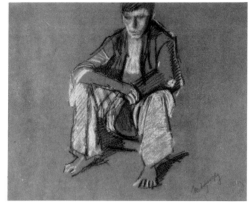

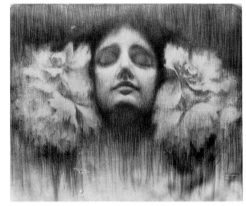

302| KÁROLY FERENCZY
The Seamstress's Song

303| LÁSZLÓ MEDNYÁNSZKY
Sitting Vagabond

304| FERENC HELBING
Dream

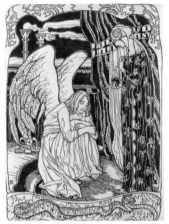

305| ALADÁR KÖRÖSFŐI-KRIESCH
In Memoriam (On the Death of Károly Lotz)

306| RÓBERT BERÉNY
Self-portrait

307| JÁNOS KMETTY
Ascension

308| SÁNDOR BORTNYIK
Portrait of Lajos Kassák

309| VILMOS ABA-NOVÁK
Life

310| LÁSZLÓ MOHOLY-NAGY
Landscape (Tabán)

311| JÁNOS MÁTTIS TEUTSCH
Landscape in Blue and Red

312| FARKAS MOLNÁR
Fiorentia

313| CSABA VILMOS PERLROTT
Lőcse

314| ANDOR WEININGER
Mechanical Ballet — Abstract Performance

315| KÁROLY PATKÓ
Nymphs

316| GYULA DERKOVITS
Fleeing Women

317| LAJOS TIHANYI
Zenith (Portrait of Branko Ve Poljanski)

318| NÁNDOR LAJOS VARGA
Adam's Funeral

319| HUGÓ SCHEIBER
Crowd

320| NOÉMI FERENCZY
Woman with Red Flower

321| ISTVÁN SZŐNYI
Ox-cart by the River Danube

322| GYÖRGY BUDAY
Navvies

323| DEZSŐ KORNISS
Szentendre Motif

324| BÉNI FERENCZY
Woman with the Statue of a Boy

325| LAJOS VAJDA
Bird and Skull

326| IMRE ÁMOS
War — Knife

327| JENŐ BARCSAY
Man and Drapery I

328| ÁKOS TOLNAY
The Ancient Castle of Buda, Turkish Rule in Hungary

329| JÁNOS VASZARY
National Salon

330| GÉZA FARAGÓ
Advertisement for Törley Champagne

331| MIHÁLY BIRÓ
Make Donations for Mihály Székely's Airplane!

332| MÁRTON TUSZKAY
Oh Joseph, Oh Joseph!... The Újság (Newspaper ad)

333| RÓBERT BERÉNY—SÁNDOR BORTNYIK
Niagara Carbon Paper

334| TIHAMÉR CSEMICZKY
Tungsram

335| PÁL GÁBOR
Choose — War or Peace — The Social Democratic Party

336| LÁSZLÓ LAKNER
Brussels June 2–5, 1972

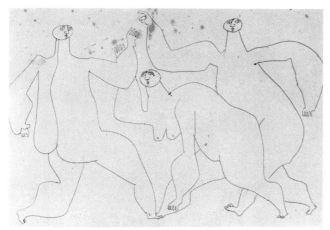

337 | GYÖRGY KONECSNI
Nudes I (Variations on a Theme)

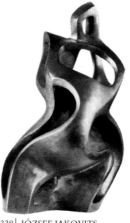

338 | JÓZSEF JAKOVITS
Reticulated Nude

339 | FERENC MARTYN
Composition

340 | MIKLÓS BORSOS
Female Head

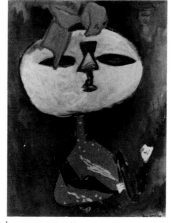

341 | MARGIT ANNA
Girl with Red Ribbon

342 | TIBOR VILT
Cage

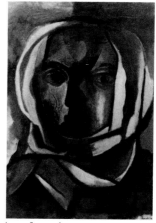

343 | JENŐ GADÁNYI
Thinker

344 | LAJOS SZALAY
Sacred Freedom

345 | GÉZA BENE
Landscape in Békásmegyer

346 | ENDRE BÁLINT
"I will have you know my mind has split in two"

347 | DEZSŐ KORNISS
*Plastic Calligraphy
(Red)*

348 | ÁKOS SZABÓ
Farewell

349 | BÉLA VESZELSZKY
Landscape (Detail)

145

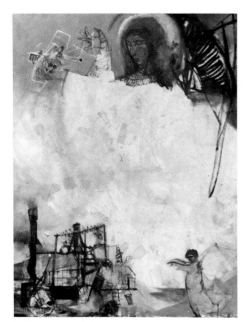

350│ BÉLA KONDOR
The Genius of Aviation (The Symbol of Flying)

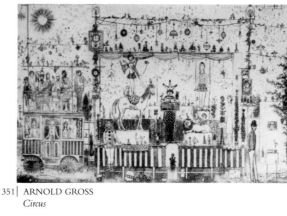

351│ ARNOLD GROSS
Circus

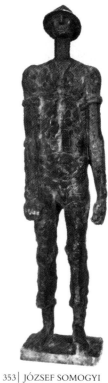

353│ JÓZSEF SOMOGYI
*In Memoriam
János Szántó Kovács*

352│ MIHÁLY SCHÉNER
Scribble

354│ VLADIMIR SZABÓ
Awakening

355│ SÁNDOR CSUTOROS
Hanging Form I–II–III

356│ ENDRE TÓT
Vertical Picture II

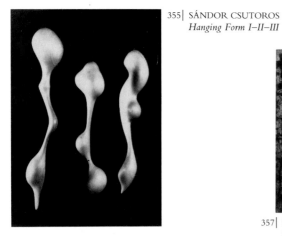

357│ LILI ORSZÁG
In Memoriam Saeculorum

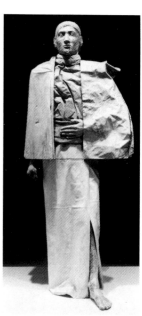

361│ GYÖRGY JOVÁNOVICS
Man

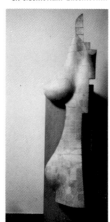

358│ TAMÁS HENCZE
Dynamic Structure

359│ ISTVÁN BENCSIK
Idol II

360│ GYULA KONKOLY
Softened Egg

146

362| IMRE VARGA
Forced March

363| REZSŐ BERCZELLER
Man and Engine

364| LÁSZLÓ PAIZS
*The Heir and Heiress to the Throne
Have Been Murdered*

365| ANDRÁS BARANYAI
Detail 1 6 70

366| GÉZA SAMU
Stag-trough

367| ERZSÉBET VASZKÓ
Fear

368| PÉTER TÜRK
*Form Arrangements with Algorhythmical
Rhythms II*

369| JENŐ KERÉNYI
Ten Commandments

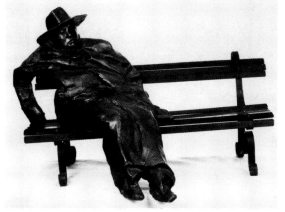

370| MIKLÓS MELOCCO
Ady — Leading the Dead

371| DÓRA MAURER
I'd Rather Be a Bird

372| ÁDÁM KÉRI
In Memoriam Petőfi

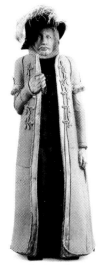

373| PÁL KŐ
Kossuth

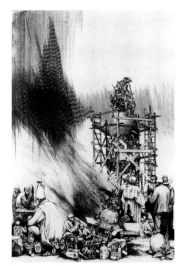

374| CSABA RÉKASSY
Astronauts

375| LIVIUSZ GYULAI
Champion

376| KÁROLY HALÁSZ
Private Transmission — Irrational Television I

147

377| IMRE KOCSIS
Outskirts

378| GÁBOR PÁSZTOR
Chess-story

379| LÁSZLÓ MÉHES
Hommage à Yves Klein

380| GYULA PAUER
Maya

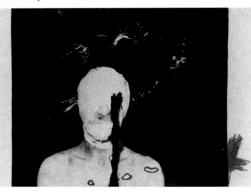

382| TIBOR HAJAS
Untitled I

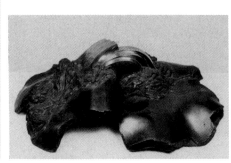

383| ÁDÁM FARKAS
The Mementos of the Future II

381| SÁNDOR PINCZEHELYI
Hungarian Bread

384| PÉTER ÚJHÁZI
Circus

385| KÁROLY SCHMAL
Phases

386| FERENC BANGA
In the Box

387| RÓBERT SWIERKIEWICZ
Weather Report 5/9

388| MIKLÓS ERDÉLY
√-1

389| KÁROLY KLIMÓ
The Burning Wheel

390| ZSIGMOND KÁROLYI
Untitled V

391| ATTILA MATA
Desire

392| MÁRIA LUGOSSY
Tektit II

393| ÁRPÁD SZABADOS
Ladyslit-ear

394| TIBOR CSIKY
Testament

395| VALÉRIA SASS
Balance I

396| JÁNOS SUGÁR
Squash

397| GYÖRGY GALÁNTAI
Half-pace

398| PÉTER GÉMES
Light-bars

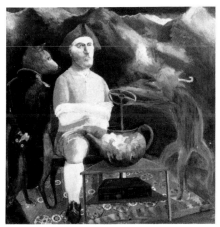

399| GÁBOR ROSKÓ
Let's See What's Happening in the Big Wide World

400| ANDRÁS WAHORN
Running Boy with Woman

149

CATALOGUE
OF REPRODUCED WORKS

The following catalogue contains a full alphabetical listing of the reproductions found in this book. In case of graphic art, the work is on paper unless otherwise indicated. When the size is given, the first is always the height, the second the width. In the case of statues, only the height is indicated; in case of medals and coins, the diametre. Under the "Signed" entry, only those texts are provided that are most relevant, such as the artist's signature, place and date, and the dedication, if any. After the inventory number, the number found within parentheses refers to the plate number. The colour plates are marked with an asterisk (★); those without the asterisk are reproduced in black and white.

ABA-NOVÁK, Vilmos
(1894–1941)
Life. 1919
Charcoal, aquarelle,
38.5 × 63 cm
Unsigned
Inv. No.: F 75.189 (309)

ABA-NOVÁK, Vilmos
The Kitchen of the Market in Szolnok. c. 1934
Tempera on wood,
60.5 × 60 cm
Signed bottom right:
ABA-NOVÁK
Inv. No.: 8104 (235)

AGGHÁZY, Gyula
(1850–1919)
Kneading Young Woman. 1878
Oil on canvas, 44 × 53 cm
Signed bottom left: Aggházy
Gyula 1878
Inv. No.: FK 4185 (140)

ALEXY, Károly
(1823–1880)
Count Starhemberg. 1844
Bronze, 48.5 cm
Signed: C. Alex, top:
Wien 1844
Inv. No.: 4924 (154)

ALEXY, Károly
King Matthias. 1844
Bronze, 57 cm
Unsigned
Inv. No.: 56.75-N (68★)

ALTORJAI, Sándor
(1933–1979)
Let me Sink Up! 1967
Collage, mixed technique on wood, 305 × 342 cm
Unsigned
Inv. No.: MM 82.354 (137★)

ÁMOS, Imre
(1907–1944)
The Painter. 1939
Oil on canvas, 102 × 81 cm
Signed bottom left: Ámos
1939
Inv. No.: 67.218-T (238)

ÁMOS, Imre
War — Knife. 1943
Aquarelle, gouache, ink,
59 × 46 cm
Signed bottom right: Ámos I.
1943 Karácsony.
Inv. No.: F 67.296 (326)

ÁMOS, Imre
Couple in Front of a Wire Fence.
1944
India ink, ink, aquarelle,
tempera, 25.6 × 25.1 cm
Unsigned
Inv. No.: F 61.109 (129★)

ANNA, Margit
(1913–1991)
Girl with Red Ribbon. 1948
Oil on cardboard, 45 × 35 cm
Signed bottom right:
Anna Margit 948
Inv. No.: 75.71 T (341)

ASSZONYI, Tamás
(1942–)
Outside and Inside. 1970
Bronze, 6 cm
Signed bottom right: AT
Inv. No.: 85.5-P (287)

BAK, Imre
(1939–)
Blue Frame. 1968
Oil on canvas, 12 × 22.2 cm
Unsigned
Inv. No.: MM 87.65 (140★)

BÁLINT, Endre
(1914–1986)
"I will have you know my mind has split in two". 1958
Photo-montage, 65 × 50 cm
Signed top left: Bálint Paris 58
Inv. No.: MM 87.198 (346)

BÁLINT, Endre
Grotesque Funeral. 1963
Oil on canvas, 92 × 66 cm
Unsigned
Inv. No.: MM 82.131 (132★)

BANGA, Ferenc
(1947–)
In the Box. 1983
Copper-plate engraving, paper,
16.5 × 12 cm
Signed on the margin, bottom right: 1983, BF
Inv. No.: MM 86.176 (386)

BARABÁS, Miklós
(1810–1898)
Vesuvius Seen from the Island of Capri. 1835
Aquarelle, 16.1 × 24.3 cm
Signed bottom left: Barabás
1835.
Inv. No.: 1903–88 (112★)

BARABÁS, Miklós
Portrait of a Lady. 1840
Oil on canvas, 53 × 42 cm
Unsigned
Inv. No.: 7566 (72)

BARABÁS, Miklós
Pigeon-post. 1843
Oil on canvas, 106 × 84 cm
Signed top left: Barabás 1843
Inv. No.: FK 155 (71)

BARABAS, Miklós
Romanian Family off to the Fair.
1843–1844
Oil on canvas, 138 × 109 cm
Signed bottom right: M. vi
Barabás Miklós 1843/4 Pesten
Inv. No.: 2753 (34★)

BARABÁS, Miklós
Portraits of Zsigmond Kemény, Mór Jókai, Pál Gyulai, and Lajos Kövér. 1855
Lithograph, 31 × 23.8 cm
Signed bottom centre:
Barabás/855
Inv. No.: 1935–4376 (293)

BARABÁS, Miklós
Portrait of the Wife of István Bittó. 1874
Oil on canvas, 84 × 66 cm
Signed left: Barabás M. 1874
Inv. No.: FK 1814 (73)

BARANYAI, András
(1938–)
Detail 1 6 70. 1970
Lithograph, diam: 50 cm
Signed on the margin bottom right: Baranyai András
Inv. No.: MM 89.172 (365)

BARCSAY, Jenő
(1900–1988)
Rolling Hills. 1934
Oil on canvas, 80 × 90 cm
Signed bottom right: Barcsay
Inv. No.: 58.2-T (98★)

BARCSAY, Jenő
Anatomical Study. 1951
Pencil; 29 × 21.5 cm
Signed bottom right: Barcsay,
1951
Inv. No.: 1955-5554 (130★)

BARCSAY, Jenő
Man and Drapery I. 1954
Pencil, 29 × 37 cm
Signed bottom right: Barcsay
1954.
Inv. No.: 1955–5555 (327)

BECK, Ö. Fülöp
(1873–1945)
Franz Liszt. 1911
Bronze, chased, 6.3 × 6 cm
Unsigned
Inv. No.: 55.58-P (275)

BECK, Ö. Fülöp
Reclining Nude. 1912
Grey granite relief, 31 × 59.5 cm
Unsigned
Inv. No.: 56.100–N (251)

BECK, Ö. Fülöp
Aphrodite. 1914
Painted plaster, 176 cm
Unsigned
Inv. No.: N 58.1.137 (101★)

BECK, Ö. Fülöp
Ady. 1920–1925
Bronze relief, 50 cm
Unsigned
Inv. No.: 56.99–N (252)

BECK, Ö. Fülöp
Miklós Ybl. 1924
Bronze, 7.5 cm
Signed bottom right: BÖF
Inv. No.: 56.1363-P (107★)

BENCSIK, István
(1931–)
Idol II. 1968
Wood on wooden stand, 170 cm
Unsigned
Inv. No.: MM 81.184 (359)

BENCZÚR, Gyula
(1844–1920)
László Hunyadi's Farewell. 1866
Oil on canvas, 147 × 121 cm
Signed bottom right: Benczúr
Gyula 1866
Inv. No.: 2773 (106)

BENCZÚR, Gyula
Louis XV and Madame Dubarry. 1874
Oil on canvas, 79 × 65 cm
Signed bottom right: Benczúr
Gyula
Inv. No.: 5575 (107)

BENCZÚR, Gyula
The Baptism of Vajk. 1875
Oil on canvas, 360 × 245 cm
Signed bottom right: Benczúr
Gyula München 1875
Inv. No.: 2798 (56★)

BENCZÚR, Gyula
Woman Reading in the Forest.
1875
Oil on canvas, 87 × 116 cm
Signed bottom right: Benczúr
Gyula München 1875
Inv. No.: 61.121 T (108)

BENCZÚR, Gyula
Among Holyhock. 1890
Oil on canvas, 150.5 × 101 cm
Signed bottom right: Benczúr
Gyula, Budapest 1890
Inv. No.: 51545 (109)

BENCZÚR, Gyula
The Recapture of Buda Castle in 1686. 1896
Oil on canvas, 356 × 705 cm
Signed bottom left: Benczúr
Gyula 1896 Budapest
Inv. No.: FK 2867 (57★)

BENCZÚR, Gyula
Matthias and Holubar. c. 1900
Oil on canvas, 60.5 × 81.5 cm
Signed bottom right:
Benczúr Gy.
Inv. No.: FK 4349 (110)

BENE, Géza
(1900–1960)
Landscape in Békásmegyer. 1957
India ink, aquarelle, oil on carboard, 49.5 × 57.5 cm
Signed bottom left: Bene Géza
Inv. No.: 70.112 T (345)

BERÁN, Lajos
(1882–1943)
Sándor Kőrösi Csoma. 1909
Bronze, chased, 5.9 cm
Signed bottom right: BERÁN
L.
Inv. No.: 55.129–P (274)

BERCZELLER, Rezső
(1912–1992)
Man and Engine. c. 1968
Aluminum,
71.5 × 53.5 × 29 cm
Unsigned
Inv. No.: MM 88.141 (363)

BERÉNY, Róbert
(1887–1953)
Still-life with Jug. 1909
Oil on canvas, 50 × 63 cm
Unsigned
Inv. No.: L.U. 58.682 (77★)

BERÉNY, Róbert
Self-portrait. 1912
Chalk, 64 × 49 cm
Signed bottom right: Bpest
912. szept. 3O Berény
Inv. No.: F 60.104 (306)

BERÉNY, Róbert
Woman Playing the Cello. 1928
Oil on canvas, 135 × 102 cm
Signed bottom right: Berény
Inv. No.: 63.70 T (189)

BERÉNY, Róbert
Scratching About. 1933–1934
Oil on canvas, 80 × 100 cm
Signed top left: Berény
Inv. No.: FK 10.478 (190)

BERÉNY, Róbert —
BORTNYIK, Sándor
Niagara Carbon Paper. c. 1930
Offset, 35 × 24.5 cm
Signed top right: BERÉNY —
BORTNYIK; bottom left:
RIGLER R.T. BUDAPEST
Inv. No.: X.Y. 79.125 (333)

BERNÁTH, Aurél
(1895–1982)
Riviera. 1926–1927
Oil on canvas, 130 × 150 cm
Signed bottom left: BA
Inv. No.: 6370 (223)

BERNÁTH, Aurél
Morning. 1927
Oil on canvas, 126 × 146 cm
Signed bottom left: BA 1927
Inv. No.: FK 3401 (95★)

BERNÁTH, Aurél
Winter. 1929
Pastel on cardboard,
74 × 100 cm
Signed bottom left: BA
Inv. No.: 63.80 T (224)

BIHARI, Sándor
(1855–1906)
Programme Speech. 1891
Oil on canvas, 75 × 127.3 cm
Signed bottom right: Bihari
Sándor
Inv. No.: 56.14 (62★)

BIRKÁS, Ákos
(1941–)
Head 14. 1986
Oil on canvas, 299 × 140 cm
Unsigned
Inv. No.: MM 88.79 (148★)

BÍRÓ, Mihály
(1886–1948)
*Make Donations for Mihály
Székely's Airplane!* c. 1918
Offset, 95 × 63 cm
Signed left side: Biró; right
side: MUINT. LENGYEL
LIPÓT BUDAPEST
Inv. No.: X.Y. 179 (331)

BOEHM, József Dániel
(1794–1865)
Annual Meeting in Temesvár.
1843
Bronze, chased, 52 cm
Signed bottom right: I.D.
BOEHM F.
Inv. No.: 85.72–P (106★)

BOGDÁNY, Jakab
(c. 1660–1724)
Still-life with Birds. 1710s
Oil on canvas, 98 × 128.5 cm
Signed: J. Bogdani
Inv. No.: 3681 (21★)

BOKROS BIRMAN, Dezső
(1889–1965)
Ady. 1924
Bronze, 32.5 cm
Signed: Bokros Birman 924
Inv. No.: 56.133–N (104★)

BOKROS BIRMAN, Dezső
Don Quixote. 1929
Bronze, 117 cm
Signed: Bokros 1929
Inv. No.: 56.131–N (263)

BORSOS, József
(1821–1883)
Girls after the Ball. 1850
Oil on wood, 121.5 × 125 cm
Signed bottom right:
Borsos J. 850
Inv. No.: 1394 (37★)

BORSOS, József
The Dissatisfied Painter. 1852
Oil on wood, 97.5 × 81.8 cm
Signed bottom right:
Borsos J. 852
Inv. No.: 3188 (81)

BORSOS, József
The Widow. 1853
Oil on canvas, 98.5 × 82 cm
Signed bottom right: Borsos
József 1853
Inv. No.: 4622 (82)

BORSOS, Miklós
(1906–1990)
Female Head. 1948
Height: 45 cm
Signed: BM 1948
Inv. No.: 76.27–N (340)

BORSOS, Miklós
Mozart. 1956
Bronze, 12.5 cm
Signed bottom right:
BM 1956
Inv. No.: 77.18–P (283)

BORTNYIK, Sándor
(1893–1976)
Portrait of Lajos Kassák. 1919
Lino-cut, 15 × 11 mm
Unsigned, indication bottom
right: Bortnyik 1919
Inv. No.: 1925–1679 (308)

BORTNYIK, Sándor
Geometrical Composition. 1922
Aquarelle, 36.3 × 25.5 cm
Signed top right in the
picture: 1922; bottom left:
Bortnyik
Inv. No.: F 59.82 (125★)

BORTNYIK, Sándor
The New Eve. 1924
Oil on canvas, 49 × 39 cm
Signed top left: BORTNYIK,
Weimar 1924
Inv. No.: 64.86 T (91★)

BÖHM, Pál
(1839–1905)
*Scene at the Bank of the River
Tisza.* c. 1873
Oil on canvas, 38 × 46.7 cm
Signed bottom left: Böhm Pál
Inv. No.: 4928 (141)

BRAUN, Ádám
(1748–after 1827)
*The Angel Makes Habakuk
Bring Food to Daniel into the
Lion's Den.* 1771
Oil on canvas, 66.5 × 86 cm
Unsigned
Inv. No.: 74.8 M (54)

BROCKY, Károly
(1807–1855)
Mother and Child. Late 1840s
Oil on canvas, 61.3 × 55.5 cm
Unsigned
Inv. No.: 2103 (68)

BROCKY, Károly
*Young Woman Watering a
Plant by the Window.* c. 1847
Aquarelle, 12 × 8.1 cm
Unsigned
Inv. No.: 1914–227 (113★)

BRODSZKY, Sándor
(1819–1901)
View of Lake Balaton. 1868
Oil on canvas, 101.5 × 161.2 cm
Signed bottom right: Brodszky
S. 868
Inv. No.: FK 4038 (103)

BUDAY, György
(1907–1990)
Navvies. 1934
Woodcut, 23 × 20 cm
Signed bottom right: Buday
György
Inv. No.: 1935-2503 (322)

BUKTA, Imre
(1952–)
Free Spraying at Dawn. 1985
Wood, metal, paper, plastic,
painted installation,
240 × 400 × 80 cm
Unsigned
Inv. No.: MM 91.24 (146★)

CANZI, Ágost
(1808–1866)
Portrait of a Woman. 1845
Oil on canvas, 72 × 59.5 cm
Signed bottom rights:
A. Canzi 1845
Inv. No.: 9744 (74)

CANZI, Ágost
Grape Harvest Near Vác. 1859
Oil on canvas, 117 × 175 cm
Signed bottom right: Canzi
Ágost, Pest, 1859
Inv. No.: 2709 (75)

CSÁKY, József
(1888–1971)
Female Nude. c. 1926
Stone, 83.5 cm
Signed bottom right: Csáky
Inv. No.: 61.1-N (262)

CSEMICZKY, Tihamér
(1904–1960)
Tungsram. 1934
Offset, 82 × 57 cm
Unsigned
Inv. No.: X.Y. 62.26 (334)

CSERNUS, Tibor
(1927–)
Model Makers. 1963
Oil on canvas, 140 × 182 cm
Unsigned
Inv. No.: MM 83.299 (136★)

CSIKÁSZ, Imre
(1884–1914)
Young Girl. 1912
Bronze, 165 cm
Signed bottom left on the
back: Csikász Imre 1912
Inv. No.: 4118 (254)

**CSIKSZENTMIHÁLYI,
Róbert**
(1940–)
Winter Night. 1976
Bronze, cast, 85 cm
Signed bottom left: CsR
Inv. No.: 82.22-P (288)

CSIKY, Tibor
(1932–1989)
Testament. 1988
Chromium steel, wood,
painted, 67 × 270 × 220 cm
Unsigned
Inv. No.: MM 88.64 (394)

CSÓK, István
(1865–1961)
*"This Do in Remlembrance of
Me" (Holy Communion).* 1890
Oil on canvas, 136.5 × 111 cm
Signed bottom left: Csók 1890
Inv. No.: 1653 (143)

CSÓK, István
Amalfi. 1937
Oil on canvas, 64 × 74.5 cm
Signed bottom left: CSÓK I.
B.p. 1937
Inv. No.: 50.574 (94★)

**CSONTVÁRY KOSZTKA,
Tivadar**
(1853–1919)
Self-portrait. 1896–1902
Oil on canvas, 67 × 39.5 cm
Unsigned
Inv. No.: 7572 (174)

**CSONTVÁRY KOSZTKA,
Tivadar**
Waterfall in Schaffhausen. 1903
Oil on canvas, 129 × 228 cm
Unsigned (175)

**CSONTVÁRY KOSZTKA,
Tivadar**
*The Ruins of the Greek Theatre
in Taormina.* 1904–1905
Oil on canvas, 302 × 570 cm
Unsigned (176)

**CSONTVÁRY KOSZTKA,
Tivadar**
*Pilgrimage to the Cedars of
Lebanon.* 1907
Oil on canvas, 200 × 205 cm
Unsigned (78★)

CSORBA, Géza
(1892–1974)
The Son of Góg and Magóg.
1913
Bronze, 44 cm
Signed bottom on the marble
stand: Csorba 1913
Inv. No.: 75.90 N (255)

CSÚCS, Ferenc
(1905–)
King Matthias. 1940
Bronze, 106 cm
Signed right side centre:
CSVCS 1940; bottom right: Cs
Inv. No.: 56.988–P (282)

CSUTOROS, Sándor
(1942–1989)
Hanging Form I–II–III. 1966
Lime-wood, 33 × 58,
25 × 65, 22 × 76 cm
Unsigned
Inv. No.: MM 89.70 (355)

CZIGÁNY, Dezső
(1883–1937)
A Child's Funeral. 1910
Oil on cardboard,
60.5 × 77 cm
Signed bottom right: Czigány
Inv. No.: L.U. 58.28 (191)

CZÓBEL, Béla
(1883–1976)
Seated Man. 1906
Oil on canvas, 170 × 80 cm
Signed bottom left:
Czóbel 906
Inv. No.: 55752 (188)

CZÓBEL, Béla
In the Studio. 1922
Oil on canvas, 93.5 × 74 cm
Unsigned
Inv. No.: FK 8742 (93★)

DALMATA, Giovanni
(?–after 1509)
*Fragment of an Altar. From
Diósgyőr.* c. 1490
Marble, 79 × 123 cm
Unsigned
Inv. No.: 55.971 (10★)

DAMKÓ, József
(1872–1955)
Hungarian Farmer. c. 1902
Terracotta, 36.3 cm
Signed: Damkó
Inv. No.: 56.195–N (170)

DEÁK-ÉBNER, Lajos
(1850–1934)
Boat Warpers. 1878
Oil on canvas, 132 × 98 cm
Signed bottom left: Louis
Ébner
Inv. No.: 63.131 T (58★)

DEÁK-ÉBNER, Lajos
The Road of the Wood Mallows.
c. 1880
Oil on canvas, 37 × 77 cm
Signed bottom left: Deák
Ébner L.
Inv. No.: FK 9697 (138)

DEÁK-ÉBNER, Lajos
Harvesters Returning Home. 1881
Oil on canvas, 94.5 × 131 cm
Signed bottom right: Louis
Ébner
Inv. No.: 5202 (139)

DEIM, Pál
(1932–)
Man and House. 1969
Wood, painted, 160 × 200 cm
Signed bottom left: Deim 1969
Inv. No.: MM 80-285 (141★)

DERKOVITS, Gyula
(1894–1934)
Fleeing Women. 1925
Copper-plate engraving,
19.7 × 23.3 cm
Unsigned
Inv. No.: 1928–1966 (316)

DERKOVITS, Gyula
Still-life with Fish. 1928
Mixed technic, cardboard,
42 × 57.5 cm
Signed bottom left: Derkovits
Gy. 928.
Inv. No.: 56.246 T (227)

DERKOVITS, Gyula
Injunction. 1930
Oil, tempera on canvas,
61 × 51 cm
Signed on the paper by the
window: 1930 DERKOVITS
GYULA
Inv. No.: 57.48 T (92★)

DERKOVITS, Gyula
Generations (Three Generations).
1932
Mixed technique on canvas,
103 × 77.8 cm
Signed top right: Derkovits Gy.
Inv. No.: 6809 (228)

DERKOVITS, Gyula
By the Railroad. 1932
Oil, tempera on canvas,
62 × 101 cm
Signed bottom left:
Derkovits Gy.
Inv. No.: 6244　(229)

DÉSI HUBER, István
(1895–1944)
Break at Noon. 1933–1934
Tempera on canvas, 80 × 100 cm
Signed top left: Dési Huber
Inv. No.: 8681　(230)

DINNERT, Ferenc
(?–1904)
Flora. 1860
Wood, 159 cm
Signed: Dinnert
Inv. No.: 69.6–N　(160)

DOMANOVSZKY, Endre
(1907–1974)
*The Resurrection of Jarius's
Daughter.* 1929
Oil on canvas, 15 × 15 cm
Signed top left: DE;
top right: 1929
Inv. No.: 68.46 T　(233)

DONÁT, János
(1744–1830)
Woman Playing the Lute. 1811
Oil on canvas, 38 × 28 cm
Unsigned
Inv. No.: FK 3847　(31★)

DONNER, Georg Raphael
(1693–1741)
Adoring Angel. 1733–1735
Lead, 200 cm
Unsigned
Inv. No.: 76.4 M　(23★)

**DONNER, Georg
Raphael's Workshop**
Portrait of Emperor Charles VI. c.
1740
Marble relief, 43 cm
Signed bottom left: RD
Inv. No.: 85.2 M　(45)

DORFMEISTER, István
(1729–1797)
*Béla III Founding the Cistercian
Monastery at Szentgotthárd in
1183.* 1795–1796
Oil on canvas, 344 × 227 cm
Unsigned
Inv. No.: 55.389　(30★)

DÓSA, Géza
(1846–1871)
*Gábor Bethlen Surrounded by
His Advisors.* 1869
Oil on canvas, 72 × 100 cm
Unsigned
Inv. No.: 2710　(111)

DÓSA, Géza
Playing the Piano. c. 1870
Oil on canvas, 29 × 21 cm
Unsigned
Inv. No.: FK 5653　(52★)

DOSNYAI, Károly
(1814–after 1850)
Franz Liszt. 1848
Marble, 31.5 cm
Signed: C. Dosnay,
Weimar 1848
Inv. No.: 4150　(155)

DUNAISZKY, László
(1822–1904)
*Self-portrait of the Artist as a
Young Man.* After 1853
Plaster, 24 cm
Signed: DUNAISZKY
Inv. No.: 7901　(157)

DUNAISZKY, Lőrinc
(1784–1837)
Tomb. 1833
Bronze, 59 × 48.5 cm
Signed: L.Dunaiszky cs. 1833
Inv. No.: 71.24–N　(151)

EGRY, József
(1883–1951)
Dock Workers. c. 1912
Oil on cardboard, 57 × 100 cm
Signed bottom left: Egry József
Inv. No.: 59.93 T　(216)

EGRY, József
St. John the Baptist. 1930
Oil, tempera on cardboard,
100 × 125 cm
Signed bottom right: Egry
József Badacsony 930
Inv. No.: 64.54 T　(217)

EGRY, József
Echo. 1936
Oil on canvas, 116 × 125.5 cm
Signed bottom left: Egry
József Badacsony
Inv. No.: 57.41 T　(97★)

ENGEL, József
(1815–1901)
Innocence. 1858
Marble, 131 cm
Unsigned
Inv. No.: 2326　(159)

ERDÉLY, Miklós
(1928–1985)
√-1. 1985
Oil, colour pencil on canvas,
147 × 195 cm
Unsigned
Inv. No.: MM 86.123　(388)

ÉRMEZEI, Zoltán
(1955–1991)
Dual Corpus. 1990
Plaster, 200 cm
Unsigned
Inv. No.: MM 91.138　(149★)

FADRUSZ, János
(1858–1903)
King Matthias (Head). c. 1890
Bronze, 76 cm
Unsigned
Inv. No.: 53.537　(165)

FADRUSZ, János
Toldi Wrestling with the Wolves.
1901
Bronze, 82 cm
Signed: Fadrusz János
Inv. No.: 56.228–N　(72★)

FARAGÓ, Géza
(1877–1928)
*Advertisement for Törley
Champagne.* 1909
Offset, 125 × 95 cm
Signed bottom right: Faragó
Géza; bottom left: Klösz
BUDAPEST
Inv. No.: X.Y. 58.121　(330)

FARKAS, Ádám
(1944–)
Mementoes of the Future. 1980
Bronze, 54 × 38 × 17 cm
Unsigned
Inv. No.: MM 83.95　(383)

FARKAS, István
(1887–1944/45)
On the Hill. 1931
Tempera, wood, 65 × 81 cm
Signed bottom right: Farkas
1931
Inv. No.: 8609　(220)

FARKAS, István
Self-portrait. 1932
Aquarelle, charcoal, 53 × 39 cm
Unsigned
Inv. No.: 60.133　(127★)

FARKAS, István
Walking by the Water Tower.
1934
Tempera, wood, 100 × 80 cm
Unsigned
Inv. No.: 9292　(221)

FÉMES BECK, Vilmos
(1885–1918)
Ödön Lechner. 1911
Bronze, cast, 72 cm
Signed bottom right: FB; right
side centre: FB,1911
Inv. No.: 55.105–P　(276)

FÉMES BECK, Vilmos
Woman with Bird. 1912
Bronze, 41.5 cm
Signed: FÉMES BECK
VILMOS BP.
Inv. No.: 56.108–N　(253)

FÉNYES, Adolf
(1867–1945)
A Lad and a Girl. 1904
Oil on canvas, 126.8 × 106 cm
Signed bottom right: Fényes
A. 1904
Inv. No.: 3276　(200)

FÉNYES, Adolf
Poppyseed Cake. 1910
Oil on canvas, 80 × 87 cm
Signed bottom right:
FÉNYES A. 1910
Inv. No.: 6697　(86★)

FERENCZY, Béni
(1890–1967)
Young Man. 1919
Bronze, 152 cm
Unsigned
Inv. No.: 68.28–N　(260)

FERENCZY, Béni
Pál Scharl. 1924
Bronze, 7.3 cm
Unsigned
Inv. No.: 82.5–P　(280)

FERENCZY, Béni
Béla Bartók. 1936
Bronze, 10.4 cm
Unsigned
Inv. No.: 70.38–P　(108★)

FERENCZY, Béni
Stepping Woman. 1939
Bronze, 39 cm
Unsigned
Inv. No.: 52.974　(105★)

FERENCZY, Béni
Woman with the Statue of a Boy.
1939
Pencil, aquarelle,
40.1 × 29.9 cm
Signed bottom right: Ferenczy
Béni 1939
Inv. No.: 1954–4891　(324)

FERENCZY, Béni
Playing Boys. 1947
Bronze, 64 cm
Unsigned
Inv. No.: 50.763-N　(261)

FERENCZY, István
(1792–1856)
Shepherd Girl. 1820–1822
Marble, 94 cm
Unsigned
Inv. No.: 3662　(67★)

FERENCZY, István
Pope Pius VII. 1823
Gold, beaten, 4.9 cm
Signed bottom:
FERENCZY. F.
Inv. No.: 86.30–P　(269)

FERENCZY, István
Rozália Schodel. c. 1838
Marble, 60.6 cm
Unsigned
Inv. No.: 2253　(152)

FERENCZY, István
*The Allegory of Power. Detail of
the Matthias Memorial.*
1842–1843
Bronze, 155 × 133 cm
Unsigned
Inv. No.: 3669　(153)

FERENCZY, Károly
(1863–1917)
*Boys Throwing Pebbles into the
River.* 1890
Oil on canvas, 119 × 149 cm
Signed bottom right:
FERENCZY K. 1890
Inv. No.: FK 3778　(64★)

FERENCZY, Károly
Bird Song. 1893
Oil on canvas, 105 × 77.5 cm
Signed bottom right:
FERENCZY K.
Inv. No.: 1867　(147)

FERENCZY, Károly
The Seamstress's Song. 1896
Chalk, 30.8 × 40.9 cm
Signed top: FERENCZY
KÁROLY N.B. 1896
Inv. No.: 1917-274　(302)

FERENCZY, Károly
*Joseph Sold into Slavery by His
Brothers.* 1900
Oil on canvas, 193 × 227 cm
Unsigned
Inv. No.: FK 724　(182)

FERENCZY, Károly
Evening in March. 1902
Oil on canvas,
116.5 × 141.5 cm
Signed bottom left: Ferenczy
Károly 1902
Inv. No.: 5249　(183)

FERENCZY, Károly
October. 1903
Oil on canvas, 125 × 107 cm
Unsigned
Inv. No.: 59.44 T　(73★)

FERENCZY, Károly
Shooting Arrows. 1911
Oil on canvas, 64.5 × 77 cm
Unsigned
Inv. No.: 59.154 T　(184)

FERENCZY, Noémi
(1890–1957)
Woman with Red Flower. c.
1930
Aquarelle, gouache,
44 × 31.3 cm
Unsigned
Inv. No.: F 58.102　(320)

FESZTY, Árpád
(1856–1914)
Golgotha. 1880
Oil on canvas, 151 × 251 cm
Signed bottom left: Feszty
Árpád Bécs, 1880
Inv. No.: 2763　(145)

GÁBOR, Pál
(1913–)
*Choose — War or Peace — The
Social Democratic Party.* c. 1946
Offset, 82 × 58 cm
Signed right side: GÁBOR
PÁL; bottom right: KLÖSZ
R.T. Bp.
Inv. No.: X.Y. 88.340　(335)

GADÁNYI, Jenő
(1896–1960)
Thinker. 1950
Oil on canvas, 80 × 60 cm
Signed bottom right: Gadányi
Jenő
Inv. No.: 68.77 T　(343)

GALÁNTAI, György
(1941–)
Half-pace. 1989
Iron, zink-plate,
115 × 200 × 28 cm
Unsigned
Inv.No.: MM 90.27　(397)

GALIMBERTI, Sándor
(1883–1915)
Tabán. 1910
Oil on canvas, 111 × 76 cm
Unsigned
Inv. No.: 74.84 T　(212)

GÉMES, Péter
(1951–)
Light-bars. 1990
Lithograph, 53.5 × 38.5 cm
Signed on the margin, bottom
right: Gémes '90
Inv.No.: MM 90.168/5　(398)

GERGELY, Sándor
(1888/9–1932)
Dancing Woman. 1918
Bronze, 37 cm
Signed: Gergely 918
Inv. No.: 62.9–N　(259)

GOLDMAN, György
(1904–1945)
Seated Worker. 1934
Bronze, 25.2 cm
Unsigned
Inv. No.: 56.269–N　(267)

GRASMAIR, Johann Georg Dominicus
(1691–1751)
Christ Being Nourished by Angels in the Desert. c. 1734
Oil on canvas, 156 × 207 cm
Unsigned
Inv. No.: 82.4 M (44)

GROSS, Arnold
(1929–)
Circus. 1965
Copper-plate engraving,
16.5 × 31.1 cm
Signed bottom right: Gross Arnold
Inv. No.: G 65.14 (351)

GULÁCSY, Lajos
(1882–1932)
Paolo and Francesca. 1903
Pencil, oil, 33.1 × 25.2 cm
Signed bottom right: Gulácsy Firenze 1903
Inv. No.: 1907-222 (120★)

GULÁCSY, Lajos
Magic. 1906–1907
Oil on canvas, 86 × 63 cm
Signed bottom right: GULÁCSY
Inv. No.: FK 10.197 (208)

GULÁCSY, Lajos
Ancient Garden. 1913
Oil on cardboard, 69 × 51 cm
Signed bottom right: Gulácsy L. Venezia
Inv. No.: 5466 (82★)

GYÁRFÁS, Jenő
(1857–1925)
Portrait of Bertalan Karlovszky. 1880
Oil on canvas, 113 × 88 cm
Signed bottom right: Gyárfás Jenő, München 880
Inv. No.: 4912 (129)

GYÁRFÁS, Jenő
The Resurrection of Jairus's Daughter. c. 1880
India ink, ink, wash,
21 × 22.3 cm
Unsigned
Inv. No.: 1925-1129/h (296)

GYÁRFÁS, Jenő
The Ordeal of the Bier. 1881
Oil on canvas, 192.5 × 283.5 cm
Signed bottom right: Gyárfás Jenő, Sepsiszentgyörgy, 1881
Inv. No.: 2777 (60★)

GYÁRFÁS, Jenő
Youth and Age. 1887
Oil on canvas, 48.5 × 53.3 cm
Signed top left: Gyárfás Jenő
Inv. No.: FK 5625 (130)

GYARMATHY, Tihamér
(1915–)
Dynamic Composition. 1946
Oil on canvas, 130 × 196 cm
Unsigned
Inv. No.: MM 82.247 (131★)

GYÖRGYI GIERGL, Alajos
(1821–1863)
Consolation. 1852
Oil on canvas, 129 × 103 cm
Signed bottom right: Giergl Alajos 852.
Inv. No.: 86.24 T (38★)

GYÖRGYI GIERGL, Alajos
Portrait of Szidónia Deák. 1861
Oil on canvas, 71 × 56 cm
Signed bottom right: Györgyi 861
Inv. No.: FK 3863 (96)

GYULAI, Líviusz
(1937–)
Champion. 1975
Ink on paper, 26 × 18 cm
Signed bottom right: Gyulai 1975.
Inv. No.: MM 79.92 (375)

HAJAS, Tibor
(1946–1980)
Untitled I. 1980
Offset, paper, 27 × 39 cm
Unsigned
Inv. No.: MM 81.27 (382)

HALÁSZ, Károly
(1946–)
Private Transmission — Irrational Television I.
1974–1975
Photograph, 50.5 × 59.5 cm
Unsigned
Inv. No.: MM 90.67 (376)

HARASZTY, István
(1934–)
Brain-cannon. 1980-1981
Steel, bronze, copper, brass, plexi-glass, 230 × 250 × 70 cm
Signed on the back:
HARASZTY ISTVÁN 1980–81
Inv. No.: MM 89.165 (143★)

HEINRICH, Ede
(1819–1885)
The Antique Collector. 1846
Oil on canvas, 97 × 73 cm
Signed bottom left: Heinrich Ede Rómában
Inv. No.: 2718 (77)

HELBING, Ferenc
(1870–1958)
Dream. 1902
Coloured lithograph, 44 × 35 cm
Signed bottom right: HELBING FERENCZ 1902. III.
Inv. No.: 1902–420 (304)

HENCZE, Tamás
(1938–)
Dynamic Structure. 1968
Oil on paper, 100 × 70 cm
Unsigned
Inv. No.: MM 90.114 (358)

HOLLÓSY, Simon
(1857–1918)
Corn Husking. 1885
Oil on canvas, 150 × 100 cm
Signed top right: Hollósy S. München 1885
Inv. No.: 4868 (61★)

HOLLÓSY, Simon
Between Two Fires.
1891–1892
Oil on wood, 17.7 × 24 cm
Signed bottom left: HOLLÓSY
Inv. No.: 2855 (177)

HOLLÓSY, Simon
The Rákóczi March (Sketch). 1899
Oil on canvas, 92 × 127 cm
Signed bottom left: Hollósy S. 1899
Inv. No.: FK 8032 (178)

HOLLÓSY, Simon
Peasant Yard with Cart.
1910–1912
Oil on canvas, 80 × 100 cm
Signed bottom left: Hollósy
Inv. No.: 57.71 T (179)

HORVÁTH, Sámuel
(Active during the second half of the 18th century)
Maria Theresa, Queen of Hungary. c. 1750
Oil on canvas, 258 × 168 cm
Unsigned
Inv. No.: L 5.098 (50)

HUNGARIAN PAINTER
(c. 1600)
King Saint Stephen.
Oil on wood, 103.5 × 101 cm
Unsigned
Inv. No.: 55.967.1 (19★)

HUNGARIAN MASTER
(12th century)
Capital. From Dömös. First part of the 12th century
Andesite, 64 × 109 × 109, diametre at bottom, 94 cm
Unsigned
Inv. No.:55.1599 (1)

HUNGARIAN MASTER
(12th century)
Frieze. From Somogyvár.
Middle of the 12th century
27 × 52 cm
Unsigned
Inv. No.: 53.582 (2)

HUNGARIAN MASTER
(12th century)
Apocalyptic Elder. From Pécs.
Third quarter of the 12th century
Lime-stone, 74 cm
Unsigned
Inv. No.: 55.977 (1★)

HUNGARIAN MASTER
(12th century)
Detail of a Gate (?). From Pécs.
Third quarter of the 12th century
Marble, 83 × 51 cm
Unsigned
Inv. No.: 55.975 cm (3)

HUNGARIAN MASTER
(13th century)
A King's Portrait. From Kalocsa. Early 13th century
Lime-stone from Piszke,
17 cm
Unsigned
Inv. No.: 53.364 (4)

HUNGARIAN MASTER
(13th century)
Tympanum. From Szentkirály.
Third quarter of the 13th century
Marble, 66 × 119 cm
Unsigned
Inv. No.: 55.976 (2★)

HUNGARIAN MASTER
(Middle of the 14th century)
The Virgin Mary. From Toporc.
1340–1350
Lime-wood, with traces of paint, 115.5 cm
Unsigned
Inv. No.: 55.900 (5)

HUNGARIAN MASTER
(c. 1370–1380)
Virgin and Child. From Szlatvin. 1370–1380
Lime-wood, painted, 111 cm
Unsigned
Inv. No.: 53.371 (3★)

HUNGARIAN MASTER
(c. 1400–1420)
St. Dorothy. From Barka.
1410–1420
Lime-wood, with traces of paint, 169.5 cm
Unsigned
Inv. No.: 52.653 (4★)

HUNGARIAN MASTER
(c. 1420)
The Virgin Mary. From Toporc. c. 1420
Lime-wood, painted,
139.5 cm
Unsigned
Inv.No.: 57,15 (6)

HUNGARIAN MASTER
(c. 1420–1430)
The Virgin at the Spinning-wheel. From Németújvár.
1420–1430
Tempera, wood, 89 × 78 cm
Unsigned
Inv. No.: 52.656 (5★)

HUNGARIAN MASTER
(Middle of the 15th century)
House Altar. From Trencsén.
1440–1450
Tempera, lime-wood,
40.5 × 60.2 cm
Unsigned
Inv. No.: 53.579 (6★)

HUNGARIAN MASTER
(c. 1450–1460)
Piéta. From Turdossin.
1450–1460
Tempera, poplar-wood,
107 × 81.5 cm
Unsigned
Inv. No.: 55.918 (7)

HUNGARIAN MASTER
(c. 1480)
The Virgin Mary. From Liptónádasd. c. 1480
Tempera, wood, 79 × 59 cm
Unsigned
Inv. No.: 52.642 (14)

HUNGARIAN MASTER
(c.1480)
The Virgin Mary Altarpiece. From Liptószentandrás.
c. 1480
Wood, painted, gilded,
229 × 270 cm
Unsigned
Inv. No.: 53.570 (15)

HUNGARIAN MASTER
(c. 1480–1490)
The Assumption of Mary Magdalene. From Berki.
1480–1490
Wood, painted, gilded,
200 × 266 cm
Unsigned
Inv. No.: 55.901 (8★)

HUNGARIAN MASTER
(c. 1480–1490)
The Annunciation. From the wing of an altarpiece from Szepeshely. c. 1480–1490
Tempera, pine-wood, 86 × 63 cm
Unsigned
Inv. No.: 55.917.1 (18)

HUNGARIAN MASTER
Mass Cerebrated by the Bishop St. Martin. From an altarpiece of unknown origin. c. 1490
Tempera, pine-wood,
101.5 × 89.5 cm
Unsigned
Inv. No.: 1637 (19)

HUNGARIAN MASTER
(15th–16th century)
St John the Baptist. From the Kisszeben high altar.
1490–1516
Lime-wood, painted, gilded,
190 cm
Unsigned
Inv. No.: 3916 (20)

HUNGARIAN MASTER
(15th–16th century)
Zechariah's Offering. From the Kisszeben high altar.
1490–1516
Tempera, lime-wood,
145.5 × 73 cm
Inv. No.: 3916 (21)

HUNGARIAN MASTER
(15th–16th century)
Mettercia Altarpiece. From Berzenke. c. 1500
Lime-wood, painted,
220 × 232 cm
Unsigned
Inv. No.: 55.834 (22)

HUNGARIAN MASTER
(c. 1500)
Piéta. From Keszthely. c. 1500
Lime-wood, painted, 89 cm
Unsigned
Inv. No.: 52.641 (24)

HUNGARIAN MASTER
(15th–16th century)
The Saint Nicholas Altarpiece.
From Nagyszalók. 1503
Lime-wood, painted, gilded,
192 × 202 cm
Unsigned
Inv. No.: 53.541 (25)

HUNGARIAN MASTER
(c. 1510)
The High Altar from Csíkszentlélek. 1510
Tempera, wood, 3l6 × 290 cm
Unsigned
Inv. No.: 53.370 (27)

HUNGARIAN MASTER
(c. 1510–1520)
The St. Anne Altarpiece. From
Leibic. c. 1510–1520
Wood, painted, gilded,
445 × 243 cm
Unsigned
Inv. No.: 53.574 (33)

HUNGARIAN MASTER
(c. 1510–1520)
The Relatives of Christ. From
Dubravia. 1510–1520
Tempera, pine-wood,
101 × 102 cm
Unsigned
Inv. No.: 8133 (32)

HUNGARIAN MASTER
(c. 1512)
The St. Andrew Altarpiece.
From Liptószentandrás. 1512
Wood, painted, gilded,
420 × 270 cm
Dated on the frame separating
the scenes in the inner side of
the wings: 1512
Inv. No.: 53.569 (31)

HUNGARIAN MASTER
(c. 1514)
Flagellation. 1514
Tempera, pine-wood,
109 × 102.5 cm
Unsigned
Inv. No.: 1639 (14★)

HUNGARIAN MASTER
(c. 1510–1520)
*The Vision of St. Anthony the
Hermit.* From Szepesbéla. 1510s
Tempera, lime-wood,
94 × 70 cm
Unsigned
Inv. No.: 53.565 (30)

HUNGARIAN MASTER
(c. 1520)
*St. Anne with the Virgin and the
Infant.* From Eperjes. c. 1520
Tempera, pine-wood,
124 × 84 cm
Unsigned
Inv. No.: 53.566 (15★)

HUNGARIAN MASTER
(c. 1521)
*The Altarpiece of Two Bishop
Saints.* From Leibic. 1521
Wood, painted, gilded,
438 × 295 cm
Dated on the legend on the
predella: 1521
Inv. No.: 53.578 (35)

HUNGARIAN MASTER
(c. 1520–1530)
*Christ Taking Leave of His
Mother.* From Nyitra.
1520–1530
Lime-stone, 117 × 103 cm
Unsigned
Inv. No.: 55.1594 (17★)

HUNGARIAN MASTER
(c. 1526)
*András Báthory's Virgin and
Child.* 1526
Marble, 68 × 51 cm
Dated on the lower border of
the relief: 1526
Inv. No.: 55.982 (16★)

HUNGARIAN MASTER
(c. 1543)
High Altar of the Virgin Mary.
From Csíkmenaság. 1543
Wood, painted, gilded,
416.5 × 275 cm
Dated in the field under the
altar statues: 1543
Inv. No.: 53.540 (18★)

**HUNGARIAN
SCULPTOR**
(17th century)
Bishop St. Denis. c. 1620
Wood, painted, gilded,
113 cm
Unsigned
Inv. No.: 7178 (38)

**HUNGARIAN
SCULPTOR**
(Middle of the 18th century)
St. Anne. c. 1740
Wood, painted, gilded,
118.5 cm
Unsigned
Inv. No.: 76.6 M (47)

HUSZÁR, Adolf
(1842–1885)
"Play on Gypsy!" c. 1874
Marble, 62 cm
Unsigned
Inv. No.: 5591 (162)

**IVÁNYI GRÜNWALD,
Béla**
(1867–1940)
The War Lord's Sword. 1890
Oil on canvas, 161 × 150 cm
Signed bottom right:
Grünwald Béla 1890
Inv. No.: 4902 (65★)

**IVÁNYI GRÜNWALD,
Béla**
Between Crags. 1901
Oil on canvas, 166.5 × 270 cm
Signed bottom right:
Grünwald Béla
Inv. No.: 2066 (185)

**IVÁNYI GRÜNWALD,
Béla**
Watering. 1902
Oil on canvas,
130.5 × 151.5 cm
Signed bottom right:
Grünwald Béla
Inv. No.: 2276 (186)

**IVÁNYI GRÜNWALD,
Béla**
Outing in Spring. 1903
Oil on canvas, 111.5 × 176 cm
Inv. No.: 5252 (74★)

**IZBÉGHY (VÖRÖS),
István**
(Active during the mid 18th
century)
*Still-life with Crabs, a Haban
Jug, a Cup, a Loaf of Bread and
a Mouse.*
Oil on canvas, 42 × 53 cm
Signed bottom centre: St:
Mich: Izbéghy
Inv. No.: 89.2 M (48)

IZSÓ, Miklós
(1831–1875)
Sad Shepherd. 1862
Marble, 95 cm
Signed: Izsó M.
TULAJDONJOGA 1862
Inv. No.: 3338 (69★)

IZSÓ, Miklós
Gipsy Laokoón. 1869
Terracotta, 23 cm
Signed: IZSÓ 1869
Inv. No.: 3342 (161)

IZSÓ, Miklós
Dancing Peasant II. 1870
Terracotta, 28.2 cm
Signed: Izsó Máj. 1-én 1870
Inv. No.: 3347 (70★)

JANKOVITS, József
(1909–)
Reticulated Nude. 1947
Bronze, 39 cm
Unsigned
Inv. No.: MM 82.129 (338)

JANKÓ, János
(1833–1896)
The Birth of the Folk Song. 1860
Oil on canvas, 75 × 108.3 cm
Signed bottom left: Jankó J.
860
Inv. No.: FK 1379 (93)

JOVÁNOVICS, György
(1939–)
Man. 1968
Plaster, textile, 180 cm
Unsigned
Inv. No.: MM 82.133 (361)

KÁDÁR, Béla
(1887–1956)
Memory. c. 1920.
Tempera on cardboard,
80 × 57 cm
Signed bottom right:
KÁDÁR BÉLA
Inv. No.: FK 8642 (231)

KALLÓS, Ede
(1866–1952)
David. 1892
Bronze, 179.8 cm
Signed: Kallós Ede
Inv. No.: 6244 (167)

KARCSAY, Lajos
(1860–1932)
Apple Picking. c. 1885
Oil on canvas, 140 × 180 cm
Signed bottom right: Karcsay
Lajos, München
Inv. No.: 66.13 T (144)

KÁROLYI, Zsigmond
(1952–)
Untitled V. 1986
Photo-painting, paper,
101.5 × 99.6 cm
Unsigned
Inv. No.: MM 89.9 (390)

KASSÁK, Lajos
(1887–1967)
Picture Architecture II
Oil on cardboard,
25.5 × 24.5 cm
Signed bottom right: KL
Inv. No.: 70.131 T (90★)

KELETY, Gusztáv
(1834–1902)
Gödöllő. 1867
Lithograph, 41 × 51 cm
Unsigned
Inv. No.: G 89.86 (295)

KELETY, Gusztáv
The Park of the Exile. 1870
Oil on canvas, 123 × 173 cm
Signed bottom right: Keleti G.
870
Inv. No.: 2750 (104)

KERÉNYI, Jenő
(1908–1975)
Ten Commandments. 1973
Bronze, 55 cm
Signed on the back: K J 73
Inv. No.: MM 81.384 (369)

KÉRI, Ádám
(1944–)
In Memoriam Petőfi. 1973
Mixed technique, plywood,
160 × 100 cm
Unsigned
Inv. No.: MM 75.38 (372)

KERNSTOK, Károly
(1873–1940)
Riders on the Shore. 1910
Oil on canvas, 215 × 294 cm
Signed bottom right: Kernstok
Károly 1910
Inv. No.: 59.34 T (192)

KERNSTOK, Károly
*Nude Boy Leaning Against a
Tree.* 1911
Oil on cardboard, 66 × 44 cm
Signed bottom left: Kernstok
Károly
Inv. No.: 9035 (193)

KERNSTOK, Károly
Riders. 1912
India ink and wash,
22.4 × 38.8 mm
Signed bottom right: Kernstok
Károly 912
Inv. No.: 1912–42 (122★)

KESERŰ, Ilona
(1933–)
Villány II. 1972
Oil on canvas, relief,
180 × 120 × 4 cm
Signed bottom right:
KESERŰ
Inv. No.: MM 87.171 (142★)

**KISFALUDI STROBL,
Zsigmond**
(1884–1975)
Finale. 1912
Bronze, 50 cm
Signed: Kisfaludi Strobl
Zsigmond 1912
Inv. No.: 4414–N (249)

KISFALUDY, Károly
(1788–1830)
Maritime Peril. 1820s
Oil on canvas, 48.3 × 75 cm
Unsigned
Inv. No.: 3175 (32★)

KISS, Bálint
(1802–1868)
*János Jablonczai Pethes Bidding
Farewell to His Daughter.* 1846
Oil on canvas, 93 × 75 cm
Signed bottom right: KB.846
Inv. No.: 2749 (76)

KISS, György
(1852–1919)
Faun with His Child. 1896
Bronze, 90.3 × 3 × 63.5 cm
Signed: Kiss 1896
Inv. No.: 1644 (168)

KISS, Sámuel
(1780–1819)
Portrait of the Mayor of Brassó.
1805
Gouache, 18 × 13.4 cm
Unsigned
Inv. No.: 1939–3423 (110★)

KISS NAGY, András
(1930–)
Evening. 1961
Bronze, cast, 84 cm
Unsigned
Inv. No.: 65.34–P (284)

KLIMÓ, Károly
(1936–)
Chariot of Fire. 1985
Oil, pastel, plywood,
176 × 203 cm
Signed bottom right: Klimó 85
Inv. No.: MM 86.400 (389)

KMETTY, János
(1889–1975)
Ascension. 1913
India ink and wash,
50.2 × 33.3 cm
Signed bottom centre: Kmetty
1913
Inv. No.: F 62.185 (307)

KMETTY, János
Self-portrait. 1913
Oil on canvas, 53 × 44 cm
Signed bottom right: Kmetty
Inv. No.: 70.32 T (211)

KNOLLER, Martin
(1725–1804)
*Portrait of Prince Miklós
Esterházy II.* 1792–1793
Oil on canvas, 59 × 37 cm
Unsigned
Inv. No.: 74.3 M (28★)

KOCSIS, Imre
(1940–)
Outskirts. 1976
Oil on canvas, 106.5 × 161 cm
Unsigned
Inv. No.: MM 79.176 (377)

KOKAS, Ignác
(1926–)
Around Man I. 1969–1970
Oil on plywood, 134 × 258 cm
Inv. No.: MM 81.345 (134★)

KONDOR, Béla
(1931–1972)
*God Save Me from Newton's
Belief! Illustration for a poem by
Blake.* 1961
Coloured copper-plate
engraving, paper, 13.7 × 15 cm
Signed on the margin, bottom
right: Kondor B.
Inv. NO.: MM 77.329 (135★)

KONDOR, Béla
The Genius of Aviation (The Symbol of Flying). 1964
Oil on canvas, 230 × 187 cm
Signed bottom left: Kondor
Inv. No.: MM 77.186 (350)

KONECSNI, György
(1908–1970)
Nudes I (Variations on a Theme). c. 1946
Pen, paper, 30.5 × 44.5 cm
Unsigned
Inv. No.: MM 80.3 (337)

KONKOLY, Gyula
(1941–)
Softened Egg. 1968
Mixed technique, canvas, 125 × 125 cm
Unsigned
Inv. No.: MM 91.100 (360)

KORNISS, Dezső
(1908–1984)
Szentendre Motif. 1935
Pastel, 46 × 24 cm
Signed bottom left: Korniss D/35
Inv. No.: F 63.171 (323)

KORNISS, Dezső
Szentendre Motif II. 1947–1948
Oil on canvas, 120 × 140 cm
Unsigned
Inv. No.: MM 81.375 (100★)

KORNISS, Dezső
Plastic Calligraphy (Red). 1959
Oil on canvas, 60 × 200 cm
Unsigned
Inv. No.: MM 81.376 (347)

KOSZTA, József
(1861–1949)
In the Field. 1904
Oil on canvas, 107.5 × 118.5 cm
Signed bottom left: Koszta J.
Inv. No.: 2577 (201)

KOSZTA, József
Corn Harvesting. c. 1917
Oil on canvas, 83.5 × 93.5 cm
Signed bottom left: Koszta J.
Inv. No.: 56.236 (87★)

KOSZTA, József
Girl with Geranium. c. 1917
Oil on canvas, 92.5 × 66 cm
Signed bottom right: Koszta J.
Inv. No.: 7424 (202)

KOVÁCS, Mihály
(1818–1892)
Battle Scene. 1848
Oil on canvas, 27 × 36 cm
Signed bottom left: Kovács M. 1818
Inv. No.: FK 9168 (79)

KOZINA, Sándor
(1801–1873)
Self-portrait. 1832
Oil on canvas, 73 × 58 cm
Unsigned
Inv. No.: 6097 (64)

KOZINA, Sándor
Portrait of Ferenc Pulszky. 1837
Pencil, aqurelle, 22.6 × 18.5 cm
Signed bottom right: Kozina 837.
Inv. No.: 1951–4435 (290)

KŐ, Pál
(1941–)
Kossuth. 1973
Wood, textile, 107 cm
Unsigned
Inv.No.: MM 81.185 (373)

KÖPP, Farkas
(1738–1807)
Landscape with Ruins.
India ink, aquarelle, limestone sheet, 42 × 58.5 cm
Unsigned
Inv. No.: 3160 (58)

KÖRÖSFŐI-KRIESCH, Aladár
(1836–1920)
In Memoriam (On the Death of Károly Lotz). 1904
India ink, paper, 32.2 × 24.3 cm
Signed bottom left: KA
Inv. No.: F 71.191 (305)

KÖRÖSFŐI-KRIESCH, Aladár
The Story of Klára Zách II. 1911
Oil on wood, 101 × 193 cm
Signed bottom right: KA 1911
Inv. No.: 6078 (209)

KÖVESHÁZI KALMÁR, Elza
(1876–1956)
Kneeling Girl. c. 1917
Wood, 35.5 cm
Unsigned
Inv. No.: 5644 (250)

KRACKER, Johann Lucas
(1717–1779)
The Dispute between St. Catherine of Alexandria and the Philosophers. 1775
Oil on canvas, 76.5 × 40.5 cm
Unsigned
Inv. No.: 80.3 M (27★)

LAKNER, László
(1936–)
Brussels June 2-5, 1972.
Offset, 18 × 83.2 cm
Signed on the hand: Lakner L. Gadányi 972;
Marked bottom right: Offset Nyomda
Inv. No.: X.Y. 73.243 (336)

LAKNER, László
Untitled. 1981–1982
Acrylic paint, car varnish, canvas, 232 × 316 cm
Signed bottom right: Lakner
Inv. No.: MM 84.194 (144★)

LÁNYI, Sámuel
(1791–1860)
Self-portrait. 1846
Oil on canvas, 63 × 50 cm
Signed bottom left: Lányi Sámuel 1846
Inv. No.: 8071 (66)

LIBAY, Károly Lajos
(1816–1888)
Regensburg: View of the River Bank. 1849
Aquarelle, 21.5 × 18.5 cm
Unsigned
Inv. No.: 1898–179 (114★)

LIEZEN-MAYER, Sándor
(1839–1898)
Queen Elizabeth and Queen Mary at the Sarcophagus of Louis Anjou the Great of Hungary. 1862
Oil on canvas, 77.4 × 65.5 cm
Unsigned
Inv. No.: 1611 (43★)

LIEZEN-MAYER, Sándor
Faust and Margaret. c. 1875
Oil on canvas, 108 × 79 cm
Signed bottom left: A. Liezen-Mayer
Inv. No.: FK 4191 (123)

LIEZEN-MAYER, Sándor
St. Elizabeth of Hungary. 1880
Oil on canvas, 262 × 186 cm
Signed bottom right: Liezen-Mayer S.
Inv. No.: 2760 (124)

LIGETI, Antal
(1823–1890)
Mártonhegy Road. 1876
Oil on canvas, 58.5 × 94 cm
Signed bottom left: Ligeti A. 1876
Inv. No.: FK 9129 (47★)

LIGETI, Antal
Rocky Landscape. 1885
Oil on canvas, 92.5 × 122 cm
Signed bottom right: Ligeti A. 1885
Inv. No.: FK 976 (105)

LIGETI, Erika
(1934–)
Mussorgsky. 1972
Bronze, cast, 11.8 cm
Signed top right.: LE
Inv. No.: 82.25-P (109★)

LIGETI, Miklós
(1871–1944)
Béla Iványi Grünwald. 1901
Bronze, 45 cm
Signed bottom left: LM
Inv. No.: 64.57-N (240)

LÓRÁNFI, Antal
(1856–1927)
István Széchenyi. 1897
Bronze, cast, 75 cm
Unsigned
Inv. No.: 56.413-P (271)

LOSSONCZY, Tamás
(1904–)
Purging Storm. 1961
Oil on canvas, 300 × 300 cm
Signed bottom right: Lossonczy 1961
Inv. No.: MM 89.23 (133★)

LOTZ, Károly
(1833–1904)
Stud in a Thunderstorm. 1862
Oil on canvas, 126.5 × 191.5 cm
Signed bottom left: f. Lotz K. 862
Inv. No.:2742 (40★)

LOTZ, Károly
Towing. Second half of the 1870s
Oil oncanvas, 114.5 × 166 cm
Signed bottom right: Lotz K.
Inv. No.: 66.157 T (125)

LOTZ, Károly
After the Bath. c. 1880
Oil on canvas, 128 × 97 cm
Signed bottom right: Lotz K.
Inv. No.: FK 2876 (126)

LOTZ, Károly
Design for the Fresco on the Ceiling of the Budapest Opera. 1882
Oil on canvas, 134 × 134 cm
Signed in the back: Cornélia tulajdona Lotz Károly
Inv. No.: 3534 (127)

LOTZ, Károly
Fan designed for Kornélia Lotz. c. 1890
Tempera, 22.2 × 39.7 cm
Unsigned
Inv. No.: 1905–212 (118★)

LOTZ, Károly
Kornélia Lotz Dressed in Black. 1896
Oil on canvas, 163.8 × 80.3 cm
Unsigned
Inv. No.: 3531 (128)

LUGOSSY, Mária
(1950–)
Tektit II. 1987
Glass, 12 × 30.5 × 39.5 and 15.5 × 31 × 39.5 cm
Unsigned
Inv. No.: MM 88.45 (392)

MADARASSY, Walter
(1909–)
Self-portrait. 1939
Bronze, cast, 6.6 cm
Signed bottom right: MADARASSY
Inv. No.: 56.1528–P (281)

MADARÁSZ, Viktor
(1830–1917)
Zrínyi. 1858
Oil on canvas, 55.5 × 48 cm
Unsigned
Inv. No.: 4882 (89)

MADARÁSZ, Viktor
The Mourning of László Hunyadi. 1859
Oil on canvas, 243 × 312.5 cm
Signed bottom right: MADARÁSZ VICTOR PÁRIZSBAN, 1859
Inv. No.: 2800 (41★)

MADARÁSZ, Viktor
Self-portrait. 1863
Oil on canvas, 73 × 60 cm
Signed right centre: 18 M 63 PARIS
Inv. No.: 7585 (90)

MADARÁSZ, Viktor
Péter Zrínyi and Ferenc Frangepán in the Wiener-Neustadt Prison. 1864
Oil on canvas, 176 × 236 cm
Signed bottom right: Madarász Victor 1864
Inv. No.: 2794 (91)

MADARÁSZ, Viktor
Dobozi and His Spouse. 1868
Oil on canvas, 116 × 310 cm
Signed bottom left: Madarász Victor
Inv. No.: 59.153 T (42★)

MADARÁSZ, Viktor
Dózsa's People. 1868
Oil on canvas, 164 × 130 cm
Signed bottom right: Madarász 1868
Inv. No.: 54.324 (92)

MÁNYOKI, Ádám
(1673–1757)
Self-portrait. 1711
Oil on canvas, 87 × 61.5 cm
Unsigned
Inv. No.: 6508 (22★)

MÁNYOKI, Ádám
Portrait of Ferenc Rákóczi II. 1712
Oil on canvas, 75.5 × 67.5 cm
Unsigned
Inv. No.: 6001 (40)

MÁNYOKI, Ádám
Portrait of Count Georg Wilhelm Werthern. 1719
Oil on canvas, 82 × 69 cm
Signed in the back: A. de Mányoki fecit Dresd. 1719
Inv. No.: 54.327 (41)

MARASTONI, Jakab
(1804–1860)
Greek Woman. 1850
Oil on canvas, 76 × 6l cm
Signed right side: Marastoni 850
Inv. No.: 4193 (84)

MARASTONI, József
(1834–1895)
John the Hero's Farewell to Iluska. 1863
Copper-plate engraving on Japanese paper, 129 × 153 cm
Unsigned
Inv. No.: 1904-139 (294)

MÁRFFY, Ödön
(1878–1959)
Forest Path. c. 1910
Oil on canvas, 64 × 77.5 cm
Signed bottom left: Márffy Ödön
Inv. No.: 57.54 T (195)

MÁRFFY, Ödön
Reclining Woman. c. 1930
Oil on canvas, 65 × 81 cm
Signed top left: Márffy Ödön
Inv. No.: 6649 (196)

MARKÓ, Ferenc
(1832–1874)
Hungarian Landscape. 1865
Oil on canvas, 31 × 39 cm
Signed bottom right: MARKÓ F. 1865
Inv. No.: FK 4236 (102)

MARKÓ, Károly the Elder
(1791–1860)
The Pest Organ (From the Aggtelek Cave Series). 1821
Gouache, 46.3 × 64.7 cm
Signed bottom right: C. Markó, 1821
Inv. No.: 1914-33 (111★)

MARKÓ, Károly the Elder
Visegrád. 1828–1830
Oil on canvas, 58.5 × 83 cm
Unsigned
Inv. No.: 3097 (33★)

MARKÓ, Károly the Elder
Landscape with Waterfall. 1840s
Pencil, India ink and wash, red chalk, 35.5 × 28.7 cm
Signed bottom right: C. Markó
Inv. No.: 1955–5623 (291)

MARKÓ, Károly the Elder
Landscape with a Scene Showing Wine Harvesting Near Tivoli. 1846
Oil on canvas, 117 × 153.5 cm
Signed bottom centre:
C. Markó p. Flor. 1846
Inv. No.: 76.32 T (69)

MARKÓ, Károly the Elder
View of the Great Hungarian Plain with Draw Well. 1853
Oil on canvas, 41 × 53 cm
Signed bottom right:
C. Markó p. A.p. 1853
Inv. No.: 6633 (70)

MARSCHALKÓ, János
(1819–1877)
István Széchenyi (Sculpture design). c. 1865
Plaster, patinated, 50 cm
Unsigned
Inv. No.: 64.43–N (158)

MARTYN, Ferenc
(1899–1986)
Composition. c. 1948
Oil on canvas, 80 × 100 cm
Signed in the back: MARTYN
Inv. No.: FK 10265 (339)

MASTER G.H.
(c. 1470)
Annunciation. Two panels from the Holy Trinity triptych from Mosóc. 1471
Tempera, pine, 64.5 × 51 cm each
Inv. No.: 52.646–647 (10)

MASTER G.H.
Holy Trinity. Panel from the Holy Trinity triptych from Mosóc. 1471
Tempera, transferred onto a new pine-board, 137 × 107 cm
Signed bottom centre:
G 1471 H
Inv. No.: 52.645 (11)

MASTER M.S.
(c. 1506)
The Visitation. c. 1506
Tempera, wood, 140 × 94.5 cm
Unsigned
Inv. No.: 2151 (12★)

THE MASTER OF JÁNOSRÉT
(c. 1480)
Crucifixion. From the St. Nicholas high altar from Jánosrét. c. 1480
Tempera, wood, 154 × 98 cm
Unsigned
Inv. No.: 55.903 (9★)

THE MASTER OF JÁNOSRÉT
St. Nicholas Commands the Thieves to Return the Treasures. Scene from the legend of St. Nicholas. Painting from the St. Nicholas high altar from Jánosrét c. 1480
Tempera, wood, 75 × 5O cm
Unsigned
Inv. No.: 55.903 (13)

THE MASTER OF JÁNOSRÉT'S WORKSHOP
(1480–1490)
The St. Martin Altarpiece. From Cserény. 1483
Wood, painted, gilded, 227 × 348 cm
Dated on the outer frame of the altar: 1483
Inv. No.: 3279 (17)

THE MASTER OF KASSA
(c. 1470–1840)
The Man of Sorrows. From Kassa. 1470–1480
Tempera, pine-wood, 47.5 × 36 cm
Unsigned
Inv. No.: 55.911 (12)

THE MASTER OF KASSA
(c. 1480)
St. Jerome and St. Gregory. From Kassa. c. 1480
Lime-wood, painted, 79 and 78.5 cm
Unsigned
Inv. No.: 7183, 55.88) (7★)

THE MASTER OF KASSA
(c. 1500)
The Virgin Mary. From Kassa. c. 1500
Tempera, pine-wood, 71 × 60.5 cm
Unsigned
Inv. No.: 55.910 (23)

THE MASTER OF OKOLICSNÓ
(c. 1500–1510)
Lamentation. From the Okolicsnó high altar. 1500–1510
Tempera, wood, 133 × 100 cm
Unsigned
Inv. No.: 184 (26)

THE MASTER OF THE ALTARS OF ST. ANNE
(c. 1510–1520)
The St. Anne Altarpiece from Kisszeben. 1510–1515
Lime-wood, painted, gilded, 445 × 260 cm
Unsigned
Inv. No.: 52.757 (28)

THE MASTER OF THE ALTARS OF ST. ANNE
(c. 1510–1520)
The Shrine and the Wings of the St. Anne Altarpiece from Kisszeben. 1510–1515
Lime-wood, painted, gilded, 172 × 190 cm
Inv. No.: 52.757 (29)

THE MASTER OF THE ALTARS OF ST. ANNE
(c. 1510–1520)
Annunciation. Altarpiece from Kisszeben. 1515–1520
Wood, painted, gilded, 172 × 190 cm
Unsigned
Inv. No.: 52.756 (13★)

THE MASTER OF THE ALTARS OF ST. ANNE
(c. 1510–1520)
The Shrine of the Annunciation Altarpiece from Kisszeben. 1515–1520
Wood, painted, gilded, 223 × 126 cm
Inv. No.: 52.756 (34)

THE MASTER OF THE HIGH ALTAR AT SZMRECSANY
(c. 1465–1485)
The Virgin Mary Altarpiece. From Nagyszalók. 1483
Wood, painted, gilded, 181 × 268 cm
Dated on the legend of the Annunciation: 1483
Inv. No.: 53.561 (16)

THE MASTER OF THE MATEOC KING CARVINGS
(c. 1500)
St. Stephen and St. Ladislas. From Mateóc c. 1500
Wood, traces of paint, 114 and 106.5 cm
Unsigned
Inv. No.: 55.894–895 (11★)

THE MASTER OF THE VIRGIN MARY FROM BARTFA (THE MASTER OF THE CHOIRS)
(c. 1467)
The Virgin Mary. From Bártfa. 1465–1470
Tempera on wood, 59 × 44 cm
Unsigned
Inv. No.: 55.908 (9)

MASTER P.N.
(c. 1450–1460)
Stations of the Cross. From the high altar at Liptószentmárton. 1450–1460
Tempera, transferred onto a new wooden board, 91.5 × 77 cm
Signed on the flag of the soldier in the back: PN
Inv. No.: 55.890 (8)

MATA, Attila
(1953–)
Desire. 1987
Wood, painted, 120 × 90 × 80 cm
Unsigned
Inv. No.: MM 88.62 (391)

MÁTTIS TEUTSCH, János
(1884–1960)
Landscape. 1910s
Oil on cardboard, 50 × 50 cm
Signed bottom left: MT
Inv. No.: FK 772 (88★)

MÁTTIS TEUTSCH, János
Landscape in Blue and Red. c. 1919
Pastel, 15.4 × 16 cm
Unsigned
Inv. No.: F 84.70 (311)

MAULBERTSCH, Franz Anton
(1724–1796)
The Death of St. Joseph. c. 1767
Oil on canvas, 324 × 159 cm
Unsigned
Inv. No.: L 5.121 (24★)

MAULBERTSCH, Franz Anton
St. Stephen Offers His Crown to the Virgin Mary. c. 1770
Oil on canvas, 31 × 19.5 cm
Unsigned
Inv. No.: 6332 (53)

MAURER, Dóra
(1937–)
I'd Rather Be a Bird. 1971
Aquatint, paper, 57 × 99 cm
Signed bottom right: Maurer 1971
Inv. No.: MM 78.156 (371)

MEDGYESSY, Ferenc
(1881–1958)
Seated Nude (Fat Thinker). 1911
Bronze, 39 cm
Signed: Medgyessy
Inv. No.: 56.482–N (256)

MEDGYESSY, Ferenc
Young Rider. 1915
Bronze, 23 × 19.5 cm
Signed bottom left:
Medgyessy F.
Inv. No.: 5413 (257)

MEDGYESSY, Ferenc
The Lengyel Family's Tomb. 1917
Stone, 180 cm
Unsigned
Inv. No.: 60.55–N (102★)

MEDGYESSY, Ferenc
Self-portrait. 1921
Bronze, cast, 10 × 10 cm
Signed bottom right: MF
Inv. No.: 55.713-P (279)

MEDGYESSY, Ferenc
Sowing Seed. 1935–1938
Bronze, 50 cm
Signed bottom right:
Medgyessy
Inv. No.: 56.766–N (258)

MEDNYÁNSZKY, László
(1852–1919)
Rain-washed Road. c. 1880
Oil, wood, 28 × 42 cm
Signed bottom right:
Mednyánszky
Inv. No.: 50.441 (59★)

MEDNYÁNSZKY, László
Fishing at the River Tisza. c. 1880
Oil on canvas, 153.5 × 249 cm
Signed bottom right:
Mednyánszky
Inv. No.: FK 7170 (142)

MEDNYÁNSZKY, László
Sitting Vagabond. c. 1900
White and black chalk, 31 × 37.3 cm
Signed bottom right:
Mednyánszky
Inv. No.: 1950–4327 (303)

MEDNYÁNSZKY, László
Farm. c. 1905
Oil on canvas, 60.5 × 100 cm
Signed bottom right: Kiss Józsefnek őszinte tisztelettel Mednyánszky
Inv. No.: FK 3783 (198)

MEDNYÁNSZKY, László
Portrait of a Vagabond. After 1905
Oil on canvas, 59 × 45 cm
Signed bottom right:
Mednyánszky
Inv. No.: 56.119 T (83★)

MEDNYÁNSZKY, László
In Serbia. 1914
Oil on canvas, 67.6 × 100 cm
Signed bottom right:
Mednyánszky 1914
Inv. No.: 5245 (199)

MÉHES, László
(1944–)
Hommage à Yves Klein. 1974–1979
Graphite, silk, 110 × 160 cm
Signed bottom left: 1974–79; right: Méhes László
Inv. No.: MM 82.13) (379)

MELEGH, Gábor
(1801–1835)
Portrait of Franz Schubert. 1827
Oil on wood, 60 × 48 cm
Signed bottom right: G.v. Melegh 827
Inv. No.: 5285 (62)

MELEGH, Gábor
Count Vince Esterházy. c. 1830
Lithograph, 2.17 × 19.8 cm
Signed bottom left (faded):
Melegh, 18..
Inv.No.: G 56.11 (289)

MELOCCO, Miklós
(1935–)
Ady — Leading the Dead. c. 1970
Bronze, iron, 46 cm
Unsigned
Inv. No.: MM 81.382 (370)

MÉSZÁROS, László
(1905–1945)
Self-portrait. 1929
Bronze, 26 cm
Unsigned
Inv. No.: 53.538 (265)

MÉSZÁROS, László
The Prodigal Son. 1930
Bronze, 177 cm
Signed bottom right: Mészáros László 1930
Inv. No.: 59.156–N (103★)

MÉSZÁROS, László
Seated Peasant Lad. 1932
Bronze, 43 cm
Unsigned
Inv. No.: 71.30–N (266)

MÉSZÖLY, Géza
(1844–1887)
Szigetvár. 1871
Oil on canvas, 19 × 49 cm
Signed bottom right: Mészöly G. Szigetvár Juli 1. 871.
Inv. No.: 50.479 (131)

MÉSZÖLY, Géza
Fishermen's Ferry at the River Tisza. 1872–1877
Oil on canvas, 77 × 148 cm
Signed bottom right: Mészöly
G. München
Inv. No.: 75.21 T (48★)

MÉSZÖLY, Géza
Fisherman's Shack by Lake Balaton. 1877
Oil on canvas, 140 × 226 cm
Signed bottom right: Mészöly
G. 1877
Inv. No.: 2775 (132)

MÉSZÖLY, Géza
Lido. 1883
Oil on wood, 23.8 × 48.8 cm
Signed bottom left: Venezia
MG
Inv. No.: 1908 (133)

MÉSZÖLY, Géza
The Big Forest in Debrecen. 1885
Aquarelle, pencil, tempera,
23.2 × 37,l cm
Signed bottom right: Mészöly
Inv. No.: 1902-1109 (298)

MOHOLY-NAGY, László
(1895–1946)
Landscape (Tabán). 1919
Pencil, 31.5 × 44.5 cm
Signed bottom right: Moholy-
Nagy
Inv. No.: 1919-588 (310)

MOHOLY-NAGY, László
Construction. 1923
Lithograph, 600 × 440 mm
Signed bottom right: Moholy-
Nagy
Inv. No.: G 90.11 (126★)

MOIRET, Ödön
(1883–1966)
Portrait of a Lady. c. 1909
Bronze, 47 cm
Signed: M.Ö.
Inv. No.: 4965 (246)

MOLNÁR C., Pál
(1894–1981)
The Virgin Mary. 1930
Oil on canvas, 148 × 81 cm
Signed bottom right:
MCP 1930
Inv. No.: 81.3 T (234)

MOLNÁR, Farkas
(1897–1945)
Fiorentia. 1922
Lithograph, 37 × 25.7 cm
Signed bottom right: W. F
Molnár
Inv. No.: G 86.20/2 (312)

MOLNÁR, József
(1821–1899)
Dezső Heroicly Sacrifices Himself for Caroberto. 1855
Oil on canvas, 152 × 187 cm
Signed bottom left: Molnár J.
1855.
Inv. No.: 2721 (83)

MOLNÁR, József
Rendezvous. 1879
Oil on canvas, 125 × 94.5 cm
Signed bottom left: Molnár J.
Inv. No.: FK 4192 (85)

MOLNÁR, Sándor
(1936–)
Principle. 1968
Oil, acrylic, canvas, wood,
90 × 130 cm
Signed in the back: Molnár
Sándor 1968
Inv. No.: MM 90.118 (139★)

MUNKÁCSY, Mihály
(1844–1900)
Yawning Apprentice. 1868–1869
Oil on wood, 31 × 24 cm
Unsigned
Inv. No.: 1897 (112)

MUNKÁCSY, Mihály
The Condemned Cell. 1870
Oil on wood, 139 × 193.5 cm
Signed bottom left:
M.Munkácsy 1870
Inv. No.: 65.54 T (113)

MUNKÁCSY, Mihály
Woman Churning Butter. 1873
Oil on canvas, 120.5 × 100 cm
Signed bottom left: Munkácsy
M. 1873
Inv. No.: 9639 (54★)

MUNKÁCSY, Mihály
Paris Interieur. 1877
Oil on wood, 70 × 101 cm
Signed bottom left: Munkácsy
Paris
Inv. No.: 4677 (114)

MUNKÁCSY, Mihály
Self-portrait. 1881
Oil on wood, 41.9 × 32 cm
Signed bottom right: A mon
excellent ami Jullien M. de
Munkácsy, 1881
Inv. No.: 5120 (115)

MUNKÁCSY, Mihály
Still-life with Flowers. 1882
Oil on wood, 55.5 × 41 cm
Signed bottom left: Munkácsy
1882
Inv. No.:75.19 T (117)

MUNKÁCSY, Mihály
Dusty Road II. c. 1883
Oil on wood, 96 × 129.7 cm
Signed bottom right: M.de
Munkácsy
Inv. No.: 2563 (55★)

MUNKÁCSY, Mihály
The Colpach Park. 1886
Oil on wood, 96.5 × 130 cm
Signed bottom left: Munkácsy
M.
Inv. No.: 2571 (116)

MUNKÁCSY, Mihály
Seashore. c. 1890
Pencil, aquarelle, 24.6 × 34 cm
Signed top left: A kedves kis
Blankának, egyetlen aquarellem,
Munkácsy Mihály Janvier 16
1895
Inv. No.: F 64.128 (117★)

MURÁNYI, Gyula
(1881–1920)
Shop-window Display Competition in Budapest. 1911
Bronze, chased, 10.2 × 6.1 cm
Signed left, centre:
MURÁNYI
Inv. No.: 55.750–P (277)

NÁDLER, István
(1938–)
Untitled (Temesvár — Bucharest II). 1990
Mixed technique, canvas,
200 × 140 cm
Unsigned
Inv. No.: MM 90.108 (147★)

NAGY, István
(1873–1937)
Landscape in Csík. c. 1928
Pastel, cardboard, 70 × 80 cm
Signed bottom right: Nagy
István
Inv. No.: 59-92 T (205)

NAGY, István
Schoolboy. c. 1932
Pastel, paper, 52 × 44 cm
Signed bottom right: Nagy
István
Inv. No.: FK 8945 (85★)

NAGY, Sándor
(1869–1950)
Ave Myriam. 1904
Tempera, oils on canvas,
89 × 60 cm
Signed bottom right: NS 1904
Inv. No.: 6524 (81★)

NAGY BALOGH, János
(1874–1919)
Self-portrait. c. 1912
Oil on canvas, 41.5 × 30.5 cm
Unsigned
Inv. No.: 5724 (210)

NEMES LAMPÉRTH, József
(1891–1924)
Self-portrait. 1911
Oil on canvas, 75 × 60 cm
Signed bottom left: Nemes
Lampérth József
Inv. No.: 65.28 T (89★)

NEMES LAMPÉRTH, József
The Catafalque. 1912
Oil on canvas, 87.5 × 85 cm
Signed bottom left: Nemes
Lampérth József
Inv. No.: 5277 (213)

NEMES LAMPÉRTH, József
Interieur. 1912
India ink, aquarelle,
36.8 × 53.5 cm
Signed top right: NLJ 1912.I.
Inv. No.: 1919-562 (123★)

NEMES LAMPÉRTH, József
Female Nude. 1916
Oil on canvas, 128 × 77 cm
Signed bottom left: Nemes
Lampérth József 1916
Inv. No.: 5509 (214)

NEUHAUSER, Ferenc
(1763–1836)
Saxon Peasant Women Milking a Cow in the Barn. 1805
Oil on wood, 59 × 79 cm
Signed bottom right:
Fr. Neuhauser 1805
Inv. No.: 90.20 M (60)

OHMANN, Béla
(1890–1968)
Portrait of Domokos Kálmáncsehi. Before 1938
Wood, 135 cm
Unsigned
Inv. No.: 68.70–N (268)

ORIENT, József
(1677–1747)
Landscape. c. 1710–1720
Oil on canvas, 60 × 75.5 cm
Unsigned
Inv. No.: 3926 (42)

ORLAI PETRICH, Soma
(1822–1880)
Portrait of the Artist's Mather. c. 1853
Oil on canvas, 51 × 37.5 cm
Signed right centre: Orlay
Petrich
Inv. No.: FK 3990 (36★)

ORLAI PETRICH, Soma
Village School. c. 1860
Signed bottom left: Orlay
Inv. No.: 60.98 T (95)

ORSZÁG, Lili
(1926–1978)
In Memoriam Saeculorum. 1968
Oil, plywood, 70 × 125 cm
Signed bottom left: ORSZÁG
Inv. No.: MM 82.132 (357)

PAÁL, László
(1846–1879)
Landscape with Cows. 1872
Oil on canvas, 78 × 132 cm
Signed bottom left: Paál László
Inv. No.: 56.131 T (134)

PAÁL László
Frogs Swamp. 1874
Oil on canvas, 63 × 92 cm
Signed bottom right: L. de Paál
Inv. No.: 1772 (135)

PAÁL, László
Morning in the Woods. 1875
Oil on canvas, 94.7 × 64.7 cm
Signed bottom left:
L. de Paál, 75.
Inv. No.: 6634 (136)

PAÁL, László
Footpath in the Forest of Fontainebleau. 1875–1876
Oil on canvas, 91.5 × 63 cm
Signed bottom left: L. de Paál
Inv. No.: 3722 (137)

PAÁL, László
Poplars. c. 1876
Oil on canvas, 53.3 × 72.6 cm
Signed bottom left: L. de Paál
Inv. No.: 5077 (53★)

PAIZS, László
(1935–)
The Heir and Heiress to the Throne Have Been Murdered. 1970
Acrylic, cast, 62 × 35 × 17 cm
Unsigned
Inv. No.: MM 81.300 (364)

PAIZS GOEBEL, Jenő
(1899–1944)
Golden Age. 1931
Tempera, wood, l27 × 100 cm
Signed bottom left: Paizs
Goebel 1931
Inv. No.: 67.17 T (236)

PALKO, Franz Anton
(1717–1766)
St. John of Nepomuk Received by King Wenceslaus. 1750s
Oil on canvas, 90 × 58 cm
Unsigned
Inv. No.: 7810 M (49)

PÁSZTOR, Gábor
(1933–)
Chess-story. 1976
Lithograph, paper,
43.5 × 57.2 cm
Signed on the margin, bottom
left: 976 Pásztor G.
Inv. No.: MM 78.117 (378)

PÁSZTOR, János
(1881–1945)
Farewell. 1906
Wood, 77 cm
Signed bottom right: 1906
Pásztor
Inv. No.: 3299 (244)

PATAKY, László
(1857–1912)
The Interrogation. 1897
Oil on canvas, 225 × 299 cm
Signed bottom right: Pataky
L. 1897
Inv. No.: 1539 (63★)

PATKÓ, Károly
(1895–1941)
Nymphs. 1924
Copper-plate engraving,
30 × 38 cm
Signed bottom right: Patkó
Károly 1924 /V.29./
Inv. No.: 1955–4294 (315)

PÁTZAY, Pál
(1896–1978)
Portrait of the Painter Aurél Bernáth. 1930
Bronze, 32 cm
Signed on the right.: Pátzay
Inv. No.: 6485 (264)

PAUDISS, Christoph
(c. 1618–1666)
Portrait of a Man.
Oil on canvas, 59.5 × 50 cm
Unsigned
Inv. No.: 80.8 M (37)

PAUER, Gyula
(1941–)
Maya. 1978
Wood, silk, 203 cm
Unsigned
Inv. No.: MM 82.132 (380)

PERLMUTTER, Izsák
(1866–1932)
Fair in Besztercebánya. 1906
Oil on canvas, 83.3 × 65.5 cm
Signed bottom right: 1906
PERLMUTTER
Inv. No.: 3869 (197)

PERLROTT, Csaba Vilmos
(1880–1955)
Lőcse. 1921
Charcoal, 61 × 48 cm
Signed bottom right: Perlrott
Csaba Lőcse 921
Inv. No.: F 67.2 (313)

157

PINCZEHELYI, Sándor
(1946–)
Hungarian Bread. 1979
Silkscreen, 86 × 61.6 cm
Signed bottom right:
Pinczehelyi Sándor 1979
Inv. No.: MM 82.345 (381)

PÓR, Bertalan
(1880–1964)
Family. 1909
Oil on canvas, 176.5 × 206 cm
Signed bottom right: Pór
Bertalan 1909.
Inv. No.: 60.136 T (194)

RÉKASSY, Csaba
(1937–1989)
Astronauts. 1975
Copper-plate engraving,
29.3 × 19.5 cm
Signed on the margin, bottom
right: Rékassy Csaba
Inv. No.: MM 80.80 (374)

REMÉNYI, József
(1887–1977)
*"For the outstanding
invention..."* (The reverse of
the Semmelweis Medal). 1918
Bronze, cast, 8.9 cm
Signed left side centre:
REMÉNYI
Inv. No.: 73.24–P (278)

RÉTI, István
(1872–1945)
Bohemian Christmas. 1893
Oil on canvas, 145.5 × 121 cm
Signed bottom right: Réti
Inv. No.: 2837 (146)

RÉTI, István
The Funeral of a Homeguard.
1899
Oil on canvas, 196 × 226 cm
Signed bottom right: Réti NB
1899
Inv. No.: 1745 (180)

RÉTI, István
Old Women. 1900
Oil on canvas, 79.5 × 65.3 cm
Signed bottom right: RÉTI
Inv. No.: 1952 (181)

RÉVÉSZ, Imre
(1859–1944)
Panem! 1899
Oil on canvas, 184 × 225 cm
Signed bottom right: Révész
Imre 1899
Inv. No.: 1746 (150)

RIPPL-RÓNAI, József
(1861–1927)
Woman with Bird Cage. 1892
Oil on canvas, 186 × 130.5 cm
Signed bottom right:
Rónai '92
Inv. No.: FK 1385 (171)

RIPPL-RÓNAI, József
*Woman in the Garden (Walking
Woman).* 1895
Pencil, aquarelle,
21.3 × 17 mm
Signed on the left: RRJ
Inv. No.: 1935-2818 (119★)

RIPPL-RÓNAI, József
Village Carnival III. 1896
Coloured lithograph,
39 × 52.5 cm
Signed bottom right: RRJ.
No l. Essaie Rónai
Inv. No.: 1900-284/e (301)

RIPPL-RóNAI, József
Christmas. 1903
Oil on wood, 67 × 99 cm
Signed top right: Rónai
Inv. No.: 9030 (172)

RIPPL-RÓNAI, József
*My Father and Uncle Piacsek
Drinking Red Wine.* 1907
Oil on cardboard, 68 × 100 cm
Signed bottom left: Rónai
Inv. No.: 6333 (79★)

RIPPL-RÓNAI, József
Self-portrait in Red Hat. 1924
Pastel, cardboard, 52.5 × 43 cm
Signed bottom right: Rónai
1924
Inv. No.: FK 1850 (173)

ROMBAUER, János
(1782–1849)
Portrait of a Man. 1813
Oil on canvas, 73 × 61 cm
Signed on the back: Jon.
Rombauer pinxit,
St. Petersburg 1813
Inv. No.: 5618 (61)

ROSKÓ, Gábor
(1956–)
*Let's See What's Happening in
the Big Wide World.* 1990
Acrylic, oil on wood,
153 × 153 cm
Unsigned
Inv. No.: MM 91.171 (399)

RUDNAY, Gyula
(1878–1957)
*Woman Wearing a Lace
Kerchief.* c. 1924
Oil on canvas, 52.5 × 37 cm
Signed bottom right: Rudnay
Inv. No.: 8233 (204)

SAMBACH, Caspar Franz
(1715–1795)
*St. Anthony of Padua with the
Infant Jesus.* 1750s
Oil on canvas, 37 × 28.4 cm
Unsigned
Inv. No.: 75.11 M (56)

SAMU, Géza
(1947–1990)
Stag-trough. 1970
Wood, 243 × 116 × 27 cm
Unsigned
Inv. No.: MM 89.16 (366)

SÁMUEL, Kornél
(1883–1914)
Narcissus. 1911
Bronze, 52.5 cm
Signed: Sámuel C. Firenze 19
Inv. No.: 59.20–N (248)

SASS, Valéria
(1950–)
Balance I. 1988
Wood, stone, 80 × 137 × 8 cm
and 10 × 10 × 8 cm
Unsigned
Inv. No.: MM 90.166 (395)

SCHAÁR, Erzsébet
(1908–1975)
Sisters. 1968
Aluminium, led, iron wire,
170 cm
Unsigned
Inv. No.: MM 76.56 (138★)

**SCHALLHAS, Karl
Philippe**
(1769–1797)
Landscape with River.
c. 1790–1795
Oil on canvas, 79.3 × 59.5 cm
Unsigned
Inv. No.: 2153 (29★)

SCHEIBER, Hugó
(1873–1950)
Crowd. c. 1929
India ink, tempera, aquarelle,
35 × 46 cm
Signed bottom left:
Scheiber H.
Inv. No.: F 66.5 (319)

SCHÉNER, Mihály
(1923–)
Scribble. 1965
Oil, wall-paint, plywood,
74 × 123 cm
Unsigned
Inv. No.: MM 91.12 (352)

**SCHLETTERER, Jacob
Christoph**
(1699–1744)
Immaculata. c. 1754
Alabaster, 48.5 cm
Signed bottom in the back,
later: G.R.D.
Inv. No.: 86.13 M (51)

SCHMAL, Károly
(1942–)
Phases. 1981
Photograph, pastel, paper,
27 × 40 cm
Signed bottom centre: Schmal
Károly
Inv. No.: MM 81.563 (385)

SCHOSSEL, András
(1824–1874)
Hephaistos. c. 1850
Iron, cast, 37.8 cm
Unsigned
Inv. No.: 85.23–N (156)

SCHÖNBERGER, Armand
(1885–1974)
In the Café. 1924
Oil on canvas, 76 × 91 cm
Signed bottom left:
Schönberger A. 1924
Inv. No.: 83.39 T (232)

SCHWARTZ, István
(1851–1924)
Portrait of a Girl. c. 1906
Bronze, chased, 10 cm
Signed bottom right: ST.
SCHWARTZ
Inv. No.: 56.785–P (272)

SENYEI, Károly
(1854 -1 919)
Design of a Well. c. 1895
Bronze, 54.5 cm
Marked on the back: Senyei K.
Inv. No.: 56.565-N (239)

SOMOGYI, József
(1916–1993)
*In Memoriam János Szántó
Kovács.* 1965
Bronze, 78 cm
Unsigned
Inv. No.: MM 81.418 (353)

STANETTI, Dionysius
(1710–1767)
St. Florianus. 1764
Wood, gilded, 248 cm
Unsigned
Inv. No.: 52.799 (26★)

STERIO, Károly
(1821–1862)
The Beginning of the Hunt.
1856
Oil, cardboard, 50 × 63 cm
Signed bottom right: Sterio
856
Inv. No.: FK 8019 (86)

STOCK, János Márton
(1742–1800)
Portrait of a Lady. 1793
Oil, copper plate, 48 × 37 cm
Signed bottom right: Stock J.
1793
Inv. No.: 64.77 (59)

STRANOVER, Tóbiás
(1684–1756)
Barnyard with Cat and Pigeons.
c. 1720–1740
Oil on canvas, 105 × 147 cm
Signed bottom left:
T. Stranover
Inv. No.: 4633 (43)

STRAUB, Philipp Jacob
(1706–1774)
St. Sebastian. 1754
Wood, painted, 119 cm
Unsigned
Inv. No.: 4963 (25★)

**STRECIUS, János the
Elder**
(active c. 1700)
The Apostle St. Peter. 1703
Wood, 200 cm
Unsigned
Inv. No.: 92.6 M (39)

STROBENTZ, Frigyes
(1856–1929)
Walking. 1894
Oil on canvas, 97 × 121 cm
Signed bottom right:
Strobentz Frigyes 1894
Inv. No.: FK 5664 (148)

STRÓBL, Alajos
(1856–1926)
Self-portrait. 1878
Terracotta, 29 cm
Unsigned
Inv. No.: 5943 (163)

STRÓBL, Alajos
Luischen. 1884
Marble, 48 cm
Unsigned
Inv. No.: 57.21–N (166)

STRÓBL, Alajos
Our Mother. 1896
Marble, 161 cm
Unsigned
Inv. No.: 1610 (71★)

STRÓBL, Alajos
Genius. c. 1910
Bronze, 43 cm
Unsigned
Inv. No.: 52.993 (247)

SUGÁR, János
(1958–)
Squash. 1989
Bronze, layered metal., relief,
diam: 80 cm
Unsigned
Inv. No.: MM 90.99 (396)

SWIERKIEWICZ, Róbert
(1942–)
Weather Report 5/9. 1984
Mixed technique, canvas,
200 × 200 cm
Signed bottom right: S R
Inv. No.: MM 90.109 (387)

SZABADOS, Árpád
(1944–)
Ladyslit-ear. 1988
Oil on canvas, 150.5 × 120 cm
Signed bottom centre: Sz.Á.
1988
Inv. No.: MM 90.35 (393)

SZABÓ, Ákos
(1936–)
Farewell. 1962
Aquarelle, tempera, panel,
70 × 125.5 cm
Signed bottom right: SZABÓ
ÁKOS 1962
Inv. No.: MM 92.2 (348)

SZABÓ, Vladimir
(1905–1991)
Awakening. 1966
Pencil, paper, 200 × 300 cm
Signed bottom right: SZ V
22, 7, 66
Inv. No.: MM 81214 (354)

SZALAY, Lajos
(1909–)
Sacred Freedom. 1956
India ink, paper, 28 × 35.5 cm
Signed right centre: Szalay
Inv. No.: MM 90.130 (344)

SZÁRNOVSZKY, Ferenc
(1863–1903)
St. Ladislas. 1892
Bronze, chased, 42 cm
Unsigned
Inv. No.: 55.943–P (270)

SZÉKELY, Bertalan
(1835–1910)
Self-portrait. 1860
Oil on canvas, 60 × 47.5 cm
Unsigned
Inv. No.: 7588 (99)

SZÉKELY, Bertalan
*The Discovery of the Body of
King Louis the Second.* 1860
Oil on canvas, 140 × 181.5 cm
Unsigned
Inv. No.: 2807 (45★)

SZÉKELY, Bertalan
The Women of Eger. 1867
Oil on canvas,
227.5 × 166.5 cm
Unsigned
Inv. No.: 2795 (98)

SZÉKELY, Bertalan
Red-haired Girl. 1870s
Oil on canvas, 56.5 × 46.5 cm
Unsigned
Inv. No.: 55.184 (100)

SZÉKELY, Bertalan
The Dancer. c. 1875
Oil on canvas, 61 × 51.5 cm
Signed top right: Székely
Bertalan
Inv. No.: 55.352 (46★)

SZÉKELY, Bertalan
Zrínyi's Charge from the Fortress of Szigetvár. Before 1884
Sepia, white paint,
36.9 × 58.6 cm
Unsigned
Inv. No.: 1939–3380 (116★)

SZÉKELY, Bertalan
View of Szada with a Draw Well. c. 1890
Oil on wood, 36.7 × 72.8 cm
Unsigned
Inv. No.: 57.112 T (101)

SZEMLÉR, Mihály
(1833–1904)
Conference. 1860
Oil on canvas, 50 × 60 cm
Signed bottom left: Szemlér
M. Pesten 1860
Inv. No.: 58.294 T (94)

SZENTGYÖRGYI, István
(1881–1938)
Complaint. 1908
Bronze, 166 cm
Signed bottom left:
Szentgyörgyi I.
Inv. No.: 3909 (245)

SZENTGYÖRGYI, János
(1793–1860)
Still-life with Flowers. 1828
Oil on canvas, 92 × 74 cm
Signed bottom right: Johann
Szentgyörgyi pinxit 1828
Inv. No.: FK 3917 (63)

SZERELMEY, Miklós
(1803–1875)
*Pannonhalma: Interior of
St. Martin's Church.* After 1845
Lithograph, 31.1 × 23.2 cm
Signed: Szerelmey Miklós
intézetéből Pesten
Inv. No.: G 79.71 (292)

SZINYEI MERSE, Pál
(1845–1920)
The Swing. 1869
Oil on canvas, 50.3 × 41.5 cm
Signed bottom right: Szinyei
Inv. No.: 6655 (49★)

SZINYEI MERSE, Pál
Hanging Out the Wash. 1869
Oil on canvas, 36 × 28.5 cm
Signed bottom left: Szinyei
1869
Inv. No.: 56.167 T (118)

SZINYEI MERSE, Pál
Paganism II. (Study). 1869
Pencil, 45.9 × 29.5 cm
Unsigned
Inv. No.: 1912-671 (297)

SZINYEI MERSE, Pál
Picnic in May. 1873
Oil on canvas, 127 × 163.5 cm
Signed bottom right: Szinyei
Merse Pál 1873
Inv. No.: 1547 (50★)

SZINYEI MERSE, Pál
On the Garden Bench. 1873
Oil on canvas, 20.2 × 33 cm
Signed bottom right: Szinyei
1873
Inv. No.: 6252 (119)

SZINYEI MERSE, Pál
Lady in Violet. 1874
Oil on canvas, 102.5 × 76.4 cm
Signed bottom left: 1874.
Szinyei Merse Pál
Inv. No.: 5078 (120)

SZINYEI MERSE, Pál
The Balloon. 1878
Oil on canvas, 41.5 × 39 cm
Signed bottom right: Szinyei
Inv. No.: 4648 (51★)

SZINYEI MERSE, Pál
Lark. 1882
Oil on canvas, 163 × 128 cm
Signed bottom left: Szinyei
Merse Pál
Inv. No.: 5098 (121)

SZINYEI MERSE, Pál
Thawing Snow. 1884–1895
Oil on canvas, 48 × 60.6 cm
Signed bottom right: Szinyei
Merse Pál 1895
Inv. No.: 6833 (122)

SZOBOTKA, Imre
(1890–1961)
Reclining Nude. 1921
Oil on cardboard, 131 × 100
cm
Signed bottom left: Szobotka I.
921.
Inv. No.: 59.27 T (222)

SZÖLLŐSY, Enikő
(1939–)
The Powers of the Universe III.
c. 1969
Bronze, cast, 10.4 cm
Signed bottom right: SzE
Inv. No.: 72.24–P (286)

SZŐNYI, István
(1894–1960)
Funeral in Zebegény. 1928
Oil on canvas, 100 × 125 cm
Signed bottom right: Szőnyi,
1928
Inv. No.: 63.137 T (225)

SZŐNYI, István
Ox-cart by the River Danube.
1933
Copper-plate engraving,
19.5 × 25.5 cm
Unsigned, indication bottom
right: Szőnyi István
Inv. No.: 1949-3347 (321)

SZŐNYI, István
Evening. 1934
Tempera on canvas,
130 × 90 cm
Signed bottom left: Szőnyi I.
1934
Inv. No.: 6696 (96★)

SZŐNYI, István
In the Yard. 1935
Tempera on canvas,
110 × 140 cm
Signed bottom right: Szőnyi I.
1935
Inv. No.: 6837 (226)

TELCS, Ede
(1827–1948)
Portrait of the Painter's Wife.
1910
Bronze, cast, 13.5 × 12.1 cm
Signed bottom right: TE
Inv. No.: 85.59–P (273)

TELEPY, Károly
(1828–906)
The Cloister of the Carthusians.
1859
Oil, 65.4 × 45 cm
Signed bottom right: Telepy
K. Róma
Inv. No.: 3239 (87)

TELEPY, Károly
The Ruins of Diósgyőr Castle.
1860
Oil on canvas, 53 × 79 cm
Signed bottom right: Telepy
Károly 860
Inv. No.: FK 4759 (39★)

THAN, Mór
(1828–1899)
*King Emeric Captures His
Insurgent BrotherAndrew.* 1857
Oil on canvas, 132 × 198 cm
Signed bottom left: A. Than
Mór, Bécs 1857.
Inv. No.: 2720 (44★)

THAN, Mór
Recruiting Before 1848. 1861
Oil on canvas, 126 × 191 cm
Signed bottom right: Than M.
1861
Inv. No.: 2751 (97)

THORMA, János
(1870–1937)
Suffering. 1892–1893
Oil on canvas, 250 × 300 cm
Signed bottom right:
THORMA
Inv.No.: 1548 (66★)

THORMA, János
The First of October. 1903
Oil on canvas, 154.5 × 215 cm
Signed bottom right:
THORMA.
Ltsz.: 2475 (187)

TIHANYI, Lajos
(1885–1938)
View of a Street in Nagybánya.
1908
Oil on canvas, 70 × 70 cm
Signed bottom right: Tihanyi
L. 08. Nagybánya
Inv. No.: FK 10.479 (75★)

TIHANYI, Lajos
Lajos Kassák. 1918
Oil on canvas, 86.5 × 70 cm
Signed bottom left: Tihanyi
L. 918.
Inv. No.: 70.134 T (215)

TIHANYI, Lajos
*Zenith (Portrait of Branko Ve
Poljanski).* 1925
Black and red chalk,
52.5 × 37 cm
Unsigned
Inv. No.: F 70.132 (317)

TIKOS, Albert
(1815–1845)
Before the Bath. 1839
Oil on canvas, 114 × 99 cm
Signed bottom left: A. Tikos,
839
Inv. No.: 57.89 T (65)

TOLNAY, Ákos
(1861–?)
*The Ancient Castle of Buda,
Turkish Rule in Hungary.* 1896
Offset, 93.4 × 69.5 cm
Signed bottom right: Tolnay
Ákos; underneath: POSNER
BUDAPEST
Inv. No.: X.Y. 72.407 (328)

TORNYAI, János
(1869–1936)
*Farm on the Great Hungarian
Plain.* c. 1910
Oil on canvas,
77.3 × 110.5 cm
Signed bottom left:
FK 1734 (84 ★)

TORNYAI, János
Share. (Sketch). c. 1910
Oil on canvas, 94 × 133 cm
Signed bottom right: Tornyai
Inv. No.: 9882 (203)

TÓT, Endre
(1937–)
Vertical Picture II. 1966
Mixed technique, paper, 55.7
× 147.5 cm
Signed bottom left: Tót 66.
Inv. No: MM 89.127 (356)

**TROGER, Paul, the
Workshop of**
(1698–1762)
The Dereliction of Magus Simon.
c. 1745
Oil on canvas, 82.5 × 48.5 cm
Unsigned
Inv. No.: 90.12 M (46)

TUSZKAY, Márton
(1884–?)
*Oh Joseph, Oh Joseph!... The
Újság.* (Newspaper ad). c. 1925
Offset, 95 × 63 cm
Signed left: Tuszkay; bottom
right: GRAFIKAI INTÉZET
R.T. BUDAPEST
Inv. No.: X.Y. 61.302 (332)

TÜRK, Péter
(1943–)
*Form Arrangements with
Algorhythmical Rhythms II.*
1970
Wall-paint on canvas,
100 × 100 cm
Unsigned
Inv. No.: MM 89.97 (368)

UITZ, Béla
(1887–1972)
Mother and Child. 1918
India ink, aquarelle,
70.1 × 65.1 cm
Signed bottom right: Uitz B.
1918. VIII.
Inv. No.: F 56.97 (124★)

UITZ, Béla
Reclining Woman. 1919
Oil on canvas, 73 × 100 cm
Signed bottom right: U.B.
1919
Inv. No.: FK 9968 (218)

UITZ, Béla
Icon Analysis. 1922
Oil on canvas, 156 × 142 cm
Unsigned
Inv. No.: 72.37 T (219)

ÚJHÁZI, Péter
(1940–)
Circus. 1980
Mixed technique, xylem fibre,
93.5 × 123 cm
Signed bottom left: Újházi
1980
Inv. No.: MM 83.5 (384)

ÚJHÁZY, Ferenc
(1827–1921)
Sad Soldier. 1850
Signed bottom centre: Újházy
Ferenc 1850.
Inv. No.: 81.7 T (80)

VAJDA, Lajos
(1908–1941)
Icon with Mask. 1936
Oil, India ink, paper,
58.5 × 46.7 cm
Unsigned
Inv. No.: 80.62 T (237)

VAJDA, Lajos
Still-life with Tower Plate. 1936
Tempera, 33.9 × 25.5 cm
Unsigned
Inv. No.: 1954-4950 (128★)

VAJDA, Lajos
Self-portrait with Lily. 1936
Pastel, paper, 84 × 62 cm
Unsigned
Inv. No.: FK 8972 (99★)

VAJDA, Lajos
Bird and Skull. c. 1914
Crayon, 83.5 × 53.8 cm
Unsigned
Inv. No.: F 67.10 (325)

VARGA, Imre
(1923–)
Forced March. 1968
Concrete, iron, bones,
26 × 108 cm
Unsigned
Inv. No.: MM 83.97 (362)

VARGA, Nándor Lajos
(1895–1978)
Adam's Funeral. 1926
Copper-plate engraving,
49.6 × 37 cm
Signed top right: Val. 1926
Bp.; indication bottom right:
Varga n L. 926
Inv. No.: 1933–2305 (318)

VÁRNAGY, Ildikó
(1944–)
The Queen of the Night. 1980
Iron, painted,
170 × 91 × 50 cm
Unsigned
Inv. No.: MM 87.174 (145★)

VASTAGH, György Junior
(1868–1946)
Horseman. c. 1901
Bronze, 50.5 cm
Signed: ifj.Vastagh György
(Budapest)
Inv. No.: 56.691–N (169)

VASZARY, János
(1867–1939)
Golden Age. 1898
Oil on canvas, 93 × 155 cm
Signed bottom right: Vaszary
98.
Inv. No.: 1614 (206)

VASZARY, János
National Salon. 1900
Offset, 65.5 × 81 cm
Signed bottom right: Vaszary J.
X.Y. 64.3 (329)

VASZARY, János
Gingerbread Vendor. 1906
Gobelin, 105 × 161 cm
Unsigned
Inv. No.: 60.139 T (80★)

VASZARY, János
*Seated Female Nude Viewed from
Behind.* 1910
Pen, India ink, 29.8x41.5 cm
Signed bottom right: Vaszary
J. 910.
Inv. No.: Vaszary J. 910.
Inv. No.: 1912–557 (121★)

VASZARY, János
In the Park. 1928
Oil on canvas, 80 × 102 cm
Signed bottom right: Vaszary J.
Inv. No.: 2595 (207)

VASZKÓ, Erzsébet
(1902–1986)
Fear. 1970
Pastel, paper, 71 × 91 cm
Signed bottom left: VASZKÓ
E. 970
Inv. No.: MM 89.88 (367)

VEDRES, Márk
(1870–1961)
Human Couple. 1903
Bronze, 36.5 cm
Signed: Vedres Márk, Firenze
1903
Inv. No.: 56.597–N (241)

VEDRES, Márk
Boy Playing the Flute. Before
1910
Bronze, 35 cm
Signed: Vedres Márk
Inv. No.: 73.18 N (242)

VEDRES, Márk
Boy Riding a Horse. 1917
Bronze, 60 cm
Signed: Vedres Márk
Inv. No.: 52.158 (243)

VESZELSZKY, Béla
(1905–1977)
Landscape (Detail). 1962
Oil on canvas, 219 × 148 cm
Unsigned
Inv. No.: MM 85.8 (349)

VIGH, Tamás
(1926–)
*The Medal of the Hungarian
Academy of Sciences.* 1961
Bronze, cast, 73 cm
Unsigned
Inv. No.: 82.29–P (285)

VILT, Tibor
(1905–1983)
Cage. 1949
Wood, nails, wire,
29.5 × 45 × 10 cm
Unsigned
Inv. No.: MM 83.283 (342)

**WAGENSCHÖN, Franz
Xaver**
(1726–1790)
The Judgement of Paris. 1773
Oil on canvas, 93.5 × 74.5 cm
Signed bottom right: F.X.
WAGENSCHÖN Wien 1773
Inv. No.: 91.1 M (55)

WAGNER, Sándor
(1838–1919)
*Titusz Dugovics Sacrifices
Himself.* 1859
Oil on canvas, 168 × 147 cm
Signed bottom right: Wagner
Sándor München 1859
Inv. No.: 2806 (88)

WAHORN, András
(1953–)
Running Boy with Woman.
1990
Oil on canvas, 160 × 200 cm
Marked on the margin, top
right: 90
Inv. No.: MM 91.111 (400)

WEBER, Henrik
(1818–1866)
*Composer Mihály Mosonyi and
His Wife.* 1840s
Oil on canvas, 84 × 68.7 cm
Unsigned
Inv. No.: 5181 (35★)

WEBER, Henrik
A Citizen of Pest. 1840s
Oil on canvas, 70.5 × 57 cm
Unsigned
Inv. No.: FK 3464 (67)

WEBER, József Lénárd
(1702–1773)
*The Holy Father — The Holy
Son.* 1766
Wood, 103 and 107 cm
Unsigned
Inv. No.: 79.1 M and 79.2 M
(52)

WEININGER, Andor
(1899–960)
*Mechanical Ballet — Abstract
Performance.* 1923
Pencil, aquarelle, 29 × 36,l cm
Signed bottom right: A.W. 23.
Inv. No.: F 87.5 (314)

**WORKSHOP IN UPPER
HUNGARY**
(Second quarter of the 17th
century)
*Epitaph Tablet of Anna Rozsályi
Kun, Wife of István Tárkányi.*
Oil, wood, painted, silver
coated, carved, 32 × 189 cm
Unsigned
Inv. No.: 57.16 M (20★)

ZALA, György
(1858–1937)
Philoktetes. 1880s
Bronze, tin alloy, 64.3 cm
Signed: Zala György
Inv. No.: 87.2–N (164)

ZALLINGER, András
(1738–1805)
*The Apotheoses of King
St. Ladislas.* 1784
Oil, copper, 62.7 × 43.3 cm
Unsigned
Inv. No.: 74.10 M (57)

ZANUOLI, Ottavio (?)
(?–1607)
*Maria Christina the Wife of
Zsigmond Báthory, Prince of
Transylvania.* 1595
Egg-based tempera, copper
plate, 17.7 × 12.5 cm
Unsigned
Inv. No.: 86.4 M (36)

ZEMPLÉNYI, Tivadar
(1864–1917)
The Home of the Poor Woman.
c. 1896
Oil on canvas, 150 × 130 cm
Signed bottom left: Zemplényi
Tivadar
Inv. No.: 1594 (149)

ZICHY, Mihály
(1827–1906)
Lifeboat. 1847
Oil on canvas, 135 × 190 cm
Signed bottom left: M. Zichy
1847
Inv. No.: 2328 (78)

ZICHY, Mihály
Demon. 1878
Black and white chalk,
86.5 × 57.5 cm
Signed bottom right: Zichy
Inv. No.: F 60.30 (115★)

ZICHY, Mihály
*Imre Madách: The Tragedy of
Man.* (Illustration). 1887
Charcoal, 79 × 50.3 cm
Signed bottom left: Zichy 87
Inv. No.: 1905-1747 (299)

ZICHY, Mihály
János Arany: Inauguration II
(Illustration). 1892
India ink, ink and wash:
43.7 × 35.2 cm
Signed bottom right: Zichy
Mihály 92.
Inv. No.: 1899–510/b (300)

ZIFFER, Sándor
(1880–1962)
Landscape with Fence. Early 1910s
Oil on canvas, 91.5 × 109 cm
Signed bottom right: Ziffer
Sándor 191
Inv. No.: 60.26 T (77★)

CURRENTLY USED NAMES OF FORMERLY HUNGARIAN PLACES

Barka	Bôrka (Slovak Republic)
Bártfa	Bardejov (Slovak Republic)
Bécsújhely	Wiener Neustadt (Austria)
Berki	Rokycsany (Slovak Republic)
Berzenke	Bzinov (Slovak Republic)
Brassó	Brassov (Romania)
Cserény	Čerín (Slovak Republic)
Csetnek	Štítnik (Slovak Republic)
Csíkmenaság	Armăşeni (Romania)
Csíkszentlélek	Leliceni (Romania)
Dénesfalva	Danišovce (Slovak Republic)
Eperjes	Prešov (Slovak Republic)
Gógánváralja	Gogan varolea (Romania)
Hontszentantal	Antol (Slovak Republic)
Jánosrét	Lúčky pri Kremnici (Slovak Republic)
Jászó	Jasov (Slovak Republic)
Kassa	Košice (Slovak Republic)
Kisszeben	Sabinov (Slovak Republic)
Körmöcbánya	Kremnica (Slovak Republic)
Leibic	Ľubica (Slovak Republic)
Liptónádasd	Trstené (Slovak Republic)
Liptószentandrás	Svätý Ondrej nad Váhom (Slovak Republic)
Liptószentmária	Svätá Mara (Slovak Republic)
Lőcse	Levoča (Slovak Republic)
Mateóc	Matejovce (Slovak Republic)
Mosóc	Mošovce (Slovak Republic)
Nagybánya	Baia Mare (Romania)
Nagyszalók	Veľký Slavkov (Slovak Republic)
Nagyszeben	Sibiu (Romania)
Nagyszombat	Trnava (Slovak Republic)
Nagyvárad	Oradea (Romania)
Németújvár	Güssing (Austria)
Nyitra	Nitra (Slovak Republic)
Okolicsnó	Okoličné (Slovak Republic)
Pozsony	Bratislava (Slovak Republic)
Rozsnyó	Rožňava (Slovak Republic)
Selmecbánya	Banská Štiavnica (Slovak Republic)
Szepesbéla	Spišská Belá (Slovak Republic)
Szepeshely	Spišská Kapitula (Slovak Republic)
Szlatvin	Slatvina (Slovak Republic)
Tópatak	Banský Studenec (Slovak Republic)
Toporc	Toporec (Slovak Republic)
Trencsén	Trenčin (Slovak Republic)
Turdossin	Tvrdošin (Slovak Republic)